The College History Series

TEXAS A&M UNIVERSITY
KINGSVILLE

The College History Series

TEXAS A&M UNIVERSITY
KINGSVILLE

Cecilia Aros Hunter and Leslie Gene Hunter

ARCADIA
PUBLISHING

Published by Arcadia Publishing
Charleston, South Carolina

Printed in the United States of America

Library of Congress Control Number: 00-105480

For all general information, please contact Arcadia Publishing:
Telephone 843-853-2070
Fax 843-853-0044
E-mail sales@arcadiapublishing.com
For customer service and orders:
Toll-Free 1-888-313-2665

Visit us on the Internet at www.arcadiapublishing.com

CONTENTS

PREFACE

At the 50th anniversary celebration of then Texas A&I University, Dr. George Coalson, chairman of the history department, accepted for his department the task of writing the history of the school for its 75th anniversary celebration. Unfortunately, Dr. Coalson, who had first come to the school as an undergraduate in 1946, and later returned as a professor in 1955, died before he could begin the project. Thus in 1996 as the 75th anniversary approached, University President Manuel Ibáñez approached us, Leslie Gene Hunter, Regents Professor of History, and Cecilia Aros Hunter, archivist at Texas A&M University-Kingsville, to write the official history of the school. He set no limits, no boundaries. He asked us to look at the documents and produce a history that would tell the story of the successes, failures, and struggles of the university.

We discussed the project, and because we have been teachers for many years, decided it would be an excellent opportunity to learn and teach history to our students. We believe that when students actually "do" history, with a real purpose and a reason past the traditional term paper, they learn to appreciate it and enjoy doing it. Thus, that fall in the Methods of History Research class, Professor Hunter assigned his students the first of several term papers researching some aspect of the school's history. They needed to learn how to find documents and people who could reveal the past. They found themselves often in the University Archives, South Texas Archives, James C. Jernigan Library, working with Cecilia Aros Hunter, to learn how to use original and primary sources. The history began to take shape as a history of the school by students of the school.

This work is indebted to the history students in those Methods of History Research classes for 1996, 1997, 1998, and 1999, and to everyone in all of the departments who worked with them to do the initial investigation. They truly helped our students learn how to "do" history. If the work is well received, it is primarily because of the work done by so many. But, in the final form, if there is any criticism, or any omissions, it is us, both Hunters, who must accept blame. We checked every term paper, its sources, and every other relevant document we could locate. We analyzed, synthesized, and evaluated the facts that ultimately were used in this volume. In some cases, the work of students was so fine that when we rewrote it, we used their words. We could find no better way to express the ideas of Eden Straw, Michelle Riley, Daniel José Velasquez, and George Cavazos Jr. so we left some of their work intact.

We found that there was almost too much information available and the task of limiting our work was difficult. The University's first historian, John E. Conner, had started collections in the Archives in 1925 and subsequent professors of history including Professor Coalson and Professor Beth Baker, had watched diligently to

make sure that the university saved its records. Conner had left several different versions, of short histories of the school written at various times. President Ibáñez was a friend of the Archives and had provided the archivist with increased funding to care for collections. The facilities at the Archives are adequate to the task. Recently many departments have forwarded their valuable documents to the Archives, so that the school's history is generally well documented, though there is a lack of information in certain areas.

Ultimately, we are grateful for the opportunity to write the history of such a noble and proud school. We have been at this campus for more than 30 years, but did not realize the struggles and difficulties that many before us had endured to bring education to South Texas. We now present to you, in memory of Professor George O. Coalson, this history so that you can understand why we ardently believe that this university has a very proud past and we anticipate that it has a promising future.

The authors are grateful to many present and former faculty, staff and students of the University who shared their memories and to colleagues and friends who read parts of this work in progress especially Sandra Rexroat, M.A. Scherer, Cheryl M. Cain, and Felipe Ortego y Gasca. We need to thank the staffs at the South Texas Archives; Texas A&M University-Kingsville; Kings Ranch Arvchives, Kingsville; the Lyndon Baines Johnson Library, Austin, Texas; the Center for the Study of American History; University of Texas, Austin, Texas; and the Texas State Library and Archives, Austin, Texas. We are especially grateful to the staff of Arcadia Publishing.

This is an attempt to recount briefly the history, mission, accomplishments, and traditions of the 75 years that this university has served the educational needs of young men and women in South Texas. It is a proud past, significant heritage, substantial contribution, magnificent legacy, glorious tradition, and promising future. The newest tradition of this school was contributed by John Jackson, the 1998–1999 President of the Javelina Alumni Association, at the December 1998 commencement ceremony. He ended his presentation with the salute "Jalisco!"

We dedicate this volume: To all past, present, and future Javelinas—Jalisco!

SOURCES

The major source for this history is the University Archives, a component of the South Texas Archives, James C. Jernigan Library, Texas A&M University-Kingsville. It contains the official records of the departments, colleges and central administration of the University going back to the founding in 1925. The collections are extensive and described in finders guides at the South Texas Archives.

Especially useful for student perspective and the mood of the campus are volumes of the student newspaper, *South Texan*, 1925–2000 and the student yearbook, *El Rancho*, 1925–1992.

There are collections in the South Texas Archives which are revealing of the University's history. Especially useful are the John E. Conner Collection, the Cousins Family Papers, and the Flato Family Collection. There are some finders guides to these collections in the on-line catalog of the South Texas Archives (http://archives.tamuk.edu).

Some of the papers of President R.B. Cousins are in Robert Bartow Cousins Papers at the Center for American History, University of Texas, Austin, Texas.

There are oral history interviews with some alumni, students, faculty members, and administrators in the South Texas Oral History and Folklore Collection at the South Texas Archives.

Newspapers were used in the research on this history, especially the Kingsville *Record* and other regional newspapers.

There are some documents concerning the National Youth Administration projects at the Texas College of Arts and Industries at the Lyndon Baines Johnson Library, University of Texas, Austin, Texas.

The Texas State Library and Archives has some relevant documents, especially reports by Robert Bartow Cousins while he was employed as State Superintendent of Public Instruction.

Research papers by students in the Methods of History Research classes were also used as a source for some topics and copies are at the South Texas Archives.

Published Journals of the Texas House of Representatives and of the Texas Senate are especially relevant for legislation dealing with the University.

Several Master's theses and doctoral dissertations, from Texas A&M University-Kingsville and other schools, were used in the course of the research on this history.

In addition, numerous books, journal articles and government publications were utilized during the course of the research. The initial citation in each chapter for these sources is given in full. In the citation of newspapers, only the first few words of the arcticle title, date, and page number have been included. Issues of the *South Texan* include from 25 to 65 articles per issue, but with the title, date, and page number should be easy to locate.

Chapter One

CREATION

SOUTH TEXAS STATE NORMAL COLLEGE

1913–1925

Student contributors:
Michael John Lynch III, Jeff Oines, Haleh T. Pilehvari,
Sandra Rexroat, Alex Richards, Amalia Riojas and Eden Straw

In 1900, Texas south of San Antonio was an underdeveloped frontier. The region below the 29th parallel included 31 counties and parts of 5 others, covering 39,260 square miles—equal in size to the states of Connecticut, Delaware, Massachusetts, New Jersey, New Hampshire, and half of Vermont. South Texas was a rural area with scattered small towns, a few large ranches, and many ranchos, some dating back to the Spanish colonial period. It was a traditional and conservative cultural environment.[1]

However, at the beginning of the twentieth century, there were regional, national, and international changes which had a significant impact upon the area—a transportation and agricultural revolution in South Texas, a national pedagogical revolution in the preparation of teachers, and a political revolution in Mexico. With the arrival of the railroad lines and land seekers, discovery of artesian water, development of irrigation, growth of commercial agriculture, influx of immigrants fleeing political violence, and migration of agricultural laborers seeking employment in South Texas, many communities felt a pressing need for more teachers. However, south of San Antonio, there were no colleges or permanent educational institutions to prepare public school teachers.

For Mrs. Lamar Gill to become a teacher required taking an arduous journey from Raymondville to attend classes at a normal school. History professor John E. Conner recounted her dedication: "To reach a training school, she went from her home to Brownsville by stage coach; from there to Port Isabel by train; from there to Galveston by steamboat; and by train again to Huntsville, where the Sam Houston Normal Institute was located."[2]

Gus Kowalski, a Kingsville attorney who had been born and raised in Brownsville, wrote about a trip his brother took in 1902 to enroll as a student at the Agricultural

and Mechanical College at College Station. Kowalski accompanied his brother to San Antonio on this occasion. He wrote:

> *My father chose to travel by stage coach from Brownsville to Alice. The stage coach used was the old frontier type, having a driver's seat in front and two seats in the back, both facing to the front. Our baggage was carried either on top of the stage or in a rack at the rear. We left Brownsville about six o'clock in the morning, and after traveling continuously two days and one night, arrived in Alice late the following afternoon. The stage stopped at relay stations to change horses, give the passengers an opportunity to stretch their legs and eat a lunch. This was every fifteen miles, except through the sand area, where four mules instead of two horses were used and the relay stations were only ten miles apart. We had to cross the Arroyo Colorado through the Raymond Ranch near the place where Harlingen is now located. We crossed the stream, stage and all, on a flat boat which was pulled across the stream by a rope extended from bank to bank. Our route took us just west of where Kingsville is now and East and within sight of the King Ranch house. Arriving at Alice in the late afternoon, we spent the night at a large two-story frame boarding house or hotel, the name of which escapes me now. The next morning we took the San Antonio and Aransas Pass, commonly known as the SAP, Rail Road to San Antonio were we stayed overnight. . . . From there, we went by train to College Station where my brother was duly enrolled as a student at A&M College.*

Gus Kowalski noted that by the time he went to Texas A&M two years later, the St. Louis, Brownsville & Mexico Railroad had been built to Brownsville. The journey—while still taking several days—was not quite as hazardous or as tedious as his brother had endured. Nevertheless, he remembered: "During our trips on the train, it was necessary for the train to stop from time to time through the sand country so that the train crew could shovel the drifting sand off the railroad track, as there was not then, as now, any vegetation in this sand area to keep the sand from blowing so badly as to cover the rails."[3]

Kingsville, Texas, a product of the transportation revolution in South Texas, was founded on July 4, 1904, to serve as headquarters for the new St. Louis, Brownsville & Mexico Railroad connecting the Rio Grande Valley and South Texas to the rest of the United States. All along the train route newly arrived families on this frontier discovered the difficulty of luring qualified teachers to the area. Kingsville and other South Texas communities concluded that it would be easier to supply teachers by training young men and women who resided in the region.[4]

In the late nineteenth century, a public school teacher did not need a college diploma to teach. University faculties were disinterested in and disdainful of the preparation of teachers. Curriculum and instructional problems gained a major place in normal schools, which were established to train teachers for the primary grades who would receive a teaching certificate but not a college diploma. High school teachers, usually holders of a bachelor's degree from a college or university, would teach small numbers of high school boys and girls from a relatively homogeneous cultural background.[5] However, at the turn of the century the educational system underwent a transformation as the numbers of students and schools increased and the available information expanded dramatically. One scholar of the education of American teachers noted: "The amount required for effective citizenship and

employment rose rapidly as the social and economic system grew more complex and technologically oriented." Professors of education changed their emphasis to "education for citizenship . . . the socially unifying effects of the comprehensive high school, and on the public schools as instruments of democracy." Schools began to include "practical courses in high school elective programs."[6]

Education reform became a major emphasis of Southern Progressives. One student of the subject concluded: "No aspect of social reform in the South during the Progressive era touched the lives of more of the region's inhabitants than the great educational awakening soon after the turn of the century." It reflected the strengths and weaknesses of reform zeal in the South and showed how social action in southern states "almost automatically assumed a regional character." The education renaissance in the South "absorbed the energies and devotion of the South's new middle class and professionals, while exemplifying what C. Vann Woodward has called 'that mixture of paternalism and *noblesse oblige* which is the nearest Southern equivalent of Northern humanitarianism.'"[7]

Another historian has noted that at the beginning of the twentieth century, southern education "experienced what many historians have described as a revolution." The southern universities, led by progressive administrators, provided the "institutional vehicle and intellectual guidance for the efforts of a new middle class to impose order on a society in flux." These universities became "agents of social change," committed to social service and "forging stronger bonds between state governments and their universities." Progressive southern academicians promoted "university extension, agricultural education, high school development, and, in general, social reform" which encouraged "the idea that the university was an instrument of the state." They also reinforced southern traditional attitudes, emphasizing "middle-class social leadership and poor white compliance."[8]

For South Texas, the unique challenge was educating non-English speaking students. There had been a population of Tejanos in South Texas who had long struggled for educational equality. The 1910 Revolution in Mexico drove a large number of Mexicans to the United States for refuge. The dramatic increase in number and distribution of Mexican children forced educators to confront the "Mexican problem" in a series of reports. In 1922, a study on illiteracy concluded that the problem of educating Mexican and Mexican-American children in Texas was "by far the most difficult human problem confronting elementary education in Texas today."[9] The education of new populations of students and the availability of teacher preparation were concomitant problems.

From 1900 to 1920, the population of Texas increased by 53 percent, but enrollment of students in higher education increased by 582 percent. It was not only a change in numbers. The student population became more diverse, creating additional educational problems. One observer noted that older cultural subjects could be taught cheaply, but utilitarian and more practical subjects were more expensive to teach. The challenge for the preparation of teachers increased.[10]

At the beginning of the century, there was only one normal school in Texas: Sam Houston Normal Institute founded at Huntsville in 1878. The population of Texas

had increased greatly, but many students desiring to become teachers could not easily travel to Huntsville. In 1901, two new normals were established: one in north Texas at Denton and another in south central Texas at San Marcos. Eventually, the Texas State Legislature responded to the needs of west Texas, east Texas, and south Texas by creating West Texas State Normal College at Canyon (1910), East Texas Normal College at Commerce (1917), Sul Ross Normal College at Alpine (1920), Stephen F. Austin Normal College at Nacogdoches (1923), and the South Texas State Normal College in Kingsville (1925).[11]

At the state level, there were several academicians concerned about educational problems. Professor W.S. Sutton of the University of Texas wrote in "Some Wholesome Educational Statistics" that in 1904 the national average spent per capita for maintaining schools in the United States was $2.99, but Texas spent only $1.63 per capita. The national average was 145 days of school per year, but the Texas school year was a little over 101 days. In the U.S., 71.54 percent of school age children were enrolled in schools, but only 66.75 percent of Texas young people. State Superintendent of Education Robert Bartow Cousins, included similar statistics in a section of his report, "Ourselves as Others See Us," in 1906. Cousin's Report documented the crisis of public education and expressed the concerns of Progressive academicians. In 1907, a group of educators led by Professor Sutton, Superintendent Cousins, and President H. Carr Pritchett of Sam Houston Normal Institute, established the Conference for Education in Texas to study the conditions of Texas education and promote more adequate standards and facilities.[12]

R.B. Cousins concluded that there were two misconceptions the people of Texas held, which prevented a more rapid development of the public school system. First, Texans commonly believed "the State school fund should furnish all necessary means of support, relieving the school districts of the necessity of even supplementing the amount provided by the state." Secondly, the public believed that Texas actually ranked very high among the states "in public school expenditures, length of school terms, teachers' salaries, etc." Such was clearly not the case.

Cousins pointed out that barely more than half the children attended classes more than half the time they should have been in school. Some schools were open six months a year, "but there are thousands of children in Texas who have the poorest possible school facilities for a term of only two or three months a year." He noted: "It is only fair to the memory of the heroes and statesmen of early Texas to maintain that they believed in the Democratic doctrine in its richness and fullness, viz.: 'Exact justice to all and special educational privileges to none.'" His statistics showed the types of teaching certificates white and black teachers held, the average monthly and yearly salaries, number of school houses of wood, brick, and stone, and the quality of white and black schools. In 1905–1906, white teachers received an annual salary of $262.80 and black teachers $226.26. Of the 7,575 schoolhouses in the country for whites, 7,441 were of wood, 39 of brick, and 95 of stone. All the schools for black children were of wood. Of the white schools, 2,731 were described in good condition, 3,720 in fair, and 1,124 in

poor condition. The condition of schoolhouses for blacks included 243 in good condition, 884 in fair, and 435 as in poor condition.[13]

Cousins noted that 5.8 percent of males in Texas over 21 years of age were illiterate. "The illiteracy of our foreign white population is the greatest in the Union save in New Mexico and Arizona." Texas had the "narrowest limit" of free school age of all the states. Thirty-five other states had compulsory attendance laws, but even the states of Louisiana, South Carolina, and Delaware which had no compulsory attendance laws exceeded Texas in average attendance. Texas had an average attendance of 64.96 percent, while the average for the United States was 69.62. The average number of days taught in 1903–1904 for Texas was 117.24 days compared to 146.7 days for the national average. The average amount spent nationally per student attending school was $24.14 but Texas spent only $13.42.

Cousins was especially concerned about the preparation of teachers—the key to excellent schools. "Texas has no greater agency for the spread of intelligence, civilization, and happiness among her people, than the State Normal Schools." Two generations of Texas leaders had followed the wise policy of producing high quality teachers. "Statesmen of Texas have seen that the first requisite of good schools is good teaching, and, therefore, the means of preparing teachers for the public schools have had most intelligent attention." He felt that it was necessary to meet the high demands of the future, that "an enlightened statesmanship would dictate not only a continuation of the generous policy of the present, but even its enlargement in every legitimate way." Each Normal school should have a practice department where the students could learn in an actual classroom situation, mentored by experienced teachers. Despite the best efforts of the normal schools at Huntsville, Denton, and San Marcos, there were thousands of teachers who entered "the schoolrooms every year without professional training." Of 10,000 teachers who attended summer schools in 1906, 4,345 took the summer normal examinations, "2,000—practically half of them—had neither professional training nor experience in teaching." He estimated that 4,000 Texas teachers left the profession each year. Only half of the 4,345 teachers who took the normal exam received the teaching certificate they sought. The present supply of teachers was inadequate and the state needed to establish another state normal school. Cousins ended his report with a quotation from J.L.M. Curry: "The public free schools are the colleges of the people; they are the nurseries of freedom; their establishment and efficiency are the paramount duty of a republic. The education of children is the most legitimate object of taxation."[14]

Superintendent Cousins was alarmed by the lack of high schools and the low level of teacher preparation. High school education took place at the critical transition when boys and girls became young men and women, but Texas had no law to establish or encourage high school and contributed no money to that purpose. Colleges and universities depended upon high schools as the source of supply for students. Less than one percent of the high school students entered colleges. Of the 914,000 public school children in Texas, only 136,000 white children in urban areas

had access to public high schools.

A half million children a year on their march along the highway of the schools, from babyhood to adulthood, from ignorance to intelligence, from innocence to virtue, reach this chasm between the primary school and the college—they fall into it, a sacrifice to neglect or greed. They can not cross it. . . . Your imagination can not exaggerate the loss the state is sustaining through this fatal defect in our school system.[15]

Although he spoke of the nobility of the teaching profession, he noted that too many teachers in Texas held low grade certificates because of a lack of secondary schools. "More than half the schools, teachers and people of the state are without the grade and quality of work that the high schools afford." Of the 17,500 teachers in Texas, 9,000 held second grade certificates which "implies the absence of high school training and intelligence." This was especially true for the young men and women in the rural areas. Some argued against raising standards of normal schools which would exclude "those country boys and girls that have had no high school training." He concluded that "the normal schools can not do their best work for the state because of the absence of prepared pupils." Texas could not postpone the struggle to create more high schools and fill the fatal gap in educational opportunities. "We shall make our schools be as points of light in Texas, imaging the stars in the bending heavens above us." Every Texan needed to help save the half million children and "guarantee that the future of the state, socially, industrially, commercially, religiously and intellectually shall be worthy of her matchless history." He warned that a state neglected the education of its young people at its own peril. "God stands in the shadow, keeping watch above His own."[16] Cousins and other educational leaders at the state level were concerned about inadequate conditions in public schools.

At the same time, there were many local efforts in South Texas to provide for more trained teachers for the region. As early as 1901, school principals organized a summer normal in Corpus Christi. In 1905, the South Texas Teachers' Institute was first held in Alice and continued for many years to bring teachers together while the Valley Teachers' Institute did the same for the Rio Grande Valley. Nat Benton, Nueces County superintendent of schools, led efforts to establish a Gulf Coast Educational Association to promote progress and cooperation in the region.[17]

By 1909, J.N. Bigbee, superintendent of schools in Kingsville, became frustrated by the difficulty of finding qualified teachers. Kingsville enjoyed an ambitious and progressive commercial club (forerunner of the chamber of commerce) with a membership eager to bring culture and education to the newly formed town. For example, in 1909, Maria Toner helped organize the woman's club to establish a public library. In 1910, Charles Flato constructed an opera house, and in 1912, the Kingsville Concert Band performed concerts every Friday evening in Miller Park. At a meeting in Judge Ben F. Wilson's office of the Kleberg County Commercial Club, Bigbee brought up the idea of a normal college. He described the scarcity of teachers and the difficulty of travel to the nearest normal.[18] He initiated a movement to have the Legislature establish a normal college in South Texas.[19] By the summer of 1913, Bigbee had helped to bring a "Summer Normal" to train teachers to Alice.

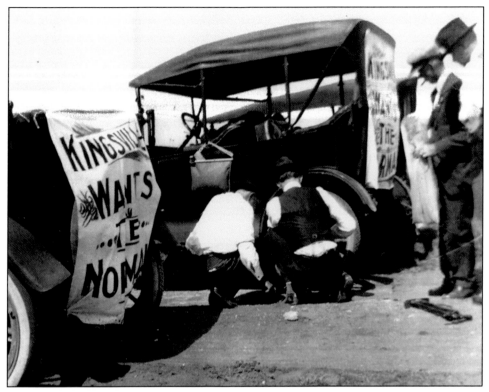

The Commercial Club organized a group as early as 1909 to try to bring a teachers college to Kingsville. They visited area communities for support.

In December 1913, at a six-day Tri-County Institute held in Alice, Bigbee presented a session on the merits of new textbooks and Luz Sanchez presented a session on "How I Teach Non-English Speaking Children to Read." Teachers at the Tri-County Institute passed a resolution asking the legislature for a Summer Normal at Alice. In June 1914, W.G. Ogiers, superintendent of Alice Schools, supervised the nine-week Summer Normal.[20] South Texas educators saw the obvious need for teacher training.

Although the need was apparent to educators, some politicians did not share the concern. In 1911, House Bill No. 146 to establish Abilene State Normal College passed the House, but died on the calendar in the Senate. In the same session—when Senate Bill No. 199 to establish the Central Texas Normal School in Waco passed the legislature—Governor O.B. Colquitt vetoed it. Colquitt explained in his veto message that there were already four normals in operation, which could graduate seven hundred teachers a year. He concluded that there did not seem to be "any need for another such Normal School." In 1913, House Bill No. 65 to establish a state normal at Waco passed the legislature only to have Governor Colquitt veto it. He noted that he had vetoed an almost identical bill two years before. The cost of establishing another school and operating the normal schools would soon take more revenue than the available ad valorem taxes levied for all state purposes. The

15

state already had four normals with 2,300 students, which, when properly equipped, could have a combined attendance of 5,000 students. An additional normal school was unnecessary and the expense needless.[21]

Governor Colquitt noted in his last message to the legislature on January 12, 1915, that the attendance at the four normal schools—Sam Houston Normal School, Southwest Texas Normal School, West Texas Normal School, and North Texas Normal School (Prairie View Normal was listed separately)—had increased from 2,500 to 4,000 students. Their budgets were: Sam Houston $71,000; Southwest Texas $61,000; West Texas $50,000; and North Texas $65,000. The governor explained that he had vetoed legislation for new normals "on the ground that additional schools of this kind were not needed." He believed that the four existing normal schools could easily accommodate and instruct 5,000 teachers annually.[22]

Despite the opposition of Colquitt, who left office in January, 1915, the need for teacher training inspired a renewed effort to bring a normal college to South Texas. J.N. Bigbee asked all towns west of Beeville and south of San Antonio to send representatives to a meeting in Corpus Christi on January 9, 1915. He wanted to plan for petitioning the next session of the legislature to establish a normal school somewhere in South Texas. The site for the school would not be considered until after presenting the petition to the legislature.[23] Delegates in attendance at the meeting elected J.N. Bigbee chairman and Judge W.H. Gossage of Hidalgo County secretary. Bigbee appointed an executive committee with one representative from Bee, San Patricio, Aransas, Kleberg, Hidalgo, Duval, Karnes, Goliad, Nueces, and Starr counties. The committee raised $1,500 for expenses and began to work to establish a college south of the 29th parallel.[24]

Local newspapers reported that the location of the normal school, "according to an honorable agreement entered into by all present, was not to be raised or agitated until the measure had become a law and a locating committee appointed." The meeting at Corpus Christi emphasized that "the larger interests of the section must not be sacrificed to local, commercial, political, or other selfish interests, but that all should stand and work together until the bill should become a law, and then each town would enter into honorable and legitimate competition for the location of the school by the committee named in the bill." The Kingsville *Record* felt that if any town violated this agreement, it should negate their claims to be the site for the new school.[25]

J.N. Bigbee traveled throughout the area and to the legislature justifying with statistics the need for a college. Comparing population growth, taxable land values, scholastic population, and numbers of teachers, he demonstrated that South Texas could support and needed the school. Bigbee noted that the multiculturalism and bilingualism of the students in South Texas required specialized training for teachers. Due to the fact that the people in the region were generally isolated and had to travel long distances for education, teachers in the area, although dedicated, were often ill equipped for the challenge of teaching in two languages to a diverse

student population.[26]

In his speeches, J.N. Bigbee pointed out that the nearest normal school was in San Marcos, which was at least 100 miles away, but an average of 350 miles by railroad transportation from any place in South Texas. Bigbee said that traveling such a great distance from home and family was not only expensive but difficult for many young people. He observed:

> *Timidity and a sort of social difference due to one's being so far removed from his native environment also prevents many students from going off any considerate distance to school for the first time. This is especially true of our Mexican teachers. And just here it is proper to remark that there are thousands of Mexicans in this section who are American born citizens, who never lived a day in Mexico, who are keen of mind and as patriotic of heart as many Americans who look with disdain upon them. From the very best Mexican families we secure a few good teachers and these Americanized and English trained teachers become great factors in the material, social, intellectual, and moral development of their own people.*

Bigbee's comments expressed a sincere concern but also the paternalism and patronizing *noblesse oblige* attitude of Progressive educators:

> *Since the Mexican is with us to stay, is it not economy, good policy and sound statesmanship (not to say nobly humanitarian), to take the crude material we have and make the best possible finished product out of it in the form of citizens? For, the Mexican improves in energy, ambition and trustworthiness as well in morality and patriotism, in proportion to the amount of education he receives. Now, if this Normal would help to make teachers who would help to lift up and make self-supporting and self-respective citizens of thousands of Mexican children, who otherwise would become social riff-raff if not actual burdens to the State, then who can oppose its creation?*

He was concerned that most Mexican-American teachers received "all the training they ever get in a small High School or short summer Normal." Bigbee believed that a normal school in the region would greatly benefit Mexican-American teachers. "With a good normal college in this, their native section, we could have ten well-trained teachers among them to where we now have one poorly trained but conscientious teacher."[27] The campaign of Bigbee and others for a normal school seemed likely to produce quick results.

On January 21, 1915, Patrick F. Dunn of Corpus Christi, representing Nueces, Jim Wells, and Duval counties; L.H. Bates from Brownsville, representing Willacy and Cameron counties; and L.P. Strayhorn from Falfurrias, representing Starr, Hidalgo, and Brooks counties, introduced House Bill No. 215 creating the South Texas State Normal College. Senator Archer Parr of Duval County introduced companion Senate Bill No. 123 the next day in the Senate.[28]

Senator Parr later explained to a history graduate student that he considered this his bill because of his personal interest in the establishment of the college for Mexican Americans. The graduate student wrote: "He knew the needs of this section of Texas, and he felt it would bring education to many of those who could not otherwise get an education. He also felt that it would bring about a better understanding between the Latin and Anglo Americans."[29]

Legislators eventually merged House Bill No. 215 to establish South Texas State

Normal College with House Bill No. 211 to establish Central West Texas Normal School into House Bill No. 116 to establish Stephen F. Austin Normal.[30] In January 1915, J.N. Bigbee lobbied for the normal school and felt confident it would be established. He reported that during an interview with Governor James E. Ferguson, the governor would not commit himself, but Bigbee felt he had presented the situation in such a way that the governor "was most favorably impressed."[31] Bigbee was too optimistic. Ferguson opposed the bill as an extravagance, believing the existing normals were sufficient. He assumed that a student who wanted to go to a normal would travel four-hundred miles as easily as two-hundred miles—the extra $6 railroad fare being insufficient to deter the quest for an education. When the 1915 Legislature passed the bill creating the three normal schools, Governor Ferguson vetoed it.[32]

Other legislation did pass, however, which caused the governor to change his mind about the need for more normals. The State Teacher's Association, the Parents-Teachers Association, and other organizations had discussed the condition of rural education especially. In 1913, there were 8,500 country schools in Texas, of which 6,500 were one-teacher schools and 2,000 of which had terms of less than five months per year. In 1914, the Interscholastic League chose the subject of compulsory attendance for their statewide debates. Texans learned that their state was one of the five least progressive states, joining Alabama, South Carolina, Florida, and Georgia in having no compulsory education. The State Teachers' Association endorsed and Governor Ferguson urged passage of a compulsory attendance bill.[33]

In 1915, 12 representatives introduced House Bill No. 402 "to compel attendance upon public schools of Texas by children between the ages of eight and fourteen years." The act required students to attend school for 60 days a year beginning in 1916, 90 days a year in 1917, and 120 days beginning in 1918. The House Committee on Education recommended passage of the bill, and representatives debated and proposed many amendments. During discussion on the final vote, the speaker instructed the doorkeeper to close the doors and permit no member to leave the chamber without written permission. Some thought the proposed terms were too long. One legislator did not want "to force negro children into white schools." Other members voted for the bill because it was in the Democratic Party platform. Others opposed compulsory attendance if there were no free textbooks. The legislation passed and the governor signed it.[34]

The law was weakly enforced for the first years and there were numerous causes for which children could be excused. Some officials charged with enforcing the law did not support compulsory education.[35] Eventually, the legislation increased the demand for additional teachers for the growing number of public school students. Nonetheless, South Texas still lacked a normal college.

After learning of Governor Ferguson's veto of more normal schools, Kingsville community leaders called a mass meeting at the Flato Opera House. Those attending selected J.N. Bigbee, B.W. Blanton, Claude Pollard, R.J. Kleberg, Caesar Kleberg, and Charles H. Flato Jr. to lead the delegation seeking a school. At the meeting, Kingsville surveyor and dairy-farmer, W. H. Young, offered to donate land for the

school. The newspaper reported: "Mr. Young arose and said that while the matter was started in a joking way, that he then and there agreed in all good faith to donate for the purpose of a building site for the proposed normal school 40 acres of land lying east of his fronting on the railroad."[36] Kingsville mounted a sustained effort for the next several years to obtain a normal college.

Charles Flato and others wrote letters to influential Texans pressing their case. One argument was that Kingsville was a progressive, wholesome community with fine public facilities, and with deed restrictions to prevent the establishment of saloons. Kingsville had never had a saloon and all normal schools were located "in dry towns." Kingsville had population of 6,000, the size of the other communities where all the normals, except one, were located. The town was "not hampered by the decay," or the "allurements or distractions" of larger communities. It did "not advertise itself as a pleasure resort, the atmosphere of a pleasure resort not being conducive to the more serious purposes of life, much less to the earnest, systematic study expected of young people in training for teachers of our children."[37] Kingsville was "a highly moral and religious town," suitable for parents to send their children—especially daughters who were interested in becoming teachers.

In April 1915, the Kleberg County Commercial Club took a second annual "get acquainted" train trip to the Lower Rio Grande Valley. The delegation visited the "Magic Valley" to obtain support for Kingsville as the site of a future normal. They visited Raymondville, Harlingen, San Benito, Brownsville, La Feria, Donna, and Mercedes and received enthusiastic receptions and assurances of support.

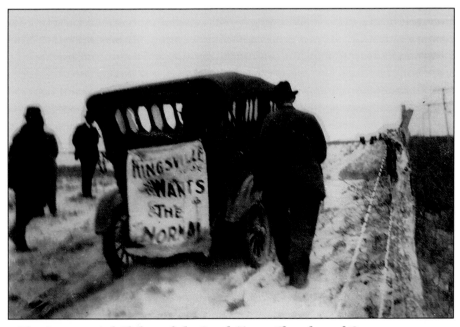

The Commercial Club and the South Texas Chamber of Commerce were adamant in the quest to convince people to bring a Normal School to South Texas.

The "Boosters" arrived at Brownsville in the early evening, "just in time to see the aeroplane flight by the U.S. Aviation Corps, and hear the sound of guns being fired in real warfare, the Carranyistas [*sic*] firing on the aeroplane in the air." The Brownsville *Herald* promised to assist Kingsville, and quoted from a speech of J.N. Bigbee "the 'father' of the South Texas normal school bill."[38]

> *He laid particular stress on the need for a teachers' college in this territory, where the great number of Mexican children creates peculiar problems that can not well be handled by an institution drawing most of its students from territory where conditions are totally unlike those of South Texas. The present normal colleges, for instance, he said, would not find it worth while to devote much time to the study of Spanish, while in South Texas a full knowledge of Spanish is a teacher's most valuable asset.*

The law was not well enforced for the first years and there were numerous causes The Kingsville *Record* decided that the tone of the *Herald* article indicated that Kingsville had won Brownsville's support.[39]

In May 1915, at a special session of the state legislature, Representative T.D. Rowell from Jefferson introduced House Bill No. 13 to create three new normal schools. The bill described the area in which each school would be built and created a locating board, including the governor and lieutenant governor.[40] Governor Ferguson visited Kingsville in early May, and was the guest of Robert J. Kleberg and King Ranch. The governor refused to comment for publication about the normal school, but did note that he was very impressed with the community.[41]

The Senate passed the bill and sent it to the House close to the end of the session. After the third reading of the bill, Speaker of the House John W. Woods of Fisher County, announced that members challenged his authority to place legislation before the House in the last twenty-four hours of the session. Former Attorney General Robert Vance Davidson, Bigbee's brother-in-law, opposed the bill, which died in the House on the last day.[42] Davidson believed that the normal was an unrealistic dream of his brother-in-law. He felt that it could not be developed because it was in the Gulf of Mexico region, and nothing useful could come from South Texas.[43]

This reaction doubtless indicated an anti-Mexican bias, unsurprising given the climate of opinion in 1915. Relations between the United States and Mexico had deteriorated after the beginning of the Mexican Revolution in 1910. In 1914, U.S. military forces seized the port of Veracruz. In 1915, the United States learned of "The Plan of San Diego" and South Texas experienced "border troubles" and the raid on the King Ranch at Norias.[44] This situation made it more difficult to convince state legislatures to establish a normal college in the region.

Dreams of a normal school for South Texas did not die with the failed efforts of 1915. The South Texas delegation renewed its efforts, and by the beginning of the 1917 session united in its determination to win a school for the area. The formidable group of legislators included Senator Archer Parr from San Diego, and Representatives E.D. Dunlap of Kingsville, J.T. Canales from Brownsville, and W.E. Pope of Corpus Christi. Representative José Tomás Canales was a consistent supporter of the establishment of a normal college in South Texas. He had been

in the Texas House from 1905 to 1910 and supported education and other reform legislation. He served as Cameron County Superintendent of Public Schools from 1912 to 1914, and had just returned to the Texas House in 1917. Robert J. Kleberg, Charles Flato Jr., Claude Pollard, Ben F. Wilson, and Edward B. Erard led citizens of Kleberg County to work for the school.[45]

Representative W.E. Pope of Corpus Christi seized the initiative at the 1917 session and introduced House Bill No. 72 establishing the normal school in Corpus Christi.[46] However, Pope alienated South Texas and found opposition to locating the school in Corpus Christi. Victoria, Goliad, Kenedy, Beeville, Sinton, Kingsville, Alice, and Three Rivers were among the many South Texas towns hoping to have the school located in their community. They opposed legislation locating the school without investigation.[47]

The House Education Committee amended the bill so that the final version established a locating committee of the State Superintendent of Public Instruction and the State Normal School Board of Regents. The bill would establish "two State Normal Schools for the education of white teachers"—the South Texas State Normal College south of the 29th parallel and Stephen F. Austin State Normal College east of the 96th meridian. Concerning claims of any town for the normal site, the locating committee would consider "the healthfulness, accessibility, general physical conditions and environments, together with the general moral tone, educational system and social qualities of the people of the said place." The bill appropriated money for the State Normal School Board of Regents to construct buildings and purchase equipment for at least four hundred pupils to be completed before October 1, 1919. The House approved on February 24, 1917, by the vote of 67 to 27, supported by Representatives J.T. Canales and W.E. Pope.[48]

When the bill went to the upper house, Senator Parr was concerned that it might be killed at the last minute as it had been two years earlier. A delegation of Kingsville supporters stalked the halls outside the Senate chamber to overcome any opposition that the normal was unnecessary. The bill passed the Senate and was sent to the governor on March 10th for his approval.[49]

When signing the bill, Governor Ferguson said: "In approving these bills I am quite well aware that a great many good people are of the belief that the schools should not be established." He had been of the same opinion "until I had carefully investigated the facts which now convince me that there is or soon will be a pressing demand" for these new normals. He noted that in 1914–1915 there had been 2,254 students in all the normal schools in Texas but the number had soared to 4,000—a 75 percent increase. "When it is taken into consideration that the compulsory education law, passed during this administration, will bring fully 75,000 new children to our public schools who have never heretofore attended any school, it is evident that it will take 2,500 new teachers to teach these additional pupils alone." The capacity of the existing normal schools could accommodate only 965 more students. In one more year existing normals would be "filled to overflowing." It would take two years to build new normals and by the time they were constructed "the additional demand for teachers on account

of the compulsory education law and the usual increase in our scholastic population will afford a large attendance for the new normals."[50] His approval of the legislation created the South Texas State Normal College, but the location remained unsettled.

The struggle to establish which town would be home to the new school began. The bill stipulated that the normal be south of the 29th parallel so that numerous towns felt they were logical choices. Many South Texans felt that Corpus Christi as a coastal town was an unsuitable location for the school. A more suitable site would be centrally located. Rio Grande Valley towns opposed Corpus Christi's candidacy because it was too far from the Valley, and it was the Valley's population that was growing rapidly. Alice and Kingsville became compromise candidates because of their central location.[51]

Kingsville made a coordinated effort to become home to the normal. Alice organized and began planning its presentation to be the site of the school. However, the Kingsville group had been organized for at least seven years and they had already enlisted the support of the Valley. A delegation of Kingsville businessmen visited Alice "in autos, banners and badges flying" to solicit support for Kingsville as first after Alice, if Alice were an applicant for the school.[52] Kingsville leaders produced an elegant brochure entitled "Kingsville Merits Your Consideration." It contained maps, statistics, photographs, and described the healthy climate of Kingsville, the moral and religious influence of the community, the intellectual and social environment of the city, and especially the accessibility of Kingsville's central location in South Texas. Kingsville attorney Claude Pollard—who would later become state attorney general—presented the report to the special locating board established by House Bill No. 72 with the comment:

> I remember, for it was but yesterday, I lay upon my wild goose feather bed upon my precious southeast gallery and as the mild south east Gulf-of-Mexico breezes kissed and gently caressed my brow and the sweet music of the soft doves lulled me to sleep, I dreamed I went to Heaven. At the gate I was met by St. Peter who asked me what I wished and I replied, "I wish to get into Heaven," and he said that he was sorry that Heaven was full up, but he could recommend a place equally as good, and he did, KINGSVILLE.[53]

After this presentation the locating board toured proposed sites to decide the location of two normal schools. Traveling through the Valley, the board was surprised at the rapid growth they found. On July 14, 1917, the board met in Dallas and voted to establish the Stephen F. Austin Normal at Nacogdoches and the South Texas State Normal College at Kingsville.[54]

Kingsville learned the news at midnight July 14, 1917, when Caesar Kleberg received a telegram stating: "On motion of Governor Ferguson, Kingsville was unanimously selected as Normal site on the third ballot. Congratulations. Joe Kendall." Those who had waited up for this news woke the rest of the community with "train whistles, fire whistles, automobile horns, and fireworks." Charles H. Flato Jr. and a carload of friends drove through Kingsville at 2 a.m. "in good old Paul Revere fashion shouting, 'The college is coming! The college is coming!'"[55]

The Kingsville *Record* published a small insert to the newspaper titled "NOR-MAL-ITE" on July 19, 1917, with local comments about the new school. The edition was dedicated to:

Corpus Christi by the Sea
Goliad by Herself
Victoria on the Guadalupe
Beeville on the Shelf.
This issue is grudgingly dedicated to the above named towns (not cities) without whose knocks (really boosts) this edition could not have been issued.
 —*The Editors*

The special "Last Edition" of the NOR-MAL-ITE from "Normaltown, Texas" also quoted a speech from Caesar Kleberg, thanking the people of the Rio Grande Valley.

Tis to the Magic Valley of the Silvery Rio Grande, its fertile acres, its hospitable and generous peoples, its demands that Kingsville was the gateway to their domain that did open the eyes of the Locating Committee and bring to bear an undisputable fact that Kingsville was the place for the Normal. So I as one do speak for all and thank you good people of the Magic Valley, and beg you command us whenever you may need us, for we shall deem it a great privilege to co-operate with you.

There were numerous humorous comments aimed at cities which had not won the normal—Beeville, Goliad, and Corpus Christi. One classified ad read: "WANTED—Some excuse to offer the people of Corpus Christi: for not getting the Normal—Commercial Club Committee." Another ad read: "LOST—One perfectly good Normal complete. $25,000 reward for safe return to Corpus Christi, Texas." There were other references to the celebration in Kingsville for winning the normal. A notice was posted that all bachelors were to gather "for the purpose of formulating plans for entertaining the lady students of the Normal." Clyde M. Allen was quoted as saying: "It is the best thing that ever happened for the Kingsville Bachelors."[56]

After the initial elation, citizens of Kingsville considered what needed to be done to construct the normal. A proper Citizens Committee of the City of Kingsville made a contract to secure 381.4 acres of donated land from the Kleberg Town and Improvement Company and C.A. McCracken and his wife Minnie McCracken under the rules of the locating committee for the school. It was divided so that 50 acres was set aside for the school site, 106 acres for an experimental farm, and the rest for ranch land. The president of the State Normal School Board of Regents informed Charles H. Flato that the state attorney general on August 24, 1917, approved the title and recorded the deed to the campus.[57]

Unfortunately, the next month international events interceded to frustrate construction of South Texas State Normal College. When the Texas legislature went into a special session, Representative W.V. Dunnam of Gatesville offered a resolution to repeal the appropriations for the creation of new normal schools. He explained that since adjournment of the regular session of the legislature, the United States had "become engaged in the greatest war within the history of mankind." The Great War (later labeled World War I) made it necessary "that strict economy should be

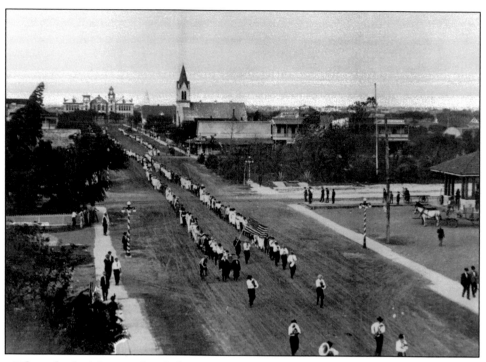

When the legislature decided to establish the South Texas State Normal College in Kingsville in 1917, the main street looked like this.

practiced in the administration of public affairs." The resolution did not pass during the first called session.[58] However, on September 28, 1917, during the third called session of the 35th Legislature, Leonard E. Tillotson from Sealy introduced House Bill No. 58 to repeal the appropriation passed to establish the normal schools.[59] Governor W.P. Hobby had decided that the state could not afford to build the normal schools. Attendance would be low because young men would be at war.[60] Colleges would be unable to contribute to their own support if men were soldiers instead of students. The South Texas State Normal College school had been chartered and the deed for the campus recorded, but construction was postponed.

The Kingsville Commercial Club committed its energy and resources to the school and in September 1918, surveyed its members to learn their priorities for the town. The most pressing problem was to "Win the War," followed by getting the normal for Kingsville.[61] Led by Caesar Kleberg, supporters traveled to Austin where the fight was furious. The session of 1919 produced only fights and squabbles about the establishment of the normal and when it ended there was still no normal school in Kingsville. At the end of the session, debate degenerated into "every known species of argument, embracing the digging up of legislative skeletons . . . the question of 'pork barrel' grabbers, and insinuations of control by interests alien to the cause of the people." Representative J.T. Canales argued vigorously to exempt the South Texas State Normal College from the funding freeze but his motion was defeated by the vote of 59 to 67. The legislation creating the school was intact, but money to

finance its construction was not available.[62]

E.B. "Ed" Erard, the mayor of Kingsville, and E.D. Dunlap traveled often to Austin from 1919 to 1921 to fight repeal efforts and lobby for construction of the normal. In January 1919, a large delegation of Kingsville notables appeared before the House Committee on Education to present "a host of figures and facts" compiled by the commercial club and distribute a large booklet of information to support their arguments. They noted that conditions which prompted the creation of the South Texas State Normal College continued, but were made more urgent as a result of the war. Many young men had interrupted their educations to go to war and now that they were returning, Texas had a duty to them. During the war, local exemption boards, especially in South Texas, learned the "striking revelation" of the illiteracy of thousands of its citizens. "Such fertile fields of ignorance" could be cultivated if the soldiers at the army camps were an example of the amount that could be learned "under the teaching of competent instructors a few hours each day." If this was true of young soldiers, "how much more valuable will it be to the young men and women of more plastic minds." In addition, many soldiers from South Texas were "Americans of Mexican origin, toward whom we owe the duty of education, to say the least."[63]

Eloquent and patriotic appeals made little impact in 1921 as legislators continued to quarrel about establishing and financing new schools. While the opposition was unable to pass a bill negating the creation of the colleges, the supporters of the schools were unable to pass a bill financing construction. Senator Archer Parr, although a strong advocate of the normal school and a very influential senator, could not win this battle in 1921.[64]

Two years later, in 1923, State Senators Archer Parr of Duval County, T.H. Ridgeway of San Antonio, Representative Dunlap of Kingsville, and the South Texas Chamber of Commerce issued an invitation for legislators to visit South Texas. They provided transportation to travel to South Texas to see the growth of the region. Legislators and Governor Pat Morris Neff left Austin on January 30, 1923, and traveled on a special train to Corpus Christi and Kingsville. In Kingsville they toured the King Ranch and attended a barbecue with approximately five hundred guests. Traveling to the Rio Grande Valley, legislators were impressed by what they saw and learned. Many felt that there was a great need for the school, but they also concluded that East Texas had more support for their school than did South Texas. Erard remembered later that he was taken aside and confidentially told by one legislator that because East Texas had more support, it would be wise for South Texas supporters to enlist their help in making it a joint effort to fund both schools. This may have been another indication of an anti-Mexican bias in the post-World War I environment. Delegations from East and South Texas ultimately found it advantageous to work together to secure passage of the funding.[65]

Two months after touring South Texas, in March 1923, the Texas legislature created an Educational Survey Commission to examine conditions of public education and to make recommendations for improvements. A chapter of the survey report, "The Non-English Speaking Children and The Public Schools," described the need

for teachers to teach children who were of Mexican descent. The report noted: "The problem presented by a non-English speaking population in Texas is largely that offered by the presence in many communities of the State of a considerable Mexican element." The commission admitted that good work was being done in some communities once Mexican children were in school. They suggested that the annual teachers' institute provide training for non-English speaking children to read and write English and "that provision be made for giving consideration to the training of teachers for work with non-English speaking groups of children" at the new college to be established in Kingsville. The state of Texas should provide pre-service training of teachers "for this specialized field of service" because "it is a State problem," the Survey Commission concluded.[66]

Reports about the "Mexican problem" in education showed that the presence of a significant number of Mexican and Mexican-American children in the school population had an impact on schools. Such reports "called upon the state to exert leadership in educational change and, if need be, legislation solutions." Texas school officials "had to respond to these new concerns if for no other reason than to alleviate the problems they presented to local administrators, teachers, and parents."[67]

Robert Bartow Cousins explained the urgent need for a Normal School in South Texas to Senator W.E. Doyle. He noted that when they had held teachers meetings in the area covered by West Texas State Normal School in Canyon, about 35 teachers attended. However, when there was a teachers meeting in South Texas 350-500 teachers attended. He suggested to Representative Dunlap an appropriation of $540,000, with $200,000 for the main building, $100,000 for an Industrial Arts building, $100,000 for an Education and Fine Arts building, $60,000 for school furniture, library, and lab equipment, $25,000 for agriculture and domestic science equipment, $25,000 for music and drawing equipment, and $30,000 for barns and livestock.[68]

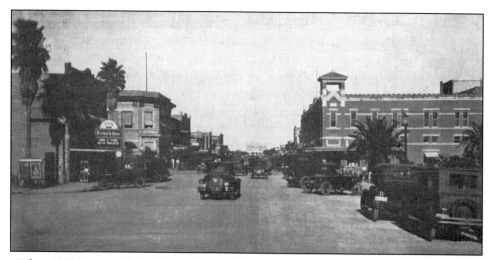

When STSTC opened its doors, Kingsville was a small community of about 6000 with a thriving downtown area.

On September 15, 1924, Robert J. Kleberg turned the first shovel of earth for the new school.

In 1923, Senator A.E. Wood of Granger introduced Senate Bill No. 176 which appropriated $340,000 for buildings and equipment and $10,000 for the president's home at the campus in Kingsville. While the fight had been long, ultimate victory was quick. This legislation also changed the name of South Texas State Normal College to South Texas State Teachers College. The name of the school changed even before the first building was constructed or the first student enrolled. The name change reflected a change in the definition of the school and an enlargement of its mission. In 1920–1925, normal schools had expanded the scope of their curriculum to become regular four-year teachers colleges, granting bachelor's degrees to teachers for all grades from kindergarten through high school. The two-year subcollege department, which had trained elementary school teachers, began to be eliminated.[69]

On June 8, 1925, South Texas State Teacher's College opened for the first session with 276 students, of which 114 were regular college students, 100 summer normal students, and 63 sub-college (high school) students.[70] After a quarter century of planning, promoting, and petitioning, the first state-supported college in South Texas opened its doors. The institution was much needed in an educationally neglected

region. Regional, national, and international events had promoted but also retarded creation of the college. A regional transportation revolution, a national pedagogical revolution, a political revolution in Mexico, and the Great War in Europe had created a demand for a college for teacher preparation in South Texas—but also a political environment that delayed establishment of the school.

Ironically, in the time from chartering the South Texas State Normal College in 1917 to the appropriation for construction of South Texas State Teachers College in 1923, there had been a change in educational philosophy which was reflected by the change in the name of the school. The institution experienced its first name change before the symbolic shovel of dirt had been turned in the ceremonial ground breaking. The physical environment of South Texas was hostile and the political climate had been inhospitable to the state's establishing a teachers college. There was a need for an institution to train teachers and especially bilingual teachers to meet the needs of the rapidly growing population of Mexican Americans. The seed of higher education had been planted in the soil of South Texas. The tasks that lay ahead in order to establish the college included constructing buildings, enrolling students, recruiting a faculty, and beginning classes.

Chapter Two
ESTABLISHMENT
SOUTH TEXAS STATE TEACHERS COLLEGE
1925–1929

Student contributors:
Julie Brandt, Andrea Sue Hernandez, James N. Krug, Richard A. Laune,
Christopher J. Maher, Jeff Oines, Sandra Rexroat, Alex Richards, Amalia Riojas,
Elsa Rodriguez, Scott L. Schaumburg, Eden J. Straw and Donna Jean Weber

Before the repeal of funding for the South Texas State Normal College, the State Normal School Board of Regents had asked Robert B. Cousins to be president of the new school in Kingsville. Cousins had served as Texas Superintendent of Schools from 1903 to 1909 and had worked diligently for establishment of West Texas Normal School at Canyon, becoming its founding president.[1] The Board of Regents felt that Cousins' experience would help him establish the South Texas college. After the Regents appointed him founding president of South Texas State Normal College, he resigned his position at West Texas Normal where he was succeeded by J.A. Hill.[2]

When the state legislature failed to pass an appropriation for the new normal school in Kingsville because of the emergency of the Great War, Cousins was in the awkward situation of having no job. He went to work for his father-in-law, who owned the Kelly Plow Company. After four years with the company, during which time he assisted in opening a new office in Houston, he decided he was unhappy in the business world and returned to his avocation in education. In 1922, he became Superintendent of Houston Schools. When he learned in 1923 that funds for construction of the new Teachers College at Kingsville had been appropriated, he resigned from Houston Public Schools effective at the end of May, 1924, to begin his tenure as president of S.T.S.T.C. on June 1 of the same year. He was eager to go to his new home.[3]

The Houston Post published an article "'Dream College' to Become Real with Cousins at Helm." It noted: "Down in the coast country is a phantom college which

President Robert B. Cousins.

for years existed only on paper in the dreams of bold pioneers." R.B. Cousins, superintendent of Houston Schools, was the president of this "dream college" and had been reelected by the board of regents each year. His duties had been light—no students, examinations, nor routine administrative problems. There was probably no college president in the country with as "soft" a job. "But now it is changed," the *Post* added.[4]

Kingsville was a "nice, clean town" with a population of about 6,000. The first catalog of the college noted: "It is well lighted and has good sidewalks, good churches, and good people." It was 262 miles from Houston, 168 miles from San Antonio, 38 miles from Corpus Christi, and 119 miles from Brownsville. "Kingsville is the gateway to the Magic Valley," the catalog boasted, "the climax of nature's effort to make men prosperous, comfortable, and happy." The catalog believed that everyone should experience the sea breezes and gulf bathing.[5]

In 1925, Kingsville had few paved streets but a sense of its own prosperity. Born as a railroad town on the Fourth of July, 1904, the men and women who came into the area wanted to make it home while community leaders wanted to create a cultural center for South Texas. Nonetheless, the town was a reflection of the people who built it. Segregated into their own area on the north side of town was a largely poor, Spanish-speaking population which had customarily been involved in

farm work, but which now sought other economic opportunities. While some were recent immigrants, many had been in South Texas for generations. Segregated on the south side of town was the African American population, which had arrived with the railroad. They had founded the Colored Trainmen of America, a strong union, which meant that this population was relatively prosperous but still segregated. In the center of town was the dominant Anglo-American population which controlled the main businesses and economic resources.[6]

The three communities were individually dynamic so that Kingsville grew as if it were three different small towns all located in the same area. Each group had its own schools, churches, businesses, and leaders. Their interaction was limited and yet, symbiotically, each was dependent on the other for its existence and continued growth.

The Anglo-American community considered itself progressive and had organized a Commercial Club that evolved into the Kingsville Chamber of Commerce. These businessmen had led the campaign to convince the state legislature to create a normal college in South Texas, and then to locate it in Kingsville. They had built an economically diversified and prosperous business community. Their wives, through the organization of a Woman's Club, had built a public library and had organized strong parent support groups for a public school system that was largely regarded as outstanding. The wives had also fought for the right of all women to vote.

However, segregation dominated ethnic and racial relations. The division of the town into three separate communities reflected prevailing assumptions of "Jim Crow." The Ku Klux Klan was a dominant political force. Some prominent men in the community—including the mayor, county judge, county clerk, sheriff, city commissioner, county commissioner, and editorial writer for the local newspaper—were members of David Crockett Klan No. 10. On the other hand, some of the most influential men in the community opposed the KKK. In 1922, the Klan elected a mayor, ousting the previous mayor who had halted one of their marches. In 1923, the Klan lynched an African-American physician who traveled from Kingsville to Bishop, six miles away in Nueces County. The people of Kingsville were eager to see their town grow and prosper, but, like much of the rest of the country, they had not yet accepted racial, ethnic, and gender equality.

Kingsville had tirelessly campaigned for the state normal school. After the locating committee had chosen Kingsville, citizens obtained the necessary funds by popular subscription to purchase land to donate to the state, and sent the title abstracts to the attorney general—who had accepted the gift in 1917. The State Normal School Board of Regents appointed Charles Flato Jr. to act as the leasing agent and, until his illness and death in 1922, he served in that capacity.[7] Flato, as an agent for the Kleberg Town and Improvement Company with the blessing of the company's president, Robert J. Kleberg, had donated some land on which the new normal college was to be built. He had been in the forefront of the battle for the normal and had led the fight whenever there was a possibility of an educational advantage for Kingsville.

His son, Charles Flato III, would later say in an oral history interview:

The first tract of land was given to this selection committee by Mr. R. J. Kleberg Sr. and my father through the Kingsville Land and Investment Company. They gave the land to establish the school. Sometimes the false impression has been that the King Ranch were the main donors and backers of A&I. They certainly have backed it one hundred percent, but there are many other people in Kingsville, in Kleberg County, that have given of their time and money, experience and foresight into getting the school off to the wonderful university it is now.[8]

In June 1924, President Cousins arrived in town to initiate construction. The legislature had appropriated $340,000 for the main academic building that would house the administration offices, library, and classrooms and $10,000 to build a home for the college president. Kingsville citizens agreed to provide an additional $5,000 and offered free utilities for the new home. By August, President Cousins brought his family to Kingsville. His daughter later recalled upon moving to the new home that "electricity wasn't very reliable." They used a fire in the fireplace to heat the home. She remembered: "When Dad went to Austin on business he made mother and me move to a hotel in town because he didn't want us out in the brush alone in the dark without a telephone."[9]

After completing the president's home, Cousins began to plan the rest of the campus. He established the Spanish Mission Revival architectural theme for the campus, appropriate for the geography, history, and tradition of South Texas.[10] An architect's drawing "Proposed Development of Campus South Texas State Teachers College" shows buildings arranged along the sides of a square with a chapel in

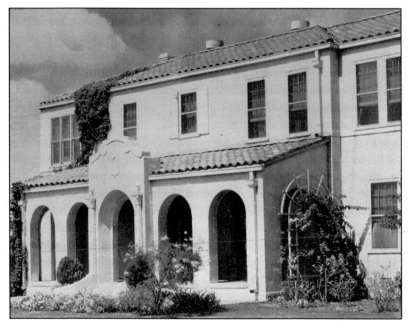

President Cousins brought his family to live in this Spanish Mission Revival style home while he planned the rest of the new campus.

the center of campus. A newspaper clipping in the South Texas Archives includes a picture with a comment in Cousin's handwriting: "This building suggested the idea of the College Bldg." His note along the margin says: "Georgetown H." John E. Conner later inquired of a friend in Georgetown and told a graduate student that the Main Building on campus was modeled after the high school in Georgetown.[11] An architectural historian has concluded that the Main Building (Manning Hall) is the only college or university building in Texas in true "Mission Revival" style of architecture, having "the curved gable parapets, the bracketed wooden eaves, and the Spanish tile roofs."[12]

Mission Revival architecture reflected the heritage of South Texas as well as Cousin's feelings about the missionary, civilizing influence of schools. His description of the Progressive work of one school in New York City with immigrant children echoes with the religious rhetoric of what might be termed an "evangelical educator." "As the children trotted down the streets with clean hands and faces, clad in clean and mended garments, there was a sharp contrast between them and the motley crew that embanked them on either side—their parents!" All these children from around the world, some of them "just off the ships," would "be made into American citizens" in these schools. He noted that *The teachers speak only English*" in teaching children the names of pieces of furniture, body parts, objects around the home or on the streets. From the first day, they taught children to salute the flag and sing the *Star Spangled Banner*. "The teacher's first effort is to teach them American patriotism." Parents were proud and satisfied "as they looked upon their own children treading the path upward from the underground life of the slums, upward toward the light of decent life." Cousins said: "I felt my heart swell with pride in our great country, and in its greatest conception—the public school."[13]

In August, 1924, with approval of the Board of Directors of the Normal Schools, President Cousins awarded the contract for the proposed Main Building to the J.N. Jones Construction Company of San Antonio. The contractor promised to complete the building by May 15, 1925, in time to open the school with a summer session. The architectural firm of Endress and Cato designed the Mission Revival style building under the supervision of the new president. George A. Endress had been architect for the Canyon Normal Building and came to Kingsville to confer about architectural style, location and material of the buildings. Cousins urged the architect to maintain a consistency in all building on the campus. If there was not enough money, he should go as far as possible to keep the facade correct and maintain the style on the outside. Even the President's home should reflect this style. From his home, Cousins oversaw construction of the new administration building while planning curriculum, hiring the first faculty and working to secure funding for the first school session.[14]

Some doubted that classes could actually start on the proposed opening date. At 8 o'clock Monday morning, September 15, 1924, several hundred Kingsville citizens attended the ground-breaking ceremony where Robert J. Kleberg, assisted by Robert J. Eckhardt of the Board of Regents of State Teachers' Colleges, "turned the first shovelful of earth in the construction of the South Texas Teachers' College."[15]

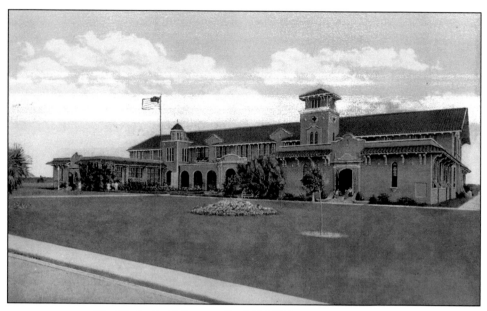

The Main Building at the S.T.S.T.C. campus in 1925.

President Cousins was a tireless and enthusiastic advocate of the "limitless possibilities" of the school, which he felt was destined to become the largest normal college in Texas. He gave sermons in churches and spoke to businessmen in Kingsville and Brownsville on "the gospel of preparedness" to help transform South Texas. The title page of the first catalog boasted: "A College of the First Rank for the Professional Training of Teachers." Within a few years, the title page had added "Open to All Earnest Students." Cousins said: "Teachers should go to teachers' college . . . just as doctors go to medical schools and lawyers to law school." He was anxious that Kingsville make a favorable impression on the first class of students. In January 1925, Cousins spoke to a mass meeting in the Flato Opera House about his concerns for adequate housing for the college students. Robert J. Eckhardt of the Normal Board of Regents startled members of the Commercial Club when he explained that the sister normal school at Nacogdoches was already underway and the "student housing situation" solved by townspeople themselves building around the campus "some of the most beautiful of residences"—not only boarding houses and dormitories—"but real homes of the most attractive sort." The Kingsville newspaper urged the community to do their duty. It would require the collective effort of citizens to solve this problem. The *Record* urged the community to respond quickly because the college was scheduled to open on May 15, 1925.[16]

On March 21, 1925, almost ten-thousand South Texans attended with Governor Miriam A. Ferguson the official laying of the cornerstone in Kingsville. The college planned the ceremony for the last week in December 1924, but canceled because of bad weather. The March 21st date enabled most public officials to attend and five hundred South Texas teachers would be in Kingsville for a meeting, allowing the college an opportunity to recruit these prospective students. Kingsville worked for

months to plan the event. Stores and public buildings were decorated with flags. Cars were available with signs on the windshield reading "Welcome, Teacher's Car, Get In" to drive visitors wherever they wished to go for free. Boy Scouts directed the hundreds of cars. The crowd began to assemble at the Main Building which was located in an open field. In a fenced off area nearby, the community served barbecue to seven-thousand people within an hour. The Magnolia Coffee Company of Houston sent people to serve three-hundred gallons of Wamba coffee, with cream for the coffee coming from Kleberg County cows.

Claude Pollard gave the main address, speaking for over an hour on the history of religion from the beginning to the present. After Pollard's speech, Governor "Ma" Ferguson addressed the audience. Ben F. Wilson Jr. was a young boy and present at the ceremony. He remembers that as the governor began to speak, there was a massive walkout of members of the Ku Klux Klan in protest to her forcing the Klan to remove their hoods. Governor Ferguson congratulated the people of South Texas and then introduced her husband. James Ferguson "pledged his wife's administration to the advancement of education in all its branches" and concluded the program.[17]

On May 26, 1925, the Board accepted the new buildings and approved the budget and the faculty. Senator Archer Parr had managed Senate Bill No. 66 to appropriate $25,000 for the first summer session and Representatives W.E. Pope, Corpus Christi; E.D. Dunlap, Kingsville; and L.C. Smith, Bishop, managed the bill through the House. South Texas State Teachers College "formally opened for its first classes on June 8, 1925, with a faculty sufficient to cover the entire field of educational procedures as required by the state for its teachers colleges." Robert Bartow Cousins said of the professors: "I personally guarantee the religious orthodoxy, the political sanity, and the personal integrity of members of the faculty."[18]

At 8 o'clock on Tuesday morning, June 8, 1925, with the raising of the flag in front of the Main Building, S.T.S.T.C. began its first day of classes. Due to a slow, drizzling rain, the two-hundred students, faculty, and guests adjourned to the auditorium where President Cousins announced: "A living fountain has burst into being, the influence of which will be felt all down through the ages to come." He reminded faculty and students that they were fortunate to be involved in setting precedents which would endure as long as the institution itself. "It is beautiful. It can and will be made a great institution, but we are here to give it its start and must believe in it, must love it, must create ideals, must set standards."[19]

An untitled document in the University Archives describes the campus setting. Much of June 1925 was hot, dry, and dusty.

There were no paved streets in Kingsville; there were no means of transportation except private cars. As some of the first members of the faculty recall, "no fans and no parasols or umbrellas could be bought in the town." The college was located outside the city limits and there was no place nearby to eat. Teachers stayed in private homes and ate downtown, walking back and forth. Soon, however, a sort of chuck wagon set up on the corner of Armstrong and Santa Gertrudis and students and teachers had lunch there. Usually it was so crowded that patrons had to stand in the open to eat. Coffee, bacon and two eggs could be had for 40 cents.[20]

The document also describes President Cousins' first official meeting with his professors: "The first faculty meeting was held in room 129 Main Building [on] June 8. That evening they all had dinner at the Buena Vista Hotel at Riviera, with President Cousins presiding. He asked each teacher to give his or her name, former home and work, and tell his church preference." Cousins had personally selected his faculty from former students or individuals with whom he had previously worked. Almost one-third of the first college faculty had studied at the bastion of Progressive Education, Teachers College-Columbia University, including head of the Art Department, head of the Education Department, two of the three education professors, two of the three English professors, head of the Latin Department, and head of the Home Economics Department.[21] Cousins' distinguished career in education had well prepared him for the task of building a teachers college.

South Texans were eager to know the new academics who came to train their teachers. The new school leader was Robert Bartow Cousins, born in Fayetteville, Georgia, in 1861 and educated in his home state, receiving his bachelor's degree from the University of Georgia. He later studied at the University of Chicago, but earned no advanced academic degrees. In 1926, Southwestern University at Georgetown, Texas, awarded him an honorary LL.D. degree to honor his contributions to education.[22] After graduation from college, he began his teaching career in rural schools in Georgia and briefly in Florida. While working as a teacher, Cousins studied law and passed the bar in 1882. In 1883, he moved to Texas where he believed he would teach until he acquired enough clients to earn his living as an attorney.[23] M.H. Pittman invited Cousins to teach Latin and Greek in the Longview Schools. In Texas he met his future wife, Dora M. Kelly, who was a music teacher. After marrying Dora in 1885, he accepted the position of superintendent of schools in Mineola, Texas, and added administrative responsibilities to his teaching duties. Two years later he became superintendent of schools in Mexia, Texas. He elevated the school to be 1 of only 23 high schools in the state whose graduates were accepted to the University of Texas without examination. Five children were born to the Cousins' family including Ralph Pittman Cousins, who graduated in 1915 from West Point. Ralph began his career as a cavalry lieutenant under Gen. John J. Pershing in Mexico. In 1916, he transferred to the Flying Corps and served most of his career "guiding the Air Force from a cloth-winged fledgling to become the mighty force of World War II." He rose to the rank of Major General in the United States Air Force.[24] With the encouragement of his growing family, R.B. Cousins sought a larger role in education in Texas.

In 1904, after being elected president of the Texas State Teachers Association, Robert B. Cousins resigned as superintendent and worked temporarily at other positions while successfully running for election to become Texas State Superintendent of Public Instruction. He began the task of unifying the state's educational system, ultimately abolishing the "community" system of school organization. Under his leadership, the study of agriculture and home economics became a part of the public school curriculum. The idea of normal school teacher training took hold in Texas where there was an increased demand for teacher preparation.[25]

In 1908, Cousins and several state superintendents from southern states toured schools in New York and Massachusetts. He described his impressions of the schools. They first visited the Horace Mann School and were very impressed by the practice school for training teachers. At the City College of New York and the Brooklyn Training School for Teachers, he saw "the finest work with the children" he had ever seen. He was interested in the Brooklyn Commercial High School where there were many immigrant children who had recently arrived in the United States. He saw a room with children from many nations, speaking many languages, taught by a teacher who spoke none of the languages of the children. All teaching was done in English and he was impressed with the pedagogy and with the impact the school had on "Americanizing" the children. He later visited Harvard, Boston City Schools, and the Department of Education in New York. On a tour in 1909, he visited schools in Iowa as well as the county and normal schools of Wisconsin.[26]

Cousins concluded that the public schools were the greatest conception of the United States. He wrote:

> Everywhere the schools penetrate the darkness with a beneficent ray of hope. They alone make it possible for millions of children everywhere to climb out of dark caverns where serpents creep and hiss, toward life in the fresh air and sunlight. Godless! The public schools are not less than the very manifest thought and purpose of God. They are the substantial realization of the mission of the God-man who walked upon the earth for thirty-three years to bless it and lift it toward His Father!

Cousins noted that schools in the eastern part of the country had devoted sufficient money to educating the masses. "History, teaching by example, has forced the lesson on the older sections that the education of the masses is not a luxury, but a necessity. Their continuance as civilized communities rests upon the proper education of the people." He felt the life and strength "of a man, a family, a state or a nation" rested upon the training the schools provided. He concluded: "It is glorious to be a teacher, and to live in Texas in the dawn of a new day—to contribute what we can to the increasing intelligence and happiness of our common country."[27]

Midway through his third term as state superintendent, he was named president of the newly created West Texas State Normal College at Canyon in 1910—probably due the excellent job he had done as state superintendent. He was able to develop a teacher training school which reflected his philosophy of education and that of progressive educators throughout the country. This school became the model for other schools for teacher preparation in Texas.[28]

In 1917, when South Texas State Normal College was created, President Cousins accepted the challenge of building another new normal school, and resigned from his position at West Texas expecting to move to Kingsville. Although his plans to build a new campus were deferred after the state legislature withdrew appropriations for new normal schools, Cousins stayed in "constant touch with those who had initiated the plans for a state-supported educational institution in South Texas and cooperated with them in pushing it." Cousins corresponded with many South Texans during this interval receiving promises of support for him to be

the president of the South Texas State Normal College and promising to work for establishment of the school.[29] While waiting for the appropriation to create the new normal school, he accepted in the interim the position of superintendent of Houston public schools.

Robert Bartow Cousins was a forgetful man, a day-dreamer, and a philosopher. His daughter remembered that he could be an embarrassment at the many social functions he had to attend as president. He would absentmindedly put the hostess' napkin in his pocket and go home with it, unless he was "frisked." His day dreaming was especially dangerous when he drove an automobile. He thought a car had the same sense as a horse—horses did not run into each other, so neither should autos. In the years when he was driving, "there were not enough cars on the roads to be really dangerous," his daughter recalled, but "someone would have to shout so Dad would wake up and pay attention."[30]

From his new home, Cousins planned the new college and recruited stalwarts for his first faculty. His correspondence with potential faculty members and presidents of other universities gives a sense of the enthusiasm, energy, and excitement with which he set about establishing the new school. Lila Baugh, May H. Dickens, and other faculty he recruited inquired about building a home or the date on which they needed to arrive for the first summer session. The president of North Texas State Teachers College in Denton wrote to Cousins that there was something appealing about his leadership or the venture of establishing a new school because some of his best people had asked him to put in a good word with Cousins, and he recommended three excellent teachers. These teachers needed to be hardy to come to the educational frontier of South Texas. Later, some of the faculty would recall that "their homes could be cleaned early in the morning and by 9 a.m. all the furniture, bedspreads, etc., would be laden with dust."[31]

One of the first students to enroll at S.T.S.T.C. later commented about the early faculty. Charles Flato III, who was the 17th student to register for the first summer class, later said he remembered Dr. Cousins very well. He also recalled how pleased his father was that Cousins had accepted the presidency and brought many teachers who had taught under him in other schools: "We got started with a very good faculty in that respect and they were very cooperative with the board of regents. So there weren't many internal conflicts. That sometimes happens with schools as they just start or after they are going." President Cousins informed his son Ralph he had been successful in selecting a faculty "and I am hoping that we shall soon get on the surfaced road and make progress."[32]

One professor described the appearance of faculty members during the first year of teaching. John E. Conner, one of the first two professors of history at the college, later wrote: "Nearly every man on the faculty wore linen cuffs and collars, and many of the wives did the washing and ironing." He commented that most faculty members, with a few exceptions, wore very proper attire. "Every male faculty member wore a coat and tie when he was in public view. One or two of the men wore seersucker instead of wool during the summer months. It is likely that seersucker decreased the wearer's discomfort. It certainly did nothing good for his

appearance."[33] These first professors were pioneering educators. The first faculty was balanced between male and female, with approximately 45 percent of the professors being women. Maria Jarvis Diaz, the first Spanish-surnamed teacher, appeared in the summer school of 1927.[34]

Faculty members were expected not only to teach classes, but also to build a school. Special courses in domestic science and art were offered. Extension courses in English, literature, math, history, and Spanish were offered in Corpus Christi. Night courses were also offered on campus. Correspondence courses were offered to all from the area who wanted them. Faculty served as judges at the Interscholastic League competitions in Alice, Aransas Pass, Austwell, Calallen, Cuero, Harlingen, Mercedes, Riviera, Robstown, and other communities. From the ranks of the faculty came speakers for graduation ceremonies and special events in neighboring communities. "These visits were made for a three-fold purpose: (1) to help in the educational development of the schools visited; (2) to find out the quality of work the schools in South Texas were doing; (3) to advertise the South Texas State Teachers College."[35]

On campus, courses were offered in art, agriculture, biology, chemistry, commerce, education, English, history, economics, government, sociology, home economics, Latin, mathematics, manual arts, music, physical education, physics, and Spanish. Students could earn bachelor of arts and/or bachelor of science degrees, with or without teaching certificates. They could also earn teaching certificates, including temporary elementary and high school certificates of the first class, permanent elementary, and high school certificates, and special kindergarten certificates, temporary special, and permanent special certificates.[36]

One year after the school opened, President Cousins described his new campus: "The main building which houses the institution in the main in its present form, is a beautiful two-story building, Spanish architecture, made in the form of the letter 'H.' The sides are tan and the roof is red tile. Walks and drives are taking their places as originally planned. Although just about a year old, the front campus is a beautiful Bermuda grass lawn interspersed with trees and flowers, which flourish in this part of the world."[37] The building included two bell towers that were stylized versions of San Antonio Mission San José (on the east side of the building over the administration offices) and Mission Concepción (on the west side over the library). A special feature of campus was "The Forum" (Art Annex building) an open-air auditorium located in back of the building, where students gathered for daily chapel, in the evenings for social functions, or sometimes for classes when the building became too hot.

In the only academic building on the campus, there were 16 offices, 21 recitation rooms, 6 laboratories for use by the classes in physics, biology, chemistry, domestic science, and domestic arts, a library, and an auditorium. Music department equipment included 2 Steinway pianos and a Victrola, besides band instruments. Physical education facilities included basketball and tennis courts, a football field, baseball diamonds, and athletic tracks.[38] Professor Conner kept records that showed that "for instructional and credit purposes the school was on the term or quarter basis, with six class days to the week, Monday through Saturday." College classes

met for one hour and sub-college classes met for forty minutes. The classes met six days a week. "In college, full-year courses were divided into three segments, with two semester hours or three term hours each quarter."[39] The college installed an automatic electric clock system with bells that allowed for orderly transitions between classes.

The first summer term for the school opened on June 8, 1925, with 114 regular college students enrolled. These students were studying for a bachelor of arts or bachelor of science in education, but did not necessarily need to work toward a teaching certificate. In addition, 100 pupils enrolled who were teachers returning for normal school courses to improve teaching skills. Although S.T.S.T.C. had become a degree-granting College of Education, it continued to have the mission of providing for the awarding of teaching certificates which allowed a person to teach without a degree. To complete the student body, 63 sub-college students enrolled who would complete three years of high school classes in preparation for positions in public school education. Students who presented credentials showing that they had completed the tenth grade of a classified high school were admitted to the Sub-collegiate class. Upon completion of the Sub-College Year Class with 16 units, the student was awarded a high school diploma and an elementary certificate of the first-class, valid for three years.[40]

Due to teachers returning to school during the summer, for more than a decade summer enrollments were larger than long-term enrollment. Summer enrollment was more female than male by a ratio of two, three, or four to one. Not until 1938 did regular-term enrollment exceed summer enrollment, and it was not until after the Second World War—when returning veterans enlarged student enrollment—

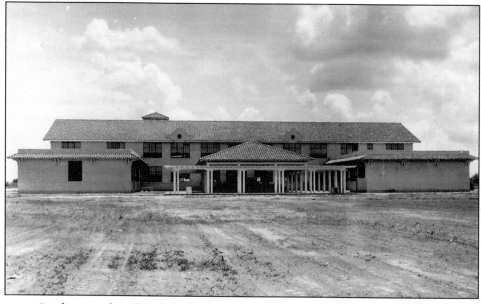

Students gathered in "The Forum," an open air auditorium behind the Main Building.

that there were more men than women in summer school. From the beginning, the college experienced difficulties in obtaining on-campus, full-time students and reached out to South Texas through various continuing education programs.[41]

The number of Mexican Americans who could afford to attend S.T.S.T.C. in 1925 was small but the need was great, especially for those seeking teaching certification. Among the 114 students in the first summer college class were four Spanish-surnamed students from Benavides. Among the 63 sub-college students were three Spanish-surnamed students from Benavides, three from Kingsville, and one from Alice. Among the 100 first summer normal students were 17 with Spanish surnames, 7 from Benavides, 4 from Kingsville, 2 from Laredo, 1 from Santa Cruz, and 1 each from Alice, Harlingen and Eva, representing 17 percent of the class. Of the 276 total students that first summer, 28 were Mexican American, 10 percent of the total. By the spring 1932 semester, Spanish-surnamed students were 7.83 percent of the enrollment, 16.26 percent of the summer enrollment for 1932, 26.74 percent of the correspondence enrollment, and 25.61 percent of the extension students. Spanish-surnamed students comprised a larger percentage of enrollment in summer school, extension, and correspondence courses than they did in the fall-spring semesters from 1925 to 1946.[42]

From the beginning, Kingsville was eager to recruit students from the Rio Grande Valley. One month after the first summer session convened, the Kingsville Concert Band with approximately 250 college boosters, faculty, and band members went on a special Gulf Coast Lines train to the "Magic Valley" to promote the school. The band performed in Raymondville, Lyford, Mission, McAllen, Pharr, San Juan, Alamo, Donna, Weslaco, Mercedes, La Feria, Harlingen, San Benito, and Brownsville. A small group drove on a side trip to Edinburg to distribute promotional literature. A panoramic photograph in the King Ranch Archives shows the train at Mission. Men wore bowler hats with "S.T.S.T. College" hatbands, women wore sashes advertising the school, and banners on the train said "South Texas State Teachers College: The Valley School" and "Next Session Opens Sept. 22nd." Other signs proclaimed: "The College Invites You," "Kingsville Welcomes You," and "Let's make the South Texas Teachers College the Best in the State."[43] Cousins reported that the school had sent exhibits and literature to fairs in Alice, Dallas, and Harlingen and faculty members had spoken to students at many area high schools.[44]

Cousins wanted students to participate in establishing the school and appointed a committee of students and faculty in the summer session to recommend to the student body the earliest traditions. Mary Bartlett, a student member of the committee, later recalled that Porter Garner was the student general chairman and John Conner, Clyde T. Reed, and May Dickens were faculty advisors. Bartlett recalled: "We met and decided to list all the names of animals, flowers, and colors to be discussed at the next meeting." They eliminated all names used by other colleges and high schools and were left with the javelina, coyote, and badger. "We wished the chosen name to be representative of our locality, to symbolize the fighting spirit, and to be a name no other school had. So the committee chose the javelina." After a

little discussion, the committee chose "royal blue and yellow gold as the colors, and the blue bonnet as our flower" even though they knew it was "the State U. flower."

She recalled that many students had never seen a javelina and they tried to capture one for display. They succeeded only in securing a pelt and some photographs. The committee presented its recommendations at an assembly of the entire student body in late September 1925. At that meeting, a vocal group from Houston tried to introduce their own ideas for the first traditions. Mary Bartlett moved that the javelina be named the school mascot. "After some discussion the vote was taken and our animal was elected, although another [the jack-rabbit] was nominated from the floor, by Marguerite Calhoun of the Houston group."

Mary Bartlett continued: "As soon as the nominations for colors were in order Marguerite Calhoun got the floor, nominating brown and gold. Her argument for those colors was based chiefly on the fact that we could use the wild sun flower (that which is about two to three inches in diameter and has the brown center) for the college flower." Calhoun said that she had seen these used at South End Junior High in Houston. When the chair recognized Bertie Bartlett, she moved that the colors blue and gold be selected because she knew they were the choice of the committee. "She concluded her argument with practically these words: 'As far as the flowers are concerned we could easily use the blue bonnet, which has a gold center. Mr. Chairman, I move we adopt the colors blue and gold, and the blue bonnet as our flower.' Motion was seconded and carried without further discussion."[45]

A year after selecting the school mascot in August 1926, agriculture professor W.H. "Aggie" Warren purchased three javelinas and began to train them to act as mascots for the games. He named them Bob, Joe, and Baby.[46] When the javelinas rooted their way out of the pen behind the Main Building and did not leave the campus, Professor Warren left the gate open. Joe and Bob were males—Joe being the largest—and Baby was a small, female javelina. It was not unusual to see the three javelinas strolling around the campus, and all three coming to Professor Warren on command. Bob followed the professor around like a dog. On one occasion, Bob ventured into Miss Hufstutler's expression class being held in the Forum behind the academic building.

> When "Bob," the middle-sized javelina, strolled over to enjoy some of the stories that the members of the class were telling about the three bears, and the little pigs whose mother went to market, the young ladies, with squeals of dismay, took to the benches with far more alacrity than if a mouse had run in on the party. . . . Bob later developed a fondness for the class-rooms, being a very intellectual pig, but it is probably fortunate that he never took a notion to visit one of Miss Hufstutler's classes on the second floor of the building.[47]

Professor Warren raised Baby so that she was as gentle as a Collie puppy. She rode in his automobile to town, jumped out and followed at his command to a photography studio to have her photo taken. She was indifferent to hurrying crowds, noisy automobiles, and unfamiliar surroundings. She was to be mascot for the school football team. Unfortunately, she fell asleep underneath an automobile

Baby, the smallest of three javelina mascots, with Professor W. H. "Aggie" Warren.

during a football game and was run over. The school newspaper reported that the mascot would recover, but thereafter only reported about two javelinas.[48]

Then on September 22, 1929, the little javelinas displayed their true spirit. Dr. Cousins was probably thinking about the events which would take place the next : morning when the School would officially open with the new name: Texas College of Arts and Industries. He may have been dreaming of the struggle to change the college name and he was inspecting the campus for the last time as S.T.S.T.C. Perhaps reflecting on his triumph, he was inattentive or unaware of his surroundings. What happened next was described in the school newspaper:

> *The president was walking about the college grounds at 6 o'clock Sunday evening. Suddenly the javelina, one of a pair that have been mascots of the college for more than three years, rushed towards him. The animal had often rushed playfully at those who were familiar figures about the place and the doctor did not realize the danger until three inch tusks had ripped open his leg. The hog turned to further attacks and having no other weapon available, the veteran educator was compelled to defend himself with his bare hands. After a struggle in which he received a wound in the left hand, he succeeded in gripping the rabid wild hog by the nose and began to back toward his house dragging the attacker with him. Finally the hog ceased its struggles and Mr. Cousins, himself nearing exhaustion, released it. Seemingly satisfied to quit the battle, the javelina trotted away.*
>
> *With blood spurting from the severed veins and arteries, the doctor stopped to make an improvised tourniquet of his belt, walked to his home and administered first aid treatment*

himself before notifying his family of his misfortune. Physicians were called and the wounds dressed.

Later faculty members killed the javelinas, preparing the head of one that had gone on the rampage for examination by the staff of the Pasteur Institute. W. G. Campbell, registrar of the college, made a record breaking auto run to Austin with the head, leaving Kingsville after 10 o'clock Sunday night, completing his mission, and being back at his desk at 11 o'clock Monday morning. The report that the head of the hog showed symptoms of rabies was received shortly after noon the same day and preparations were made at once for Dr. Cousins removal to the Pasteur Institute.[49]

Cousins explained to his sister and to his mother what had happened. The javelina was raised from a small pig to become the mascot for the athletic teams and had been kept in a pen for two years. The animal had recently "acquired the bad habit of breaking out." Late on the Sunday afternoon while Dr. Cousins was walking on campus, he noticed that the animal had broken out of his pen again and "contrary to my expectations of the matter, attacked me." In the struggle the javelina wounded the calf of Cousin's left leg and the ring finger on his left hand. Cousins fought back: "The strategy consisted in grabbing him by the nose and holding his mouth tight together, and dragging him some distance from his pen." This quieted the animal "so that I thought it safe to turn him loose, which I did, where upon he turned and trotted quietly back to his own place."[50]

Dr. Cousins traveled to Austin in an ambulance, accompanied by Dr. J.H. Shelton because "the danger of hemorrhage from the deep wound in the left leg of the victim made the attendance of a physician necessary during the trip." In an undated interview in the university archives, Edith Cousins, daughter of the president, reported:

Three Javelinas were acquired as mascots since they were quite prevalent in this area. One of the Hogs was huge in size and apparently wild. He attacked President Cousins and as a result the president had to go to Austin, Texas, where he underwent a series of twenty-one shots because the animal was rabid.

After this incident the student body wanted to change the name but President Cousins said "no." He said, "We named this team Javelinas because the actual Javelina will fight to the finish, he will defend his cohorts, and he will decoy his enemy away [from] one when he is wounded. Our boys are still examples of Javelinas, therefore, we will not change the name.[51]

Another article in the school newspaper reported "The javelina has had a reputation for always being a fighter." They are small; seldom being more than twenty inches in height and forty inches in length. "When attacked, the pigs stand their ground with such determination that they usually send their larger enemy scurrying off to safety." In a fight, "they boldly face their enemy and begin crowding in with a short rushing drive." An unusual attribute of their fighting style "is that one flock is aware of another flock's danger and will come to its rescue. They will stay until the enemy is either killed or driven off, or until the last javelina is killed." When the faculty also offered to change the school mascot, President Cousins said to them: "I was on that javelina's territory, and he put up a grand fight. The animal is typical of this section of Texas and it certainly has the fighting spirit that would be exemplified in our athletic teams."[52] The javelina mascot became a proud tradition

and has represented the school ever since.

With 21 teachers and not quite 300 students, the new school entered the first fall term enthusiastically. By November 18, 1925, the students published their first issue of the school newspaper that they named the *South Texan*. They announced that a staff for the school annual, entitled *El Rancho*, had been elected and would produce the first issue at the end of the academic year.[53] Students were aware that they were setting precedents for the college.

On June 22, 1925, during the first summer session, 17 students and faculty members met to organize the Robert J. Kleberg History Club, which became the first student society formed at S.T.S.T.C.[54] May H. Dickens, one of the first two history professors, was club sponsor and its first president. The purpose of the club was to "collect and preserve the facts, legends, traditions, and material evidences of the past; endeavor to stimulate a keener and wider interest in the historical affairs of Texas; and thus honor and perpetuate the memory of our fore-bears." Club members started collections through donations that would grow into what is today the John E. Conner Museum and the South Texas Archives, Jernigan Library.

Three days later, the Dora K. Cousins English Club became the second club organized. The Elena Mar Spanish Club was organized in the fall term. It was devoted to the study and use of the Spanish language, conducting all programs and business of the club in Spanish. The programs were planned to give members a wider appreciation and knowledge of the customs, history, geography, literature, and art of Spanish-speaking peoples. The South Texas Nature Chapter of the Agassiz Association (the Nature Club) and the Classical Club were also chartered. The "Magic Valley" Club, composed of students from the lower Rio Grande Valley, strived to "endear the College to the Valley, and to magnify the Valley in the College."[55]

The music department organized a Chorus Club for women interested in music, a Treble Clef Club—an honorary with membership selected by the music director—and a college orchestra. These groups regularly performed for students in assembly and also traveled to neighboring cities to present programs and recruit students. In the first spring semester, music professor A.H. Engle took the Chorus Club on a tour of Gregory, Taft, Goliad, Victoria, and Cuero.[56]

Students and faculty assumed the responsibility of building the school. By the end of the first term, as students were planning to return to their homes for the Christmas break, the school newspaper urged them to go home as advocates and recruiters for their school. The *South Texan* asked them to tell their friends and neighbors the reasons they too should enroll at S.T.S.T.C.[57]

The December 2, 1925 issue of the student newspaper announced that Professor W.H. ("Aggie") Warren, head of the college agriculture department, was setting out palms around the college as fast as he could get both sago and date palms. The students also helped Professor Warren in the establishment of the school grounds. The first senior class planted a row of yucca at the east (Armstrong Avenue) side of the campus on February 22, 1927.

Professor "Aggie" Warren was "a campus character, with bald forehead and drooping mustaches." He dressed informally and Dr. Cousins described him as "ubiquitous."

Faculty and students planted palm trees to help beautify the campus.

"ubiquitous." He went to the post office for the college mail, which he distributed to the boxes in the office of the president's secretary. "He seemed to meet all trains, especially the early ones and brought returning faculty or students to the campus. He was always eating fruit and when he met a young woman he always offered her a bite of plum, peach or apple. He was a florist, too, and brought his 'first bloom' with a pretty speech to each faculty woman."[58] Professor Warren acquired a "delineascope" which he added to the equipment of the art department, to show slides, photographs and drawings. He intended the equipment primarily for the art department, but wanted it to be available to the agriculture and biology departments. He personally planned to use it to project slides he had of birds and bird-life.[59]

Warren also secured a team of Percheron horses from the King Ranch in January 1926, and "disked and dragged the campus preparatory to sodding it with Bermuda grass." He prepared two acres west of the president's house for a small experimental citrus orchard. Warren purchased 42 citrus trees in the Valley and planted them on the campus. One year later, by February 1927, he had 219 citrus trees in the 2-acre grove. His efforts were a precursor to the college's development in 1947 of the Citrus Center at Weslaco.[60] In addition to preparations of the college grounds, others staff members prepared facilities and programs for the first class.

The January 6, 1926 issue of the *South Texan* announced that the new library had processed more than four-thousand books, and seven newspapers. Ann L. Kirvin was the only librarian for the first four years. She had a bachelor's degree but no library experience when appointed. In the fall 1925 semester, with the help of a

woman librarian from San Antonio, she cataloged the collection. Thereafter, she had no secretary and only part-time student help. The library was located in the west wing of the Main Building. In January 1926, Ms. Kirvin announced a closed–shelf policy. For the first academic year 1925–26, she spent $9,533.75 for books and $216.25 for magazines. The total expenditures for 1927–28 were $5,740.12 (of which $1,980.91 was for books and $356.50 for magazines), which amounted to $15.03 per student, and accounted for 3.1 percent of the college expenditures for that year.[61] By December 1926, a state Committee on Teachers Colleges reported there were 8,500 books in the library and that it was one of the best small libraries, more than meeting requirements for the degree work of the college.[62]

In addition to the library preparations, plans were made for the physical education program. President Cousins reported in January 1926, that the school was hampered by a lack of gymnasium and pool. "I thought that our physical exercises might be cared for outdoors for a while, but we find that too much time is lost on account of unfavorable weather." S.T.S.T.C. needed a temporary or a permanent gymnasium as soon as possible. He informed regents that he would have asked for the building and equipment earlier "had I fully understood the climate of this section and the world-wide urge for improving this phase of education." Each student should learn "the elemental laws of health, diet, exercise, habits and the balance." Students should be able to disseminate this information in the schools at which they taught "improving the health and the happiness of the people" whom they serve.[63]

Lewis J. ("Neighbor") Smith, the S.T.S.T.C. athletic director, proudly announced that 70 percent of all men not excused from physical education were participating in a major sport. Coach Smith maintained: "In these games lessons are learned every day which are more impressive than any that are taught in the class-room; better, because one learns by example and illustration much more quickly than by precept." He believed young men and women learn the principles of "mutual dependence, co-operation, division of labor, and independent self activity" combined with a strict "unwritten code of honor."[64]

Coach Smith was the only member of the athletic staff and was coach of football, basketball, baseball, and track for four years. He had no athletic budget, but whatever equipment he requested of President Cousins he always received. "Neighbor" Smith later remembered that of the students the first fall semester, about 40 were men and 30 of them went out for football. They were "a tough breed and they played football because they enjoyed it" and they had to be tough because "we usually never made a substitution in some of our hardest games because we didn't have anyone worth substituting." In the first football game, against Brackenridge High School of San Antonio, the Javelinas won 32-0. The coach's most serious problem in that game was keeping the fans off the field because they had no place to sit and "insisted on standing on the field." Coach Smith's tactics were relatively simple: "I had a wet weather offense and a dry weather offense." One of his greatest wins was his "mud victory" using his "wet weather offense" against Southwest Texas State in 1928 in a "four or five inch driving rain." He instructed the quarterback not to run a play behind the 50 yard

line but instead "punt and let SWT do the fumbling." The javelinas blocked two punts and recovered them in the end zone to win 4-0. "I don't think I ever lost a ball game," he later remembered, "when it was raining good and hard." After four years as coach, he quit the gridiron to become dean of men and professor of history.[65]

In addition to a football squad, the school also fielded men's teams in basketball and track. Women were active in basketball. The *South Texan* reported that there was an attempt to organize a baseball team and both men and women tennis teams.[66] These teams apparently were started too late to be reported in the *El Rancho*.

The English Club sponsored the first student drama presentation. A play entitled "Come Out of the Kitchen" delighted the audience in April.[67] Also in April, the music department sponsored the first South Texas Music Contest, which became a popular annual event. Ten high schools with 112 contestants came to campus to compete.[68] The contest grew and subsequent years saw the number of contestants and participating schools increase substantially.

The faculty worked to help students have fun while they were in school in Kingsville. Edith Cousins, the president's daughter, recalled: "There wasn't much to do then. Nobody had cars, especially students. I doubt that there was a student on campus who had a car—a lot of the faculty didn't either—and we had to create our own fun. So, in those earlier days, the faculty and students were one." Since the community had few offerings for entertainment, the students and their teachers came together to socialize. These were Prohibition years, so entertainment consisted of bridge clubs, beach parties, a costume party for Washington's birthday, and learning how to square dance. The school newspaper reported frequently on student trips and excursions organized and closely chaperoned by faculty members.[69]

In the early years, much of the student social life centered at the boarding houses where students resided. President Cousins reported in January 1926, that "boarding houses have grown with the necessity for them" and board and lodging cost $30–$35 per month. He thought "the boardinghouse keepers are intelligent, sane, and helpful in handling the students." More boardinghouses were being built west of the railroad closer to the campus. In the 1920s, students had to reside in Kingsville, lacking automobiles and because of the state of transportation. A minister in Falfurrias invited President Cousins to meet with his men's bible class and noted that it took him one hour and forty minutes to drive to Kingsville in his Ford.[70]

Boardinghouses were located mostly on West Richard and West Alice. Some information about their locations and the year they were started can be gleaned from telephone books, *El Rancho* yearbooks and *South Texan* newspapers. The 1927 *El Rancho* shows Misericordia Hall, run by nuns for Catholic girls in the 300 block of North Armstrong, Baker House, and Warner House. Mrs. F.G. Frede's House at 732 W. Richard began in 1926; Mrs. J.F. Goode's House at 513 W. Richard began in 1929; Mrs. R.C. Smith began a boardinghouse in 1929; Mrs. M. Nuckols' House at 715 W. Richard began in 1933; Mrs. M.L. McAda House at 725 W. Richard began in 1939; Mrs. L.F. Cavazos' House at 623 W. Ella began in 1939; Madge Falkenburg's House at 725 W. Richard began in 1940; Minette Hargrove's House

at 230 W. Lee began in 1940; and Mrs. Patricia Davis began her boardinghouse in 1942. It is not clear what year several houses were founded, including Mrs. W.S. King's House at 732 W. Richard, Mrs. C.V. Richard's House at 928 W. Alice, Mrs. W.C. Craig's House at 604 W. Alice, Mrs. Eliseo Martinez' Home in the 400 block of East Lee, Mrs. Emeterio De Leon's Home in the 200 block of East Lee, the Salazar Home in the 400 block of West Santa Gertrudis, and the Trevino House in the 400 block of East Richard. A fire at the Dawson House in March 1947, destroyed the clothing and personal belongings of two coeds and damaged the property of eight others. Interviews with some of the "housemothers" indicated that they were married women or widows, with children of their own, and boarded three, four, five, ten, or twelve young students.[71]

One boardinghouse came into being in 1930 when two young ladies arrived in Kingsville and inquired from the minister of their church where they could find lodging. He suggested the home of Mr. and Mrs. Pedro Gonzalez, who had a modest home with a room for their two daughters and a room for their young son. Mrs. Gonzalez convinced her husband to move their son in with his sisters, and rent his room to students. Thus came into being what students affectionately called "Lupita's Dorm." They housed students from distant parts of Texas as well as students from Mexico, Puerto Rico, Venezuela, Honduras, and Costa Rica. They were able to save the income to send three children to college, all receiving master's degrees.[72]

Since there was little recreation for young adults in Kingsville, the faculty also organized social functions for themselves. All unmarried members of the first faculty belonged to the Lopher Club. "Lopher" was an acronym for "Left on Papa's Hands—Ever Ready." The group met every two weeks and gave elaborate parties with fanciful decorations and unusual refreshments. Whenever a faculty member married, the custom (until 1936) was for the college to give the couple a complete chest of sterling silver. In 1928, 16 faculty women cooperatively purchased land and built a cabin near Flour Bluff. They called their hideaway the "Sans Souci Club" and the student newspaper reported about activities at the cabin. At the beginning of World War II, the government assumed the property for the Corpus Christi Naval Base. Social life of the faculty in the early years included picnics, rides in the country, fishing trips to the gulf, parties on the *Japonica*, a pleasure boat at Corpus Christi and dinners at Corpus Christi hotels.[73]

The February 3, 1926, issue of the *El Rancho* reported on an interesting new program at the school. Kingsville school Superintendent J.H. Gregory, who was also the dean of the S.T.S.T.C. sub-college, and President Cousins announced that in the future all Kingsville schools would be used as laboratories for teacher training. The aim was to send "out as teachers young men and women not only well schooled in the subject matter, but with teaching experience."[74]

While serving as state superintendent of schools, President Cousins had long worked toward expanded teacher training in the real classroom under the supervision of teachers who were actually teaching students. He had written: "In connection with each Normal School there should be a practice department, consisting of a

room or rooms properly equipped for doing primary and intermediate work of the highest quality. This work should be done under the supervision of teachers who know education as a science, so that advanced students of the Normals, not only observing this work, but taking part in it, may receive the training which comes from doing the work according to the laws of mental growth under the eye of the expert."[75] With the announcement that teachers in training at South Texas State Teachers College would receive training in a real classroom, Cousins' put his theory into practice.

The following term another progressive move in education was announced. The *El Rancho* reported that the college had hired Dorothy Hetrick and Vila B. Hunt, both former students of S.T.S.T.C., to be teachers of an experimental program in teaching children whose first language was Spanish.[76]

In March 1923, the Texas State Legislature created an Educational Survey Commission to examine conditions of public education and recommend improvement. Chapter XV of the survey report addressed the need for teachers to teach children who were of Mexican descent. The report noted the opening of the new teachers college at Kingsville and suggested provisions be made for training teachers to work with non-English speaking children. The report noted that there were many students in schools whose first language was Spanish. The survey staff explained that "the problem of teaching children who already have speaking control of the vernacular is very different from teaching non-English-speaking children." They believed that both non-English and English speaking children "will make better progress if they are segregated in the early school grades." The staff was concerned about the impact of this recommendation, and added: "This recommendation has been made with some reluctance, as there is danger that it will be misunderstood." Segregation varied from community to community. "In some instances it has been used for the purpose of giving Mexican children a shorter school year, inferior building equipment, and poorly paid teachers." The survey staff concluded that this was "an unwise procedure." The commission emphasized that its recommendation for segregation was based "on educational principles." Ultimately the Survey Commission expressed concern about the danger of allowing communities to handle the "Mexican problem" as they would see fit. The final recommendation was to create legislation to meet the needs of Mexican children.

One of the educational experts who consulted and assisted with the Educational Survey Commission report was the dean of women and director of primary education at the new college. Educated at Columbia University, Lila Baugh had worked with President Cousins when he was Superintendent of Houston Public Schools. She had been an educator with Houston schools for 18 years and had been principal of Allen High School. Baugh was involved specifically with the portion of the report about inadequate instruction for Mexican children.[77]

Baugh began to address problems of bilingual education immediately. As early as July 1926, students in Baugh's class presented to a student body assembly the work they were doing with classes of young Mexican children.[78] The demonstration involved activities in which children were to move or place furniture items in certain areas of the

play house after they were given instructions in English. The demonstration allowed the children to do, see, and hear what they were trying to learn.

The announcement that the school would now offer course work on how to teach Mexican children was innovative and progressive, although from a present day perspective patronizing. Mexican children and adults still faced considerable bigotry and discrimination in South Texas. The school where the S.T.S.T.C. student teachers worked with Mexican children was some distance from the college, near the County Courthouse in the section of Kingsville known as a Mexican "barrio." From the earliest days of Kingsville, the schools were segregated at the elementary level. In 1910, the school district had built a school for the instruction of Mexican children, generally referred to as the "Mexican Ward School." In 1925, the school was officially named Stephen F. Austin School.[79]

According to the *El Rancho*, education classes at Austin School were to be "an experiment to test and formulate suitable methods of teaching Mexican children." Approximately 80 pupils were chosen at random from the beginner's class of the Mexican Ward School. "The purpose is to teach these children, who knew practically no English at the time they entered, in such a way as to give them the necessary vocabulary so that they might complete the first grade in the nine months instead of twice that amount as is usually the case with Mexican beginners."[80]

In 1928, the University of Texas conducted several studies on the education of Spanish-speaking children and included a section on the methods of Lila Baugh. Education 225 was developed for teaching in schools in South Texas for the first through third grades. Baugh described her schools as a "four-room building" designated to S.T.S.T.C. by the Kingsville public schools. With about 40 students in each room, the school included first through third grades. The four teachers had taken the Education 225 class and had nine months training in the experimental school.

> The problem set for each teacher in each grade is to teach English so dynamically and vividly that the prevailing custom of Mexican children spending two years in each grade because of the language handicap may be removed and these children advanced at the same rate as English-speaking children. When they have finished the third grade our objective is that they shall have an adequate speaking, reading, and writing vocabulary that functions readily and will make it possible for them to take the course of study from the fourth through the upper grades as easily as native Americans.

Professor Baugh's general plan was "to have the children learn English through becoming adjusted to their environment and through acquiring good habits of living." Her outline included I. Health Habits (1. Foods, 2. Cleanliness, 3. Posture); II. Environment (1. Schoolroom, 2. Playground, 3. Home, and 4. Community). The study included some examples of dialogues that one teacher, Vila B. Hunt, had with her first grade class at the end of the fall term.

The University of Texas study noted there were 187,000 Spanish-speaking children ages seven to seventeen in Texas, about one in eight children of school age. Despite Texans' professions of faith in public education, in actual practice there were varying degrees of segregation, inferior buildings, inadequate equipment, antiquated supplies, poorer teachers, and shorter school terms. Mexican and Spanish-speaking

children entered school later and dropped out earlier. Probably over 90 percent of these students began school unable to understand or speak English. "Only about one-half of 1 percent of the white enrollment in the colleges and universities of Texas consists of Mexican students." The report concluded that research on this subject had barely begun and urged further study and the need for more teachers. "The Mexican child needs nothing so much as to be known and understood by men and women of deep human sympathy."[81]

President Cousins explained to a legislator: "The problem which presents itself peculiarly to a South Texas institution is that of preparing teachers for those public schools in which there is a large element of non-English speaking children, and the main effort is to reduce the time of preparation of these children for doing the regular grade work in English." He noted that the current view was that it took two to four years for a Mexican child to be able to do the first grade work and then pass through the grades with the English speaking children. The Department of Education at S.T.S.T.C. had "set itself diligently to the solution of that problem" and had succeeded in disproving the theory "by getting the Mexican children ready during the first year to take up the second year of the regular public schools along with other children." He was proud that the school had "done a rather remarkable piece of work in a very short time." Superintendents of public schools in South Texas "are coming to us for teachers trained in our department of education because of the reputation which our training department has made for doing this work."[82]

The county superintendent of public instruction for Starr County visited the school and was delighted to learn that some faculty members "were entirely in sympathy with our border problem of dealing with non-English speaking people." The superintendent reported that she had tried for a long time to encourage Mexican-American boys and girls to go to college in Kingsville. In the summer of 1929, she sent several "native teachers to Kingsville for the summer term." The results were one of her proudest accomplishments: "These teachers gained an entirely new vision. They have come home greatly encouraged as to their own possibilities; aware of the rich opportunities offered them within a short distance of their home." Every one of them intended to return for summer school and almost all of them had registered for correspondence courses. "Now, they want Mr. Porter to come every week and conduct an extension course." She felt that "the native girls can do more to build up a feeling of good will and interest in our country in behalf of our state school than I could ever do in a thousand years." There were "a fine lot of boys and girls in our rural schools" and she intended to try every means to get them to complete high school and attend college: "My Mexican girls tell in glowing term of the friendliness and cordiality with which they were received." She assured President Cousins: "You will hear more and more from Starr."[83]

Baugh's program which started during the 1920s can be considered the precursor to an educational concern that would ultimately develop into a bilingual/bicultural curriculum that was the first doctoral degree offered at the Kingsville campus. Her approach was the "direct method" of English-Only pedagogy which followers of the French linguist Francois Gouin—such as Henry Goldberger of Columbia

University—advocated for teaching a new language to immigrant children. It avoided use of the native language entirely. What she called teaching "dynamically and vividly" was referred to in literature as the "dramatic" method. One student of the history of bilingual education has concluded: "Direct method lessons were hallmarks of Progressive Education." He also noted that Texas A&I became "a key pedagogical laboratory in the development of English-Only pedagogy for Mexican Americans." The "Americanization" approach is considered outmoded and reactionary according to contemporary bilingual education philosophy, but it was progressive for its time.[84]

Baugh's ideas about teaching non-English speaking students were considered progressive, and her actions as dean of women were equally protective and patronizing toward the young women who came to the school. She was protective of the young women who came to the school. From the earliest days, female students received instructions to visit with the dean of women for:

> 1. Consultation and information about rooming and
> boarding places and regulations.
> 2. Conference about change of boarding places.
> 3. To report illness of women students.
> 4. Consultation about student social life.
> 5. Friendly consultation on student problems.
> 6. Permission for out-of-town trips.
> 7. All students or groups go to Dean of Women for
> permission for social gatherings of various kinds and for
> selection of chaperons for such events.[85]

Male students were to consult the dean of men for many of the same reasons, but rules were not as strictly enforced and there were fewer male students. Taking into account ambiguities of names, some of which listed only initials, the first catalog shows that female students outnumbered male students in the first summer session. Of the college students, there appeared to have been 86 females and 28 males; of the sub-college students there were 42 females and 21 males; and of the summer normal students there were 91 females and 9 males. In total, there were 219 female and 58 male students—a ratio of four to one—the same proportion of female to male teachers in the state of Texas. However, among the future teachers in the normal, women outnumbered men ten to one. This trend continued for years. In 1930, the registrar reported that women were 90 percent of students enrolled at the summer normal. Of 17 Spanish-surnamed students in the normal school, 14 were female, over 82 percent. At the beginning, the college was clearly perceived as a "training place for women who will teach." It would be over a decade until male students outnumbered female students.[86] These were pioneering young women, and rules for young ladies were more stringent.

Rules were rigid in the early days of S.T.S.T.C. The *Student Hand Book* explained: "To be absent from class without cause is an offense against the college. When a

student has been absent from class, he should report immediately to his instructor the reason for such absence." Instructors decided upon hearing the excuse if the absence should be considered reasonable or unacceptable and unexcused. If a student received four unexcused absences, he or she was immediately dropped from all classes. There was a route of appeal. The *Hand Book* also called for "each student [to] form the habit of using correct English" and gave examples. A list of "Habits Students Should Form" included attending assembly, not squandering time and paying all bills promptly.

The school catalog said that "South Texas State Teachers College is not a kindergarten in which infants are to be fed; nor a reform school for delinquents; but it is a place to which young ladies and gentlemen come with some preparation, and with the purpose to get ready for rendering efficiently an important service. Deviations from standard conduct have usually been the result of false standards brought from elsewhere, or a lack of instruction on questions of good conduct." It warned: "To become common figures on the streets, in hotels, barber shops, railroad depots, soft drink shops, or other public places is most compromising and undesirable conduct." Young men and young women should be "properly chaperoned at all times" at parties. "Auto rides at night or out of town at any time by boys and girls, or by young ladies and gentlemen who are College students, is considered grossly improper—an unpardonable College impropriety." After students entered a building, "all conversations should be in subdued tones, and gentlemen should remove their hats." "The most polite young men tip their hats to ladies, to all members of the faculty, and to elderly men whom they meet."[87]

Estimated costs to attend school for one year were between $279.00 and $305.00, including room, board, fees, books, and incidentals. Scholarships were available. During the four year existence of the South Texas State Teachers College, enrollment in regular session students increased by 288 percent, going from 257 in the first regular term to 739 in the academic year 1928–1929. Courses offered in extension also grew so that 161 students took advantage of such courses in 1926–1927, while 345 were served during the 1928–1929 school year.[88]

Citizens of Kingsville continued to take a strong interest in development of the school. The community was involved in providing housing for students and supporters believed that dormitories would help increase enrollment. By March 1926, a group of leading citizens, mainly from the Commercial Club, decided to approach Governor Miriam "Ma" Ferguson to lobby for funds for continued growth of the college.[89] The Board of Regents formally requested $400,000 from the state to build a health education building and a dormitory for women.[90] The gymnasium would include office space and laboratories and the dorm would house 150 female students. The governor agreed only to an appropriation of $25,000 to build the gymnasium.[91]

President Cousins began planning for a new building that would be architecturally in harmony with the Main Building and the president's home. By December 21, 1926, the school newspaper reported the symbolic ground breaking had taken place and construction had started even though the appropriation was insufficient to cover the full cost of the size of gymnasium desired. Coach Smith was anxious for the new

The gym was added to the campus buildings by 1928.

physical fitness facilities to be finished so he could prepare for sports competition. Until the gym was completed, he worked with his students in the outdoors because the weather in South Texas was mild. The catalog maintained: "There are no local causes of sickness. House flies are not abundant under ordinary sanitary care. Mosquitoes are very scarce. . . . There are no swamps or stagnant water nearby. The saltwater vapor is curative for sensitive throats and lungs. The winters and summers are even and health giving. It is not a hot, dry country. Summers are delightful."[92]

By January 6, 1928, the new gym was completed. The curved gabled parapet theme on the front of the building was in Spanish Colonial Revival style of architecture and complemented the Mission Revival architecture of the Main Building. Students commonly referred to it as "The Alamo." The first basketball game played in the new gym saw the Javelinas beat the Roy Miller Buccaneers, a high school team from Corpus Christi, 44-12.[93] The Athletic Department began planning for a natatorium that was partially available by the summer of 1928.[94]

The young school had many things to accomplish and new challenges to face. In April 1927, the administration announced that the school had been accepted into membership in the Texas Association of Colleges and had applied for, and was expected to be granted, membership in the Association of Colleges and Secondary Schools of the Southern States. President Cousins attended the meeting of the Southern Association in Jacksonville, Florida in November 1927. He made a ten-minute presentation to the committee. He informed his wife: "We have complied

with every demand." The committee would make its report to the general meeting on Friday night. He was confident: "I am not uneasy. There is only one thing they can do—let us in." A few days later, he reported: "They said our school is all right but too young. Must wait a year! The h ___ you say?" A year later, the college learned in December, 1928, that it had been admitted to the Southern Association of Colleges. Membership in these associations would facilitate transfer of S.T.S.T.C. college credits to other institutions of high education.[95]

On May 23, 1927, the first commencement exercise was held and students formed the S.T.S.T.C. Alumni Association. A year later, Porter Garner, the first male student to register in 1925, graduated and was elected president of the Alumni Association, which became fully chartered.[96] The first Mexican American to graduate from the college was Adelina Pena De Garcia, who received a bachelor of arts degree at the August 19, 1929 graduation. The following year, Reynoldo L. Adame and Consuelo Eva Cavazos graduated.[97] Also during 1927, President Cousins formulated new plans for the growth and development of the school.

Cousins corresponded with one of his in-laws about the encroachment by state colleges and denominational schools into the area of teacher preparation and about the lack of state support for teachers colleges. In 1927, he complained: "The Legislature was pretty drastic and to a degree reactionary in making appropriations." They gave the school little room for expansion in the next two years but enough to carry on at the current level. "Evidently the Governor was in sympathy with the chief committeemen, Senator Wood and Claude Teer, because after they had cut to the bone, the Governor took his little rip saw and went in a little deeper, being nothing left to cut."[98]

President Cousins corresponded with educators and legislators about teacher training and higher education in Texas. He thought that Texas did not need more colleges, but some publicity was being given to the idea of building another college in East and in South Texas. He told his in-law, R.M. Kelly: "Almost any boy or girl, excepting those in the extreme west, can step in a 'Tin Lizzie' at his door and in four or five hours pass by several colleges and find the one he wants." He said the existing schools combed the state "with a very fine toothed comb" seeking students. If there was to be new "Tech" colleges in East and in South Texas, one or more of the state institutions "should be enlarged or converted into such an institution." The School at Commerce, Nacogdoches, or Kingsville should be enlarged. The President of Texas Tech wrote Cousins about his concern that the state already had as many colleges as it could provide for and that the establishing of a Technological College was not as simple as it sounded.[99]

At a meeting in Brownsville, the South Texas Chamber of Commerce urged the establishment of a major institution of education to be known as South Texas Technological College or "South Texas Tech." Cousins was one of 30 delegates from Kingsville at the meeting. The Resolutions Committee advocated changing the mission of S.T.S.T.C. from a teachers college to a technological college with expanded training of teachers. The Chamber of Commerce group received the idea enthusiastically and Senator Archie Parr and Representative E.D. Dunlap strongly supported it.[100]

This was a bold move on the part of President Cousins. At a time when the school had only 283 students, he pushed to expand the mission of the college. This was perhaps the most important decision of Cousin's administration. He had concluded that the college could better serve South Texas as a technological college instead of primarily as a teacher training institute.[101]

In January 1929, Senator Parr introduced Senate Bill No. 293 to change the name of the school to Texas College of Arts and Industries and to expand the mission. The college would continue to provide teacher training, but also become a college for many other subjects of study. There was no opposition to the proposal in the Senate. Senator Parr implied that it was nothing more than "a bill to change the name of a little college in my district." However, a hard fight in the House almost defeated the legislation. J.D. Bramlette, Superintendent of McAllen Public Schools, went to Austin to lobby those in the House for the enlarging of S.T.S.T.C. to a school "on a large scale." He went over in detail "word for word and gave the figures that Mr. Seale prepared regarding this vast stretch of fast growing country" with Representative John F. Wallace of Teague and other legislators.[102]

The president of the Board of Regents reported to Cousins that he had visited Governor Dan Moody and "urged him every way possible not to veto your school bill." He explained to the Governor that unless Kingsville got the expanded school, South Texas would persist "until they force one to be placed at some other point in the valley." The Board of Regents would "never consider to have a Teachers College" placed at Edinburg "or any other point south of Kingsville." Governor Moody believed that all colleges in the state should be for teacher training except for the University of Texas, Texas A&M, and the Texas State College for Women. There was an effort to change Edinburg Junior College (now the University of Texas-Pan American) into a larger school. The governor opposed creating additional institutions and did not think the state had adequate resources to support existing colleges. It was more frugal to enlarge the mission of S.T.S.T.C. than to create another school. On March 26, 1929, he signed the legislation "as the lesser of two evils." He did not reveal that he signed the bill until April 3, 1929. E.D. Dunlap sent a telegram to Kingsville that afternoon confirming the governor had signed the legislation. The bill became law on June 12, 1929, to change the name of the college to Texas College of Arts & Industries.[103]

However, before the school changed its name, other events transpired. Frank Elmore, a popular student on campus, built a new fashionable student "hang out" called the Javelina at the corner of Armstrong and Santa Gertrudis.[104] The Home Economics Department purchased a home at 217 North Second Street to serve as a Home Economic Cottage and training laboratory for women studying domestic arts. Young women were expected to live one semester in this cottage and take turns doing homemaking chores and learning how to manage a budget.[105] New traditions were established that endured for a long time.

There were three student assemblies each week with Dr. Cousins presiding and the faculty sitting on stage. There was some community singing at each chapel session, with singing from "The Assembly Hymn and Song Collection." Favorite songs were "I Dreamt That I Dwelt in Marble Halls," "Krambambuli," "The Midshipmite," "There's

Music in the Air," and "Love's Old Sweet Song." Students enjoyed singing rounds, such as "Row Your Boat."[106]

In 1928 and 1929, the school elected a Queen of May and Queen at Maytime with a court of beauties and accompanying coronation, dances, parties, and general merriment. It was the social event of the academic term. On July 20, 1929, the *El Rancho* announced that in the future "Lantana Ladies" would be elected as beauty queens to be featured in the school annual. Students in chapel had voted to make the *Lantana Horida* the school flower. The 1929 issue of *El Rancho* featured the first Lantana Court, saying, "As does the Lantana, so do the Lantana Ladies grace our campus."[107] The Ladies that year graced the pages of the annual, but there was no Queen announced and perhaps there was an attempt to allow the May Day Queen festivities, like the school name of South Texas State Teachers College, to die a graceful death. Beryl Barber, the last Queen of May, was featured in an edition of *El Rancho* that touted the new school name, Texas College of Arts and Industries. The *El Rancho* urged the school be called Texas A&I.[108]

The Kingsville *Record* reported that on Monday morning, September 23, 1929, the school opened at 8:00 a.m as Texas College of Arts and Industries with two-hundred freshmen waiting to sign up. It also reported that in the afternoon, Dr. Cousins was taken by ambulance to Austin to receive 21 days of rabies injections. Over its long history, the university has experienced turmoil during several name changes. On this occasion, President Cousins was attacked by a rabid javelina on the eve of a name change![109]

The South Texas State Teachers College had been established, the Main Building, president's home, and gymnasium constructed, students enrolled, faculty recruited, curriculum developed, classes held, and traditions established. The library opened, music programs performed, and athletic teams took the field for S.T.S.T.C. The school was a training institution for teachers, most of whom were young women. Innovative programs were established, such as the experimental school for teaching Spanish-speaking students. Within two years of opening the new college, President Cousins developed plans to expand the mission of the college—this, at a time when the school had fewer than three hundred students. This bold move led to the creation of Texas College of Arts and Industries. A new name for the school, a new mission and a new tradition all arrived in 1929. The name change and mission would expand again, but the college and higher education were now firmly rooted in South Texas. Additional challenges soon confronted the College. One month after the rabid javelina attacked President Cousins, the bear mauled the New York Stock Exchange.

Chapter Three

BUILDING

TEXAS COLLEGE OF ARTS AND INDUSTRIES

1929–1940

Student contributors:
Joe Ely Carrales III, Jesenia Guerra, W. Scott Kilgore, Robert Kornegay, Richard A. Luane, Corey Lin Norman, Levett Norman, Jeff Oines, David R. Peña, Raul M. Puig, Sandra Rexroat, Alex Richards, Richard Rose, Scott L. Schaumburg, Rhonda Sliger, and Margarita Zuñiga

Senator Archer Parr from Duval County, a supporter of education for South Texas, had introduced the bills that had first created the South Texas State Normal College. He proved himself once again to be a friend of the college when he introduced Senate Bill No. 293 in 1929. It expanded the mission and curriculum to provide for more technical training—which was greatly needed in the area—and changed the name from South Texas State Teachers College to Texas College of Arts and Industries. Senator Parr's bill passed easily through the upper chamber by a vote of 25 to 4, then went to the House. Kingsville's Representative E.D. Dunlap, who had sponsored the bills to create the school, found his work in the House to be more difficult in 1929. The House agenda was cluttered and the bill progressed slowly. Eventually, the House passed the legislation by a vote of 78 to 22, but when it went to the governor for his signature there was further concern.[1]

Governor Dan Moody had opposed enlargement of the program at the Kingsville school because he believed that all state institutions of higher learning except the University of Texas, Texas A&M, and Texas State College for Women, should be limited to teacher training. He felt that the state should not finance additional colleges and universities. However, at this time there was also a campaign in the Rio Grande Valley to change Edinburg Junior College into a four-year school. The governor decided that it would be more economical to expand the mission of S.T.S.T.C. rather than create another state-supported four-year college in Edinburg.[2]

Governor Moody hesitated before signing the bill, and even after signing it delayed announcing that he had done so. When he signed the bill, the governor explained:

> *This bill changes the name of the South Texas State Teachers College and enlarges the scope. I am opposed to creation of additional institutions of the college and university class in this state for the present and believe that these existing should be coordinated and better supported. We do not have available revenues to adequately support our existing institutions, and, until we can give better support to present schools, certainly the available funds should not be scattered over a wider area by creating more institutions to draw upon such funds.*[3]

President Robert B. Cousins was delighted by the passage of the legislation, but "on the anxious seat" about funding "for the summer school, or for money enough to run through" the spring 1930 session. He explained to his son: "The Governor's vetoes of our contingent item slips a sharp knife into the vitals of our institution." The governor and legislature were "all tangled up on a number of things" and the state was "now enjoying the excruciating interest of the fifth called session." He told his son: "Just so long as we are at the point of observation we are reminded of the mother's response to the little girl, who told the mother excitedly, that the daddy had just fallen off the house, sixteen stories high, when she said 'Yes, I saw him when he passed the window.' The Governor seems to have no more interest in us than if he'd seen us fall."[4]

Cousins explained to students the implications of the name change. The college would "continue to aspire to be among the best schools in the South for the training of teachers." The name change did not dilute the dedication of the school to serving South Texas. Administrators had "a very permanent conviction" that the most important concern of all Texans was the education of their children "and the college, regardless of its name, will be true to its trust in furnishing the schools of Texas with its best possible products."[5] The college had an expanded mission.

The school would now offer courses in the liberal arts, industrial arts and commerce, education, and military science. Liberal arts would include courses in language, literature, mathematics, natural sciences, and the social sciences—including history, civics, and sociology. Industrial arts and commerce would include classes in agriculture, agronomy, horticulture, fruit and grape culture, farm management, animal husbandry, including stock breeding, feeding and marketing, dairying, and its allied industries; civil, electrical, textile, mechanical, agricultural, and architectural engineering; as well as business administration—including courses in bookkeeping, shorthand, typewriting, accounting, business law, and office practices. Homemaking would include courses in the chemistry of cooking and other forms of culinary arts: care of health, home nursing, and care of children; the making of cloth and clothing, planning and decorating homes, and other forms of domestic services. Teacher training would continue with even more courses.

Although the legislation mandated expanded course work and degrees, the legislature provided no additional funds other than what had been appropriated for South Texas State Teachers College. The administration argued persistently for funds to operate. In the quest for increased funding, the school reported that the

estimated average cost of educating students at S.T.S.T.C. for 1928–1929 was only $220.00 compared to $296.00, the average cost for teachers colleges in the United States. In the years since the beginning of the college, the state had provided only $373,000 for buildings. There had been no appropriation for additional buildings although the school had grown an average of 31 percent each year. Faculty had increased from 23 members in 1925 to 33 in 1929. Additional funding was needed to finish the Health Building, which although started in 1926 was still incomplete.[6] The college clearly needed increased financial support to fulfill its expanded role. President Cousins traveled to Austin to request additional funding, but the legislature and the governor were not inclined to be generous to institutions of higher education. In July, 1929, the new appropriation, while not as great as needed, was at least a small increase and allowed for the completion of the health education facilities on the campus.[7]

Cousins welcomed the new Board of Directors in May, and said: "We should enter the fields where there is most need of industrial and technical men and women, which seem to be these: 1. Farm Engineering or the Farm and Ranch; 2. Architecture and Drawing; 3. Civil Engineering; 4. Electrical Engineering; 5. Mechanical Engineering." He noted: "We shall be interested at first in laying a firm foundation for engineering courses in the first two years." By studying the curriculum of other colleges, he found "that all engineering courses are practically identical during the first two years and that they stress mathematics, natural sciences and English, and that they stress greatly algebra and physics above every other subject." He maintained that the college's mathematics department could easily provide for the expanded curriculum; however, biology, chemistry, and physics would need more laboratory equipment and space. He felt that the physical education program was too small and the health equipment inadequate. He also informed the board: "We are not equipped with supplies and housing space for even those farm implements that are easily obtainable and necessary for farm engineering, such as pumps, ditchers, windmills, planters, cultivators, tractors, etc." T.C.A.I. would need the simpler engineering instruments, such as levels, transits and compasses, used in land surveying and road construction.[8]

President Cousins was enthusiastic about the college's potential and the students were excited. At 3 p.m. on Tuesday, April 3, 1929, students heard in chapel that the governor had signed the bill. They left the auditorium to form an auto parade down the main street of Kingsville, honking horns, shouting the college yells and letting the town know of the victory. Students organized a dance that evening in the college gym where speakers explained the advantages of the expanded mission. Next afternoon, students attended a gigantic picnic on a nearby farm—coeds brought picnic lunches and men provided ice cream and soda water.[9]

A *South Texan* editorial urged students and administrators to call the school "A&I" because they felt that "T.C.A.I" was "too long and ponderous to be handled by the public with any alacrity or enthusiasm. Brevity is the soul of institutional nomenclature as well as of wit."[10] The Kingsville *Record* had suggested the abbreviated name and students endorsed the idea.

As a result of the name change and expansion of the curriculum, the Southern Association of Colleges and Universities—which had granted S.T.S.T.C. accreditation—announced that the school would need to seek approval once again. The legislation changing the name of the school had also mandated expansion of the programs being offered, but the legislature had not provided what the Southern Association considered adequate funding. Accreditation of the school by the Southern Association of Colleges ceased in 1929 until the school's programs could be reevaluated. As a result, the new Texas A&I had to reapply for membership and once more reprove itself worthy of accreditation.[11] President Cousins wrote a response to the criticism that the college did not have adequate resources in January 1932.[12] The college collected and furnished enough evidence to the Southern Association to obtain readmission in December 1933.[13]

In July 1929, a student milestone was passed. The first and second students to register at S.T.S.T.C. when it opened its doors on June 8, 1925, received their bachelor's degrees at the summer school commencement. Ema Stewart, who had become principal of Woodrow Wilson grammar school in Houston, and Porter S. Garner, who was superintendent of the Premont schools, earned their degrees while continuing their work in education.[14] There were also milestones ahead for the athletic program.

Until 1929, Lewis J. Smith had served as athletic director of the school. The first letters were awarded to fifteen football players in December 1925, at the end of the first season. They had played seven games, winning four, losing two, and tying one. Their opponents the first year were junior colleges, high schools, and the Kingsville Firemen. A description of the 1928 awards ceremony noted: "Chapel attendance-records were shattered Wednesday when the word was passed around that the sweaters for the football boys would be distributed during the chapel period." Names of which athletes would receive letters had not been announced and there was speculation about who would receive the 13 stacked boxes on the platform. "And it was noticed that some fair coeds were a little more attentive than usual to the prospective lettermen." Cousins told the students of their responsibility emphasizing that the sweaters were given them in recognition by the school that they were the "best in the field." Coach Smith distributed the dark blue slip over sweaters with a gold block T on the front to the lettermen.[15]

In 1929, A.Y. ("Bud") McCallum arrived and became the athletic director. Football was a favorite sport for men, and the school fielded teams for both men and women in basketball. Men also participated in track and baseball in the early years. The women's basketball program ended in 1928 and was not revived until 1968. The baseball program existed from 1926 to 1930, but was discontinued until 1993. Many school traditions arose because of enthusiasm created by the sports program. In 1929, Coach McCallum applied for membership in the Texas Intercollegiate Athletic Association (T.I.A.A.). During the last season the college played as independents, the football team won three games, lost four, and tied one. However, led by Coach McCallum, the "Fighting Javelinas" established their championship tradition and in 1931 and 1932 were T.I.A.A. conference

champions. In 1932, they were the last T.I.A.A. champions when the conference ceased existence.[16]

Under Coach McCallum in the 1930s and 1940s, the Javelinas became known as the "toughest little team in the nation." A few weeks before his inauguration in 1933, United States Vice President Elect John Nance Garner ("Cactus Jack") who came from Uvalde, suggested that West Point should schedule a game with Texas A&I in the near future. He felt that Southwestern colleges were not given adequate national recognition for their athletic accomplishments.[17]

T.I.A.A. was impressed with the quality of the athletic program when the Javelinas joined, noting: "That the college is willing and able to enforce the standards of the T. I. A. A. is indicated by the fact that the administration expelled four of its most outstanding athletes during the spring of 1930." The local Rotary Club committee provided part-time employment to deserving young men and women who needed help defraying their college expenses. It was "in no sense an employment bureau for athletes, although some of the students provided with employment have been athletes."[18] Other teachers colleges formed the Lone Star Conference after the demise of the T.I.A.A. but did not admit Texas College of Arts & Industries at first. In 1934, the group finally admitted the South Texas school on probation with the understanding that if they won the title that year they could not hold the official championship. Other members of the Conference included Southwest Texas Teacher's College, San Marcos; North Texas State Teacher's College, Denton; East Texas State Teacher's College, Commerce; Stephen F. Austin Teacher's College, Nacogdoches; and Sam Houston State Teacher's College, Huntsville. On October 26, 1934, the Javelina football team defeated the Sul Ross Lobos 19-0 playing the first night game under the lights at their home field before a Homecoming crowd of 3,500.[19]

Although the Lone Star Conference seemed to admit the school provisionally in 1934, the Javelinas actually continued as independents. The school annual, *El Rancho*, reported that the Javelinas played as independents during the 1933 through 1935 seasons when they joined the Alamo Conference. In 1937, they were co-champions with St. Mary's of the Alamo Conference. In 1938, they were Alamo Conference champions and became a football power.[20]

There were notable athletes and heroes among the players on the earliest teams, each struggling against different challenges. Some examples were listed in the 1935 yearbook. The highlight of the 1934 season was the game at Kyle Field in College Station, where the underdog Javelinas held a 14-7 lead until the last three minutes when the Aggies scored on a pass, ending the game in a tie at 14— the first time A&I tied a Southwest Conference team. Allen Barnes, a 212-pound fullback from Karnes City, the largest man on the squad, played an inspired game tackling and punting. Barnes played in two more games, but suffered a relapse of influenza just before the Homecoming game against Sul Ross. His medical condition deteriorated and he was taken to a hospital in San Antonio. Later, an autopsy showed that "Teddy Bear" had a large tumor and had been in no condition to play. The team dedicated the season "To Our Fallen Comrade."[21]

The fighting Javelina football team of 1934. Allen "Teddy Bear" Barnes, who died of a tumor, is in the circle.

El Rancho printed an "In Memoriam" page for another football player, Lawrence Thomas Allen, who had lettered for four seasons from 1929 through 1932. The 200-pound All-Conference Center had been captain of the football and basketball teams and student council president. His nickname was "Chesty." In 1934, he was learning to fly an airplane with the Army Flyers at Kelly Field. The *El Rancho* wrote a eulogy:

> *On the Twenty-fourth of April, searchers from the sky found Lawrence Allen in the wreckage of the plane whose wings had failed him. There is something heroic, something splendid about "Chesty's" falling that way—through the night. He himself would not have chosen a better way to go. It was entirely fitting. It was a brave man's death. And in that wild spin earthward—with the wind screaming through the struts—and with all the world turning dizzily—we can't help but suggest it—we know they were there—the wrinkles playing about the corners of Chesty's mouth. Unconquerable—even in death.*

That same year, one freshmen football player fought a different kind of battle—a struggle for equality. Everardo "Balo" Lerma was the first Mexican American on the Texas A&I football team, being "utility man" for the squad at end, tackle, defensive back, and quarterback. He played on 1934–1937 squads and also fought to a draw for heavy-weight boxing championship of the "T-Association." In his senior year, the Javelinas traveled by bus to Mexico City to play the National University of Mexico, the first international game for Texas A&I. Lerma was Captain for the day and was "mobbed by fans wanting his autograph." The Javelinas won 26-12.[22] "Balo" Lerma

may have been the first Mexican American to play on any college football team in Texas.

In 1937, a young man named Gilbert Steinke, from Ganado, Texas, registered at A&I where he became a football legend—not only as a player but as a coach who would lead the Javelinas to many national championships. Coach McCallum informed the journalism professor who was also the publicity director that he had two players who were good enough to be designated "All-American" Gil Steinke and Stuart "Goof" Clarkson. The publicity director explained that a great deal of work and promotion was required to develop the reputation of All-Americans, so they should concentrate on one player. He chose to promote Clarkson. When the Associated Press designated Clarkson a Little All-American in 1940 "there was dancing in the streets around A&I." In 1941, the Associated Press reselected him for the honor. In the 1941 season, the Javelinas compiled a total of 336 points, just two less than the Texas Longhorns, the national scoring champions. The publicity director later recalled: "Steinke was never aware, so far as I know, that I had sabotaged him in favor of the other man."[23]

Steinke played four full seasons as an A&I halfback and led the Javelinas in rushing for three consecutive seasons. As a senior, he averaged 105.1 yards per game, second highest in the nation that year.[24] For this achievement, he earned honorable mention as Little All-American. He also held the single season rushing record for the Javelinas for many years. In addition, Steinke earned All-Alamo Conference honors as a junior. While he is most remembered for his football career, Steinke also was a strong player on the basketball and track team.

As sports teams grew in importance on campus, school spirit increased and students began many traditions during the 1930s. Although the world struggled with the Great Depression, students seemed hopeful about the future and eager to enjoy their college years. Mamie E. Brown of the education faculty and Marian E. Wood of the music department and director of the orchestra composed the school song—"South Texas State Teachers College." At the Music Morning Program in chapel in early March 1929, Professor Engle announced that one-thousand copies of the school song had arrived and were available in the College Book Room for only 25¢ each, but it was not until 1937 that A&I had a school "fight song."[25] Noble Cain came to the school as a judge for the annual Music Contest, sponsored by the music department, and enjoyed the campus so much that he later returned as a visiting professor. He composed the "Wild Hog March" for the band to play at games.[26]

In 1929, students changed the school flower from the bluebonnet to the *Lantana Horida* and elected the first Lantana Court of pretty college coeds. It was not until the spring 1930 term that the official coronation was held and the festivities that surrounded the event grew into a tradition which attracted participation from high school students and citizens throughout South Texas. Special annual themes for costumes were selected including "Spanish," "Pirates," "Garden," "Pioneer Life," and "Medieval Pomp." *El Rancho* reported on the festivities, and proceeds from the election of the Lantana Court helped fund the school annual. In future decades, Lantana festivities became a more elaborate, unifying student and alumni spirit.[27]

The "T-Association," an organization of varsity lettermen, sponsored the first Homecoming. For many years afterwards, the Ex-students Association sponsored the event which always included a meeting of the association and a football game. The student government assumed responsibility for other activities held during the preparation for Homecoming, especially the bonfire, for which various student organizations gathered wood. The school organized the festivities to welcome back alumni, but in later years it became very popular with current students. Alumni enjoyed returning for the fall game and the spring Lantana festivities.[28]

The spirit of the campus was exciting in the 1930s with enrollment growing impressively. One of the selling points for locating the school in Kingsville had been the safe and wholesome family and church environment of the community. The original mission had been to train teachers and the first students had been primarily women. In 1932, summer enrollment statistics showed that women outnumbered men by four to one.[29] By the fall semester of 1935, the registrar announced that for the first time in the college's history men were in the majority. Approximately 53 percent of the total enrollment were men and only 47 percent were women. The registrar felt that the shift indicated that T.C.A.I was no longer considered just a school to train female teachers, but was also an academic campus to train men to serve as professionals.[30]

These changes also reflected new economic and ethnic conditions in South Texas. The focus of the school changed more toward agriculture, industry, and engineering, not only in the name change but also because it reflected the Depression era. Now, industrial and agricultural training seemed an even more vital necessity. The mission of training teachers for Mexican-American children did not cease, but the Spanish-speaking population of South Texas decreased from voluntary and forced repatriation. An estimated 500,000 people returned to Mexico—half being from Texas, some being "U.S. citizens caught up in the immigration sweep." Although the number of Mexican Americans who could attend public schools or afford to attend college might have declined, the numbers and percentages of Spanish-surnamed students actually increased at Texas A&I. Spanish-surnamed students enrolled during summer terms from 1927 to 1934 increased from 18 to 134, representing a change from 4.6 percent to 21.05 percent of the college's enrollment. During the summer terms 1934 to 1940, Spanish-surnamed students accounted for 20 to 25 percent of the enrollment. During the regular term from 1926 to 1932, Spanish-surnamed students increased from 11 to 47, a change from 3.48% to 7.83% of the total enrollment. In the regular terms 1935 and 1936, there was a slight drop in the number of Spanish-surnamed students, but the numbers increased by 1937 to 125 students, 12.01 percent of enrollment, and further by 1940 to 214 students, 16.64 percent of the student body. Thus, both total numbers and percentage of Spanish-surnamed students increased during the depression.[31]

The first Spanish-surnamed teacher who appeared in the catalog for the regular term was Aminta Gonzales, who had a B.A. and M.A. from the University of Texas. She taught as an Associate Professor in the 1934–35 full term and as a professor of Spanish in summer school sessions from 1937 to 1941. In 1941, students in

her classes on Spanish American Civilization (Spanish 307) and History of Mexican Literature (Spanish 309) spent a minimum of two weeks studying in Saltillo, Mexico. She resigned in July 1942.[32]

Enrollment increases also reflected curriculum changes. Male students dominated programs in agriculture and engineering. The school offered agriculture courses from the beginning, and the department conferred the first degree in agriculture at commencement exercises in 1931. However, under the expanded mission, agriculture grew with the assistance of the large King and Kenedy ranches which "generously opened their facilities and made available their large and valuable funds of knowledge and experience in the fields of Animal Husbandry." These ranches became in effect "a huge and inspiring laboratory for students at the College." As the two ranches expanded their studies in soil, pest control, pasture development, conservation, range grasses, genetics, and other phases of the livestock business, students of agriculture enjoyed an opportunity to study and work with professional specialists.[33]

Students in agriculture programs also gained practical farming experience on the more than 400 acres of land devoted to the cultivation of a citrus orchard, corn, hegari, milo maize, Sudan and Rhodes grass, and other feed crops, as well as cotton and a wide variety of vegetables. A poultry flock of three hundred hens produced many dozens of eggs, and a dairy and beef herd provided enough milk and meat to feed those students who learned and lived on the farm.[34]

In 1933, the Texas State Board of Vocational Education approved Texas A&I for training teachers of vocational agriculture under provisions of the Smith-Hughes Law.[35] As early as 1929, the agriculture department joined the Kleberg County Dairy Show program and offered a short course in which lectures and demonstrations by experts were offered to area farmers and ranchers. By 1939, more than a thousand agriculturists were in attendance and the course was offered in conjunction with the South Texas Live Stock and Agriculture Show. The homemaking program joined forces with the men's groups and offered demonstrations for county home agents and other interested women.[36] Other new programs of the college expanded as well.

In 1930, the school of engineering advertised that their purpose was "to train men for positions in fields of technical activity and also for executive and administrative service in industry and transportation." The curriculum was "to introduce the student to the different fields of engineering practice" and was "based on fundamental training in English, the sciences, and in economics." The catalog explained that the first two years of courses leading to a degree in civil, electrical, mechanical, and chemical engineering could be taken at the Kingsville school, but until adequate buildings and equipment were obtained no degrees could or would be granted.[37] By 1934, the engineering department expanded course offerings so students could complete a degree in general engineering.

In 1935, the Board of Directors authorized a course in natural gas engineering.[38] "The location of the College in the center of one of the earth's largest oil and gas regions, invited attention to those industries."[39] Professor R.L. Peurifoy, head of the engineering division, and Frank C. Smith, president of the Houston Natural Gas

Company and a strong supporter of T.C.A.I., worked to introduce the curriculum for a Bachelor's degree in gas engineering.[40] Gas and oil company officials were eager to cooperate and offered suggestions and assistance in development of this field of study.[41]

In 1937, Frank H. Dotterweich received his doctorate in chemical engineering from Johns Hopkins University. While at Johns Hopkins, he worked part-time for Consolidated Gas Corporation and Electric Light and Power Company of Baltimore. A year later, he had received a furlough from the company to participate as a member of the U.S. Olympic Lacrosse team in Holland. When he finished his degree, he accepted a position at Texas A&I to establish a gas engineering program which for a time was the only program of its kind and ultimately became among the best in the country,. When it was accredited 12 years later, it was the only program of its sort in the South, Penn State having the only other such program in the nation.[42]

Although the school experienced many accomplishments during the 1930s, it also suffered losses. In 1932, students mourned the death of their first president. In February, President Cousins had traveled to Georgia to attend the funeral of his mother and had contracted influenza on his return trip. He went to work on Monday but became ill on Tuesday, March 1, 1932, and went home. The influenza developed rapidly into pneumonia and he died on Thursday evening, March 3, 1932. President Cousins lay in state in the office of president, with a student honor guard. So many people from South Texas attended the memorial services in the auditorium of the Main Building that many were unable to hear the tributes. John L. Nierman described Cousins as a "master teacher" and "a great scholar, a great friend, and a great gentlemen." An editorial in the San Antonio *Express* said that of all his many services to education, Dr. Robert B. Cousins would probably be remembered as "the administrative founder of 'South Texas Tech.'" The editorial concluded: "May worthy successors make of 'South Texas Tech' the great school he had planned!" Senator Parr introduced a tribute to Robert Bartow Cousins in the Senate. In 1954, The Texas Heritage Foundation named Robert B. Cousins one of the "Heroes of Education" as a "Developer of College Presidents" for the "Centennial of Public Schools program" at the State Fair.[43]

Legends about President Cousins flourished, and later accounts of the attack by the rabid javelina have become increasingly complex. Almost 70 years later, accounts are current that he died as a result of the javelina attack! His ghost is said to haunt the president's home, pacing restlessly at night watching over the campus he designed and built.[44]

President Cousins' death stunned the students, who waited to see where his replacement, Wynn Seale, would lead them. Seale had worked closely with Cousins to transform the Teachers College into a technological college. As the chair of the South Texas Chamber of Commerce Education Committee, he had been a vocal supporter of those South Texans who wanted to expand the school. He was an experienced educator, having served as superintendent of Robstown Schools and business manager of Corpus Christi schools.[45] He thought of President Cousins as his friend, adviser and counselor.[46]

The Great Depression was at its worst in 1932 when Wynn Seale became president of the growing school in great need of funds to provide facilities for the students. In 1932, a new threat loomed. The State Legislature, responding to a proposal by the governor, considered making several four-year colleges—including Texas College of Arts & Industries—into two-year colleges. A scrapbook of newspaper clippings in the University Archives reveals the intensity of the debates. The Joint Organization and Efficiency Committee of the legislature intended to recommend that six of the eight state teachers colleges be deeded to their local communities to become junior colleges. If that proposal failed, they recommended the University of Texas operate the schools as junior branches. They also proposed removing all technological courses from Texas Technological College and all agricultural courses from Sam Houston Teachers College, leaving those to Texas A&M. They proposed that all graduate work be abolished except at the University of Texas and Texas A&M. If the community of San Marcos refused to accept its teachers college outright, it would be given to the city for use as a high school. Other proposals included transferring A&I to the University of Texas to operate as South Texas Junior College and abandoning the School of Mines in El Paso as a state institution. The scrapbook contains newspaper clippings from around the state with responses and testimony in legislative hearings from higher education leaders. The college gathered statistics about population, agriculture, transportation, industrial possibilities and needs, tax strength, and voter capacity of the area for the legislature. T.C.A.I. remained a four-year college, but with reduced funding, which continued to be a major problem.[47]

From the beginning, the college had been underfunded, receiving small state appropriations. In the first four years, as student enrollment increased from 258 to 418, the annual appropriation dropped from $164,670 to $126,920. During the depression, as enrollment increased from 418 in 1929 to an estimated 836 in 1937, funding wavered between 62 percent and 101 percent of the 1926 base appropriation, i.e. from $102,086 to $166,445. The administration compiled statistics that showed the 36 counties within 125 miles of the college comprised 10.1 percent of the state population, and contained 9.2 percent of the property valuation of the state. Texas College of Arts and Industries received 2.8 percent of the state appropriation for higher education.[48]

President Seale recognized that there was a serious need for student housing. When the college first began in 1925, citizens of Kingsville had opened their homes to students. Over the years, as student enrollment had increased, sufficient housing became an increasing problem. After determining that the legislature was unlikely to approve money for additional buildings, Seale began seeking other funding. He wrote to Congressman Richard M. Kleberg that he had heard it was possible "to construct a public building through the aid we might get from the Reconstruction Finance Corporation." He did not know if that was correct, but "when I heard of this I naturally thought of the possibility of financing the construction of a dormitory, or, perhaps, some other needed buildings at our College."[49]

69

The federal government had established several programs to provide funds to stimulate the national economy. Texas A&I applied to the Public Works Administration for funds to construct two dormitories and a cafeteria. After submitting the formal application, Wynn Seale and his new bride traveled to Washington D.C., to lobby for his proposal. The newlyweds then traveled to Detroit for a meeting of the Rotary International.[50] While at Mackinac Island, Michigan, at a preliminary session to the convention in Detroit, President Seale died on June 26, 1934, of cerebral hemorrhage at the age of 47.[51] His wife of less than a month accompanied his body to Kingsville where it laid in state in his former office before being sent to Floresville for burial.[52] He had been president for little more than two years.

One of the ambitious men who wanted to succeed President Seale was the secretary to Congressman Richard Kleberg: Lyndon Baines Johnson. Luther E. Jones recalled that someone connected with the college approached Johnson although "all he had was a B.A.. degree." Jones remembered: "There was a period of several weeks when he dreamed, talked about what he would do [as president], talked it all out—how he would revolutionize the college, slant it towards agriculture, make it the greatest college in the United States." Instead, in the summer of 1935, Lyndon Johnson became the Texas state director of the National Youth Administration, a position that enabled him to help many colleges.[53]

As head of the Texas NYA, Johnson faced the formidable task of providing assistance to massive numbers of needy people with only a tiny budget. He was concerned for college students among the almost 125,000 young Texans ages 16 to 25. He had a $500,000 budget—less than 2 percent of the total NYA budget— to deal with colleges scattered across an area occupying almost one-ninth of the continental United States. He told a group of Texas educators in September 1935, that there were several options of what to do with young Texans: "We could starve them to death; we could send them to school; we could kill them through war. Obviously the answer lay in sending some of them to school; giving some of them vocational training; finding work projects for others. That briefly is the work cut out for the NYA." He was eager to help students enroll for the fall semester. Johnson devoted his considerable energies to the tasks in 16 to 18-hour work days, 7 days a week. Johnson met with Governor James V. Allred who promised cooperation. Lyndon Johnson's NYA and other New Deal programs provided assistance to the students and administrators at the college in Kingsville.[54]

While Texas College of Arts and Industries mourned the death of President Seale in June 1934, the college received a telegram addressed to Seale and signed by Senators Morris Sheppard and Tom Connally and Representative Milton West informing him that a loan for $300,000 had been approved for construction of two dormitories at the college. The *South Texan* noted: "Mr. Seale had made two trips to Washington in arranging the dormitory loans, and the telegrams indicated that his last visit, made only a week before his death, resulted in the approval of the measure by the Public Works Administration."[55]

Before his death, Seale had made plans to construct two dorms—one for

women and one for men—to be of a Spanish Mission style architecture, consistent with Cousins' campus plan. The dorms were to be located across from the Main Building on the south side of West Santa Gertrudis Street. Subsequently, the Board of Directors met and named the women's dorm in honor of R. B. Cousins and the men's dorm in honor of E.W. Seale.[56] The cafeteria, located between the two dorms, was ultimately named for the third president of Texas College of Arts and Industries, James O. Loftin. Cousins Hall, Seale Hall, and Loftin Hall were the first major buildings constructed on the campus since the original structures and were historic New Deal projects.

R.C. Eckhardt, secretary and member of the Board of Directors, announced that arrangements for the buildings had been made and that they would meet within ten days and proceed with construction without delay. By February 23, 1935, construction had started and by September, young men started moving into their new residence hall.[57]

Since the new dorms could house only one hundred men and one hundred women, the need for student housing continued. Students joined the effort to build and provide housing by entering into programs to construct their own homes through cooperative ventures. Twelve young men became joint owners of "Hagler House" and expected to be able to go through college on 50 percent less than the average student paid for board and room. They named the home in honor of J.A. Hagler, who promoted and worked untiringly on the project. Hagler had graduated and was teaching vocational agriculture in Stockdale. Agriculture professor Russell J. Cook had suggested construction of cooperative housing to a group of vocational agriculture teachers attending a meeting in the summer of 1935. Hagler went home to raise money and returned with funds for the lumber and construction work.

Each of the 12 young men involved initially invested $50, but the need for additional funding brought their total investment to $67. When construction was finished, each owner's investment was calculated as their cash plus hours of work contributed. The price that subsequent owners would need to buy into the cooperative upon the graduation of a member was based on the calculation of cash plus hours worked. The land belonged to the college, and the administration supervised construction and operation. An acre of ground west of the gymnasium was provided and the only restriction was that the students who occupied the house needed to follow college rules. The young men, most with no carpentry experience, worked at construction as a part of their regular course-work. When rains delayed the project they moved into an unfinished cottage and continued construction when classes permitted. Students were responsible for furnishing and maintaining the home, cooking, cleaning, and performing all necessary chores.[58]

Other cooperative housing was established at T.C.A.I. Javelina Hall was a cooperative for athletes.[59] A cooperative home known as Westervelt House was constructed by agriculture students. The cost for materials, supplies, equipment, and supervision was $6,075 and employed 24 young men part time, with 6 men supervising. The project was "a physical improvement to the college campus" and

benefited the young people who "are from rural communities and are being given work experience and training in agronomy, farm mechanics, rope and leather work and the care and repair of farm equipment."[60] Later, Edwin Flato of Corpus Christi made a donation that allowed the expansion of the Westervelt House which subsequently became the Westervelt-Flato House. The college applied for a grant from Lyndon Johnson's NYA to provide funding for 25 prospective students to build a cooperative home across the street and to the west of the new Science building.[61] When the grant was approved, Ben Bailey—the head of the art department and also a trained architect—designed a Spanish Mission courtyard complex. Young men worked at the construction of the house in the summer and fall before entering the college as regular students.[62] By November 1939, the NYA courtyard was completed and students moved into their new home. Due to their contribution to the building, room and board cost only $17 per month.[63]

Students also built two workshop buildings, the athletic dorm, and the Texas A&I College Music Hall. They made caliche blocks which they used in constructing these buildings. They also learned skills valuable for national defense, with half taking radio classes in codes and the other half in wood and metal crafts for jobs in wartime industries. A student of the NYA program in Texas concluded: "The Kingsville project furnished a marvelous opportunity for hundreds of disadvantaged Mexican Americans in South Texas."[64]

A sense of how many students were involved comes from the *South Texan* in the summer of 1937, which reported that the NYA had employed 107 students part-time on the campus in the previous year. Some had worked as much as fifty hours a month. One group of boys helped improve the citrus grove. Thirty-two students trained in clerical and stenographic jobs; nine worked in the college library; forty labored on campus improvements; four served as lab assistants; and three worked as vocational and shop assistants. Ben Bailey Jr. announced that the students assigned to him had built a pottery kiln. Over 8,000 needy students had been employed at 86 Texas colleges and universities in the preceding year.[65]

The cooperative housing adventures were strictly monitored by the college administration and appeared to have been only for young men. All activities of the homes were handled through a central office. The college assigned a housemother to oversee food preparation and all purchases and also assigned chores and verified that the house was properly maintained. Students paid between $15 to $19 per month for room and board and were required to work a number of hours to maintain the home.[66]

Along with housing problems for increased student enrollment, there was a need for other campus facilities. Besides the dormitories completed in 1935, the college constructed a homemaking cottage, a model farm home, and several small facilities to house engineering courses with Public Works Administration (PWA) grants. In addition, the school constructed a dairy barn, 4 concrete tennis courts, sidewalks, and replanted 30 palm trees around the new dormitories with Works Progress Administration (WPA) funds. T.C.A.I. constructed three thousand feet of cyclone fence around the citrus orchard and two clay tennis courts with Civil

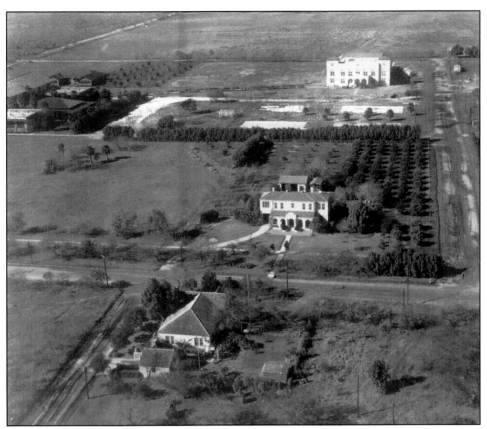

By 1929 when STSTC was renamed Texas College of Arts and Sciences, the campus included the president's home, the Main Academic Building and the gymnasium. Nearby, faculty homes and student boarding houses were being built.

Works Administration (CWA) funds. Federal Emergency Relief Agency (FERA) funds provided for building 2 miles of fence, 2,000 yards of drainage ditches and placing 1,500 cubic yards of dirt on the athletic field. The school also applied for WPA funds to complete a new concrete and steel stadium to seat 2,400 and a wooden stadium to seat 1,200.[67]

In January 1936, the school newspaper announced that Governor Jimmy Allred had come to the rescue of an A&I project to renovate the Administration Building and to build two new brick–veneer cottages, one for the home economics department and the other as a model farm home. The college president and the local legislator persuaded the governor to assist with financing the construction. The college had appropriated $14,500 for the work and the governor added $12,000 so that the project, with another loan from the PWA, could proceed. Architects Phelps and Dewees of San Antonio designed the new buildings but their bids came in too high for the money appropriated. President Loftin and Representative E.D. Dunlap visited the governor and convinced him to grant additional funds to construct the buildings.[68]

The two homes were to serve as laboratories for the girls who wanted to be homemakers and the boys who wanted to be farmers. Junior and senior home economics majors were to live in the homemaking cottage for a specified length of time and have complete charge of its management. Their duties were to include planning and supervision of at least one formal dinner for guests and other informal dinners, including the caring for unexpected guests. This period of home management was a requirement for a Smith-Hughes Certificate in vocational home economics, embodied in a course called "Residence in Home Management House" from 1936 to 1979.[69] Although the department moved from the main campus building into its own new facility in 1960, the cottage continued to serve this laboratory function until 1979.[70]

The Model Home served young men in a similar way, with the boys maintaining the home and grounds, but the young men did not reside in the home. Instead, they lived in the Aggie dorm or Hagler Cooperative Home, both located on the college farm, where they operated the dairy, a poultry farm, a citrus orchard, and other agricultural enterprises to gain experience and pay in part for their upkeep.[71]

Even with the construction in 1935 of Seale Hall and Cousins Hall, there continued to be a housing shortage. The school anticipated an increase of 250 students in the fall 1938—the dormitories had waiting lists and the boardinghouses in town were taxed to the limit to accommodate students. Enrollment reached 1,133 at the beginning of the fall semester of 1938 and administrators estimated that 15 students had left because there were no dorm rooms available. Of the 35 on the waiting list for Cousins Hall, they feared half would probably go to another school if they could not soon obtain a room. An application to the PWA for funding to construct a girls' dorm revealed that Seale and Cousins Hall had opened so late in 1935 that there were some vacant rooms the first year and a default on $8,000 in bonds. Although the dorms were full the next years and paid their expenses and amortization of debt, the PWA reacted unfavorably to the application. President Loftin immediately sent clarifying information and an amended application to Congressman Richard Kleberg.[72]

Congressmen Milton H. West, Richard Kleberg, and Lyndon B. Johnson along with Senator Tom Connally wrote letters of support to the PWA. Sam Fore Jr., editor of the Floresville *Chronicle Journal* and a member of the Board of Directors of A&I, forwarded a letter from Sam Johnson, Secretary to Congressman Kleberg, urging President Loftin: "Let's keep hammering and hammering hard." The PWA doubted that the loan would be acceptably secured. The file contains an extensive correspondence about President Loftin's visiting PWA offices in Washington in October 1938. In April 1939, the PWA informed Loftin that they now recommended approval of the project, but having no further funds to allot had closed Texas A&I's application file.[73]

After five years of operating dormitories, a detailed statistical study was conducted in 1941 of the financial history. A graduate student studied occupancy, revenues from rent and board, costs of operations for food, building maintenance, equipment, utilities, laundry, telephone, insurance, ground upkeep, and bond indebtedness.

He concluded that the cost of building maintenance and equipment was increasing, expenditures for food decreasing, salaries and wages were trending downward, and expenditures for utilities were complicated but trendless. Total expenditures per student were decreasing. In the first three years, revenues had not been large enough and it was not until 1939 that revenue was sufficient to pay both bond and interest requirements. In 1940, the college refinanced the bonds. The most significant factor was occupancy, because many costs were fixed. "This being the case, any decrease in occupancy, especially within the year, is a direct loss." A decline in student enrollment in 1941 when interest payments were due, or a decline in enrollment by 1943 when the first principal payments were due would be serious for the school. The study noted that T.C.A.I. had to refinance the bonds because the administration had been given little encouragement about securing additional funds for dormitory construction.[74]

However, in June 1937, students learned that Governor James Allred had approved a legislature appropriation of $200,000 for a science building. It was the first time since the construction of the gymnasium that a major building appropriation had been recommended by the legislature and approved by the governor.[75] When the cornerstone of the new building was placed on April 2, 1938, several hundred educators, political leaders, business and professional men and women, and other supporters gathered to hear Governor Allred speak about the importance of education.[76]

Students appeared grateful for the support because an editorial in the school newspaper urged them to welcome the guests and show their appreciation.[77] Approximately 1,500 invitations were sent to Texas State officials, educators, industrial leaders, the press, members of the Senate Finance Committee, officers of Women's Clubs, South Texas Chamber of Commerce, and the State Board of Education. While many accepted the invitation, those who could not sent hearty congratulations. The publisher of the Luling *Signal* said: "We are proud of the splendid work Texas A. and I. is doing." The vice-president of the Houston *Post*, and the first Poet Laureate of Texas commented: "As a Texan, and as an admirer of the eagerness and gallantry of youth, I have great pride in what the college is doing and planning for our young people." The editor of the Brownsville *Herald* wrote in the same vein: "We, here in the Valley, are really interested in the growth and development of A. & I."[78]

Following the cornerstone ceremonies, Dr. E.H. Hereford—College Examiner for the State Department of Education—toured campus to study curriculum, facilities, faculty, administration, students, library, and finances. His subsequent report glowed with praise. He reported that laboratory facilities were lacking, but the new science building would correct that problem. He especially praised the department of agriculture, which he found to have an excellent program with ample facilities and an enthusiastic administration. He praised engineering and noted that the school had an outstanding department of gas engineering which was of special significance to the many gas and oil companies in Texas which were contributing handsomely to its maintenance. He felt that the college was rendering a valuable service in this

field. Finally, he noted that the college had excellent music training in voice, and one of the nation's outstanding choruses. These programs provided excellent glee club leaders and voice trainers for public schools in the southwest.[79]

Indeed the music department had consistently served the college well. The first issue of *El Rancho* reported on the Chorus Club—a woman's chorus that sang in chapel several times during the term—and prepared special programs for Easter, Christmas, and commencement. The Treble Clef Club was an honorary organization, whose members were selected through competitive tryouts, which toured the area presenting programs for the enjoyment of other South Texas communities. The orchestra was under the direction of Amos H. Engle, head of the music department. All of the musical groups presented programs at chapel and assembly and for the area communities.[80]

In the spring term of 1926, Engle issued an invitation to area schools to gather in Kingsville for a music contest. A few area schools responded, sending slightly more than one hundred students to compete. Those who competed were so enthusiastic that the following year ten area high schools sent 225 participants. Thereafter the Music Contest became a popular spring event, with almost nine hundred students participating in 1931. That year, Engle, who had suffered terrible injuries in World War I, died in a San Antonio hospital while undergoing surgery. The school newspaper carried tributes to the long-suffering faculty member who they said was a "great and true friend." One story about him concluded: "It is but another illustration of the awful cost of war. It takes the young and the vigorous, the strong and the promising and destroys them. He leaves behind a terrible aftermath of sickness and sorrow and suffering. The casualties of war are not yet counted."[81] Another story noted:

> *Mr. Amos H. Engle came to the South Texas State Teachers College at the time of its opening in the summer of 1925 as head of the Department of Music. He immediately made the work of his department, its organization and promotion, his chief task and delight. Any labor that would in any way increase the efficiency of the department and contribute to the general progress of the institution was performed by him.*[82]

Although the founder and inspiration of the Music Contest died, the contest continued to grow. By 1939, more than 3,500 people attended the contest, which was held in conjunction with the Region VII of Texas Music Educators Association on the A&I campus. That year participation came from 27 South Texas counties— from Wharton on the east, Laredo on the west, Pleasanton on the north, and Brownsville on the south.[83] The service rendered to the college by Engle exemplified the commitment of early faculty and students who were building a small college in rural South Texas—together and against great odds.

Campus spirit could be seen as enrollment and programs continued to increase. While agriculture, engineering, and music were well established, new programs were also being started. In 1935, the Board of Directors voted to allow graduate work in some fields and appointed the first Graduate Council to implement the new program. Following several meetings of the newly created Graduate Council, the college decided to offer graduate level courses for the first time in the summer

session, 1936. Both master's of arts and master's of science degrees were offered in the fields of agriculture education, chemistry, economics, education, history, mathematics, and physics.[84] The program was so successful that in the first year more than one-hundred graduate students enrolled. By June 1937, Lucy Rose Chamberlain received the first master of arts in education and Harold Owen Brown received a master of arts in history, writing his thesis on "The Building of the Texas-Mexican Railroad." The graduate program had begun.[85]

The college began other programs to satisfy its expanded mission. The legislation creating A&I had mandated the study of military science. The school had applied for a Senior R.O.T.C. unit but learned in October 1935, that the Washington office had rejected its application because of a law forbidding additional mounted units at that time. Apparently they had applied for a cavalry unit, certainly historically appropriate and suitable for South Texas descendants of cowboys and *vaqueros*. The federal authorities urged the A&I to make a new application for a motorized artillery unit of R.O.T.C.[86]

Catalogs do not reveal a military science program until 1937, when there was a listing for "The Department of History and Government and Military Science." Classes in history and government had been offered from the opening of the college, but Military Science 201-202, six semester hours, was added in 1937. The course was "Military Science and Tactics." The course description indicated that students would study: "Organization of the Army, organization of the field artillery, military discipline, courtesies, and customs of the service. Close order drill (theoretical) including ceremonies. First aid and field sanitation. Artillery material and ammunition. The firing battery, the battery detail, and military motor transport." The program expanded as concerns about war in Europe increased in the summer of 1939. In the June 1939, *Catalogue*, three new military science classes (one semester hour each) were added: Military Science 1, dealing with the organization of the army and of the field artillery; Military Science 3, dealing with map and aerial photograph reading and firing battery; and Military Science 5, dealing with elementary ballistics, calculation of firing data, and requiring three hours of laboratory.[87]

The first consignment of motorized units for the newly established National Guard battery arrived in June 1937. Three 2 1/2-ton Indiana trucks arrived, being the first of sixteen to be stationed with Battery F of the 133rd Field Artillery, which would have two 75-mm guns and two "Prime-Movers," huge 10-wheel tractor trucks to set the guns in place. There would also be from six to eight steel-bodied station wagons to help in moving the battery and an ambulance.[88]

Then in 1939, the Civil Aeronautics Authority requested permission to establish a program to train civilian pilots at the college. If approved, young men ages 18–25 could take 72 class hours in ground school and two hours a week in flying.[89] By the end of the year, Emerson Korges, college electrician, announced the selection of 10 students from 30 applicants to start the training. The purpose of this program was to train 1,100 American college men as first-class pilots.[90] The Civilian Pilot Training course was discontinued with the inauguration of an Aviation Cadet Training course

at the new Kingsville Naval Auxiliary Air Station.

In June 1940, the Board of Directors placed the entire facilities of the college at the disposal of the Government in its National Defense Program and began providing preparation for service in the army and navy. National defense courses were added in January 1941, and the following month, courses in engineering, science, and a Management War Training Program was offered on the campus by the United States Office of Education.[91]

Early in 1941, 150 men who had volunteered to serve in the campus National Guard unit were entered into the regular United States Army under Captain Ben B. Bailey Jr., an associate professor of art who was also a graduate of Virginia Military Institute. The lieutenants were Ben F. Wilson Jr., Raymond Keller Jr., and J.H. Lightfoot. First Lieutenant Ben F. Wilson stated: "Because so many of our men do have higher education, I expect that many of them will be promoted to other units as officers." They were Company F, 2nd Battalion, 133rd Field Artillery Regiment. They mustered in at Flato Park, and after camping a few weeks at the racetrack in Kingsville, they trained at Camp Bowie at Brownwood, Texas.[92] At the critical juncture when the United States was struggling to stay

Battery F, 133rd Field Artillery, was formed and trained on the TCAI campus. Art professor Ben Bailey and former student Ben F. Wilson, Jr. were among the officers.

out of war and male students increasingly preparing for war, leadership of the college changed abruptly.

In May 1941, James O. Loftin—third president of the Texas College of Arts and Industries—resigned to return to San Antonio, Texas, where he expected to enter private business. The board accepted his resignation and named Professor J.L. Nierman to assume his responsibilities until they could appoint a new president. In August, the school newspaper announced that Loftin had been named president of San Antonio College.[93]

Loftin had assumed the presidency of Texas College of Arts and Industries shortly after the death of Wynn Seale in 1934, and had served the school while it experienced considerable growth. At the summer 1934 commencement, shortly after he had been named president, he had pledged to carry on the college programs initiated by Cousins and Seale. The school and the Kingsville community had expressed their enthusiasm, with local churches and businesses placing large welcoming advertisements in the Kingsville *Record*. South Texas supporters of the college had high expectations for Loftin. His experience in public school education served him well during his tenure as president. He had begun his career in education as an elementary school teacher and eventually became an administrator in the San Antonio School District. He served as the first principal of Lanier High School and the San Antonio Vocational School and Technical High School, establishing the vocational education program for San Antonio schools. Just before becoming president of Texas A&I he was president of the Texas State Teachers Association.[94]

The 1939 school annual, *El Rancho*, expressed the esteem in which the students of T.C.A.I. held this president: "Red-headed and affable, he is conceded to know his business." The education profession knew him as "a stickler for ideas of economy and administration" and as an administrator "whose duties are never too pressing to allow friendly and understanding conferences."[95]

E. Jay Janota, who attended the college from 1937 to 1940, later reported about a night raid that he and two friends attempted on president Loftin's citrus orchard, which was protected by a 6-foot fence. In planning the caper they failed to notice that President Loftin had a "massive mastiff" guarding his trees. "Kurt Neubauer, perhaps the most agile, was selected to go over the fence, fill a gunny-sack he carried with the choice fruit and meet [Ernest] Mooney and I on the far side where Mooney would be waiting to help him with the sack of fruit, and I would be in my faithful Model-T Ford (1931) with engine running for a quick get away in Bonnie-and-Clyde style." Mooney and Janota had just arrived on the far side "when we found Kurt climbing the fence just ahead of this large dog." This misadventure taught the young men "to some degree to stick to the straight and narrow."[96]

After Loftin's resignation, the Board of Directors immediately turned their attention to seeking his replacement.[97] Frank C. Smith, president of the Board of Directors, later reported that when the board began its search for Loftin's replacement they had set goals and standards which they wanted for the college to maintain. They

The snow storm of 1940 caused students to frolic in front of Loftin Hall, the cafeteria between Seale and Cousins dorms.

then sought the person whose leadership would be able to accomplish these goals. These goals included:

(1) To improve the curriculum and quality of its service to the student "in order to bring the practical and cultural service of the College to the highest level attained by senior educational institutions of the state."

(2) To provide the highest quality of educational opportunity to the greatest number of students. "The Board is more concerned, however, that the growth shall be in the quality of the work done than in the quantity of the students."

(3) To insure that the professional societies that evaluate educational achievement recognized Texas A&I graduates "commensurate with that accorded graduates of other senior colleges of Texas."

(4) To render its utmost service to the country in this, "its time of greatest need and peril in its history."

(5) To assure that its students are able to live "full lives with enriched opportunities for service" through technical and cultural education.[98]

The man the board felt could meet these goals was Dr. E.N. Jones, the dean of Baylor University at Waco. He had earned his bachelor of science at Ottawa University, which also awarded him an honorary LL.D degree. He earned his Ph.D. at the University of Iowa. His postgraduate study was in university administration at Columbia University, the school that had trained so many of the first faculty at S.T.S.T.C. After completing his doctorate, he began his academic career at Baylor University and rose through faculty ranks into administration. The board felt that they had presented to the school a leader the faculty and students could follow with pride, confidence and enthusiasm. The board president said: "The new President shares with the Board its highest hopes

and aspiration for the future development of the College, and a bright vision of its service to our country and our government."[99]

Correspondence in the papers of Charles Flato III, whose family had donated land for the college and who was an early student at S.T.S.T.C., contains a letter pertaining to Loftin's resignation and the subsequent hiring of President Jones. Flato's family had political influence and he was a well-known community leader. He was also a personal friend of John C. Patterson, chief of the Division of Inter-American Educational Relations, Washington D.C. In 1942, Patterson contacted him to inquire about charges of discrimination and unfair treatment of Mexican-American students at Texas A&I. "It has come to my attention confidentially that some misunderstandings have arisen at A and I between persons who are of Mexican descent or sympathies and others who are less in keeping with the times." Patterson asked Flato to investigate and report his findings because "officials of both republics know of the situation and, I, as a loyal Texan hope we can reduce the amount of prejudice in our home state and thereby help to develop the international understanding which our poor old world needs so badly."[100]

By December 1942, Flato had investigated and responded: "The Latin-American situation that has been brought to your attention was not new to me as it is a condition that has been the outgrowth in my opinion of several unfortunate circumstances caused, to a great extent, by having a man at the head of the Texas College of Arts and Industries for a number of years who lacked the ability and capacity of being a college president." He explained: "Because Mr. Frank C. Smith, of Houston, President of the Board of Directors of A. and I. College, was very concerned with getting the right man for his successor, the school operated through the 1941-1942 term with only an acting president." Flato concluded:

> *I have no proof, but I am of the opinion that there is some sectional politics behind some of the talk of Latin-American discrimination at A. and I. As to the feeling within the student body, there is little that I know about this except that there is certainly not as much differences socially or fraternally between Anglo-American and Latin-American students now as there was when I attended A. & I. in 1925.*[101]

When Jones came to the college, and learned from Flato of the charges, he immediately took action. Jones wrote to Flato that two young ladies had recently complained of discrimination in securing dormitory rooms. He reported that as a result of his investigation and report to the Board of Directors, it had unanimously approved his recommendation on August 28, 1942, that Latin-American students be admitted to the dormitories during the long session. He further stated:

> *It is my own opinion: (1) That any student who is permitted to register at the College should be permitted to enjoy the privileges of residence in the Dormitories. (2) That now, more than ever before, every constructive effort should be made to further inter-American relations. (3) That the Texas College of Arts and Industries is strategically located for the assumption of leadership in a program of Pan-American culture in areas not already under development by the University of Texas. As one constructive method of establishing such a program, I hope we may construct a Pan-American (or International) House on the campus as soon after the war as possible.*[102]

At the board's direction, Jones wrote to the Executive Secretary of LULAC on August 28, 1942, "to express to you its appreciation for your interest in our problems here." There were two pieces of information that he wished to convey. "First, the Board of Directors did not vote to continue Mrs. Oftedal in the office of the Dean of Women for the coming session. In the second place, the Board voted to remove the problem which has existed in connection with the securing of rooms in the dormitories by Latin-American students." Board action provided that Latin-American students "are to be admitted to the dormitories subject only to the regular waiting list procedure."[103]

The school newspaper reported a few weeks later: "Formerly Dean of Women, Miss Agnes Halland Oftedahl is no longer here."[104]

As the world descended into war, the South Texas college accepted its new president. The college had struggled and expanded in a hostile environment and its roots were deep in the South Texas soil. With the change of the name and enlarged mission, the school had confronted limited funding and the need for growth during the Depression years. The college had survived the reaccreditation problem with the Southern Association and the threat of the legislature to reduce it to a two-year junior college. The adversity of the depression decade seemed to increase students enthusiasm and strengthened alumni loyalty. Texas College of Arts and Industries had added programs in agriculture, engineering, graduate studies and had continued to earn the support of the South Texas communities. The college had developed an aggressive athletic program, an outstanding music program, and the beginnings of a military science program. However, troubles of war loomed on the horizon to challenge the students, faculty and administration.

The campus was at the disposal of the military and classes devoted to the war effort.

Chapter Four
TRIAL AND TRIUMPH
THE WAR YEARS
1941–1954

Student contributors:
Abel Alvarado, Debra Cardona, Joe Ely Carrales III, Carla Chapa, Marisa Correa,
Darren Earhart, Diane Denise Elizondo, Marco A. Gloria, Adam Gonzalez,
Efrain Gracia, Eric Grant, Jesenia Guerra, Melva J. Guerra, Tanisha Michele
Hicks, Roger Hill, Debra Ann Jones, Robert Kornegay, Richard A. Laune, Lee
Moore, Corey Lin Norman, Raul M. Puig, Michelle Riley, Elsa Rodriguez, Richard
Rose, Scott L. Schaumburg, Rhonda Sliger, Kevin Alexander Thomas, Donna Jean
Weber, William Keith Wommack and Margarita Zuñiga

Marie Bennett from Falfurrias was one of the students on the Texas A&I campus
in December 1941. She later wrote that "Mr. Monty" (Dr. O. M. Montgomery),
an instructor in English who taught classes in journalism, described that "Day of
Infamy" in one of his books.

> *"On Sunday afternoon, December 7, 1941, about two o'clock, I received a telephone call*
> *from Bill Holmes, my special friend and prize student.*
> *"Do you have your radio on?"*
> *"No, why?"*
> *"Turn it on. You'll see why. Good-bye, I want to listen."*
> *The radio was announcing to me and to most Americans that we were at war with Japan.*
> *It was a very different world from that moment on. The old world was gone. We found*
> *new problems, new situations. Not many of us were unaffected by the changes.*[1]

The Second World War was a major transforming event of the twentieth century.
It changed the world, nation, state, and Texas College of Arts and Industries. In
the 15 years between 1940 and 1955, colleges and universities in the United States
underwent substantial changes, and Texas College of Arts and Industries was no
exception. The profile of the student body changed significantly. A student from
1940 returning to the campus would have been astonished by the transformation.

When the war began, the campus became dedicated to the defense effort. In 1940, there were slightly more than 1,100 students enrolled at the College. Faculty and students responded to the crisis of World War II by entering the military service. A&I College catalogs for the war years contain many footnotes indicating that faculty members had resigned or were on leave. The college placed the campus on a wartime curriculum. As the college dealt with the conditions of World War II, it also adjusted to new administrative leadership.

The catalog for the 1942 summer session was at the printers when the announcement was made that Dr. E. N. Jones was to be the fourth president of the Texas College of Arts and Industries. An insert announced that he was to assume the presidency and the school and the community welcomed him. Enrollment for the summer 1942 term was up for new students, but had started its decline in the Fall 1941 term for advanced students as men and women volunteered for military service. On June 6, 1942, six days before he assumed the presidency of T.C.A.I., Jones had spoken to one of the largest graduating classes in the history of the school urging "the return to religion as the solution to the problems presented by the three modern 'fates'—machines, money and molecules."[2] In his speech, entitled "Man's Image of Man," he denounced race prejudice and race hatred, warning that the contemporary doctrines of racial superiority common the world over were utterly without foundation and would have to be eliminated before anything resembling world peace could be attained.[3] The administration, faculty, and students made many adjustments for the war effort in the next years.

Jones faced the task of reorganizing the college during a World War that would see many of the country's young men and women killed and many others changed by what they experienced. In 1940, the board of directors had notified national authorities that all college facilities would be put at the disposal of the government in the National Defense Program. Many young men at the college had already taken courses for college credit or non-credit leading to preparation in national defense. Faculty aided in teaching national defense courses both on the campus and at extension centers. One faculty member, Vila B. Hunt, who had been the supervisor with the Experimental School, became a teacher at the Colorado Relocation Project in Poston, Arizona, training evacuees who had two years of college to become teachers in the Japanese-American relocation centers.[4] The A&I administration accepted the policy, as recommended by the Association of Texas Colleges, and granted last term seniors the right to graduate, provided they remained in school until at least the middle of the last semester preceding graduation. Thus, students could graduate as much as seven and one half credits short.[5]

The *South Texan* began to report about former students who were enlisting, receiving promotions, or who were killed or missing in action. Brady Parker, who had downed four Axis planes in Royal Air Force raids over Germany in early 1942, was reported missing in June.[6] Wallace Dinn, a former A&I student from Corpus Christi, was the first American to capture a Japanese Zero pilot since the beginning of the battle for Guadalacanal.[7] Ex-student Edgar B. Erard Jr. was promoted to the rank of captain in the Air Force.[8] Pearl Hightower, a 1933 graduate, was the first A&I

alumna to join the Women's Army Auxiliary Corps.[9]

Battery F of the 133rd Field Artillery was called into active service on November 25, 1940. The college boys were glad to be taking their one year of training "so they could return to college" as one member later recalled, but that turned out to be "the longest year that they ever witnessed—from 1940 to 1945." The unit trained in Texas, Louisiana, and Oklahoma and was later transferred to the 202nd Field Artillery and later the 961st Field Artillery Battalion. Battery F participated in 294 days in combat in France and Germany, traveled over 2,000 combat miles, threw 49,090 rounds of high explosive and smoke at the Germans, and supported 12 units in combat. The war was taking its toll upon the college, students, and alumni.[10]

Anticipating a drastic reduction in male students enrolling in the fall term, Coach A.Y. McCallum suspended football and revamped his department to emphasize intramural sports. Military forces requested that the college intensify the physical fitness program to prepare men for service. He and his coaches attended a physical education short course on how to train instructors to conduct classes in preflight physical fitness programs. McCallum decided to emphasize intramurals, using returning lettermen as coaches for the intramural teams. He wanted his program to reach every man and woman on campus.[11]

Jones decided that an inauguration ceremony for the president would be inappropriate during wartime and requested only an installation ceremony. Since the new auditorium had been completed recently, the administration decided to dedicate the auditorium, conduct an installation ceremony for Jones, and hold homecoming festivities all at the same time, without a football game. Attendance was smaller than usual because of gasoline rationing and students and alumni being absent in military service.

On December 12, 1942, alumni gathered in a new auditorium with a 1,450 seating capacity to hear C. A. Davis, student body president, and Finley Vinson, Ex-Students' Association president, present the World War II Service Honor Roll. Taps were played as the names were read of former students who had died in action.[12] The board was later displayed at the entrance of the Main Building and the Ex-Student Association added names as necessary.[13] Those names with a gold star were those who had died; those with gold bars were missing in action.[14]

Dr. Homer P. Rainey, president of the University of Texas, addressed the alumni and Frank C. Smith, president of the Texas College of Arts and Industries Board of Directors, installed President Jones.[15] Smith announced that the new auditorium would be named the Edward N. Jones Auditorium and the Science Building—completed in 1939 but never named—would be called the John L. Nierman Science Hall. Professor Nierman of the Department of Chemistry, was the first member of the faculty to hold a Ph.D. Students nicknamed the big-hearted, jovial man "Bear Tracks." He had served as director of the Graduate Division and as acting president each time the college had faced the loss of its president.[16] A special part of the ceremony was the laying of the auditorium cornerstone. That evening, the alumni attended the eleventh annual performance by the music department of George Frideric Handel's oratorio *Messiah*.[17]

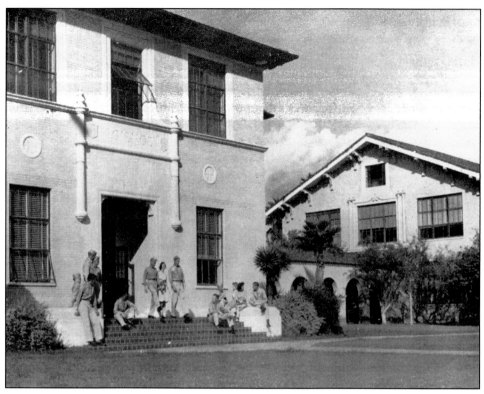

The John L. Nierman Science Building, constructed in 1938, was named for a
Chemistry professor.

There were other changes in the normal activities on campus. The campus was
on a wartime schedule, operating 24 hours a day, continuously using classrooms
and laboratories for training.[18]One month after Pearl Harbor, John E. Conner, dean
of T.C.A.I, asked the Headquarters Eight Corps Area at Fort Sam Houston which
engineering classes would best suit students who had only one or two years before
they reached service.[19] The catalog listed instruction in the national defense program,
including courses in welding, airplane mechanics, and aircraft sheet metal. The
engineering department offered classes in radio communication, industrial safety, and
engineering drawing.[20] The administration urged every department to serve the war
effort through classroom education. One example was a memo sent from President
Jones to John E. Conner of the Department of History. Jones wrote:

> *A bulletin just received makes the following suggestions with reference to course of*
> *instruction in the Dept. of History and Government. "The Department of History can study*
> *inflation, price control and rationing in earlier American wars, and speeches by American*
> *leaders on price control in earlier periods. The topic of democracy can be considered in its*
> *historical perspective noting the change in emphasis from liberty to equality as exemplified*
> *in the rationing of goods. Standards of living in earlier centuries, even of the nobility, can*
> *be compared with our present standard of living that entails sacrifices of automobiles,*
> *electric equipment, radios, etc. The practices of price control, rationing, and conservation*
> *in other countries can be compared with our own economic wartime program."[21]*

Even the newly created nursery school made a contribution to the war effort. Johnny Mae Haun, an A&I graduate who served as the director of the nursery school, said that the nursery school was training students in early childhood education and providing a place for working mothers to leave children when they went to their jobs to help the war effort. The home economics department had opened the nursery school in 1938 in the Home Economics Cottage. In 1941, Haun became the director of the program and moved the little school into what had previously been the football players' dressing rooms. Since football had been discontinued for the duration of the war, home economics coeds renovated the facilities for their nursery school. During the summer of 1943, they added a screened porch which doubled the floor space and enabled them to accommodate 24 children and their teachers. In 1945, they added a kindergarten to include children from ages two to six in nursery and kindergarten classes. Classes were held from 2 p.m. to 5 p.m. each week day.[22] Eventually the curriculum involving the nursery school students expanded so that home economic students learned how to make clothing for young children.[23]

The war on the campus home front even saw changes in programs for teaching Spanish-speaking children. As part of the Good Neighbor Policy, a Department of Inter-American Affairs was established in Washington with a Division of Education. The Texas State Department of Education participated in programs of the Department of Inter-American Affairs. Texas educators studied educational conditions of Mexican American children and held workshops about educating and promoting better understanding between English-speaking and Spanish-speaking Texans. Kingsville's Stephen F. Austin school, was described as one of the best in Texas. The 1,100 students were segregated, but it was one of the few where "the Latin American children are provided with equal facilities." The principal, A. D. Harvey, had spent years studying "the most effective methods of instruction for Spanish-speaking children" and during the summer was on the staff of Texas A&I, "where many of his teacher-students are themselves Latin Americans."[24]

Texas College of Arts and Industries, Southwest Texas State Teachers College, and Sul Ross State Teachers College drafted a cooperative proposal to study border conditions entitled "Border Institutions Attack Border Problems." Texas A&I submitted a proposed budget for $30,500 for a wide variety of initiatives, including salaries and materials for vocational and industrial education, vocational agriculture, and home economics demonstration. The administration proposed two full scholarships for natural gas engineering for students from Mexico and Central and South America, 30 partial scholarships to train teachers of English for teachers from Mexico, 29 general scholarships, improvements in library facilities, a conference in the Rio Grande Valley, and expenses and publicity. The Coordinator of Inter-American Affairs reacted with enthusiasm but suggested an expansion of the program to include more Texas colleges. In January 1944, ten colleges met in Austin and discussed improved Inter-American understanding by better teacher preparation and educational materials. As a result a second conference was held the next month to encourage all colleges and universities in the state to participate.[25]

President Jones was an active participant in Inter-American activities for the next several years and suggested to George I. Sanchez at the University of Texas that A.D. Harvey be a substitute when Jones could not attend meetings. Harvey directed Workshops in Inter-American Education at Texas A&I in the summers of 1944 and 1945. On October 30, 1944, Texas A&I held the first Inter-American Relations conference in Kingsville, which was followed by seven additional ones around the state in the next month. Jones attended the First Regional Conference on the Education of Spanish-speaking people in the Southwest in Austin in December 1945, which included distinguished participants from Arizona, California, Colorado, New Mexico, and Texas. The Inter-American Educational Program informed Congressman Lyndon B. Johnson about the activities of the Executive Committee, set up in 1943 as a "clearinghouse" for the diverse programs at the colleges and universities in Texas. Jones was a member of the Executive Committee and reported that A&I had presented several workshops, teacher-training programs, and lectures in a three-year time period. He noted that 123 college students, 3,050 public school children, 159 administrators, teachers and supervisors, and approximately 2,800 members of the general public had participated in this program.[26] Not only faculty and administrators were involved in Good Neighbor activities on the campus home front, but also students.

The *El Rancho* reflected the "Inter-American" mood in the 1942 yearbook. The cover displayed flags of American nations and the foreword noted: "Because this college is nearer to the Latin-American nations than any other in the United States, we constantly strive for a better understanding and greater friendship among the peoples of the Western Hemisphere." The Lantana Queen was photographed in a Mexican native costume with a letter in Spanish from the Ambassador from Mexico. The yearbook showed Lantana Court Ladies wearing native costumes with letters of congratulations from ambassadors or presidents of American republics.[27] Despite traditional celebrations such as Lantana Court, the campus was changing dramatically.

Total student enrollment declined for each year of the war as young women became WAVES and WACS and male students disappeared to become soldiers, sailors, marines, and airmen. Men had been in the majority on the campus since 1935, but now there were many more female students. Spanish-surnamed students on campus declined precipitously from 214 in 1940-41 (16.64 percent of the enrollment) to 32 in 1943-44 (6.9 percent of the enrollment). By the spring semester of 1944, total enrollment declined to 358, the lowest number since 1926-27. There were 87 men—47 freshmen, 19 sophomores, 4 juniors, 10 seniors, and 7 graduate and post-graduate students. Only one-fourth of the students were male, and slightly more than one dozen were upper classmen.[28]

There were several indications of the feminization of the campus. A committee of faculty and students decorated the second floor of the new auditorium for use as a social center by the college and as a lounge for off-campus girls who traveled to the college daily.[29] The *South Texan* noted that feminine curtains now could be seen in the women's-only lounge on the second floor of Jones Auditorium. Seale Hall, previously a men's dorm, became a woman's dorm with dainty curtains in the windows.[30]

The student newspaper reported how the campus changed during the war years. Georgia W. Bergeron, professor of education, had been on the faculty since 1928. In 1932, she started decorating room 131 at the east end of a hall in the Main Building as her office, but also as an unofficial student union. She began her decoration of the room with a piece of Oaxacan pottery and a water jug. Soon students and guests added gifts and the area became the setting of weekly Wednesday afternoon coffee hour. Students dubbed her "The Autocrat of the Coffee Table." Sometimes members of the football team had assisted in serving many noted persons who visited the college as guests.[31] During the war, there were no football players and Bergeron's office coffee shop entertained mostly former students who had returned from their war exploits.

In addition, the *South Texan* reported that completion of Jones Auditorium had enabled the library to expand into the space formerly occupied by the auditorium with a larger periodical reading room, more space for cataloging, and a shelving work area. The Forum and the gymnasium continued to "ring out on Saturday nights for a full social program, including a dance every other weekend. Cadets from the Naval Air Base form the stag line, and the Navy Band provides the music."[32] The social highlight of the school years continued to be the Lantana Coronation, but because of transportation difficulties the high school duchesses were unable to attend. In 1943, the alumni celebrated homecoming at the Lantana celebration in the spring.[33]

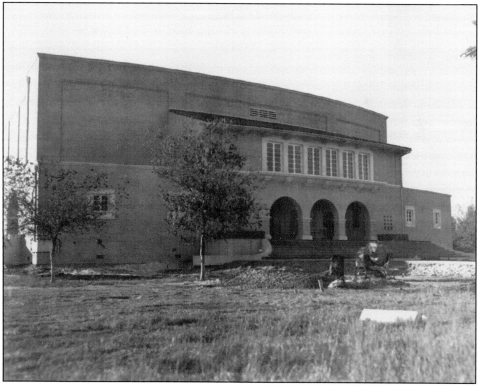

The auditorium, completed in 1942, was named for President A. C. Jones.

Fraternities disappeared because of the lack of men, but sororities grew. Classes were smaller and hallways less crowded. Mail call became more important as those on the home front waited to receive news from those at the battle front.[34] At the commencement services, degrees were awarded in absentia to men in service. In May 1944, a degree was awarded to William W. Holmes Jr., who was stationed in Central Africa, and his mother was present to receive his diploma. William M. Montgomery Jr. was awaiting enlistment into the U.S. Navy, and his mother-in-law received his degree for him. Paul T. Priesmeyer was stationed in San Diego, and his sister, who was then a student at Texas A&I, received the diploma for her brother.[35]

Anticipating the needs of returning veterans, the college obtained several new scholarships and loan funds and added considerably to equipment in the industrial shops and engineering departments. Central Power and Light Company donated equipment for complete electrical engineering laboratories in alternating and direct currents. This was the first complete installation of its kind in South Texas designed for instructional purposes but incorporating features of machinery used commercially. Lon C. Hill, then president of CP&L said:

> *I am confident that with the vision and progressive energy which have distinguished your institution in the past, this new electrical laboratory will be of genuine value to all of South Texas. The Central Power and Light Company is concerned with the industrial, agricultural and population growth of the South Texas Area which it serves. As the only degree-awarding college in this territory, Texas A&I has a real opportunity for the educational leadership essential to this growth. It also shares the responsibility of training men and women who will make the most of South Texas' many resources.*[36]

As the war neared its conclusion, the country and the college made preparations to accommodate returning service men and women. Texas A&I appointed Dr. Otto R. Nielson, dean of the college, veterans advisor. His office was to help veterans receive benefits granted through Public Laws 16 and 346, popularly called the "G.I. Bill of Rights." The legislation provided that any person under 26 years of age when entering service and who had been enlisted for more than 90 days of active service with an honorable discharge was qualified. Men and women who met eligibility requirements were entitled to education or training or refresher or retraining courses at approved institutions for a period of one year, or for shorter periods as required for them. Upon satisfactory completion of the first year, veterans were to be entitled to additional periods of training not to exceed the time of their actual service. Training was not to be given in excess of four calendar years, and all training was to be completed within seven years of termination from the service. Included in the benefits were tuition fees, books, supplies to amount to up to $500 a year, and a subsistence allowance of $50 for a single person and $75 for those with dependents. Those older than 26 when they entered service were required to show proof that their education was interrupted to qualify for the benefits. Disabled veterans who did not meet the service time requirements could receive benefits through a special appeal.[37]

The Board of Directors at the college prepared for the returning military personnel by appointing four advisory committees composed of representatives and successful men within agriculture, business, and engineering fields of South Texas to act as consultants for development planning. Jones announced that Texas A&I, the "only four year college in South Texas, feels especially responsible to the region from Del Rio east to Floresville, Cuero, Victoria, and Port Lavaca and south to Brownsville."[38] The committee appointed to consider campus and plant development received the charge of devising a campus master plan for facility growth, including the construction of eight to ten major buildings.[39]

By September 23, 1944, the administration named the firm of Eggers and Higgins as architectural consultants in collaboration with the architectural firm of Phelps and Dewees and Simmons of San Antonio, which had previously been involved in the college building program. The plan for expansion on the campus was to include "erection of an administration-library building, a student union building, new dormitories for women students, a new building for engineering, agriculture and home economics, a fine arts building, a business administration building, a building for education and teacher training, a heating plant and maintenance shops and eventually a museum building."[40]

Beginning with the fall 1944 semester, the enrollment once again began to increase. From the spring 1944 low of 358 students, it increased to 438 students. New students included the first appearance of returning veterans. The registrar noted that the 192 new students included "freshmen, transfers, sailors, WAVES, and war veterans" and registration was up by 21 percent, but the female-to-male ratio was still more than three to one. The department with the largest enrollment was chemistry where 95 students had registered, most of them women.[41]

In the next few years, veterans dramatically changed the composition and complexion of the campus. More students were male, Anglo and from out-of-state or international origins. Fall 1944 enrollment of 443 increased to 526 in the fall of 1945, then to 724 in the spring of 1946. In the 1946–47 year, the student enrollment soared to 2,061 students, with 1,173 of them veterans. Before the war there were few out of state or international students. In 1946–47, however, registrar's records reveal that there were now 74 students from 26 other states and 5 foreign countries. The number of Spanish-surnamed students increased in absolute numbers, but their percentage of the overall student population was approximately 10 percent.[42] Male-to-female ratio reversed itself, with men now outnumbering women three to one.

Marie Bennett (Alsmeyer) later described her experiences about coming home after the war. "I felt I did not belong back in Falfurrias. Only a few of my friends were at home, and I missed the continuous excitement of being on my own." She found her native countryside seemed flat after having lived in the San Francisco Bay area. "Finally, I was being forced to make some long-term decisions and determine what I wanted to do for the rest of my life."[43] She had joined the WAVES in 1941 and been sent to Boot Camp in New York City, Hospital Corps School, and duty as a pharmacist's mate on the west coast. Now she, too, was searching for what to do

with the rest of her life. As she reviewed her options she returned to the Texas A&I campus and recalled:

> *I found part of the answer as I visited the college campus where I had spent my freshman year. It was a pleasant drive across the great King Ranch, and I absorbed the beauty of scrub mesquite and signs of early spring. Santa Gertrudis cattle grazed in front of the Big House, the ranch headquarters, on a slight rise across acres of improved pasture, and a few miles farther I could see the red Mexican tile roofs of the campus buildings.*
>
> *I looked at the corner window of the dormitory wondering who was occupying my room now and walked in the shade of the bougainvillea and bright hibiscus towards the Administration Building. Tall unkept palm trees, hanging heavy with ripe black dates, waved in the gentle Gulf breeze, hiding the tiny hands of green-yellow bananas on the small wide-leafed trees nearby. The big change was in the students trolling across the campus. They seemed so very young. I felt as if I hand never been on this campus before; everything seemed changed from the way I remembered.*
>
> *In the old Administration Building I studied the large wooden plaque with the names of several hundred former students who had served in the armed forces during World War II. Near the top of the first column was "BENNETT, MARIE . . . WAVES." And then Archie Barber and Leland Marsters, Vollmer and Steinke. Some of the names were marked with asterisks and they would never again visit their alma mater.*[44]

The World War II Service Honor Roll which Marie Bennett examined, was recreated at the entrance of Manning Hall (Main Building), which was remodeled in 1999. In 1995, a gray marble marker was dedicated in front of the Student Union Building:

> IN HONOR AND MEMORY OF THOSE WHO SERVED IN THE
> UNITED STATES MILITARY IN EUROPE AND IN THE PACIFIC
> DEFENDING THE FREEDOM THAT WE ARE ABLE TO ENJOY TODAY
> MAY WE NEVER FORGET THEIR SACRIFICE
> 50TH ANNIVERSARY
> END OF WORLD WAR II
> 1945–1995

This generation of returning veterans transformed the campus. A series of tables in the 1946–47 records of the Registrar's Office gives a breakdown of students by class, gender, veteran status, and major. In the fall 1946 semester, there were 538 freshmen veterans, 202 sophomore veterans (including two women), 102 junior veterans, 83 senior veterans, and 11 graduate students who were veterans. The freshmen surely had never been in college, but the upper class veterans had interrupted their educations for military service. Engineering was the major for 297 veterans and 112 non-veterans; business administration was the major for 219 veterans and 156 non-veterans; and agriculture was the major for 190 veterans and 78 non-veterans. Other majors included pre-medical, pre-law, journalism, education, history, and several others. There had been 107 female business majors and only 49 male business majors, but the addition of the veterans changed the ratio to 267 men and 108 women.[45] Veterans presented a challenge for the university to develop new programs, new facilities and new accommodations.

One response was evident in January 1945 when the college initiated a new program in citriculture. Since the founding days of the school the agriculture department had worked and experimented with citrus and date trees. Farmers in the Rio Grande Valley had shown a strong interest in this research. As early as 1922, the citrus growers of the Valley were interested in establishing a citrus experimental station.[46] By 1945, the growers had organized and were anxious to have a branch of the Texas A&I agriculture department in their area. Rio Farms Board of Directors, in conjunction with the Rio Grande Valley Planning Board located at Weslaco, offered an initial gift of $10,000 and land to develop a branch of the college in Weslaco to train students in citriculture, agronomy, and vegetable production.[47] President Jones said at that time that the amount of citriculture training offered in the United States was very limited and that "the Establishment of such a station is badly needed not only in Texas but in the country at large." The program Texas A&I proposed for the Valley would "include all steps from the development of trees in nursery to the sale and distribution of fruit and the processing of by-products." The college intended to develop a program not only in citriculture training but also in vegetable production and marketing as the second major step in the program.[48]

Subsequently, the college learned that Rio Farms could not make the land and gifts available for the Citrus Center because that would violate the establishing charter of the business which specified that the "assets of the corporation must be used primarily for the social and economic betterment of low-income farm families."[49]

Dr. J. B. Corns, director of the project, had started work on January 1, 1946, by consulting with officials in various cities and locating several tracts of land in widely separated areas that appeared to be suitable for the program of experimental work and training. Corns and the Weslaco Chamber of Commerce worked until they located 80 acres on which the center was ultimately built. The Weslaco Chamber of Commerce promised to underwrite the purchase and established a Fund Drive Committee which met for the first time in October 1945, where the group members pledged $31,000. Subsequently, the group solicited other donations to fund the construction of the center, which opened in the fall of 1947 with a new director, Dr. P.W. Rohrbaugh. The college spent $40,892.54 to construct and equip an administration building at the citrus center in 1948. Dr. Rohrbaugh established a program that in ten years enrolled seven hundred students in courses in citriculture, vegetable growing, and allied subjects. The center set five experimental plots in citrus on the original tract, and subsequently added one at Bayview, one at Monte Alto and another northwest of Edinburg. The center staff provided several hundred consultations with growers, tests on soils and other types of services to growers in the Valley.[50] The center was a new adventure in growth, as the Texas College of Arts and Industries developed into a college with branch campuses.

By 1946, returning veterans inundated many college campuses. At A&I, a housing shortage—which had been a problem at the school since it opened in 1925—became even more critical. The immediate problem of expanding enrollment was reflected in the enrollment for the first summer term of 1946 of 1,196 students, surpassing the previous record of 777 in the summer of 1937.[51] To meet the demands of

expanding enrollment, the college had to obtain additional property to house and educate students.

A study of the college's effort to deal with soaring numbers of students is an interesting tale.[52] In 1946, Texas A&I—like colleges and universities across the United States—experienced record enrollment when World War II veterans took advantage of the Servicemen's Readjustment Act of 1944, better known as the G.I. Bill. The G.I. Bill provided veterans up to $500 a year toward education expenses and a $50 monthly living allowance.[53] In addition to congested classrooms, colleges were faced with housing shortages. To combat this problem, the college secured a loan from the state of Texas to finance the purchase of 60 portable housing units. This allowed the college to expand enrollment by another 198 students in the spring of 1946.[54]

The college continued expansion efforts in April 1946 with a $50,000 Federal Works Agency loan and the approval of $150,000 in local bonds. The city of Kingsville and the Texas A&I academic community raised an additional $71,000 to expand the physical plant.[55] These funds provided for construction of three dormitories, a student union building, and an administration-library building. Although these funds ensured future growth of the college, the immediate problem of rapidly increasing enrollment remained unsolved.[56]

Peace-time brought another concern to Kingsville. Despite efforts of Mayor John Cypher and Jack Kidd, president of Kingsville Chamber of Commerce, the U.S. Navy announced in September 1945 that Naval Air Auxiliary Station-Kingsville would be decommissioned and placed under caretaker status on August 1, 1946.[57] In 1942, the Navy had constructed an auxiliary air station in Kingsville to support the Naval Air Station in Corpus Christi. NAAS-Kingsville was part of the "University of the Air" that, together with NAS-Corpus Christi and Chase Field in Beeville, succeeded in training approximately 31,000 aviators (including future president George Bush) for World War II.[58]

On July 22, 1946, President Jones and Frank Smith, Texas A&I board president, presented results of a survey of the 3,000 acres of NAAS property to Kingsville Mayor Cypher and Jack Kidd. Jones and Smith contended that A&I could use NAAS facilities to house an additional five-hundred students for fall 1946 semester.[59] In a special session of County Commissioners' Court on the following day, commissioners unanimously approved a motion that Kingsville and Kleberg County lease NAAS-Kingsville for $1.00 a year plus maintenance costs. The commissioners' report stated that the NAAS property could then be subleased to Texas A&I to help deal with the expanding enrollment.[60] They also discussed possible uses for the facilities the college would not use. Some ideas were to sublease the recreational facilities on the station to private businesses and to hold livestock shows in the hangars.[61] The Navy Department agreed and the lease was signed on August 15, 1946, with the property designated as A&I's East Campus.

Under lease terms, Texas A&I acquired 97 furnished trailer units that were rented to married students and their families for $80 per semester. Each unit was equipped with a detached bathhouse, and a laundry room was available for every

20 units. Single males were housed in five former officers' quarters. Each room had furnishings, a closet, and a lavatory. Room and board fees for male dormitories were $165 per semester. Seventy-five to one-hundred females were housed in former cadet barracks with room and board fees of $190 per semester (their fee included one-round trip bus ticket per day to the main campus, with service provided by the Kingsville Air Bus Company during class hours). Students who lived in East Campus dormitories took their meals in the East Campus Dining Hall.[62] The East Campus facilities enabled the college to meet expanding enrollment, which peaked at 2,110 students in the fall of 1947.[63]

East Campus residents rated the campus as rather boring that fall. Like most young adults in the post-war era, students did not own automobiles and the bus service was restricted. Therefore, the students spent most evenings on the isolated East Campus. Veterans comprised 920 of the 1,704 students enrolled for the fall 1946 semester, a majority of the students on the campus.[64] Students who were veterans complained that the only positive quality of East Campus was the fact that they resided in such close proximity to women.[65]

When the college leased the Ship's Service Building built by the Navy to a Corpus Christi businessman, the social atmosphere of the campus improved.[66] In October 1946, the college reopened the 1,500 seat former navy movie theater, allowing students to watch their favorite films for 25¢. Students could purchase a hamburger and ice cream soda in the Cactus Snack Bar, bowl a few games at the campus bowling alley, or shop at the small East Campus Grocery or the Kingsville Base Bakery. The Base Photo Shop and P&T Steam Laundry provided other conveniences for residents. Income from the East Campus grew from $173,295.26 in 1946 to $240,722.54 in 1948.[67]

If a student tired of the Ship's Service Building scene, he or she could attend a college-sponsored dance at the Officer's Club. Alpha Phi Omega fraternity hosted the "Washington's Birthday Dance" each February and the engineering clubs organized the Christmas Ball. Another popular event was the "Backwards Dances" sponsored by the Press Club where the girls assumed the role of escort and purchased the "corsage" for the boys. A favorite spot for spring and summer dances, as well as other informal events, was "Mesquite Grove," an outdoor concrete slab with a bandstand, benches, and barbecue area located south of the hangars on East Campus.[68] The Grove was the site of the first dance held on East Campus. All students and faculty were invited and the bus company extended its hours so the students living on the main campus could attend the event.[69]

Other facilities on the campus contributed to the event schedule as well. Residents attended the Santa Gertrudis Chapel for Sunday services and those interested in exercise used the Physical Training Building. A&I-sponsored activities like the "All-Day Picnic" and the "A&I Baby Show" took place on the large picnic grounds.[70] Tennis courts, handball courts, volleyball courts, a skeet-shooting range, a swimming pool, and athletic grounds were home to an active East Campus Intramural League. Football and swimming were popular sports on the campus.[71]

Stuart Evans, a Kingsville entrepreneur, leased the swimming pool. The grand opening of the pool on April 15, 1947, was a festive affair, with the "Beach Fashion Queen of 1947" contest as the grand finale. In the contest, 35 young women competed for the title which was won by A&I student Mary Bayliss, who sported a $185 bathing suit made of gold mesh—a staggering sum for such attire. According to the Kingsville *Record*, Rita Hayworth had modeled the strapless bathing suit at an earlier date.

Another event at the grand opening was a coin diving contest for boys under age 15. Thirty-five dollars in coins were thrown in the pool and the boys were allowed to keep whatever they retrieved. Also listed on the schedule of events were exhibition division, clown diving, and various men's swimming races. Admission prices at the event were 14¢ for children and 35¢ for adults. With attendance estimated at 1,000, the opening was a huge success.

The pool opening introduced the East Campus to the broader Kingsville community and it quickly became a focal point of the town. In spring, the pool hours were 11 a.m. to 7 p.m. and in the summer from 10 a.m. to 10 p.m. Two lifeguards were on duty at all times. Beginning and advanced swimming classes were offered daily.[72]

Activity further increased in September 1947, when Texas A&I relocated the Division of Agriculture to East Campus. The move was necessary because the agriculture division had grown by 1,277 students and 6 faculty members in 3 years. East Campus became the home for the agronomy, animal husbandry, and agricultural engineering programs. Shop buildings, hangars, and administrative buildings were converted into offices, laboratories, workshops, and even barns. The Division of Agriculture also used 1,200 acres of the former naval station for livestock and crop research as part of the college farm.[73]

One grass research project on the college farm was conducted in conjunction with the Soil Conservation Service and the U.S. Department of Agriculture. As part of the project, students enrolled in the agronomy program planted approximately one hundred varieties of grass seeds to determine which types were best suited for South Texas soil. Faculty and students also participated in grain sorghum research with the Corn Products Refining Company to develop a crop with a higher yield. Other crops cultivated on the campus were onions, cotton, corn, and carrots, the latter sold to the King Ranch as horse feed.[74]

Students enrolled in animal husbandry classes took part in a livestock feeding program. The college farm was home to herds of registered Brahmas, white-faced cattle, and Jersey milk cows. The college dairy, located in a former airplane hangar, provided milk to faculty members and students on campus, who could also purchase eggs at the poultry farm. Tending hogs, sheep, and horses was another part of students' curriculum. The Aggie Club, the agriculture social organization, constructed a rodeo pen near one hangar that was being used as a stable. Aggie Club-sponsored rodeos were popular events on campus. In the evenings, faculty members and other students watched the competition crowded around small campfires to stay warm.[75]

TCAI used the Naval Air Station as an East Campus for agriculture classes and living quarters for faculty and students.

East Campus' vast space was a perfect location for the annual Aggie Club Round-up, a reunion of all Aggie Club members. In May 1947, seven hundred Aggies attended the first Round-up ever held on East Campus. The festivities included various western bands, a "blind boxing" contest, a rope trick exhibition, a friendly game of baseball, and a barbecue dinner with all the trimmings. The Texans, a western band from San Antonio, entertained the Aggies at the evening dance held at the Mesquite Grove.[76]

In addition to the annual Round-up, the college farm on East Campus was home to the South Texas Fair and Exposition in November 1949 and 1950. Beginning with a large parade through Kingsville, attendance at the six-day event averaged an amazing 60,000 spectators each year. The event consisted of a collegiate rodeo, a carnival and midway show, and continuous stage show performances for adults and children. Hangars were used for art, educational, livestock, and agricultural exhibits. Contributors of the exhibits were area 4-H Clubs, Future Farmers of America groups, Future Homemakers of America groups, and Home Demonstration Clubs. In addition, local organizations set up food booths. A livestock auction sale was part of the festivities as well. In fact, the first auction of the famous King Ranch Santa Gertrudis Bulls and quarter horses took place at the 1950 Fair.[77]

The 1949 exposition saw the first Collegiate Rodeo in South Texas at Texas A&I, with the College Rodeo Club entering a large team. One of the stalwarts on the team was Elizabeth Tucker, who had been the only undergraduate contestant in an all-girl rodeo a couple of weeks earlier. She had slipped and was knocked unconscious in the bronco riding, and won fourth place in bull riding, although she had never ridden a bull before. A quarter horse from the King Ranch was the prize awarded to top all-around cowboy. Sul Ross took first place, but Texas A&I's team came in second, ahead of Oklahoma A&M, Texas A&M, and four other colleges. Fourteen colleges and universities sent teams to the second annual intercollegiate rodeo at Texas A&I, with New Mexico A&M winning first place, Sul Ross second, and Texas A&I third.[78]

As East Campus continued to grow and become a large part of Texas A&I, it seemed the benefits of the acquisition of NAAS-Kingsville were immeasurable. Students, faculty, and administrators realized the indispensable role East Campus played in supporting higher enrollment. Texas A&I used the facilities wisely to enhance student life and arouse community support for the college. Dr. Jones noted its value in the 1948 edition of the college yearbook *El Rancho*: "The East Campus represents one of the most complete and finest conversions from wartime to educational use of any military facility in Texas." The Kingsville *Record* also praised the expansion noting that, "overnight the college was able to gain what would have taken, in these days of material shortages, ten years to construct."[79]

The material shortages the newspaper referred to also affected housing availability. Housing shortages in Kingsville were an obstacle when the administrators of Texas A&I sought new faculty members. To resolve the problem, cadet barracks at the former base were used to house new faculty members and their families. The college charged faculty members $37.50 per month for each unit including utilities.[80]

The barracks floor plan made for an interesting arrangement between the six families who shared each building. Most families had the use of four rooms adjoined by a main hall making it necessary to pass through a public hallway to move from one room to another. One of the four rooms served as a make shift kitchen/dining room and was outfitted with a stove, refrigerator, sink, and table. Since the rooms were large, the housewife had to make a long trek from the pantry—a former clothing closet—to the cooking area. Community-style baths were partitioned by a curtain and each family was assigned a specific section. The only phone in the building was in the lobby, so the residents would take shifts answering the phone and taking messages.[81] Even though this arrangement seems inconvenient compared to modern accommodations, the resident families had experienced years of economic depression and war. The inconveniences, therefore, were not considered harsh and the families appreciated the opportunity to forge lasting relationships with their housemates.

Newlyweds David and Pat Neher of the agriculture department faculty, shared a building with five families. Among the five families there were twelve children and only one child of school age. When asked about their memories of East Campus,

they smile. Their memories are filled with late night games of Canasta interrupted by a sleepy child in search of a parent. Fortunately for the parents, the barracks floor plan negated the need for a baby-sitter. Children slept in their rooms as parents gathered for their evening entertainment in the lobby or a family room. Other fond memories of the Neher's are "family" Thanksgiving dinners shared with their housemates.[82] For many faculty members, Kingsville was far from home and the family atmosphere eased the transition to a new town.

Faculty members recall that the facilities at the East Campus provided a wonderful place to raise children. It was an isolated environment where parents knew all of the residents so the children were free to roam. Communal showers were great fun for playing in the water and the runways made outstanding and safe places for parents to teach their children how to drive. John Howe lived on the campus from age seven to nine. His father, Dr. J. W. Howe, was director of the Division of Agriculture. John's days on the campus were full of adventure and fun. He and his friends rode their bikes all over the campus, built forts, went on exploring missions and occasionally got into trouble. With newsreels of the war still fresh in their minds, John and his friends played soldier with a keener skill than modern-day children. The former air station was the perfect site for battles. The hangar that lodged the Gulf Coast Flying Service, a crop-dusting flight school, was one of John's favorite spots.[83] Jack Mathis, owner of the company, would let John sit in the planes and play fighter pilot. Sometimes Jack would give John a ride in one of his many planes. Of course, John's mother was not always aware of his adventures.[84]

Expansion efforts on the main campus were realized in September 1949, when two of the three dormitories scheduled for construction in 1946 were completed. One hall was given the name of Baugh Hall and housed 163 women and the other hall, May Hall, housed 165 men. Since housing was now available at the main campus, the college encouraged students to move from East Campus. As a result, the women's dormitory on East Campus (Lantana Hall) closed on January 28, 1950, and the students were assigned rooms in either Baugh or Cousins Hall.[85]

Operations on East Campus were scaled down again in the fall of 1950 when East Campus Dining Hall was closed because only a small number of male students remained on East Campus. In addition to the dining hall, East Campus Grocery closed its doors. In response, Gregg's Grocery in Kingsville began to offer a delivery service to residents of East Campus three days a week.[86] Moreover, recreational services were reduced when on January 31, 1949, an early morning fire destroyed the Ship's Service Building as well as the movie theater, snack bar, bowling alley, and library.[87] Furthermore, when the Student Union Building opened on the main campus in October 1950, the college had a new ballroom and extensive space for social events. Hence, the social facilities on the East Campus were no longer needed or used. In reaction to reduced activity on East Campus, the bus schedule was modified to only five round trips per day.[88] Despite the decreased operations, many agriculture students continued to live on East Campus because of the proximity to the farm and agriculture classes.[89]

Just as Texas A&I became less dependent on East Campus, the United States became entangled in a war in Korea. A story on the front page of the *South Texan* was entitled: "Korea Here We Come: Mushrooming War Spells End To Carefree Days in College."[90] In late 1950, the number of men on campus declined as veterans volunteered for active service and other young men were drafted. In the first two weeks of January 1951, a draft panic swept the A&I campus, and 130 Texas A&I men volunteered or were drafted in the national emergency. President Poteet called a special mass meeting of male students to outline credit policies and selective service laws. Dean James C. Jernigan startled hundreds of male students by announcing that if they withdrew before the end of the semester, they would not receive their grades. He relented later in the week.[91]

In the fall of 1950, Navy officials contacted A&I concerning the status of the former air station. In December, A&I President Ernest Poteet, who had assumed the presidency upon the resignation of E. N. Jones in 1948, announced that the Navy had requested that A&I evacuate the station by the summer of 1951. The president reassured the community that College Hall, the new administration-library building, would be completed in early 1951 and added that the space created in Manning Hall by the move would be available for agriculture classes. However, he expressed concern for the college farm, farm shop classes, and faculty housing located on the East Campus.[92]

President Poteet's worries evaporated at the formal dedication of College Hall in February 1951. At the ceremony, Richard M. Kleberg, representing King Ranch, presented the college with a gift of 500 acres of land adjoining the main campus to build a new college farm. In March 1951, the board of directors allocated funds for an academic building on the new property for class space.[93] East Campus was disappearing. With difficulty, faculty families gradually found places to live off the East Campus, although rent was not as reasonable and they missed the camaraderie of their small community.

Even though Texas A&I continued to use East Campus until June 1, 1951, Naval Air Station-Kingsville was reactivated on April 1, 1951. A staff of 12 officers and 200 enlisted personnel resumed control of the base.[94] The Korean War caused a decline in college enrollment as had the Second World War. There was a decrease in students on campus in 1951 and 1952, but a two-year-period of slow growth followed. In the fall of 1949 there had been 2,100 students enrolled, but by the fall of 1951, there were only 1,500 students on campus. In 1953 and 1954 the enrollment of regular students increased with more veterans enrolling. Korean veterans enrollment grew from 904 in 1954 to 1,268 in 1955 to a peak of 1,553 in 1958. These students enrolled under the first Korean bill, Public Law 550 (December 27, 1950) and the Korean G. I. Bill, Public Law 894 (July 16, 1952). By 1955 the student body had increased to 2,500 students.[95]

Before the advent of the Korean War, the college president had begun grappling with an organizational problem. World War II and the creation and maintenance of the East Campus had been main preoccupations of President Jones. He had little time to deal with other administrative tasks. In 1942, when Jones assumed

the presidency, the Board of Directors had given him an injunction to "improve the scholastic program and the service aspects of the college," authorizing "such reorganization in administrative pattern and in assignment of personnel as might be necessary to accomplish this purpose." By 1946, Jones decided that it was time to implement the new organization. He announced that there were now divisions of Agriculture, Arts and Sciences, Business Administration, Engineering, Graduate Studies, and Teacher Training. A director would administer each division and be responsible for several departments.[96]

Jones had appointed a committee which spent months of intensive study on the college's organizational history before recommending the reorganization. It noted that the college had opened with what had been called "colleges" of Liberal Arts, Education, Industries and Commerce, and Military Science. In 1930, after the state legislature expanded the school's mission, the administration reorganized and renamed the "colleges" as "schools" of Liberal Arts, Agriculture, Business Administration, Education, Engineering, and Home Economics. By 1932, after the Southern Association of Colleges and Universities visit and withdrawal of accreditation, Texas A&I reorganized into 15 "departments." At that time, S.A.C. found that "entirely too much work was taken on with meager resources" and that the faculty was inadequate for the amount of work being done but, with the reorganization, the school again won accreditation. In 1939, Southern Association again placed the school on probation announcing that salaries were too low and the library facility was inadequate. By 1940, the school had again secured accreditation. During World War II, further reorganization seemed unnecessary as the numbers of students declined to a low in the spring 1944 semester. The decrease in students resulted in a reduction of faculty, programs, and need for additional facilities. Nonetheless, the board of directors continued its efforts to be adequately organized and established committees to study the physical facilities and the curriculum. Information was secured from other colleges and universities and President Jones began formulating the new organization for a more efficient way to operate the school.[97] Based on the careful work of the committee, the reorganization into "divisions" was recommended and implemented by a new president, Ernest Poteet.

Effective August 31, 1948, Jones submitted his resignation as president of T.C.A.I. to become Vice President in charge of Academic Administration at Texas Technological College in Lubbock. His wife had suffered from a chronic sinus condition since coming to Kingsville and needed to move to a drier climate. Upon resigning, Jones said: "It is difficult to leave A&I and Kingsville. For five years the daily uncertainties of a war period and months of transition following conspired to make college administration here and elsewhere nothing less than a struggle. The past year of my six years of association with A&I has been a normal one." Developments at Texas A&I brought tremendous satisfaction to him and had been "a pleasant sample of the months and years ahead if we could but stay." He noted that his family had made many friends in Kingsville. "To each member of the faculty and staff and to the friends of A&I in Kingsville and out over the state we express

our deep regret in having to break our associations." He was certain that past achievements were "but forerunners of the many outstanding attainments in future A&I history, which will surpass those to date."[98]

Immediately, the board of directors named Ernest Poteet, former Director of the Texas A&I Teacher Training Division, to serve as acting president, and started the search for a new president. Slightly more than a month later, the board announced that they had selected Poteet as the new president. Poteet had served as a superintendent of schools in Mercedes and Harlingen, Texas before assuming the position as the first director of the Teacher Training Division at A&I.[99]

The Master Plan submitted in 1944 called for constructing eight to ten new buildings including a Student Union. During Poteet's administration, 34 large buildings, small maintenance buildings, and sheds were constructed or renovated, tripling the number of buildings at the college.[100] Construction had already started on the long awaited Memorial Student Union. As early as 1936, the student government had started a building fund.[101] The movement for construction was temporarily abandoned during the war, but in 1945, the board of directors resumed the quest.[102] The Kingsville Chamber of Commerce pledged $50,000 toward construction and expected that the Ex-Students' Association and the Student Council would help fund the project.[103]

After almost 13 years of working for a student union building, the college finally started construction in August 1949.[104] The community worked together to fund it. Donations were received from subscriptions by local area people, from the faculty, the Ex-Students' Association, and Howard E. Butt and Lon C. Hill, both members of the board of directors. The board also issued bonds and the dean of men held an auction of all items in the lost-and-found station. On September 15, 1949, student body president, George "Dusty" Rhodes, turned the first shovel-full of sod at the ceremonial ground breaking.[105]

On March 19, 1950, the Student Union Decorating Committee arranged for a student tour of the facility even before completion.[106] On October 28, 1950, the $470,000 SUB was dedicated as the highlight of the Homecoming Festivities, which attracted the largest crowd ever at a Texas A&I Homecoming.[107] On November 6, 1950, it opened for student use and became the center of social life on the campus. The student facility included a bookstore, foyer, post office, main lobby, lounge, reading room, game room, and offices on the first floor. A ballroom occupied most of the second and third stories. A private dining room and conference room occupied the upper floor. There was also a small radio broadcast station.[108] In December 1950, the Tejas Room opened with a full menu from doughnuts to meal plates. With the addition of the short order and snack bar, income from the student union grew from $3,164.09 in 1951 to $63,782.14 in 1952.[109]

The opening of the SUB marked the decline of another campus landmark. The Tejac, a one–story brick structure at the corner of Santa Gertrudis and Armstrong, had long served the school as the campus hangout. The cafe/store had opened in 1929 when Fred Elmore, a student and athlete at S.T.S.T.C., had constructed it to earn income while he was at school.[110] The next year, students E. J. Tegarden

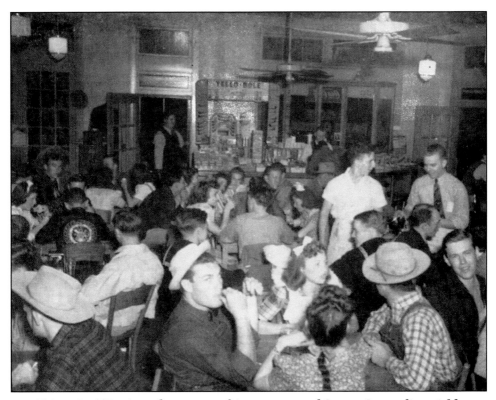

Tejacs (or T-Jacs) at the corner of Armstrong and Santa Gertrudis quickly became a popular college hangout.

Jr. and R. Jack Sims, purchased it and renamed it the "Tejac"—a combination of their names. In 1931, they sold it to Ralph Lanier, then superintendent of schools in Riviera, who was involved in its operation until 1966. "Prof" Lanier, as he was affectionately called, changed the name to the A&I Store, but over the next years students continued to refer to it as the Tejac. A train accident in the 1920s had robbed Lanier of his left arm and right forearm. The "Prof" was a familiar sight "with his mechanical right hand, behind the Tejac counter," serving food, advice, and comfort to hundreds of students over the years. His shop had provided employment and a social setting for students of the college. "It served as a message center and meeting place for students and was the scene of sorority and fraternity pranks and initiation frivolities." Lanier later recalled: "It was a confectionery at first, but then we started adding things and you could buy practically anything from school supplies to paint brushes."[111] After the SUB opened students divided their time between Tejac's and the new facility until 1966, when the store closed and remained only in the fond memories of the students who once frequented it.[112]

In line with the campus master plan, the post World War II years witnessed a substantial building program. In 1950, the college constructed the Alfred L. Kleberg Engineering Hall to accommodate growing programs. The Robert J. Kleberg Agriculture Hall opened in 1959. College Hall, which housed the administration

building and the library, was constructed between and across the street from the two Kleberg Hall buildings in 1950. The library would move out of College Hall and across the street in 1968. A dairy barn, feed lot sheds, fertilizer storage area, farm office, farm manager house, a barn, a hay storage area, a poultry house, a hog barn, and a livestock pavilion were added in the decade of the 1950s. The Forum, an open air auditorium behind the old administration building, was walled in to create a home for the John E. Conner Museum. To house students, besides the addition of Baugh and May Halls, the campus added Lorine Jones Lewis Hall and R. C. Eckhardt Hall in 1956. Student family apartments for married students opened in 1959. In 1949, construction began on a new $275,000 stadium with a seating capacity of 7,200 to accommodate the fast-growing football program. The football team opened the 1951 season against Texas Lutheran on September 15, 1951, in the new facility christened "Javelina Stadium," defeating the Bulldogs 37-7.[113]

Under the leadership of Poteet, the college experienced a major building expansion and student enrollment grew from 2,100 to over 3,100. Student spirit resulting from construction and growing enrollment made for an exciting campus environment. The tradition of Lantana festivities was important as were the many student clubs and organizations.

During the 1953 football season, student pranksters undertook a program of appropriating and caring for the mascots of rival teams. The class earned the nickname of "'53 Kleptomaniacs." They stole every mascot from the schools A&I played that football season. The school newspaper proudly announced that the school heroes had taken an anchor from the University of Corpus Christi, a Mexican honeybear mascot from Sam Houston State in Huntsville, and Austin College's Katy Kangaroo. Their greatest prize was when they stole "Lee Roy," a six-hundred-pound tiger while he was en route from San Antonio to Kingsville for a game between the Javelinas and the Trinity University tigers. When Lee Roy's escorts stopped in George West, Texas, for some refreshments, the A&I men hijacked him, his truck and trailer, his trainer, and the trainer's wife. Although the students who had been sent to escort Lee Roy tried to pursue the culprits, they were unable to do so as their car unexpectedly malfunctioned. In Kingsville, large crowds gathered to welcome the stolen mascot. The tiger was kept under guard at the new dairy barn, and the trainer and his wife were accommodated at a local hotel. At the game the following night, the Trinity students chanted "We want Lee Roy" and the A&I students responded "We got Lee Roy!" The A&I students kept the tiger until a brief ceremony on the 50-yard line when they allowed Trinity students to repossess their mascot. During the game the A&I students introduced a tradition which had previously been common for the Trinity students. After each Trinity score, it was customary for Lee Roy to be marched around the field. At that game, the A&I students marched a newly acquired javelina named "Porky" around the field after each A&I touchdown.[114]

In 1954, an A&I alumnus returned to the campus. Gil Steinke, who graduated in 1942, had thrilled football fans when he became an honorable mention Little All-American fullback then went off to play professionally for the Philadelphia

The "'53 Kleptomaniacs" abducted Trinity University mascot Lee Roy.

Eagles. His professional football career was interrupted by World War II, but he subsequently played for five seasons with the professional team. Later he served as assistant coach at Alice High School, coach at Trinity University, freshman coach at Oklahoma A&M, and then worked on the coaching staff at Texas A&M. Steinke was to be the coach when the Javelinas played their first season in the Lone Star Conference.[115]

Also in the fall 1954 semester, the school faced a very serious problem. The 1917 charter of the South Texas State Normal College had stated that it was for the education of "white teachers." The subsequent charter for Texas A&I said: "There is hereby established in Texas, in the City of Kingsville, Kleberg County, a co-educational institution of learning for the white youth of this State, which shall be known as the Texas College of Arts and Industries."[116] Russell Hayes, an African American who had attended school in the segregated Kingsville school system, was a life–long resident of Kingsville and a Korean War veteran. He applied for admission to the school. When he spoke with Dr. Poteet, he learned that the board of directors had informed the president that they had no choice, because of the charter, but to deny Hayes admission.[117]

After the board ruling, Hayes said he would take his case to the Veterans Administration in Washington. He later commented: "I laid my life on the line for my country. . . . I don't want any exceptions, I just want my rights." Hayes felt that he had a right to attend A&I because the Veteran's Administration approved it as

a school for veteran training.[118] The Veterans Administration refused to support his application. Deputy Administrator Ralph H. Stone wrote a letter stating: "The retention or admission of students or trainees are matters entirely within the discretion of the particular education institution or training establishment in which admission is sought."[119] Hayes accepted the board's decision and enrolled at Prairie View A&M.[120] The integration of Texas College of Arts and Industries was postponed.

The college had faced challenges during the Second World War, when many of the students entered military service and the enrollment at the campus had dwindled to 358 students in the spring of 1944. Many students from Texas A&I made the ultimate sacrifice during the war. The survivors, veterans returning to campus after the war, caused the college to expand to include an East Campus and to undergo a building boom on campus. During the Korean war, the campus experienced a decline in student enrollment with expanding enrollment following the war as veterans used the Korean G. I. Bill to enroll in college. Social changes after the war posed new challenges of racial integration, ethnic militancy, gender equality, and anti-war protests of students. There had been a changing of the guard, too, best symbolized by the retirement in 1955 of the last of the original faculty, Jennie L. Splawn, a professor of English for over thirty years.[121] Texas College of Arts and Industries faced new problems and difficulties without any of the founding faculty present to lead the campus into the future.

Chapter Five

GROWTH

TEXAS COLLEGE OF ARTS AND INDUSTRIES

1953–1967

Student Contributors:
Mary Armesto, Rafael Barrera, Diane Bancroft Borse, Debra Cardona, Joe Ely Carrales III, Melissa Correa, Diane Denise Elizondo, Marco A. Gloria, Rolando Gonzalez, Carlos Guerra, Jackie L. Hunter, Debra Ann Jones, Daniel Lopez, Erika Lopez, Esequiel Naranjo, Corey Lin Norman, Letitia L. Ortiz, Elsa Rodriguez, Richard Rose, Kevin Alexander Thomas, Jaime Trevino, Donna Jean Weber, William Keith Wommack and Margarita Zuñiga

The college had endured challenges from the Great War, Great Depression, Second World War, and the Korean conflict. Returning World War II, veterans had placed considerable strains on curriculum, facilities, and faculty of Texas College of Arts and Industries, which went through a building boom and established an East Campus. In the 1950s and 1960s the school was a microcosm of larger tensions in the nation. The country entered a time when minorities demanded equal rights. The Cold War, Civil Rights movement, and Hispanic militancy were all manifested on the campus. Russell Hayes lost the skirmish to gain admittance to the college, but the struggle for equality continued. The decades to come were tumultuous. Although the school newspaper often lamented that A&I was a dull place where nothing exciting happened, the fact was that the problems of the rest of the world affected the students in Kingsville. In addition, Texas A&I enjoyed a substantial growth in enrollment, programs, and facilities. At the end of this period, Texas A&I faced the identity crisis of yet another name change and mission redefinition.

President Ernest Poteet experienced a problem when he received applications for admittance from not only Russell Hayes, but also Robert W. Burrell and Lavernis Royal—African Americans who were Kingsville residents interested in attending their hometown college.[1] In each case the president responded: "In view of the terms of the enabling act establishing Texas College of Arts and Industries, it is

our understanding that the administration of this College does not have authority to grant admission to you. Your application, which you filed with the office of the Registrar and director of admissions, is being referred to the Board of Directors."[2]

A letter from the local Veterans County Service Officer in early August 1954, warned Poteet of the possibility of an application from Hayes and also about rumors that another local veteran, E.C. Cornell, and May Alice Jefferson, the daughter of a member of the Colored Trainmen of America union, also intended to apply for admission.[3]

The Corpus Christi *Caller* published an article about Hayes' application and the local population reacted with greatly differing opinions.[4] An A&I student wrote that it had been reported that an African American could not be accepted at the college because it was established for "white youth." The student noted, however, that the charter did not "say anything about Latin American people, who are certainly not white." He said in fact "many of them are a very dark complexion." The charter did not "mention Asiatic people, who are of a bronze complexion." The student continued: "When someone mentions a white person, a person does not think of a Latin American or Asiatic person." However, both of these groups were permitted to enroll at the College in "a violation of the act." He thought it was inconsistent to permit them to attend but to forbid a black student. "And if you do not permit the Negro youth to come, then, to be <u>lawful</u> as according to the phrase in the act, you must stop permitting all Latin American and Asiatic students to come." He felt the college administration ignored the clause for two groups but enforced it for another group at its own discretion—it was "as though you had no act at all."[5]

An alumni wrote that he had recently read in the Corpus Christi newspaper that an African American had applied for admission to the school. He noted:

> *The paper stated that the college was set up for white people. If as an ex-student of your school I have any power, then let the negro attend A&I. I can not possibly see why the color of a person's skin should keep him from attending any school. Provided he is able to learn and keep up with his work, he should have the same right to attend A&I that I have. Further let me say that while I was a student of your school there were many South Americans attending classes. It was evident to me and to many of my classmates that several of these people were part negro. Had these same people been citizens of the United States they would have been refused admittance because of their negro ancestry.*[6]

The Woman's Society of Christian Service, First Methodist Church, Kingsville sent a letter supporting integration at the college.[7] Also, the Kingsville Inter-racial Executive Board sent a petition supporting integration at A&I.[8] No letters were found in the files of the University Archives that opposed Hayes' registration.

Ultimately, the board rejected the admission application of the three African Americans, but the next year Ellvin Clifford (E.C.) Cornell applied for admission.[9] This time Poteet responded: "According to the interpretation of the state statutes by the Board of Directors of Texas College of Arts and Industries, you would not be eligible for admission to this college at this time."[10]

In February 1956, a delegation from the National Association for the Advancement of Colored People went to the board of directors to plead for the admittance of

blacks to T.C.A.I. Dr. Boyd Hall of Corpus Christi spoke for the group: "Just as we love this nation, so do we love Texas." Although Texas was located geographically in the South, he noted, it had never resisted progress as some other southern states had. He said that the United States Supreme Court in rulings on May 17, 1954 (*Oliver Brown vs. Board of Education of Topeka, Kansas*), and May 31, 1955, had said that "the equal protection clause of the Fourteenth Amendment prohibits the states from maintaining racially segregated public schools."

Hall pointed out that "the greatest desegregation in this state has occurred in the area of Kingsville" and in communities such as Alice, Aransas Pass, Beeville, Corpus Christi, Edinburg, Harlingen, Karnes City, Refugio, Robstown, Sinton, Woodsboro, and many others. He also reminded the board that area colleges—Del Mar College, Pan American College, and Victoria College—were desegregated. The courts did not force those schools to integrate by Court order. "All of them were desegregated as a result of voluntary action of their respective board." He felt that Texas A&I had not joined those desegregated schools "because you have not been properly requested to do so." The Texas N.A.A.C.P. recognized that the Board of Regents, the president, and the faculty controlled the college. "If any one wishes anything done about this college, they have only to make their request known to you, the Board of Regents." He pleaded:

> Give the lie to the Communist overlords that are saying that Americans cannot implement the United States Supreme Court's decision of May 17, 1954. They say we cannot, I say we can.
> We speak the same language, worship the same God, and pay allegiance to the same government. Why shouldn't we know and understand each other better. Grant it, Honorable Board—receive the gratitude of your constituency, your State, your Nation and your conscience. [11]

The Board of Regents minutes record only briefly: "E C. Cornell requested that he be admitted as a student to Texas College of Arts and Industries. Other representatives spoke in favor of his request. Following the presentation the representatives excused themselves. After some discussion it was moved by Dr. Henry Renger, seconded by John H. Wimberly, and carried unanimously, that the board reaffirm the stand taken by that body on June 1, 1954." [12] The school remained segregated.

One month after the action of the Board of Regents of Texas College of Arts and Industries, the United States Supreme Court affirmed "a lower-court ban on racial segregation in tax-supported colleges and universities." The court ordered the University of North Carolina to admit three African-American students. This ruling extended specifically to higher institutions of learning—the May 17, 1954 decision outlawing segregation in the public schools. That opinion had dealt only with elementary and high school pupils. The court said that although the 1954 case was limited to the facts presented to it, "the reasoning on which the decision was based is as applicable to schools for higher education as to schools on the lower level." [13]

As if in anticipation of this ruling, the Texas Intercollegiate Students Association meeting at Abilene Christian College, with student leaders from Texas A&I in attendance, passed a resolution urging them to work toward the

elimination of discrimination. They should "look with disfavor" upon any plan related to segregation "which would seek to nullify the strides toward racial integration which have been made by our constitutional courts" and upon any scheme which would replace "public education with private education in an attempt to evade the decisions relating to integration as announced by our constitutional courts."[14]

In May 1956, the next regularly scheduled meeting, the Board of Directors minutes report: "Dr. Poteet then asked the board to consider the application of Alma Hampton (colored) for admission to Summer School, 1956, whereupon the Chairman of the Board suggested that the matter of desegregation of A&I College be taken up for discussion. The matter was discussed at length, both pro and con, and every member of the Board expressed him or herself, which at one time was about evenly divided."

The Board passed a resolution noting that the U.S. Supreme Court on May 17, 1954, and May 31, 1955, ruled: "The fundamental principle of racial discrimination in public education is unconstitutional. All provisions of federal, state and local law requiring or permitting such discrimination must yield to this principle." The resolution also stated that "Vernon's Civil Statutes of the State of Texas, requiring that white children and colored children shall attend separate schools, is unconstitutional and of no further force and effect, and that all qualified children of all races are entitled to attend the same schools." These were the same rulings noted by Dr. Boyd Hall in his appearance before the Board on February 2, 1955. The board now found it necessary to adhere to these rulings. The resolution concluded:

N OW, THEREFORE, BE IT RESOLVED THAT HEREAFTER NO YOUNG MAN OR YOUNG WOMAN, A CITIZEN OF THE STATE OF TEXAS, SHALL BE DENIED ADMISSION TO THIS COLLEGE BY REASON OF RACE, OR COLOR, BUT THAT ALL YOUNG MEN AND YOUNG WOMEN OF WHATEVER RACE OR COLOR, RESIDENTS OF THE STATE OF TEXAS WITH THE REQUIRED SCHOLASTIC AND OTHER QUALIFICATIONS, SHALL BE ADMITTED TO THIS INSTITUTION, UPON COMPLYING WITH THE RULES AND REGULATIONS FOR ADMISSION.

The Board further ruled that "all college owned and operated housing facilities be available to white students only. Motion carried unanimously."[15]

On June 9, 1956, the *South Texan* reported that two African-American women, both graduate students, had enrolled without incident. Erma Rebecca Summers who had a B.A. in education from Texas Southern University, enrolled in the summer of 1957 and was the first African American woman to graduate from Texas A&I, earning an M.A. in education in 1959. In the fall semester of 1956, ten African Americans, including E. C. Cornell, enrolled and were recorded as the first "Colored students enrolled in A and I College for a long-term semester."[16]

This time, the files in the University Archives reveal a much more negative reaction. One former student crudely wrote: "Your decision to admit Niggers to A&I College will mean that many parents who had intended entering their boys in your College

Erma Rebecca Summers, enrolled in the summer of 1957. She was the first African American woman to graduate from Texas A&I, earning an M. A. in education in 1959.

will not do so now, as in my own case, for I had intended having my son attend next fall, But not now."[17]

Another alumnus wrote about the integration resolution: "The type of thinking behind your actions is rampant in our state today. If unchecked it will lead to the federalization of all our local and state institutions and to the socialization and the eventual communization of our country."[18]

A postcard from a person in Dallas said: "It is regrettable that you and your Board cannot see that the current desegregation mania is of communist origin and designed to appease communism and certain organized minorities who seek to destroy us. If segregation is wrong, why did we become the most powerful nation in the world with it?—producing the most of the best of everything known to history."[19]

Enrollment of African Americans seemed to some alumni another indication that the school was becoming too liberal. As indicated in the files about the *South Texan*, alumni felt editorials by students were too radical. A 1941 alumnae from Dallas wrote President Poteet about editorials in the November 10 and December 1, 1961 issues. "The attack on education, capitalism, House Committee on Unamerican

Activities gives me a new insight to a 'Liberal Arts College.'" A prominent Corpus Christi attorney who was a member of "Citizens Alert" concluded that *South Texan* editorials were "about as rabidly pro-communist as anything I have seen." He felt: "It is a real tragedy that A & I should harbor such a nest of termites like these." Actually, the student newspaper was not terribly radical and was much more interested in football games.[20]

In 1957, the president of East Texas State Teachers College in Commerce inquired about the possibility of an African American on Texas A&I's football team. He wrote: "Information has come to me that it is likely you will have Negroes on your athletic teams next year and particularly football. Thus far this institution has not been 'invaded,' and I think you know something of the situation that might be created here." He continued: "It is fully realized that this situation presents a somewhat delicate problem. Moreover, we want you to know that we are never interested in engaging in any activity which would weaken the competitive ability of our opponents. This possibility in no way enters into the situation. Our concern is with the probable reaction since we have never been faced with this type of situation before." The East Texas president concluded: "It is my understanding that your institution has already been integrated but at this time ours has not. Accordingly, our problems in local situations appear to be considerably different."[21]

Poteet responded immediately, explaining that "Texas College of Arts and Industries will not have a Negro on its football team next fall if present indications can be used as a basis for judgment." He added that it was very probable, however, "that the day will come soon when some colored boys will earn places on our athletic teams." He noted that two or three African-American students in Kingsville High School had already expressed an interest in attending Texas A&I. "I would suggest that we let the matter 'simmer' for a while. Perhaps the Lord will help us work it out before the problem gets out of hand."[22]

Texas A&I was the first integrated school to have a black athlete in the Lone Star Conference and in the state of Texas. In 1960, Sid Blanks, a native of Del Rio, was the first African American to receive a football scholarship. About this experience he later recalled: "After I arrived, I realized that I was the only black that reported for practice. It really didn't bother me because I spoke Spanish fluently and became very friendly with four Spanish guys who were practicing football. Coach Steinke also played a big role in making me feel at home."[23] The young football player remembered that competition was so keen for a place on Coach Steinke's championship team that he was too busy to really feel if there were problems among the students because of his race. "I am sure there could have been many negative repercussions during my first few weeks; and, maybe there were repercussions. But, if there were any," Blanks added, " I feel Coach Steinke curtailed anything that would have been detrimental to me."

Integration had come to the campus, but only partially. It was not until several weeks into the semester that Blanks realized that, in fact, Texas College of Arts & Industries was not totally integrated. The coach had arranged for him to live

with a Kingsville family, telling him that he would feel more comfortable in a home environment. Only in a speech class presentation made by a classmate did he learn that in fact he could not live in the athletic dorm because of the Board of Regents ruling. The football player decided that out of respect for Coach Steinke he would not "really push the issue." He felt that he was a part of the total team.

As had been anticipated by the East Texas State Teachers College President in his 1957 letter to President Ernest Poteet, when the Texas A&I squad traveled to Commerce for a football game, the team encountered serious problems. Blanks recalled:

> The teams stayed in a small town by the name of Greenville, Texas because there was no hotel to house a team in Commerce. As we drove into the city limits of Commerce, there was a large billboard which read, "Welcome to Commerce, Texas—The Blackest Land and the Whitest People." Upon arrival at the hotel, there were several people who wanted to see, I suppose, if I would be the first black, not only to participate in a football game in East Texas, but also to be the first Black to sleep in the only hotel within a 100 mile radius. . . . The [hotel] manager had made arrangements for me to stay with a nice black family who would house me overnight. The Black family walked up and introduced themselves and assured me that I would be welcome and safe in their home and they would be pleased to have me. Before I could react in any way, Coach Steinke had retrieved all the keys and promptly ushered us out. The manager wanted to know what the problem was. Coach Steinke answered him by saying, "If we all can't stay here, then we all leave." Seeing that this was probably the bulk of the hotel's business during football season, the manager felt like it would be more profitable to have the whole team stay in his hotel. Not only did I get a room in the hotel, but my roommate and I slept in the bridal suite!

Sid Blanks also remembered that during the game there was a great deal of name calling. "But, my teammates backed me up by opening up big holes in the line so that I could run for long yardage." As a result, "the name calling only made my teammates block harder and me run faster." Soon the opposition realized that "their little nasty ignorant remarks worked against them instead of for them."

Sid Blanks remembered that prejudice "was much more of a problem on the field than off the field." He concluded about his time at A&I: "I could see I had won a big victory for blacks everywhere against people who were small-minded and afraid of something they knew nothing about." He believed that the people who had been in authority "to make changes that should have been made long before I came to school" did not have the courage or insight "to allow something in this capacity until they saw the result of what, to me, is a great man, Coach Steinke." Blanks was not the first African-American athlete at T.C.A.I. Hank Allen had been on the A&I basketball team and Herman Robinson on the track team the year before Sid Blanks played football. Blanks excelled in sports and led the way for more African-American athletes to attend A&I. He played for the Houston Oilers for six years after leaving Texas A&I.[24]

On December 20, 1962, the Board of Directors completed integration by making available all college facilities—including dining halls and residence halls—to all students regardless of race, creed, color, or religion. In 1967, Dr. James Jernigan, who had replaced Poteet as president, issued a "General Statement of Policy Regarding Inter-Personal Relationships at Texas College of Arts and Industries." He

Jake Trussel, Kingsville newspaper man and A&I alumni, presented Sid Blanks with Associated Press All-American Certificate while coach Gil Steinke looks on.

reaffirmed the 1956 board action and further stated that "No one on the faculty, staff or even Board of Directors of this college is authorized to advise any student as to whom he or she will date or with whom he or she will associate unless such person giving the advice is the parent or legal guardian of the individual advised." Jernigan concluded the policy statement by noting: "The above has been written for clarification of administrative policy because of one recent substantiated case of discrimination, plus other rumored instances, for which I am truly sorry, that have been brought to my attention."[25]

Football had been an important activity on campus since the founding of the college. Now the struggle for equality was aided by the football team and by the school's most beloved coach. A native of Ganado, Texas, Steinke played four years for the Javelinas and was the leading rusher for three straight years. He averaged 105.1 yards a game in his senior year—the second-best record in the nation. In 1941, he was named honorable mention to the Little All-American team. Steinke served five years in the U.S. Navy during the war, then played five seasons with the Philadelphia Eagles and was that team's top safety and led them in interceptions in 1947. That same year he led the NFL. in punt returns with a 14.8 yard average. He became head coach of A&I in 1954.[26]

At the beginning of the 1959 football season, the mascot javelina "Scrappy" was quoted in the *South Texan* predicting that this would be "The Year" with the squad ending up at the top of the Lone Star Conference. Scrappy quoted the "Wild Hog March" (Fight Song):

> SO NEVER STOP 'TIL THE LAST GUN IS FIRED
> AND THE SCORE IS TOLD.
> SOCK THEIR KABINAS, YOU JAVELINAS—
> BLUE AND GOLD.

The 1959 team defeated Corpus Christi University, Trinity, Texas Lutheran, Howard Payne (forfeit), East Texas, Texas-Arlington, Sam Houston, Stephen F. Austin, Lamar, Sul Ross, and Southwest Texas. The season record of 10-1 was the best college record in Texas. The Javelinas shut out Hillsdale of Michigan 20-0 to win a slot in the N.A.I.A. National Holiday Bowl Classic in St. Petersburg, Florida. On December 19, 1959, the fifth ranked Texas A&I team played the Bears of Lenoir Rhyne (North Carolina). Lenoir Rhyne had ranked number one in the N.A.I.A. polls the entire season and had defeated Southern Connecticut to advance to the Holiday Bowl. More than 9,500 fans in the stadium at Lang Field and 15 million viewers on a national telecast watched the Javelinas score on a 32-yard pass on their first possession. They scored a second touchdown on a 77-yard pass play and a third touchdown on a 57-yard pass run. The defense held Lenoir Rhyne's Little All-American tailback to 74 yards on 25 carries, and the Bears only crossed midfield twice by the final three minutes of the third period. The final score was 20-7 and Coach Steinke's Javelinas had their first N.A.I.A. National Championship.[27]

By the time Coach Steinke retired in 1977, he had completed four years as an A&I student and athlete and twenty-three years as head coach. He enjoyed a 182-61-4 career coaching record and his teams won a reputation usually reserved for only top university division squads. During his tenure,the Javelinas won six national N.A.I.A. championships, with three consecutively in his last three years. The team also won ten Lone Star Conference championships. The squad played in five different countries and in twenty different states. He was named N.A.I.A. National Coach of the Year four times, American Football Coaches Association District Coach of the year twice, and was runner-up in the national A.F.C.A. Coach of the Year for two seasons. Coach Steinke was Texas Sports Writers Association Coach of the Year in 1975 and Lone Star Conference Coach of the Year three straight years. He was L.S.C. Coach of the Decade for the 1960s and was inducted into the N.A.I.A. Hall of Fame in 1971.[28]

At the end of his coaching career, the Javelinas were in a "Victory Streak" that ran from 1973 to the 1977 season—42 games without a defeat or a tie. Only two other college football teams have won more in a row. Texas A&I's streak was the longest of any college division team, N.A.I.A. team, state of Texas, or Lone Star Conference team.[29] The $1.7 million Physical Education Center was completed in 1970, but named in January 1976, the "Gilbert E. Steinke Health and Physical Education Center" (SPEC).[30]

Gil Steinke, center, surrounded by team members after winning 1976 NAIA football championship

Steinke's ability as a coach was reflected by his having 11 players in the professional ranks when he retired in 1977, and having 6 players drafted in the first round in the previous 12 years. Further, he had four others selected in the second round and four more who were third round choices during his time as the coach. His teams produced 41 All Americans and numerous all-conference and All Texas College players.[31] When Gil Steinke spoke, the community paid attention, and when football games were scheduled, South Texas listened to or, if possible, attended the games. A winning tradition did not assure proper treatment by the Corpus Christi newspaper. In 1967, a *South Texan* editorial complained about the poor coverage of Javelina football in the Corpus Christi newspaper despite being undefeated and ranking in the top ten nationally.[32]

Numerous traditions grew up around the football games, but during the Steinke era some reached a peak and others declined and disappeared. The Javelina mascot had been adopted in the first year of the school's existence. Through the years after the deaths of Bob, Joe, and Baby—the first little javelinas who followed their trainer around whenever he whistled—there were mascots named Henry, Henrietta, Little Henry, Scrappy, and three named Porky.[33]

During the early years, the mascot was leashed between two students at the games. Later mascots were caged. Scrappy, captured in 1958, was an especially feisty animal. Caught near an oil lease in Freer, Texas, by five A&I students, the boys endured two ruined tires, two chewed boots, and several scratches. After capturing Scrappy, the boys put him in the back seat of their car and two were assigned to hold him down. Scrappy chased one student to the front seat and nearly chewed off the boot of the student who remained in the back seat. To unload Scrappy from the car, the boys put a large bucket over him and a board under him and lifted him out of the car. For several years thereafter, Scrappy attended the games and delighted

the crowds, going especially wild every time the cannon was fired. In 1968, the mascot was Henrietta, who had been captured when she was a day or two old. A Premont student fed her with a toy doll bottle for the first weeks, fed her bread and milk until she got baby teeth and then he gave her commercial hog food. She was as tame and frisky as a puppy. Her handler noted: "She likes people and enjoys being playful. Whenever she sees me coming she squeals and barks with happiness." The students obtained permission from the Texas Parks and Wildlife Department to keep Henrietta. At football games she was transported in a cage mounted on a two-wheel trailer, with special safety protection so that spectators could not agitate her or stick their hands into the cage.[34]

Two items related to the mascot are the Javelina Battle Flag and the Javelina sculpture located in the median of University Boulevard on the campus. The Battle Flag contains the image of Porky wearing the school beanie. The image was created by Amado Peña, a graduate of A&I and now a well known Southwest artist, who entered a sports department contest and won a $10 prize for his efforts.[35]

The Javelina sculpture is the most recent addition to the tradition. It was first proposed in 1964 when campus organizations asked that a sculpture be created and placed in the circle at Santa Gertrudis and University Boulevard (then College Boulevard). Coach Steinke presented the College with the first check toward the creation of such a statue.[36] However, it was not until 1986, when Dr. Eliseo Torres, himself a graduate of Texas College of Arts and Industries, commissioned the bronze statue by an A&I art school graduate named Armando Hinojosa. The Alumni Association raised more than $70,000 for the statue. The statue, called "Leaders of the Pack," was unveiled February 14, 1986, as a Texas Sesquicentennial event and as part of a Conner Museum exhibit entitled "Armando Hinojosa: A 20 Year Retrospective."[37]

Armando Hinojosa designed and Javelina statue entitled "Leaders of the Pack."

School songs have long been a tradition. Students were more aware of the fight songs, but other songs were composed and were sung or played at various functions. University Archives include copies of the "South Texas State Teachers College" song with lyrics by Mamie Brown and music by Marian Wood.[38] (The title of the song was later changed to reflect the school's name change.) Also there is a copy of "We Are the Exes from Texas A&I," a song with words and music by Halla Stuart Eubanks.[39] Others are "Hail A&I" written by Mrs. Edwin Ernest, wife of the head of the Music Department, and "The Javelina Victory March."[40] In 1937, a music composer from Chicago named Nobel Cain came to A&I as a visiting instructor during the summer term. During his stay he composed and arranged "Wild Hog March" (or "A&I Fight Song" as it is sometimes called), which was the only official school fight song for several years.[41] The school newspaper reported that in 1927 Francis Beaver wrote two songs: "Alma Mater," sung to the tune of "The Lord is Great," and "To Our Alma Mater." "The Yucca" was another South Texas State Teachers College Song. Professor Engle arranged yet another song, "Blue and Gold."[42]

Those who attend Javelina football games today, however, are more familiar with the school's second fight song, "Jalisco." The familiar song was introduced to the crowd during the 1949 season when Javelina band members grew tired of playing military marches. Billy Jaime and Reinhold Hunger, having experience with the *conjunto* music popular throughout South Texas, decided that the students would appreciate a more familiar sound. The two played various Mexican songs which delighted the crowds and eventually other band members joined them. Another band member, Bryce Taylor, remembered many years later that "our band director at that time, Erwin Ernst, disapproved at the beginning, but later liked it."[43]

The 1959–1960 *Texas A&I Student Handbook* listed "Jalisco" as the "unofficial" school fight song. Student handbooks listed it with the designation "unofficial" and the "A&I Fight Song" as the "official" song. In a letter to the editor of the *South Texan* in 1969, a writer complained that the band was not playing "Jalisco" after touchdowns.[44] The newspaper published an article about "Jalisco" which mentioned that it was from Old Mexico and was considered the anthem of A&I. Professor Joseph Bellamah, chairman of the music department, who had arranged the music for a marching band, estimated that it was played between 17–54 times per game.[45] On December 2, 1969, the Student Council voted to make "Jalisco" an official fight song.[46] On June 5, 1971, the board of directors declared "Jalisco" an official fight song with the same status as the "Javelina Fight Song."[47]

As students became accustomed to winning football teams, they established another tradition during the decades of the 1950s and 1960s: the ringing of the bell in front of the Student Union. The bell arrived in 1957 when Commander D.C. Ball of Naval Air Station Kingsville delivered it to the campus on loan. On September 13, 1957, the bell was rung for the first time in a pep rally.[48] Thereafter the bell's resting place became a gathering spot for pep rallies and it became a tradition for the freshmen to ring what became known as the Victory Bell, for 15 minutes to announce a Javelina win in a football or basketball game. The tradition continued until 1967 when a *South Texan* reporter preparing a story for the

school newspaper on the history of the bell discovered that the bell was missing. The reporter, Jan Weeks, who was also editor of the school annual, finally located it in a school maintenance storage area. William C. English, college comptroller, explained that the removal of the bell was due to "several complaints regarding the noise people were making ringing the bell."[49]

In the feature story, however, Weeks reported that any night, but especially during final exams, when the bell rang the word quickly traveled through the campus that it was time for a "panty raid!" The bell would ring until a large group of men gathered on the lawn. They would then run around the coed dorms whooping and hollering in hopes that some young ladies would work up the courage to throw a pair of panties out of their windows.[50] Although the administration officially denied the panty raid story, one campus official who preferred to remain anonymous said: "Do not quote me, but strictly off the record, the bell was taken down because of the panty raids." The newspaper reported that after the reporter investigated the administration's crime, the bell was quietly returned to its resting place in front of the Student Union Building. In December 1967, President Jernigan issued an edict condemning panty raids—which caused the students to ring the victory bell to summons a "protest" panty raid in response.[51] The president said he would not change his policy, and although no official explanation has ever been given, the bell remains clapperless.

Another noisy and spirited tradition was firing cannons following a Javelina football score. The first documented use of a victory cannon, as it was named, appeared in the 1956 football season. It was only a rifle mounted on bicycle tires, and there is little information about it.[52] During the 1960 season, the Rangers, a campus group promoting school spirit, built a tube-like cannon that was fired after the Javelinas scored. A three man crew cared for the cannon and worked to give the fans a spirited show. The operation of the cannon was carried out in what was considered military precision, with snap and vigor reflecting long hours of practice. The cannon was located on the southwest corner of the Javelina Football Field. Prior to firing the cannon, the crew made certain that it was again firmly emplaced because it moved at each firing. When the Rangers secured the cannon, they swabbed out the bore, inserted the powder charge, and rammed wadding down the barrel. The crew precisely measured some black powder, generally in a "softdrink cup filled to the bottom of the well known trademark" because it was found to hold exactly the right amount to produce a deep-throated roar. The newspaper report on this procedure said that "little credence is given to the canard that inadvertent use of an off-brand cup hastened the demise of the original cannon."

This second cannon was owned by the student body but was passed to each class for custody. The Student Council supplied the funds for the black powder. The artillery crew paid to transport the cannon to out-of-town games.[53]

On Dad's Day in 1963, three A&I students presented the school with a new cannon, a replica of a Civil War howitzer proudly dubbed "Little Jav." A sign on it said that "Little J" was built by C.R. Fraser of Beeville and presented to the student body to foster school spirit. C.R. Fraser was the father of junior class president, Bob

The 1965 blue and gold cannon, named "Little Jav," was house at the ROTC building.

Fraser. The two Fraser men and friends had spent weekends building the weapon in their Beeville home workshop. The cannon was placed in the Student Union where it remained chained to a pillar between games. The *Bee-Picayune*, Beeville's weekly newspaper, reported that "the barrel of the cannon is 40 inches long, and is five and a half inches in diameter on the outside." The bore was two inches, encased with piping a half inch thick, and the breech was twelve-inches long with a six inch. "The cannon, true to the early American type, is a muzzle loader, and fires by lighting a fuse at the breach. The cannon has been test fired and painted in blue and gold, colors of Texas A&I College."[54]

In 1966, "Little Jav" was retired after the Lone Star Conference ruled that the cannon could no longer be fired during conference games. R.O.T.C. cadets had noticed at that fall's registration that the cannon, which was then kept on the front lawn of the Student Union Building, was deteriorating from exposure to the weather. They petitioned the Student Council for custody so that they could properly maintain it. When the Student Council officially transferred the cannon to the R.O.T.C. building, volunteers dismantled Little J, cleaned and reassembled it, and restored much of the woodwork. Cadets secured it in front of the R.O.T.C. building. Colonel L. M. Pederson, professor of military science believed "the cannon would be more appropriately displayed in front of the R.O.T.C. building, where it could properly be cared for." He added that maintenance of the cannon, like

the ceremonial raising and lowering of the flag, were proper responsibilities of R.O.T.C. program. Genie Penebaker, 1966 Student Council president, commented that the cannon was only temporarily placed in the custody of R.O.T.C. If the Lone Star Conference changed the ruling, the cannon would return to the student body for use.[55] In 1991, another cannon was introduced following a school newspaper contest, "Name The Cannon." The winning name was "Black Thunder," but because of the Lone Star Conference ruling, it is not used during conference games and in fact is little used at all.[56]

The R.O.T.C. students who assumed responsibility for the cannon were part of a program the school had worked hard to secure for almost two decades. The legislation establishing Texas College of Arts and Industries had specifically created a department of military science. In 1935, the college submitted an application for the establishment of an R.O.T.C. unit, but no action was taken. When the United States entered World War II, the college became a training institution for the military effort and by 1945, again sought the establishment of an R.O.T.C. program.[57] With the assistance of Ben F. Wilson Jr. and the Kingsville Chamber of Commerce, Dr. E.N. Jones sought to obtain a R.O.T.C. unit, but was never successful.[58]

For the next five years, Wilson continued his advocacy of Texas A&I as a site for an R.O.T.C. unit in letters to congressmen and other Washington officials.[59] Supporters preferred an Artillery unit. As late as October, 1950, a letter from the office of Senator Lyndon Johnson, who had supported the college's application for a program, reported that the Secretary of the Army planned no R.O.T.C. program for T.C.A.I. in the 1951–1952 term.[60] However, on April 15, 1951, the Texas A&I "Detachment of the 4305 ASU, Texas R.O.T.C. Instructor Group" was activated under the provisions of "General Orders No. 62, Headquarters Fourth Army, 1951." It was to establish a "Signal Corps R.O.T.C. unit—the first senior division unit in the South Texas area"[61]

Five Army officers visited campus in March, 1951, and Lt. Col. G.M. Bacharach was the main liaison from the Office of Executive for Reserve and R.O.T.C. Affairs of the Department of the Army. He informed the administration that staff for the unit would arrive before May and would begin processing applications of interested students. Since the Korean conflict was then of concern to many students, and because he wanted to discourage draft evasion, Colonel Bacharach announced that enrollment in an R.O.T.C. unit "does not guarantee draft exemption. Instead, a certain number of deferments will be granted to an institution on a quota basis."[62]

Colonel Leonard F. Walker arrived in May 1951, to serve as commanding officer.[63] To promote the new R.O.T.C. Unit, Col. Walker and his staff began an intensive public relations program including meetings to get acquainted with as many of the faculty and students as possible. One staff member was assigned to publish at least one article in each issue of the school and/or community newspaper. They designated March 3 of each year to be "R.O.T.C. Day" when the cadets would perform a "Pass in Review" and give the faculty and student body an impression of the program. All officers became members of one of Kingsville's service organizations.[64]

The college provided two offices in Manning Hall for the administrative side of the unit and two assigned classrooms in Nierman Hall. A building on campus was eventually modified to serve as an armory, and the old football field was designated for use as the R.O.T.C. drill field. At first, there were no facilities available for a rifle range, but construction very soon began.

The Cadet Corps was organized into Battalion Staff, four cadet companies, and a band. In addition to these standard sub-units, two extracurricular organization were founded: The King's Rifles and the MARS radio club. The King's Rifles was a group of the best drilled cadets who performed for the local public and in national contests. In competitions they often ranked first and they also furnished color guards and honor guards for special occasions. The MARS radio club was for cadets who were interested in communications. The unit obtained an F.C.C. amateur radio license in 1951, but were unable to secure the necessary equipment until January, 1952. When equipment arrived, there were no qualified operators. It was not until the fall of 1952 that the station was fully operational.[65]

The high point of social activities during the first year was the establishment of a tradition: the Annual Military Ball. Each year the unit hosted a dinner and dance at which they presented a Queen of the Ball and each unit's sweetheart.[66]

In the early days of the R.O.T.C. corps, women were limited to participation as queens or sweethearts or to joining the Women's Army Corps (WAC) for noncombatant military duty. WAC units were created as an auxiliary corps in 1942 and formally established within the regular army in 1948. The WAC often commissioned its enlisted members, and in 1970, Carla Lynn Rogers of Kingsville became the first Texas A&I student to be commissioned in this manner.[67]

In March 1972, Lt. Col. Donald L. Williams, PMS, inquired of the Commanding officer of the 5th U.S. Army about how women should be viewed within the R.O.T.C. programs. The president of A&I had concurred in authorizing the university to be nominated as a pilot institution for women in R.O.T.C. In so doing, President Jernigan wanted to be certain that women would be able to attain top leadership positions within the corps, that they would receive financial support during advanced coursework, be eligible for scholarships and that they would be eligible to participate in extracurricular activities such as the drill team.[68]

On March 23, 1972, the Department of the Army announced that ten schools, including Texas A&I, had been selected to begin offering Army R.O.T.C. to women in the coming fall semester. They announced that although the regular application period for R.O.T.C. scholarships had closed, special arrangements were made to award scholarships to qualified women that year. Women participants were to be commissioned second lieutenants upon graduation.[69]

In September 1972, 31 coeds participated in a program called Cadet Ladies. These women were hostesses for functions such as barbecues and homecoming activities. The units soon had to make room for female cadets, not merely "hostesses." In October 1972, 15 women participated in R.O.T.C. at A&I under the plans laid out by the Secretary of the Army. The trial program was a success and the Army announced that in the spring semester 1974, four-year R.O.T.C. programs would be available to

women at units around the country. The first woman graduate was Jesusa Salinas from Gregory, Texas, who graduated in 1976 and was commissioned a second lieutenant in the U.S. Army.[70]

From the earliest years of the school, the fall semesters were the most lively and memorable. Generally associated with football season, Homecoming, and the related festivities were a time when students met with alumni. In 1931, the "T-Association" hosted the first homecoming when alumni returned to campus to organize an Ex-Student Association and participate in festivities that concluded with a football game.[71] The first tradition associated with this event was the burning of the bonfire. Until 1942, when there were no football games because of World War II, it was traditional for the entire student body to assist with the wood gathering. The bonfire tradition returned in 1946 and continues today.[72] At various times throughout the history of the bonfire, different groups have been responsible for the actual bonfire. In 1953, the bonfire nearly collapsed when the replica of Austin College's Administration building was added to the top.[73] In 1968, R.O.T.C. cadets

Students stood in long lines in the library to register in 1967. Tradition dictated that freshmen wore beanies until after Homecoming.

built the bonfire.[74] In 1992, the Aggie Club assumed the responsibility of building the bonfire and built a very large fire from 3,500 wooden pallets.[75]

Two other traditions closely associated with the Homecoming ended in the late 1960s and early 1970s: the wearing of beanies and the Shirt Tail Parade. The traditional freshman beanie was worn during the first few weeks of the fall semester to identify and unite the freshman class. Freshmen were those who had less than thirty credit hours toward a degree. Student handbooks included rules for how to wear the beanie, which was either a shiny green (1947) or blue and gold in color. Freshmen were admonished that it was to be worn to all school functions, with the exception of formal events, from 8 a.m. to 9 p.m. While wearing the beanie, freshmen could not enter the front door of the Administration Building.[76]

The Shirt Tail Parade dated from 1937 when male freshmen were told to gather at the east end of the football field for a pep rally at the bonfire. They then performed a snake-dance to the corner of Armstrong and Santa Gertrudis, where they stripped out of their pants and painted their bodies with "warpaint." They then tied their pants around their necks and ran to the center of the Kingsville downtown area following behind a truck carrying the yell leaders. When they arrived at the designated area downtown they elected the freshman yell leader and attended a free movie at the theater. In some years during the Shirt Tail Parades, freshman girls wore war paint and were required to smoke cigars; the three worst-dressed girls received a prize. Following the bonfire, or at the homecoming football game halftime, a tug-of-war was held over a mud pit. If the freshman won, they could discard the beanies immediately. However, if the upperclassmen won, the freshmen had to wear their beanies for two more weeks.[77]

For almost 40 years the school tradition that highlighted the social activities of the spring term was the Lantana Celebration. In a 1929 students' election, they selected the Lantana horida as the official school flower. The title "Lantana Ladies" was coined for campus favorites who were featured in the "Beauty" or "Royalty" section of the school annual. In May 1930, the first Lantana Queen was crowned in an elaborate and colorful ceremony. Sweethearts of various campus organizations took part in the presentation and were known as duchesses.[78]

In the years that followed, the pageant underwent many changes—most of which increased the grandeur and popularity of the event. By 1932, students decided to ask area high schools to send representative duchesses to participate in the activities. In the early 1940s the official rules governing the election of the royal court were placed in the student constitution. The election was set for the fall, but the coronation itself remained a spring tradition.[79]

Due to the war, Lantanatime and Homecoming were held jointly from 1942 through 1946. Due to the few men on campus, the school did not field a football team and alumni were asked to visit the campus instead for the Lantana celebration. After the war, it became traditional for alumni to return for both the fall football Homecoming and the spring Lantana festivities. In 1948, a Lantana Parade was introduced. By 1956, the planning committee decided to also invite representatives

from other colleges to serve as duchesses. The official coat-of-arms for Lantana was adopted in 1957.[80]

Lantana was a cherished tradition that many alumni remembered wistfully. For example, Martha Stanley later wrote about the Lantana celebration during the war years when "College men by the numbers were disappearing from campuses all over America, answering their country's call to arms. But life—including life at A&I—went on."

That year the student body elected Alicia Krug from Kingsville as Lantana Queen. She was a bright, beautiful senior and a gifted dancer who had delighted audiences at the college and throughout the area. The college and the community were not surprised when she went to New York to study acting and dancing and became very successful. Martha Stanley recalled that Alicia Krug "danced in the Broadway musical 'Mexican Hayride,' and she understudied the lead in the Rogers and Hammerstein musical 'Oklahoma!' She also appeared in the movie version of 'Oklahoma.' Her home town in South Texas was mighty proud of her!"

Traditionally, the previous year's Lantana Queen crowned her successor. In the spring of 1945, students did not expect Alicia to be crowning the next queen; her New York career was so successful that she would hardly take time to return to Texas A&I. But as Martha Stanley remembers:

> At some point during the coronation production the house lights went out, and a spotlight trained on the stage. When Alicia stepped into that spotlight, the crowd exploded to its feet screaming, clapping, whistling. . . . Bedlam reigned for perhaps two minutes. Then the crowd rapidly quieted and settled back in their seats, as the first strains of the much loved music to "Oklahoma" were heard through the auditorium. Her long hair styled in a sophisticated bun, wearing a dress that was white, sheer, and flowing, ever so slowly Alicia began to dance—an exquisite ballet that kept a near-capacity audience spellbound.
>
> No one who was there could ever forget the night Alicia Krug brought Broadway to Jones Auditorium.[81]

In the 1960s and 1970s, when Texas A&I students—like college students all around the country—disassociated themselves from the mundane activities of their college predecessors, students eventually abandoned and forgot the parade, beanies, and tug-of-war activities. The years 1953–1967 witnessed new traditions and excitement on the campus as new programs such as R.O.T.C. were initiated and student enrollment soared. In the Fall 1953 semester, 2,108 students enrolled at the university, 1,266 men and 842 women. The names of the students enrolled in the 1953–1954 long term reveals at least 445 Spanish-surnamed students, or 21.11 percent of the students. At the May 1954 commencement, 205 students received bachelor and master degrees, 115 men and 90 women. There were 21 Spanish surnamed male graduates, 18.2 percent of the total, and 21 Spanish surnamed female graduates, or 23.3 percent of the total. In the Fall 1967 semester, a total of 5,376 students enrolled, 3,335 men and 2,041 women. There is no list of names of all the students enrolled, but there is a list of May graduates. Of the 530 receiving degrees, 292 were male and 238 were female students. Among these there were at least 87

Spanish surnamed males, or 29.7 percent of the men, and 56 Spanish surnamed females, or 23.5 percent of the women. If the percentages remained consistent between graduates and total student enrollment, there were approximately 990 Spanish surnamed male and 480 Spanish surnamed females in the student body, or 27.3 percent.[82]

Even in the halcyon days of the late 1950s and early 1960s, the college experienced recruitment and retention problems. For example, in the long term 1957–58 there were 3,354 students enrolled, 2,350 men and 1,004 women. On the list of students enrolled, there were 700 readily identifiable as Spanish surnamed, 20.87 percent of the students.[83] A study of the freshman class of 1957 revealed that of the 469 entering freshman, 98 graduated on schedule, which represented 21 percent of the total compared to a national average at the time of 38.6 percent. There were still 65 or 14 percent of the students registered as undergraduates at A&I in the spring of 1961. Therefore, 306 or 65 percent had withdrawn and "some of whom had transferred to other schools." One in five had remained and completed a degree program in four years.[84] Student retention was problematic at the time when 80 percent of the students were Anglos, and several studies expressed concern about the trend.

A study of the expectations of students and the experiences of freshmen students who remained in college and those who withdrew in the Fall 1961 semester showed that approximately 18 percent withdrew prior to the second semester, significantly higher than the national average of 11 percent. Those who remained in school felt they had had more homework and tests in high school, that the college offered the courses they needed and teachers answered their questions. This group also tended not to have been away from their home for as much as one month before coming to school and were interested in joining a sorority or fraternity. They had fewer jobs while in high school, did not feel they would need much money for extras in college, and had not driven their own or the family car to high school.[85] As more students began to own their own automobiles, commuting to campus increased. Another study about the income-expenditure patterns of the college in 1961 expressed concern that resident enrollment had been not increasing at the average rate from 1955 through 1960.[86]

Another study, profiling the freshman class of 1967, revealed that most students were single and received full financial support for their education from their parents. Females were more likely to live on campus in their freshman year than males. About 60 percent were Protestant and 40 percent were Catholic, and females were more likely to attend church than males. Female students were more inclined to major in education and males in engineering, business administration, and natural sciences. They came from families whose average size was 5.67—larger than the national average. The study concluded that urban areas prepared students for college better than rural areas, as indicated by drop-out rates. Approximately 20 percent of the students had spent most of their lives in communities smaller than 2,500 population, 38 percent in communities smaller than 20,000 and 42 percent in communities over 20,000 population. The authors did question how cosmopolitan a community of 20,000 could be. Parents had strongly influenced the students to attend college,

with males being more influenced by their fathers. The students' parents were mostly still married (85 percent), with only 8 percent having a parent who had died and only 7 percent having parents who had divorced or separated. These freshmen of 1967 had experienced little or no horizontal mobility during their lives and by enrolling in college were striving "to surpass the educational level of their parents and by implication change the social class and mobility pattern for their own future families." They rated the academic and social climate of the university "average" but the level of faculty and of "school spirit" as "above average." The study showed that approximately 27 percent of the students were Mexican American, 70 percent were Anglo, and 3 percent were African American and other.[87]

In 1962, Mexican-American students organized the Laredo Club to foster better relations among A&I students, but especially those from Laredo who wanted to "combine cultural aspects in relation to academic life" and raise money for scholarships.[88] Over the years the group sponsored dances, participated in the school carnivals, and brought speakers to campus. They organized for social activities and service and were not generally considered to be campus activists or radicals, not likely, for example, to be organizing and fighting for "La Causa" or "La Raza." Generally members of this ethnic group had not been included in the campus sororities and fraternities nor the very powerful Aggie Club. While the school's administration had expressly abandoned and forbidden segregation and discrimination based on ethnicity or race, there was, in fact, little social interaction among the different ethnic groups.

In 1962, the club was successful in gaining the election of Irma Montemayor from Laredo as the first Mexican-American Homecoming Queen at Texas A&I. Again in 1963, the Laredo Club sponsored Rosario Mora from Falfurrias, who was elected Homecoming Queen.[89] Traditionally, the largest and most coveted social honor was to be elected Lantana Queen. In 1963, the Laredo Club decided to seriously challenge the traditional election of an "Anglo" woman.

By 1963, the concept of the Lantana celebration was already being challenged by many. The *South Texan* reported that it was the general consensus on the A&I campus that something needed to be done about Lantana. At a panel discussion in the Student Union Building, sponsored by the Christian Fellowship, information was presented that attendance and participation in the festivities had drastically fallen and that it was an expensive venture that required an exorbitant amount of faculty time. Students and faculty generally conceded that the event was an excellent source of publicity for the school and a vehicle for women who wanted to be recognized for their beauty and talent; however, except for attending the Coronation Ball, few students participated. Most felt that the festivities were too expensive, the parade was of little interest, and the high school duchess participants were not especially excited about coming to a college campus. The students decided that Lantana was a stale tradition that needed drastic renovation.[90]

Furthermore, the Aggie Club—which did a disproportionate amount of the work building parade floats and preparing for the festivities—was growing disinterested.[91] Horace Salinas, who designed the Lantana ladies' elaborate dresses, had grown

weary of designing the dresses, while the girls selected for the honor and who had to create their own costumes were not always successful in their sewing duties.[92] Student suspicion of the Lantana celebration was an expression of the national revolt by college students against banal activities. In the 1960s, young people wanted their college experience to be more than just a party time; they wanted to stand for causes.

Traditionally, student organizations had nominated their candidate for Lantana Queen and supported that girl as a bloc. The Aggie Club and Greek fraternities and sororities sponsored a disproportionate number of winners because they were better organized. In the 32 years that Lantana Queens had been presented, only five of the young women had not been members of one of the Greek social groups, and most had been nominated or supported by the Aggies. None of the Queens had been Spanish surnamed. On campus it was generally known that the support of the Aggie Club was significant and the Greeks generally sought that support.[93]

Changing attitudes about Lantana were intertwined with changing attitudes towards sororities and fraternities on campus. In 1927, Alpha Sigma sorority became the first Greek social organization formed on the S.T.S.T.C. campus. Two years later, in January 1929, Delta Theta sorority was founded and later that year in October, Omega Tau Omega sorority was established. Probably because women so greatly outnumbered men until 1935, fraternities did not organize as quickly. Kappa Sigma Nu and Delta Sigma Chi made their first appearance in the school annual in 1937, each listing charter members. Kappa Sigma claimed to be the oldest national fraternity on the A&I campus.[94]

Through the years, the school annual and the school newspaper recorded many activities of these associations which offered a social life for the students. Rush weeks, teas, parties, and activities on the campus were central to the life of the groups. College campuses throughout the United States supported "the Greeks" as an part of the college adventure. However, during the 1960s, campuses changed and many students resented the Greeks, who seemed to be a privileged class.

Throughout this time, Mexican American students had largely been limited, or limited themselves, to such organizations as the Spanish Club under its many names including the Elena Mar and La Giralda Spanish Club, the Amado Nervo, the Hispano Club, and the Laredo Club. Photographs in the *El Rancho* reveal Spanish-surnamed students in numbers proportionate to their numbers in the student body, in the Newman Club, the Catholic student association, the scholastic honoraries, and in some clubs associated with their course of study, especially teacher education.

The Laredo Club had been organized for several years and had been an exclusive club primarily for students from the city of Laredo. In some annuals they claimed to be open to students who shared their interest, however, their primary social function was a dinner banquet in Laredo. Many of the Mexican American students on the campus in the mid-1960s would later claim that the Laredo Club was as exclusive and elitist as the Greek organizations.[95]

After successfully campaigning to elect of one of their members as Homecoming Queen, it appears from the *South Texan* that the Laredo Club decided to elect

their candidate Lantana Queen in 1963 and staged an aggressive campaign. They had tried in 1962, but had failed in part because the Student Council had changed the rules. Until the 1962 election for queen, students voted for one candidate and the young lady receiving most votes was named Lantana Queen. Six runners up were named Lantana Ladies. In 1962, when the Laredo Club nominated two candidates, the Student Council rule change was that students were to vote for six candidates and the winner would be queen. Not voting for six candidates would disqualify the ballot.[96] The two girls from the Laredo Club were ultimately named to the royal court, but only after two other candidates were disqualified after being elected.[97]

In 1963, the Student Council announced in advance that students were to vote for seven candidates and the queen would be elected in a subsequent run-off election. The Laredo Club nominated seven candidates and conducted a campaign that included charges of discrimination and bloc voting.[98] The Corpus Christi *Caller-Times* sensationalized and distorted the story creating negative publicity about the A&I campus. The *Caller-Times'* story indicated that the Lantana celebration was being overshadowed by racial bickering.[99] The *South Texan* responded with an editorial that said: "News of the recent A&I Lantana Court election has been generated by certain *Caller-Times* reporters in order to make news. Many of the facts were distorted and quoted out of context." And the article was unfounded as a whole. It had not only increased hard feelings among students, the editor concluded, "but has also given A&I a bad name." [100]

Letters to the editor in the *South Texan* had been expressing dissatisfaction with the power of the Greeks for some time. One student wrote to the school newspaper

Sara Sue Sheley was the last Lantana Queen elected without controversy. Here she is shown with her court and the Lantana Court of Arms in the background.

in November 1963, raising issues about the election. Although the Laredo Club nominated seven candidates, six of the young women withdrew on the eve of the election, yet their names remained on the ballot. Since students were required to vote for seven candidates, it could be assumed that those supporting the Laredo candidates voted for the seven they nominated. The writer noted that since only one was a true candidate, that one should have been a finalist. However, the lone Laredo candidate was not among the finalists and did not win the title of Lantana Queen.[101]

Following the selection of the queen in that year, the Lantana celebration committee announced that plans for the 1964 festival had been altered from previous years. The Lantana Queen, elected in controversy, was to be crowned, but there would be no parade and no campus decoration contest. Duchesses from area schools would be replaced with a program for scholars from South Texas high schools. Each area high school was asked to send their top ranking male and female students, and the school expected approximately 180 students to attend. The committee would award ten to fifteen scholarships, worth $100 for a full year's tuition. College departments were asked to present programs to the visiting scholars.[102]

An opinion poll conducted by the *South Texan* published in the December 13, 1963 issue indicated that students, at large, supported the changes mainly because they did not understand the purpose and reason to have the Lantana celebration at all. A student editorial in the March 6, 1964 issue of the *South Texan*, however, announced that many students were upset with the changes, especially the elimination of the high school duchesses.[103]

President James C. Jernigan said that Lantana has "proved too costly from the standpoint of time and money to develop these floats which were used for a very short time." He indicated that the Lantana Committee concluded during the spring and summer of 1963 that Lantana had reached a peak from the standpoint of a colorful and elaborate production. They eliminated the floats and parades to provide the funds for the scholarships.[104]

The Lantana celebration controversy certainly indicated a discontent with the status quo and with elitism. The results of the election resounded through the next decade until the festival ultimately died for lack of interest. In addition to anti-elitism sentiment, there were ethnic controversies on campus.

As the Mexican-American presence on campus increased from approximately 20 percent toward 30 percent and as national civil rights issues increasingly concerned students on college campuses across the nation, minority students on the T.C.A.I. campus demonstrated a heightened awareness and activism. By 1964, Chicano activist José Angel Gutiérrez had enrolled at Texas A&I and gave voice to the discontent felt by many minority group members not only in Kingsville, but throughout Texas and the United States.

Student housing in Kingsville had been a serious problem since 1925 but especially for minority students. José Angel Gutiérrez noted: "The fight against discrimination brought forth unity and challenge among Mexican American students at A&I." Mexican American students experienced several types of discrimination. "On the

one hand, we were not allowed to reside in the dorms in any integrated fashion. The few Mexican Americans who could afford to pay for dormitory housing were segregated. Most of us lived in boarding houses or apartments owned by Mexican Americans near the campus, of which there were only a few."[105] Gutiérrez felt that Chicanos at A&I were denied information and support services and there was a lack of communication between Chicanos and Anglos. Minority group members were rarely, or never, selected for leadership positions in student organizations or for social honors. Dating between the two groups was discouraged by the administration. Chicanos were segregated, according to Gutiérrez, in dorms, in classrooms, and in all social functions although they comprised 25 percent of the total student body. He concluded: "This campus had more Mexican American students than I had ever seen anywhere, so I set out with the help of my housemates to organize them all."[106]

The Civil Rights movement had become a concern of students on college campuses across the nation. Texas A&I was an expression of a national demand for equality for all citizens including African Americans, Mexican Americans, and women. Before the movement could blossom to a full maturity on the campus, another controversy usurped center stage. In 1966, the Texas College of Arts and Industries Board of Directors voted unanimously to request the change of name of the College to the "South Texas University." Representative L. Dewitt Hale filed House Bill No. 392 on February 7, 1967, to change the name to "South Texas State University." On February 9, 1967, after learning of the Hale bill, the board agreed to the proposed name change, though they wanted it known that they preferred the name originally proposed. President Jernigan had not known about Representative Hale's intention to introduce a bill with the proposed name being "South Texas State University," but once it was introduced he urged the board to accept that name since he felt it was the change to university status that was important.[107]

With the publicity that came from filing the legislation, *South Texans* exhibited considerable interest but alumni response was negative. Jernigan conferred with board members and decided to prepare a questionnaire to solicit opinions of faculty, staff, students, alumni, and the general public. In all categories of respondents the majority favored the name "University of South Texas." Of the 3,666 ballots mailed 1,811 were returned, showing that half of those surveyed had enough of an opinion to respond.[108]

A powerful voice that expressed disapproval of a change that would not keep "A&I" as a part of the name was Coach Gil Steinke. In a statement to the school newspaper Steinke said: "As an ex-student and being connected with athletics, I think the name A&I means something. I am definitely for the University title but I don't think we will gain enough by losing the entire name of A&I in place of something like South Texas."[109] Later, at Student Council "Gripe Night," nine football players appeared to protest a Student Council resolution in support of the name University of South Texas. Jerry Gates said: "It seems to me that the Student Council should represent the views of the Student Body on the name change. If you took an election vote right now, more people would vote for the name of Texas A&I than any other. The Student Council should represent the wishes of the Student Body, not those of the

administration." Athletes felt that a name without "A&I" would destroy tradition and make athletic recruitment more difficult. Another football player, Larry Pullin said: "Right now we are trying to build our athletic program. But nobody's going to come to a school they have never heard of. They'll say, 'South Texas State University? Where's that?'"[110]

President Jernigan learned that "The subcommittee of the State Affairs Committee reviewed the data submitted by you, the students, the faculty and staff and ex-students, and in our judgment amended House Bill 392 to carry the name of Texas A&I University."[111] Dr. Jernigan forwarded copies of the letter to the board of directors and accepted the name change.

The college had reflected changes in regional, national, and international developments from the beginning. At the initial battle to establish the school, a South Texas transportation revolution, a national pedagogical revolution and a political revolution in Mexico had affected creation of the college. The Great War, Great Depression, World War II, and Korean conflict had an impact on campus. In the 1950s and 1960s, the campus was a microcosm reflecting larger tensions in the nation. The Cold War and the Civil Rights movement were evident on the campus. The college experienced an identity crisis in dealing with racial integration and ethnic militancy. Texas College of Arts & Industries also experienced the additional identity crisis of another name change and mission expansion. In the years ahead, anti-elitism, ethnic militancy, the struggle for gender equality, and opposition to the war in Vietnam became even more prominent forces on the campus challenging students, faculty, and administration.

Chapter Six

TIME OF TURMOIL

TEXAS A&I UNIVERSITY

1968–1977

Student contributors:
Mary Armesto, Rafael Barrera, Diane Bancroft Borse, Debra Cardona, Joe Ely
Carrales III, Darren Earhart, Diane Denise Elizondo, Angela M. Garcia, Mark
Gingrich, Rolando Gonzalez, Carlos Guerra, Jesenia Guerra, Tanisha Michele
Hicks, Jackie L. Hunter, Debra Ann Jones, Daniel Lopez, Erika Lopez, Esequiel
Naranjo, Corey Lin Norman, Gabriel C. Pena, Laura Perez-Soliz, Alex Richards,
Richard Rose, Jaime Trevino and Donna Jean Weber.

Texas A&I University experienced turmoil from the late 1960s to the late 1970s. Controversies concerning racial integration, minority student rights, and denunciations of the Greek system accelerated along with newer demands for gender equality and an end to the war in Vietnam. Although the student newspaper contained traditional stories of music performances, football games, student activities, elections, and other campus events—the most controversial and emotional stories in the *South Texan* were about race, ethnicity, gender, and the Vietnam War. Some of the underground campus newspapers emphasized these topics to an even greater extent. Texas A&I was no different from other colleges in this respect, but Mexican-American issues were also prominent at A&I and in other schools in the Southwest. The university was an important center for Hispanic college activists in Texas. Editorials, letters to the editor, rallies, workshops, panel discussions, lectures, and debates addressed discrimination and minority rights. Compounding the concerns of administrators was the fact that new institutions of higher education were being created in South Texas. No period in the history of the school had been without difficulties, but the challenges in this period were formidable. In fact, a climate of crisis often prevailed in the late 1960s and the 1970s.

The school was thriving in 1967. It had survived another name change trauma and enjoyed a period of substantial growth. The name change reflected the battle

to redefine and expand the school's mission to better serve South Texas. College campuses around the nation experienced serious stresses in the 1960s, and Texas A&I University in Kingsville was no exception. The generation of academicians and administrators who began their careers in the years after World War II found the demands of the younger generation of students a severe test of their flexibility and adaptability.

James C. Jernigan, who would later lead the effort to make the Kingsville campus the flagship university in South Texas, first arrived on the campus in 1946. He came to Kingsville with his wife Frances to assume the position as director of men's activities. Subsequently, he served the school as director of student life, director of student personnel services, and dean of the college before being named president of Texas A&I in 1962.[1] While he was president, he instituted the nation's first bilingual degree program, pioneered the National Teachers Corps project, initiated an Upward Bound program, and administered the nation's first natural gas curriculum accredited by the Engineer's Council of Professional Development.

Dr. Jernigan was responsible for the establishment of Texas A&I University-Laredo—the state's first upper-level school for undergraduates—and Texas A&I University-Corpus Christi, also an upper level school.[2] He established the Texas A&I University System, which ultimately became the University System of South Texas, and was named the first chancellor.[3]

The establishment of a university system was a bold move to unite the forces for higher education in South Texas, but met with only marginal success. It delayed the establishment of strong competition for the Kingsville institution, but never managed to bring harmony and a united effort among supporters of the other area colleges. Pan American College at Edinburg—which had started as a junior college in 1927 and became a four year school in 1952—played a key role in conflicts and debates over how to organize higher education in the region. It generally opposed joining a partnership with other colleges and universities of South Texas.[4]

While the board of the A&I System felt that growth of higher education in South Texas could proceed only with the unified efforts of all of the colleges and universities, the Board of Directors of Pan American University adamantly resisted a merger and in an attempt to completely stave off such an action entered into negotiations with the University of Texas System. As early as 1972, the Board of Regents of the Texas A&I System had approached the Pan American board only to be refused. The Edinburg school's board of directors voted to merge with the University of Texas System, but enabling legislation was opposed and defeated by the legislators of South Texas. Then President Ralph F. Schilling wrote: "In light of the apparent diversity of interest between both universities [A&I and Pan American] and Pan American University's continued growth both at the Edinburg and Brownsville campuses without such a University of South Texas System, it is the feeling of the majority of the members of our Board of Regents not to seek such a System at this time."[5] Again in 1982, Pan American University President Miguel Nevarez commented about the continued efforts of the A&I System to merge all of the schools of South Texas: "It's a good idea in some respects, but I don't think from Pan American's viewpoint we would

be interested in joining any system right now. I just don't see the advantages. . . . It would just add another layer of bureaucracy."[6]

Administrators at the Kingsville and Corpus Christi campuses of the Texas A&I System were concerned about the possible merger and the intrusion of the powerful University of Texas system into South Texas. Both Gerald Robins, president of the Kingsville campus, and D. Whitney Halladay, president of the Corpus Christi campus, expressed their alarm about the possibility of such a merger in letters to Chancellor Jernigan. Halladay wrote:

> *Should this [UT/Pan American merger] occur, I am convinced that our development as a system will be seriously jepordized. The strength and resources of the University of Texas System, should it accept Pan American, would make it most difficult, if not impossible, for our system to expand in the area of professional programs. Such developments in South Texas would likely be assigned to Pan American because of the experience and resources represented by the University of Texas System.*

Robins informed Chancellor Jernigan: "I am fearful that the presence of the University of Texas in the Valley, with its politically knowledgeable expertise will tend to neutralize and eventually negate the service A&I has been rendering in this area for fifty years."[7]

While the battle to keep the University of Texas System out of South Texas went on for almost 20 years, ultimately the war was lost in 1989 when Pan American became a part of the University of Texas System and Texas A&I was merged into the Texas A&M University System. In the 1960s, the American Council on Education noted that one of the emerging patterns was the increasing consolidation and coordination of state systems in higher education after World War II. State legislators wanted "to eliminate wasteful duplication of programs resulting from competition among state institutions, to facilitate realistic and scientific budget requests, and to establish the rationale for developing new institutions and campuses." The process of "systemization" was a recent national phenomenon which grew out of political and bureaucratic impulses.[8] Texas was swept up in this national trend toward consolidation into larger state systems and the colleges in South Texas did not escape.

In the struggle to survive, Texas A&I University confronted many obstacles in the years between the first talks and the final mergers with the larger systems. On the Kingsville campus, Dr. Jernigan—first as president of the school and subsequently as chancellor of the system—fought to keep the school dominant in higher education in South Texas. One of his earliest efforts began in 1968 when the Texas State Coordinating Board for Higher Education asked Texas A&I to begin planning an upper-level center in Laredo. At the time there were no upper-level schools in the state and the Coordinating Board was proposing an experiment. Following two years of planning, in the fall of 1970 the state's first upper-level institution opened to fill a gap in the state's educational system by offering students in a relatively isolated area educational opportunities at the junior, senior, and graduate levels. It was believed that many students who would not otherwise do so could pursue baccalaureate and graduate degrees in those areas farthest away from established institutions of higher

James Jernigan, to the left of the speaker appeared at a meeting of the Board of Regents of the University System of South Texas.

education. In the beginning, the upper-level school shared a campus and other facilities with Laredo Junior College through an arrangement in which classrooms, laboratory, office, and library space were leased from the Junior College.[9]

The program at Laredo emphasized bilingual education, an area that had been significant in the mission of the Kingsville campus since 1925. It also pioneered in other areas, such as having faculty members work cooperatively with Transitron Electronics to teach language skills to Transitron employees. Transitron was a multi-million dollar corporation based in Wakefield, Massachusetts. Language skills were a difficult obstacle to the executives coming from Massachusetts to work with a Mexican workforce. Through the continuing education program, the Laredo school taught Spanish speakers to communicate in English.[10]

Also in 1968, the Texas State Coordinating Board determined that an upper-level school was needed in Corpus Christi, one of the largest metropolitan areas in Texas without a state supported four-year college. The only four-year college was the private University of Corpus Christi (UCC), which had been established by the Baptist General Convention of Texas in 1947 after inadequate research and planning. The college had struggled through deaths of important leaders, and with inadequate facilities, lack of accreditation of important programs, too few students, and too little money from the denomination or the community. It had tried to establish programs it could not support; building construction and the athletic program were expensive and led to unfunded indebtedness. Too few Texas Baptist students attended the school, and when the administration eventually recruited in the Eastern United States, many students were not Baptists, leading some Baptist pastors to fear that the college would be "paganized." Nor

did the institution serve the local Mexican American population. Many of them were Catholic and felt uncomfortable in a Baptist environment; in any case they usually could not afford the higher tuition at a private school. Student enrollment barely exceeded 900, never reaching the 1,200 number at which private liberal arts colleges can operate efficiently.[11]

The Coordinating Board's 1969 *Challenge For Excellence* requested the state legislature to authorize an upper-level institution in Corpus Christi to open in 1974 with an initial enrollment of one thousand students. At first, Texas A&I administrators opposed the creation of a state-supported upper-level college in Corpus Christi. Jernigan explained to legislators that the state needed to avoid needless duplication of facilities and curriculum and unnecessary competition for the same tax dollars and students. He eventually urged legislators to allow Texas A&I to develop this upper-level school to prevent the duplication on campuses in such close proximity. An independent study by Southwest Research Institute recommended the establishment of an upper-level college, but separate from Texas A&I and UCC. In 1969, Senator Ronald Bridges introduced Senate Bill No. 175 to establish a state-supported, coeducational institution of higher learning to be called Corpus Christi State University. The legislature was unable to agree on a bill and there were no substantial developments in 1970.[12]

In January 1971, Representatives L. DeWitt Hale, Joe Salem, Frances Farenthold, and Carlos Truan introduced House Bill No. 275 to establish a state-supported, coeducational institution of higher learning in Corpus Christi to be known as the University of South Texas. Senator Ronald Bridges introduced the same legislation as Senate Bill No. 131. In April 1971, a bill came out of the House Education Committee that would create an upper-level school administered by Texas A&I University. There were substantial obstacles to overcome: obtaining the agreement of the Baptist General Convention of Texas that UCC would be independent; that the board of trustees be self-perpetuating; that the Baptist church continue to fund the school during a transition period; that some property be retained for religious purposes; and that there be sufficient acreage available to meet state requirements for an upper-level campus. There was also the problem of paying off the indebtedness, which had been compounded by the destruction Hurricane Celia had done to the buildings at UCC in August 1970. Finally, in May 1971, the legislature passed a bill to establish an upper-level school named Texas A&I University at Corpus Christi and sent it to the governor for his approval. On June 10, 1971, Governor Preston Smith signed the bill in the UCC Library.[13]

In February 1972, the Texas A&I board voted to accept the UCC site for the upper-level campus; the Coordinating Board endorsed the same site in May 1972. D. Whitney Halladay, the president of East Texas State University, became the president of Texas A&I University-Corpus Christi. Citizens of Corpus Christi passed a bond election on December 9, 1972, by a vote of 14,265 to 3,979 for $1.5 million to pay off the debt of the school and purchase the site for the upper-level university. In May 1973, the board of UCC voted to transfer the property of the campus (except for 10 acres for religious purposes) to Texas A&I University. The new branch campus

opened for the Fall 1973 semester on the campus which had served the area as a private Baptist college for 26 years.[14]

Texas A&I-Corpus Christi claimed to have a different type of student and a different structural organization. Each college was responsible for all the plans of the teaching areas, "the graduate courses, the continuing education program, the interdisciplinary work among others." The school announced that there are "no departments in the traditional sense, all teaching areas being centralized under the college dean who carries the departmental heads' functions. The deans are the paper people, thus freeing teachers for their principal functions, teaching and advising students." Administrators planned to offer college credit for relevant experience before students entered the university or after they became students. From three to six hours of experience could be credited to the major field of study. A modified contract system was instituted. Student and advisor were to examine the student's goals, what the student had already done toward those goals, and then tailor a course of studies to fulfill the uncompleted goals. Each dean was charged with formulating a plan to satisfy the goals of his or her discipline.[15]

With the creation of the school, the Board of Directors of Texas A&I also determined that a central system administration headed by a chancellor should be established to coordinate the three degree-granting campuses and the Citrus Research Center at Weslaco. Jernigan therefore requested the Coordinating Board to authorize the establishment of a central administrative system office with adequate staff to properly administer programs on various campuses of the university. He also asked that the title of chancellor be awarded to the president of the A&I campus at Kingsville, and noted that because funds had not been appropriated for such an office and many of the tasks would overlap, he would continue to serve as president of the Kingsville campus and chancellor of the system without additional funding.[16]

At a special called meeting, the Coordinating Board approved Jernigan's request for the creation of the Texas A&I University System.[17] Although the Coordinating Board approved the centralization, the Texas A&I Board of Directors did not appoint a chancellor. They decided, however, that the Kingsville campus president should assist in development of the Corpus Christi school and that its president should be responsible to Jernigan. The Board established committees to consider a site for the campus and to develop rapport with the leadership of Corpus Christi.[18]

At the board meeting in April 1972, the trustees finally voted to establish a Texas A&I University System with a chancellor in Kingsville and separate presidents for each of the three campuses. The Board named Jernigan chancellor to serve in the dual capacity of chancellor and president of the Kingsville campus until the state legislature appropriated money for an administrative office of chancellor. The board gave Mario Benitez, vice president at the Kingsville campus, additional administrative authority since Jernigan would have two jobs.[19]

The idea of a system that would include all institutions of higher education in South Texas was not yet dead. The Texas A&I board continued to seek through resolutions and discussions a University System of South Texas to include the A&I campuses and the Pan American University campuses in Edinburg and Brownsville.[20] By 1976,

after Jernigan had resigned and been replaced by Halladay, the Board decided to seek statutory authority for the system and a name change for the campuses at Laredo and Corpus Christi.[21] Finally, in 1977, the Texas State Legislature created the University System of South Texas to replace the Texas A&I University System and changed the names of the sister schools to Laredo State University and Corpus Christi State University. Pan American University did not join the University of South Texas System.[22]

The fight to form the system and establish the other institutions of higher education in South Texas involved considerable politicking and a great deal of time and effort. The problems came at a time when many colleges faced turmoil, and nationally students were concerned with social issues. Nevertheless, these efforts were far from being the only problems facing the college. Texas A&I students, however, were especially concerned with the Chicano movement and activism increased during the late 1960s when José Angel Gutiérrez and Carlos Guerra organized campus chapters of *La Raza Unida*, the Political Association of Spanish Organizations (PASO) and the Mexican American Youth Organization (MAYO). The call for a Chicano Studies program was partially fulfilled when Texas A&I established a bilingual degree program and an ethnic studies program, offering a minor in that subject. The administration also responded to student and faculty activists by passing a Faculty and Students Bill of Rights and Responsibilities and the formation of a faculty senate.[23]

Jernigan asked the campus chapter of the Texas Association of College Teachers (TACT) in the spring of 1966 about greater faculty participation in University

Student activists brought chapters of La Raza Unida, MAYO, and PASO to campus and demonstrated for Chicano rights.

governance. TACT president George Coalson appointed a committee chaired by professor Hildegard Schmalenbeck to investigate. After studying the constitutions of over 15 college and universities and lengthy deliberations, the committee recommended the establishment of a faculty organization. In December 1966, President Jernigan called a faculty meeting to select a committee to draft a constitution for a faculty senate. The faculty elected 15 members and Jernigan appointed 3 members to the ad hoc committee, which began deliberations in January 1967. The committee elected professor Olan E. Kruse chairman and met almost weekly in the spring semester of 1967. A general faculty meeting was held on the proposed constitution, which was ratified May 2, 1967, followed soon thereafter by the approval of the president and the board of directors. Elections were held in May and the faculty senate held its first meeting in September 1967.[24] However, the student bill of rights and a new faculty senate were insufficient to stem the tide of controversy. The nation's young people pushed harder for a rejection of what they saw as the ills of the past, and A&I students focused on issues relevant to Mexican Americans.

When the school first opened in 1925, the dean of women and professor of education, Lila Baugh, had faced the challenge of training teachers to work with students whose first language was Spanish. However, segregation and discrimination had not been seriously challenged. By the 1960s, minority group members were no longer willing to accept the status quo of Anglo domination. In 1968, Mario Benitez of the modern language department introduced a bilingual degree program for undergraduate studies in other than governmental specialization, to offer bachelor's degrees in agriculture, business administration, and engineering. Those who were not foreign students would take 12 hours of Spanish especially designed for the program, with an emphasis on making speeches, report-writing, and conducting conferences. Foreign students would concentrate on learning the English language. Graduates of the program were to receive degrees in their areas of specialization with a bilingual certificate. In Benitez's view, the Bilingual certificate "means that we are guaranteeing an employer that this person can function properly both in English and Spanish in the subjects in which they have majored. So just knowing Spanish is not enough. They also have to know the terms that are proper for their respective disciplines."[25]

In 1973, Senator Carlos Truan, a 1959 graduate of Texas College of Arts and Industries, authored and steered through the state legislature a bill that established a bilingual/bicultural education program for the State of Texas that served as a model for the country. Recognizing that there were many children in the state from language environments other than English, it provided for financial assistance to establish bilingual education programs. The legislature mandated that every school district with 20 or more children of limited English-speaking ability had to implement a bilingual program by the 1974-1975 school year.[26]

Texas A&I had long dealt with the challenge of training teachers for the area school districts with non-English speaking students. With the passage of this bill, the school was poised to move aggressively in the preparation of teachers to satisfy the

need. In the summer of 1970, Texas A&I offered two summer institutes for teachers and for classroom aides who worked with migrant children, funded by the Migrant and Preschool Program of the Texas Education Agency.[27]

In 1971, the dean of the College of Education accepted and approved a committee report that established a bilingual education program for undergraduates. By September 1972, the program was instituted to train teachers in linguistics, general linguistics, bilingual methodology, Spanish and English dialects, and Spanish as it applied to the various parts of the elementary curriculum. Teachers were to be able to teach in all areas of elementary education in Spanish and/or English.[28]

The first graduate of the program came in May 1974, and by 1975, the school had received approval for a doctoral program in that field—the first in the nation. In the doctoral program, students could specialize in areas of teaching English as a second language, teaching Spanish language skills, applied linguistics, bilingual methodology, supervision of bilingual instruction, and research in bilingual instruction.[29]

Student activists of the time were eager to do more to develop understanding and awareness of area minority group members and continued to work for a Chicano studies program. In the Fall 1969 semester, Professor Ward Albro of the Department of History offered a course on "Mexican Americans in the Southwest" as a special topics class, but noted that it would become a regular class in the following year. At the May 21, 1970 meeting, the board of directors approved an ethnic studies program.[30] Jernigan promptly announced that it would go into effect by September 1, 1970. The program was an outgrowth of a proposal made by PASO and an ad hoc committee, appointed by Jernigan, to study the grievances and recommendations made by Mexican-American students. The *South Texan* praised the decision to create an ethnic studies program and noted that the history department was already offering courses in Mexican–American and African-American studies. Jernigan named Victor Nelson, a graduate student in history from Brownsville, to be the program coordinator to work with Robert Rhode, vice president, and dean of the university.[31]

The coordinator was to gather material from other colleges and universities to design a program that would incorporate courses already taught in the sociology and history departments, and establish a special section in the library to house materials for the study of ethnic relations. Lectures and symposiums on the culture and history of the Mexican American were to be another component of the study. The long range goal was to seek and acquire materials to assist in developing the program and in finding qualified Mexican-American and/or African-American personnel for faculty and staff positions at the university. Victor Nelson said that the overall goal of the program was to sensitize people to the problems and cultures of minority groups, primarily the Mexican-American.[32]

An outgrowth of the minority student interest in their culture was expressed in the work being done by the art and drama departments where young people prepared for a career in the arts. César Martinez, Amado Peña, José Riviera-Barrera, Carmen Lomas Garza, Santa Barraza, Luis Gutiérrez, and Bruno Andrade were young art

students learning their craft at Texas A&I who would later become prominent in the national art community.[33]

The drama department—which had an active program since the formation of the school in 1925—finally received the right to offer a Bachelor of Arts degree in 1971. In 1972, Professor Joseph Rosenberg formed La Compaña de Teatro Bilingüe to perform for the largely Spanish-speaking population of South Texas. Rosenberg admitted that he possessed only "an indifferent command of the Spanish language but a great amount of good will towards the promotion of Hispanic culture" and with the assistance of his wife, "a student of her native culture, Mexican," he began the process of creating El Teatro. He maintained that "the venture we undertook was to create a theatre company the actors which could perform in both Spanish and English." At first he found it difficult to recruit actors who could or would perform in Spanish. The professor found "our main obstacle, however, was social pressure, which, one way or another had created in Mexican American students a feeling of hesitancy to move into affairs reserved for the 'Anglo' elite."[34]

Although the new performing group faced many obstacles, Rosenburg was able to begin with a small touring production of a play entitled *La Fiaca* in April 1973, and then developed an exchange program with schools in Mexico. By 1974, the University of Nuevo Leon in Monterrey brought their theater group to the Kingsville campus and went on to perform by invitation at an international theater festival in Scotland. That spring El Teatro Bilingüe began an extensive tour of Texas and Mexico featuring a production of *Travelesnik*, including performances by the author of *La Fica*, Ricardo Talesnek, and his actress-wife, Henny Trayles. The tour grew to include

The Frank C. Smith Fine Arts complex was built to house the speech/drama, music and art departments during the building boom in the early 1960s.

142

other Latin-American countries and traveled to Spain under the sponsorship of the American Embassy. Rosenburg and his students faced multiple obstacles of financing and language, but overcame them, expanding their linguistic and interpretive skills. They traveled extensively throughout the Southwestern United States and the Latin-American world, repeatedly garnering praise and awards. In 1977, the group entered competition in the American College Theatre Festival and was selected to open the final phase at the Kennedy Center for the Performing Arts in Washington D.C., where they received the Amoco Award of Excellence. As a result of this honor, the Texas House of Representatives awarded them a Certificate of Citation for their excellence. Later that year, they presented two short plays by Cervantes in the Chamizal International Siglo de Oro Festival and received awards for best director, best leading actor, and best leading actress.[35] In 1985, Rosenburg retired from the university and moved into the private sector of directing. The concept of El Teatro Bilingüe was not able to survive the loss of its leader.

In addition to bilingual education, a Chicano studies program, Chicano artists, and bilingual theater, there were many other ethnic activities on campus including Mexican-American students publishing underground newspapers—*El Chile* and *El Machete*—and organizing groups like MAYO and PASO. They had joined La Raza Unida, a political party, and staged demonstrations on campus and in the community, advocating minority rights. On September 16, 1970, local students joined the National Chicano Walkout (from schoolrooms), marching from the Student Union building to the Kleberg County Courthouse, calling for the impeachment of former business professor J.R. Manning, who had been elected Mayor of Kingsville.[36] The student underground newspaper, *El Machete*, complained that the professors were a "disgrace" to their profession. "Most are here to enjoy the good life of sailing, fishing, hunting, tennis, etc. and could care less about professional obligations and 'student wards.'"[37]

More important to the local student activists was the fight for equal rights in housing. Historically, Kingsville had been a segregated community. Mexican Americans lived in the barrios on the north and east side of town and African Americans lived in a small area called "the Quarters" in the southwest part of the city. Both communities had generally understood the boundaries, with Anglos occupying all other parts of Kingsville.

In the dorms there was also segregation and there was generally little or no mixing of the groups. The dean of women made dorm assignments so that foreign female students were separated from the non-foreign female students. Mexican-American female students were housed with the foreign women in the older, less modern dormitories. There was strict control and regulation of the lives of students, with the dormitories locked up at night and the coeds needing to sign even to go to the library.[38]

Student activists in the early 1960s had rallied around the cause of seeking integrated and fair housing practices. Now they became more adamant in their demands, as was evident in issues of off-campus housing. José Angel Gutiérrez recalled that as early as 1964, he and his friends would call to inquire about a listed

rental property and would be assured that it was available. When a Mexican or black student would visit the property it would inevitably have "been rented" or the rent price would be double or triple the advertised price. To verify that the rental property had in fact not been rented, a follow-up call would be placed and the property would once again be available. Another check on the availability would be for a phone call to be placed by a person with a heavy Spanish accent. The property would be unavailable. Then a black student would call and be told that the property was available. However, when the African American appeared to see the property, it would be no longer available. A subsequent telephone call would reveal the property was once again available.[39]

In 1969, the student council took up the cause of finding better housing for students. It had expanded from being an ethnic issue to one that was a problem for all students. The student government established a committee to survey all students who lived in Kingsville, but not with their family. They identified 1,800 students who should be included and sent survey forms to determine the condition of their housing. In 1970, the *South Texan* carried an open letter to Kingsville about housing discrimination and an editorial encouraging the city council to pass an open-housing ordinance. The city council's Human Relations Committee urged the city to pass an open-housing ordinance and Jernigan spoke at the committee meeting in support of such a resolution.[40]

Representative Carlos Truan, who was in his first years of a long tenure of public service, introduced House Bill No. 362 in the 1971 Legislature, calling for the establishment by law of a bill of rights and responsibilities for both landlords and tenants. The proposed law called for the establishment of remedies for certain violations, asked that security deposits be returned within thirty days, and prohibited retaliatory evictions and/or rent increases without cause or proper notice. He also introduced a House Resolution No. 517, which established an interim committee on landlord-tenant relationships.[41]

Shortly after this action, three students—Carl Simpson, Rick Cope, and Jerel Shaw—discovered that a local landlady was willing to rent an apartment to Simpson and Cope until she discovered that the third roommate, Shaw, was black. They filed charges with the Kingsville Human Relations Committee. The college student council, under the leadership of student council president Carlos Olivarez, voted support. By the fall of 1971, the council established the Student Housing Authority (SHAY) to combat housing discrimination against students. Simpson and Shaw filed charges with the U.S. Department of Housing and received a settlement from the landlady when she was found guilty of discrimination. Representative Truan's bill ultimately died without action, but the young representative returned to the campus to express support for the student cause and urge students to continue to work within the established system of government.[42] The housing problem sensitized and mobilized many students on campus.

PASO, which had been previously involved in the housing dispute, now grew bolder, becoming involved in Kingsville city politics. While the student council was concerned about housing availability, Carlos Guerra led PASO members to protest the

lack of paved streets in the area of town where Mexican Americans lived. PASO called for a park, clean drainage channels in the barrios, and the dedication of more county money to worthwhile projects. PASO members also joined a boycott of a Kingsville junior high school by students and parents who were demanding that the school stop the practice of punishing students for speaking Spanish on the school grounds. Students who were members of the Mexican American Youth Organization (MAYO) demonstrated at a local school about speaking Spanish at school. When several were arrested, the Mexican-American Legal Defense Fund sent lawyers—including an A&I alumnae Juan Rocha, who had campaigned for student council president in 1958—to defend the protesting students. Four hundred protesters held a silent vigil at the city police station. MALDEF attorneys convinced the crowd to disperse so that police would release protesters who had been arrested.[43]

There were numerous other examples of student involvement and activism in the late 1960s. Seminars, petitions, editorials, letters to the editor, and protests were some of the manifestations of the Chicano movement on campus. A two-day seminar on Mexican-American unity in February 1969, began "with the 'liberation'—excluding Anglos from the premises—of the SUB Ballroom by the main speaker." PASO and other activities picketed Kingsville City Hall and the Kleberg County Courthouse "to dramatize four community development 'demands.'" Jernigan received a list of nine grievances from PASO and appointed a committee to study the issues. A group of students opposed to PASO circulated a petition and a campus group supporting the Mexican-American "cause" composed of people other than Mexican Americans unofficially headed by Pam Hill, a student from Corpus Christi, circulated a petition in support of MAYO. Editorials and letters to the editor by students and faculty members discussed Chicano issues. In 1972, student government endorsed Ramsey Muniz of La Raza Unida Party for governor, which upset some students. Turmoil in the student council in the 1971–1972 school year led to a reorganization of student government into three branches, with the student council now renamed the student congress. Student government heard complaints that the Greeks discriminated against minorities in 1970, and a 1973 *South Texan* story reported that when a sorority pledged a Mexican-American girl it was only the second time Greek sisterhood had reached across ethnic lines.[44]

In the spring of 1969, former Texas State Attorney General Waggoner Carr visited the Kingsville campus and spoke to many of the young activists, challenging them to become the answer to the problems plaguing the country and being targeted by student protests in Kingsville.[45]

African-American students on campus also expressed concerns about discrimination and segregation. In November 1968, they formed the "Afro-American Society of Texas A&I University" to increase awareness and unity of black students on campus. That same week, a panel discussion by three administrators, two faculty members, and one student discussed the topic of inter-racial dating. The faculty members and one administrator believed it was the role of the parent to discourage mixed dating. Another issue, of discrimination of rental houses in Kingsville and of segregation in the dormitories, was a problem the Afro-American Society leaders talked about in

a four-hour interview with a *South Texan* reporter. They also expressed frustration when they tried to get the college to lower the flag to half-mast on the day after the assassination of Dr. Martin Luther King Jr. Incidents and problems in the dormitories were other concerns.[46]

By the late 1960s, another group of students began to express concerns in the student newspaper. Female students began to demand gender equality and discuss women's issues. In October 1967, a three-part series on the sexual revolution and the new morality appeared in the *South Texan* and a social worker spoke on campus about the problems of unwed parents.[47] In a January 1971 issue of the *South Texan*, a letter writer denounced the outlawing of abortion and called for women to have a choice. In March, the Women's Liberation Club was formed, drawing membership from students, some wives from the U.S. Naval Air Station-Kingsville, women employees of the university, and faculty wives. In 1972, Texas A&I became one of ten universities in the country to establish an Army R.O.T.C. program equally open for male and female students who had four years of college left to complete. Married women, even with children, were to be accepted into the program. Classes were to be coed and women were eligible to compete for four-year scholarships.[48]

Esther Pena was one of the female students who found it difficult to accept some of the rigid rules imposed on women athletes. In 1975, Pena—who had been voted the most dedicated A&I volleyball player by her teammates—became involved in a dispute about wearing a bra when competing on the team. Although woman's athletic director Betty Brewer had called her "probably the best woman athlete to ever come to Texas A&I," she also confronted Pena and required her to wear the bra or not play with the team. Pena maintained that the bra hindered her movement, and when she left practice, the athletic director treated this as a resignation from the squad. The underground newspaper *El Chile* proclaimed: "The entire HPE department discriminates [against] Chicanos, women sports, and other minorities." Esther Pena and some teammates later claimed that the issue was forced because she had complained about the inequality of funding and support for women's sports compared to men's sports.[49]

Women athletics had struggled to obtain full funding and equality when reestablished in 1968. Coaches of women's teams were not given release time to coach and the travel budget was small. Women had to provide their own uniforms to play, which meant some of the players made their own. The women's basketball squad had to stay at dormitories of their opponents because they could not afford motels. Several times their transportation was provided by parents or coaches.[50] In response to concerns about such issues, the U.S. Congress had passed Title IX in 1972 to provide for gender equality.

In early 1976, Pena filed a complaint with the U.S. Department of Health, Education, and Welfare, under the provisions of Title IX, which said in part that no person was to be treated differently or discriminated against on the basis of sex by a school receiving federal assistance. The school's comptroller acknowledged that if the charge was supported, Texas A&I would lose funding for its many research projects and aid and loan programs amounting to almost $1.9 million in the previous year.

Esther Pena, second from the right in the back row, was an outstanding volleyball player.

While the school did not acknowledge fault, the funding for the women's athletic program was almost doubled and the women's athletic director resigned, returning to classroom teaching full-time.[51]

A report in the University Archives entitled "Title IX Self-Evaluation: Preliminary Report" recommended that "future [A&I] catalogues should depict women engaged in some of the academic activities often reserved in the past for men." Thus, the Texas A&I students and prospective students "will be encouraged to recognize talents without regard to sex." Further, the report said that there was a "need to bring women into important positions in the University." There were eight men and only one woman on the board of directors. There were no women executive officers or administrative officers, only one woman as an officer in the alumni association, and only one on the alumni board of directors, and a current graduate council listed in the catalogue was all male. The report ultimately concluded: "This preliminary investigation suggests that Texas A&I University in Kingsville has on the whole treated all faculty and students as individuals, without discriminating on the basis of sex." However, changes in American society "demand comparable changes in a university, especially with regard to growing respect for all human rights." Everyone in the university community should be "aware of the intent and scope of Title IX regulations so that all of us will be encouraged to re-examine our attitudes and our behavior toward others." If all students, staff, and faculty "are to make full use of their talents in this university community, there can be no place for unreasonable stereotypes and unfair treatment of individuals or groups." The report, authored

by Julia Smith, a Mexican-American professor of English, also recommended an examination of the athletic budget, including athletic scholarships.[52]

If the female athletes thought the report would help, they were disappointed. A few weeks later, in the fall of 1976, the university dropped the women's softball team from the athletic program. For budgetary reasons, the administration cut the softball team, but also the men's tennis team. The women's tennis team was allow to remain in the athletic program. Coach Livia Diaz was disappointed and women athletes were angry that they had not been notified earlier so that they could have transferred to other schools. The softball team was cut because it was larger and the expenses were greater than the women's tennis team.[53]

Female students expressed concerns about other aspects of campus life. In January 1970, the dean of women, Carrie Lee Bishop, announced the extension of curfew hours from 10:30 p.m. to 11 p.m. Monday through Thursday, from 11 p.m. to Midnight on Sundays, and a continuation of the 1:00 a.m. curfew on Friday and Saturday. The student newspaper noted the conditions on other college campuses and indicated a national trend toward totally abolishing dorm hours. In January 1971, a survey of women students living in the dorms revealed that they favored the complete elimination of the curfew. Eventually in May 1971, the coeds voted 484 to 244 to abolish a curfew. In 1976, dorm women conducted a "Jock raid" in retaliation for a "panty raid" by the men the evening before. There were concerns about other women's issues. When the Women's Liberation Kingsville Project asked the director of student health services about the distribution of contraceptives at the infirmary, they learned that none were distributed. The director of student health services also reported that if an unmarried girl became pregnant, "they are reported to Dean (Carrie L.) Bishop who in turn notifies the parent to 'come get them.'"[54]

South Texan articles and letters to the editor was only one forum for the students to voice concerns. One of the most popular forums for student opinions was the "Speaker's Corner," which first met on March 12, 1969. Meeting each Wednesday in front of the Student Union Building, faculty and students were invited to express their views on any topic between noon and 1 p.m. The main topic in the Spring 1969 semester was the role of the Mexican-American movement in the Southwest. Speeches increasingly dealt with the Vietnam War in the fall of 1969. Over two-hundred students attended the Speaker's Corner on a Wednesday in November 1970, which was called off after four hours when "a heated debate" occurred between Chicanos, blacks, and one Anglo about housing problems in Kingsville. The "Corner" reconvened the following day when 150 students continued the debate for three hours more.[55]

Just as the *South Texan* had contained stories on alumni at war during World War II and the Korean conflict, there were similar stories during the Vietnam War of students being killed in combat, being decorated for heroism, or of families receiving awards for their loved ones posthumously. Students often composed poems about the war, Vietnam veterans, and returning warriors. Veterans who had returned to campus described their war experiences. In 1970, the R.O.T.C. program

The "Speakers Corner," organized by the speech department, gave students a forum to voice their opinions.

built a memorial patio dedicated to seven of the graduates of Texas A&I R.O.T.C. who had been killed in Vietnam.[56]

Unlike earlier wars, however, this time there were also students and faculty demonstrating against the war. For example, in 1969 at a Speaker's Corner devoted to a Vietnam Moratorium, history professor Paul Soifer explained why he was wearing a black armband. In April 1970, the Students for Peace and Progressive Action (SPPA) set up a symbolic graveyard, conducted a peace fast, held teach-ins, and one evening held a candlelight rally at the Kleberg County Court House. An estimated three-hundred students attended the rally wearing arm-bands and peace symbols. The next month, a sharply divided student council debated and passed a resolution deploring the invasion of Cambodia. The next year, an editorial in the *South Texan* denounced the continuation of the draft and the Vietnam War. Another editorial asked "Is Vietnam Worth Sacrifice?"[57]

Students were sensitive to other contemporary issues. They even mounted a small environmentalist protest. In March 1970, the Committee to Combat Pollution decided to march from Kingsville to the Celanese Plant near Bishop. At the weekly meeting in the Biology Earth-Science Auditorium, the students met with Celanese

officials. They learned of the efforts by the corporation to reduce their emissions that contributed to air pollution. The student protest was unusual in that it was in support of Celanese for these environmental efforts.[58]

Students manifested hostility to authority in other incidents, showing they were unwilling in the late 1960s to accept traditional university restrictions. Student life was tightly controlled. The dean of women's dress code demanded that female students wear dresses. Students were discouraged from walking across campus holding hands. If a female student went to study at the apartment of a boy living off campus even as early as up to 9:30 at night, it was sufficient to expel her from the university. The dean of women talked to the female students about the suitability of their boyfriends or fiancés. To have a bottle of beer in a refrigerator at an apartment was cause for being brought to the disciplinary committee. Students were held to different standards by ethnicity, with Hispanic students sometimes expelled for lesser offenses and Anglos not expelled for more serious ones. This intrusion into students lives alienated, segregated, and diminished the students. Ultimately, protests by students were fueled by the dean of men and the dean of women trying to control their lives in no longer acceptable ways.[59] Some of the rules which had been tolerated by earlier generations seemed ludicrous to the 1960s generation. For example, in 1968, the refusal of Paul Pambianco to wear a necktie and semi-formal attire to Sunday dinner at Loftin Hall led the college administration to ask him to vacate his dorm room in Cousins Hall. The sophomore from Seattle usually wore blue jeans, a sports shirt, and motorcycle boots. He obtained signatures of 285 of the 532 males who used Loftin Hall dining facilities on a petition to repeal the dress code. Dean of men, J.E. Turner, ordered Pambianco to vacate his room by November 24th. The student council voted to support the petition to repeal the dress code.[60]

The *South Texan* printed letters from critics, supporters, and Pambianco, and wrote an editorial criticizing the administration. The university disciplinary committee denied Pambianco's appeal and placed him on "disciplinary probation." When Pambianco went to register for the Spring, 1969 semester, registrar William Hall sent him to see President Jernigan, who informed the student he had to sign a statement that he would not go to lunch on Sunday without a tie. Without a tie he could not live in Cousins Hall or register. In February 1969, the male students voted 245 to 51 to change the dress code to "clothing that is neat and clean." The women dorm residents voted to change their rule of "wearing a dress or dressing up for every meal" to dressing neatly and comfortably at all times. The vice president for student affairs, the dean of men, and the dean of women approved the new more lenient rules, which still forbade the wearing of sweatshirts, T-shirts, shorts, cutoffs, warmups, or swim trunks in the dining room.[61]

While some students were involved in the serious task of protesting social injustice or infringements of personal liberties, the campus continued to have some of the more light-hearted activities, too. The Javelinas had been frustrated in their quest for another national football championship since 1959. In 1967, they had a 9-0 record, had ended the season ranked No. 3 nationally, but received no invitation to

a playoff. In 1968, the squad had reached the final championship game only to lose to Troy State of Alabama. In the 1969 season, the fans were hopeful that the Javelinas could win another N.A.I.A. championship. The Hogs started the 1969 season by winning their first six games, defeating Trinity University, Long Beach State, Angelo State, Stephen F. Austin, East Texas State, and McMurry. The seventh game was unlucky, with the Javelinas losing to Sul Ross 13-12. Texas A&I won the last three games against Howard Payne, Sam Houston State, and Southwest Texas State. In the last game of the regular season against arch-rival Southwest Texas, the Javelinas came up with their own version of the 12th man. Just before the half, the Hogs had no running backs left because of injuries. Joe Bravenec, a spectator in the stands who had been a red shirted freshman all season, suited up and played fullback for the remainder of the game—carrying seven times for 35 yards as the Javelinas won 28-13. The post season rated Texas A&I No. 3 and paired them for a bowl playoff against No. 1 ranked New Mexico Highlands. In the playoff game, Texas A&I trailed 23-22 with a little over a minute to play. Quarterback Karl Douglas threw a 33 yard pass which Eldridge Small grabbed from over the head of the defender in the end-zone with 1:12 to play. The Javelina 28-23 victory put them in the championship game against Concordia College of Minnesota.[62]

On Saturday afternoon, December 13, 1969, over 15,000 fans in Javelina Stadium watched the Javelinas score on the second play of the game on a 66 yard pass from Karl Douglas to Eldridge Small. The Cobbers tied the game briefly at 7-7, but the Javelinas scored two more touchdowns within four minutes in the second half. The Javelina football team defeated Concordia 32-7 and coach Gil Steinke again claimed the N.A.I.A. national football championship. The campus and Kingsville celebrated. The student newspaper printed photographs of the festivities and noted that students and alumni were "suffering with a huge case of the 'smiling fatigues.'"[63]

Nevertheless, ethnic sensitivities of the 1960s were manifested even at the championship game. A cheerleader invited a student dressed in a Confederate uniform and carrying a large Confederate flag to stand on the track near the cheerleaders during the game, and several other students displayed Confederate flags. A student spokesperson for the Afro-American Society said the flag offended many students. President Jernigan issued a statement that he could see no place for the Confederate flag at any of the gatherings at Texas A&I because it might "be embarrassing or insulting to any member of this university community." Jernigan noted: "Innumerable changes occurred in our society in the 1960's. In the area of human relationships as some problems were solved, new ones arose." The student council passed a resolution by 24-3 denouncing the incident.[64] The incident reflected ethnic concerns current on most college campuses, but did not seriously detract from the accomplishments of the Javelina football team.

The Steinke juggernaut was formidable. In the 1970s, the Fighting Javelinas won 5 N.A.I.A. national championships and set a 42 game "Victory Streak" without a loss or a tie, exceeded by only two other teams in history. In 1970, after a regular season with only one loss, the Hogs defeated Wisconsin-Platteville in the semi-finals, and

defeated Wofford (South Carolina) 38-7 to repeat as back-to-back N.A.I.A. national champions. There followed three years of rebuilding, with 7-3, 6-5, and 2-8 seasons. The "Victory Streak" began with the defeat of Southwest Texas in the last game of 1973. The exhilarating teams of 1974, 1975, and 1976 had three undefeated seasons. In 1974, the Hogs defeated Cameron (Oklahoma) in the semi-final and Henderson (Arkansas) in the final to become national champions. In 1975, the Javelinas defeated Oregon College 37-0 in the semi-final and Salem (West Virginia) 37-0 to repeat as national champions. In 1976, the Javelinas defeated Western Colorado in the semi-finals and Central Arkansas to "three-peat" as national champions. Gil Steinke was so highly regarded that when President Robins resigned in 1977, rumors circulated that Coach Steinke would be the next president of the university.[65] In the arena of student activities, athletic events continued to be a vital and important unifying activity on campus.

With the changing complexion of the campus, social events experienced great changes and the Lantana festivities finally had the first Mexican-American queen. The major controversy surrounding that Lantana election appeared to be a constitutional issue. Some advocated keeping the winner of the contest secret, but the student supreme court, headed by student activist Carlos Guerra, ruled that to keep the name secret would be in violation of the Student Council Constitution that said election results were to be reported within two days after the election.[66]

Lantana was in its dying days, but the issues involved feminism more than ethnicity. By 1969, the student council discussed reorganizing the festivities because of decreased interest. Only eight students showed up to build the Lantana float for the 1969 Buccaneer Days Parade.[67] In 1970, Jim Prewitt, Student Union director responsible for planning the celebration, noted that the Lantana celebration was at that time "on a miniature scale" compared with celebrations of the past, but he hoped it could be redeveloped.[68] As the TUSK Magazine concluded, "Lantana was the victim of apathy and changing interests." Coeds concluded that beauty queen contests were outdated. In 1971 and 1972, the administration decided against holding the celebration and in 1973 and 1974, when it briefly returned, the *South Texan* decided against covering the event. The female editor denounced the "sexist pageant" because it was from another era and did not deserve coverage. The ceremony resembled a commercial "and the women are the product." Lantana expressed attitudes toward women that did not deserve to survive. The editor wrote: "It is a female auction. They parade for the buyers . . . all the elements are there except the bidding."[69]

Students were not involved in social protests every day. The social awareness and political activism of students evident in many *South Texan* articles appeared alongside stories of activities of fraternities, musical recitals, drama presentations, clubs, and student elections. In the spring of 1974, nude streakers became a common sight on campus. Students attended classes, dated, took examinations, procrastinated about doing homework, partied, and cheered for Javelina athletes. *South Texan* coverage of traditional activities in this era included that fact that in 1968, the Delta Tau Delta fraternity became the first to own a "home." It could

accommodate ten men and was located next to the King Drive In Theater on 14th Street. In 1969, students formed an "unofficial fraternity" named Tau Tau Ha Ha Ha Ha Tau "to protest the methods of initiation and the general 'snobbish atmosphere' which surrounds fraternities and sororities." The annual Greek Week with a convocation, beauty pageant, bike race, chug-a-lug contest, bar-b-que, Olympics, party, and a dance, included participation by chapters of Alpha Tau Omega, Lambda Chi Alpha, Tau Kappa Epsilon, Delta Sigma Pi, Sigma Chi, Delta Tau Delta, Kappa Sigma, Zeta Tau Alpha, Alpha Chi Omega, Alpha Delta Pi, and Chi Omega. In 1970, the mascots "Henrietta" and "Jalisco" disappeared from their cages. There was speculation that there had been foul play, but because no blood was found at the scene, they probably were not harmed. The students wanted them returned—no questions asked.[70]

Throughout this time the school had been expanding at a substantial rate. Student enrollment increases caused the housing problem to become a major preoccupation not only of the student activists, but also of the administration, which tried to seek funding for new dormitories and classroom space. From 1925 to 1960, there were 24 major buildings constructed for campus instructional and support services use. During the decade from 1960 through 1975, 22 buildings were constructed to use for classrooms, laboratories, offices, and dormitories.

The new buildings included a fine arts complex with a music, art, and speech/drama triad; Lon C. Hill Hall to house science laboratories and classrooms; and Sam Fore Jr. Hall for language and literature classes. The new library was built in 1967 and named for then president James C. Jernigan. Further, the industrial arts building, the infirmary, the university bookstore, the new Steinke Physical Education Center, the Biology/Earth Science building, and the home economics buildings were added. New dormitories constructed for men and women were named Ernest H. Poteet Hall, John F. Lynch Hall, J.C. Martin Jr. Hall, and the Turner-Bishop complex. Other large and small constructions projects meant that the campus had more than doubled in buildings space to accommodate the increased student population, which reached its peak in 1971 when 8,096 students enrolled.[71] As the enrollment increased, so did diversity.

Mexican-American enrollment did not suddenly appear on the campus in the 1960s. From the beginning there had been a Hispanic presence in the student body. In the 1925 summer school, 10 percent of the total students and 17 percent of the Normal School students were Spanish surnamed. During the 1930s, the Mexican-American enrollment actually increased. The largest number of Spanish surnamed students enrolled during summer schools, with over 21 percent of the 1934 summer school being Mexican Americans. By 1940, almost 17 percent of the students in the regular term were Spanish surnamed. During World War II, total enrollment dropped and total Hispanic enrollment declined drastically. By 1943–44, only 6.9 percent of the students were Hispanic. After World War II, veterans increased overall students enrollment, and although Spanish surnamed students increased in absolute numbers, they comprised only 10 percent of the students by 1947. Mexican-American students steadily increased in the years after the Korean War,

153

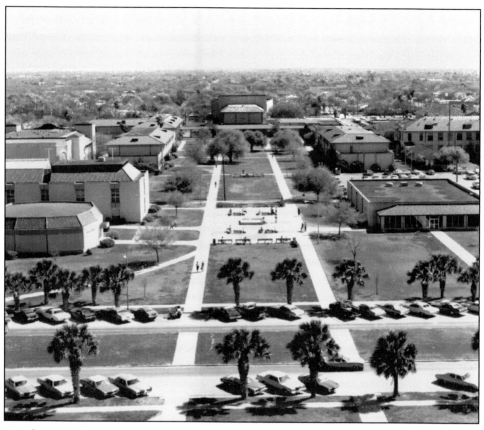

By the 1970s the Mall was the center of the campus. The Fine Arts complex can be seen at the top of this photo. Other new buildings included the Sam Fore building for Language arts, center left; the Earth Science/Biology Building, bottom left; the Lon C. Hill Physics Building, center right; and the new bookstore added on to the back of the Student Union Building, bottom right.

reaching 21.11 percent of the students by the 1953–1954 term. In 1957, the Spanish surnamed students were approximately 21 percent of the student body. A "Proposal for Ethnic Studies" compiled statistics based upon counting Spanish surnames in the Hog Call that showed by 1964–65, the Mexican-American population was 22.8 percent. A growth spurt in Spanish surnamed enrollment took place in the last three years of the 1960s. By 1967–68, the enrollment increased to 25.2 percent, and to over 30 percent in 1968–1970.[72]

The Kingsville campus was the most comprehensive institution of higher education in South Texas, but already that position was being challenged as Pan American University at Edinburg grew at an impressive pace. New schools at Laredo and Corpus Christi promised to attract a share of students in the region. Although campuses at Laredo and Corpus Christi were a part of the University System of South Texas, they competed with the Kingsville campus, and the Texas A&I faculty began to worry when the enrollment fluctuation started in 1972. In the next 25

years, a major preoccupation of the school would be recruitment and retention. Enrollment fluctuations began at a time when the school was no longer led by men who had either risen to administrative levels from the ranks of the faculty or were from South Texas. The school faced a quick succession of administrators that made stability and security even less certain.

In 1972, when the Board of Directors agreed to establish a chancellor's office independent of any of the campuses within the system, the Kingsville campus formed a search committee for a new president to replace James Jernigan—who had been serving as both chancellor and president of the A&I-Kingsville campus. The campus was experiencing student unrest and the administrator needed to be a leader with great sensitivity and diplomacy.

In August 1973, the board announced the appointment of Gerald Burns Robins as president of the Kingsville campus. The following month Dr. Phillip D. Ortego, one of the finalists for the appointment as president, filed a complaint alleging improper procedures used by Texas A&I for insuring the protection of civil rights of minorities. Claiming that his interview before the Presidential Search Committee appointed by Chancellor Jernigan "was a sham" and that they "asked irrelevant questions in probing his views on La Raza Unida Party," Dr. Ortego went on to assume the position of Vice Chancellor for Academic Development at the Hispanic University of Denver. Robins arrived in Kingsville to be greeted by student protesters in front of College Hall and an 11 percent decline in enrollment.[73]

Coming from the position of professor of education at the University of Georgia, he had served as president of Augusta (Georgia) State College from 1957 to 1970. During his time as president, the school had been converted from a junior college to a senior college. Robins had served his entire academic career in Georgia and found his venture into South Texas something of a surprise. He was not used to such "flat land" but did like the consistency of architecture on the Kingsville campus. He would later report that he did not find an exceptional amount of student and faculty unrest on the campus. He did, however, remember that there had been some labor disputes with some of the staff, that the students had demonstrated when the governor had visited on campus during the 50th anniversary celebration, and that the faculty had been upset when financial exigencies forced him not to renew the contract of a tenured faculty member.[74]

As enrollment continued to decline, faculty became increasingly anxious about their positions. The Faculty Senate established an Ad Hoc Committee on "Student Recruitment and Retention. Students began to feel the strain under which their faculty was working and the student newspaper reported after surveying the faculty that "uneasiness has crept into faculty ranks. At this point, non-tenured professors are feeling the pinch, while tenured faculty debate among themselves as to the methods or principals that should be used by the administration in deciding who receives terminal contracts."[75] Billy Jaynes Chandler, professor of history, circulated a petition for the A&I chapter of the American Association of University Professors asking Robins to appear before the faculty to explain the financial crisis the school faced because of the enrollment decline. Chandler's

petition said that secretiveness of administration actions was causing a serious decline in morale.[76]

Later that spring, President Robins's office released information that they had submitted guidelines for dismissal of faculty to the Texas Attorney General's office for evaluation. The guidelines had earlier been submitted to the Faculty Senate. The crisis was blamed on the decline in enrollment, which was being experienced all over the country. The Faculty Senate established a special Ad Hoc Committee on the Possible Release of Non-Tenured Faculty Members to study the issue.[77] Faculty members were concerned and critical of the administration. According to the *El Rancho* faculty stated that "the Aegean stable needs cleaning but Robins probably isn't the Hercules we were hoping for." That spring, the university gave Dr. James Tylicki, a tenured associate professor of physics, a terminal one-year contract and informed him he could teach for the 1974–1975 term but would not be rehired for the 1975–1976 term because of financial exigency. That same year, another tenured professor and 18 nontenured faculty members were also terminated. The faculty senate was stunned and the mood of the campus was sullen.[78]

Professor Wayne Gunn of the Department of English left the university in 1972 on a Fulbright Fellowship and remained in France to teach for the next several years. When he returned to the campus in 1977, he found the student body substantially changed and the faculty discouraged. Another professor told him: "Be happy that you missed it all." Professor Gunn found the "faculty depressed by downsizing."[79] After a five-year absence, he noticed distinct changes. In 1972, the students had included "draft dodgers," "surfers," and "kickers." It had been more a residential campus, with more activities, parades, football, more blondes, and more Greeks. The school attracted students from a wider region, with more from urban San Antonio, the Valley, Uvalde, and Victoria. By 1977, Gunn saw no more draft dodgers, and few surfers or kickers. The Aggies were not as dominant and there were fewer students from San Antonio or Uvalde. Speakers corner was moribund; the students having no opinions to mention. The complexion of the campus had changed, and racism was more subtle. Overall, Gunn felt faculty was discouraged, depressed, and had developed a bunker mentality.[80] Professor Gunn's memories reflect the change in climate of opinion on the campus.

Robins had lost the good will of the faculty very quickly. As enrollment continued to decline and the mood of the campus continued to experience turmoil from the students and fear on the part of the faculty, Robins and the board of directors agreed in 1977 that he should return to the college classroom and allow them to find another president for the A&I campus.[81]

In the same period, Jernigan had lost the confidence of the Board of Regents as chancellor in 1975 and was forced to resign. Board members were no longer willing to allow school administrators to operate independently and without regard for their advice. For several years, Jernigan had only reported to the board, and had not necessarily operated as they wanted. The board felt that they were more in tune with the mood of the student body, and indeed the country, that was demanding a serious change in the operation of institutions of higher education.[82] Jernigan

had come to the A&I campus shortly after World War II when returning veterans were changing the age of the typical student. He had risen to the presidency of the school in 1962, just after the school had integrated and just as the movement for additional civil rights was beginning. His administrative experience was acquired at a time when school officials could dictate dress codes, curfews, and strict guidelines of curriculum. He was flexible enough to respond to the changing times and the turmoil of the 1960s and 1970s, but not willing to accept other people's opinions—faculty or board members.

The decade of turmoil changed the university. The tumultuous, exhilarating, and vocal days of student activism of the late 1960s and early 1970s alienated some supporters of Texas A&I in South Texas. Enrollment decline, financial exigency, and downsizing of faculty created another crisis that traumatized the faculty, which became demoralized, depressed, and defensive.

The late 1970s then introduced an entirely different mood and entirely different problems. The profile of students was quite different from those of the late 1960s. The War in Vietnam was over, the most intense civil rights protests, ethnic militancy, and feminist activism had declined and was replaced for the most part with malaise and student inertia. In the next few years, the university would be faced with challenges for its very survival. A rapid turn-over in administrators, student apathy, competition for too few students by too many colleges in the region compounded the many and daunting problems.

What the faculty and area supporters did not realize or accept was that problems facing A&I were not just local issues, but national problems. Robert Birnbaum, in his work *How Colleges Work*, outlined the chronology of change at academic institutions which very much described the developments at Texas A&I. Birnbaum pointed out that at many colleges in the United States at the beginning of the 20th century, there began a shift in the make up of the board of directors. Increasingly the boards were composed of businessmen who were demanding that colleges be run as were their businesses.[83]

Institutions of higher education had moved into an era where the work of administration was done by professional administrators and faculty were no longer called on to do the duel work of teaching and administration. While previously the college president had been from the ranks of academia, now the board wanted them to be trained in business management. In fact, the entire administrative staff was increasingly professional administrators, just as faculty became exclusively the professorate. As the three groups developed, often with what appeared to be conflicting goals, they grew into more adversarial components of the college. The board and the external forces such as legislatures and other funding organizations wanted to quantify the quality of education. The administration generally was not necessarily a part of the professorate, which had assumed some administrative chores and generally also taught. They came to the campus as administrators and moved on generally fairly quickly. Outside pressures made their roles most powerful only because of a veto power they exercised.

157

The faculty was also not as static as it had been previously. Now the faculty was increasingly divided into at least two groups. The first group included those who identified with the campus at which they worked, and while they did research and published, they viewed their primary function as teaching and service to the school where they served. The second group were those who viewed their first obligation to their discipline. They were primarily researchers and identified not necessarily with the school where they worked, but with the discipline in which they researched. They sought and received large grants and moved often to find better research facilities. They generally received higher pay, because of the grant funding and the movement in jobs, but contributed less to the daily life of the campus. Faculty members who were more permanent tended to resent those who were more mobile. Those who were more mobile did not have the same commitment to the institution, served less on committees, and often did not live in the community. They spent a few years on campus and then moved to other universities. These two groups of faculty often found themselves at odds with each other, and with the administration.

All over the country in the 1970s enrollment at colleges and universities were declining. The student body was also changing. As the competition for students increased, colleges no longer accepted only those who were academically inclined and prepared. It was felt that the quality of the new students had declined, and perhaps it had, but it might have also been that a greater number of students who in the past would not have attended college were now being urged to enroll. More traditional students—resident on campus and involved in student activities—began to be replaced by many nontraditional students, less involved in campus life. A nontraditional and mobile student population took longer to graduate and participated less in school activities. Having to combine work and school, students required different types of assignments and considerations. There was an increased need for remedial education as students across the nation became less prepared for college course work. Since the administration was increasingly a professional administration with the responsibility of recruitment and explaining retention, it was generally viewed as an administrative failure when the school faced declining enrollment.[84] Faculty at the A&I campus were expressing the same demoralization that faculties all over the country were feeling. The A&I faculty was unaccustomed to the changes and some were resistant. There were unique and individual circumstances, but the broader source of a sense of demoralization was an expression of a nationwide sense of frustration at the changes in higher education.

Chapter Seven

Malaise and Retrench-
ment

The University System of South Texas

1977–1988

Student contributors:
*Arnold Barrera, Rafael Barrera, Joe Ely Carrales III, Darren Earhart, Diane
Denise Elizondo, Mark Gingrich, Marco A. Gloria, Efrain Gracia, Carlos Guerra,
Jesenia Guerra, Neal K. Hicks, Tanisha Michelle Hicks, Roger Hill, Joseph Daniel
Redner, Rhonda Sliger, Eden Straw and Jaime Trevino*

Disillusionment with public education escalated in the late twentieth century, but higher education seemed immune until the turmoil of the 1960s and 1970s. One scholar concluded that by the 1980s there was an avalanche of publications announcing the decline of academia, the corruption of higher education, the betrayal by the professorate, and the collapse of the universities. Christopher J. Lucas noted that even if the "crisis" was overstated, higher education was in trouble in part because higher education had been slow to respond to external forces, but even more so because of a crisis of purpose within the university. Lucas traced some of the latter crisis to the concept of the multiversity, "a multipurpose institution dedicated simultaneously to teaching, research, and service," which had gained the ascendancy. Another source of the problem in the Lucas analysis was "that the United States in recent decades has overbuilt and overinvested in higher education." The solutions, he argued, were several. Universities needed to rededicate themselves to undergraduate teaching. Faculty had "a professional obligation to struggle anew with the age-old problem of restoring greater coherence and intelligibility within a common undergraduate curriculum." Colleges and universities had to learn "how best to respond to public demands for accountability."[1] The crisis in higher education varied from institution to institution, from private to public colleges, and from region to region, but Texas A&I experienced many of the same problems as other universities.

The tumultuous decade from the late 1960s to the late 1970s transformed Texas A&I and left bitter feelings among alumni, administrators, and faculty. Enrollment decline, financial exigency, and termination of faculty demoralized the campus. From the late 1970s to the late 1980s, the university experienced a period of malaise and retrenchment. The profile of students changed—with greater diversity and increasingly more mobile and non-traditional students. The *South Texan* reflected a decline of interest in student government, a decreased concern for athletic achievements, a diminished number of student activities such as dances, and a greater preoccupation with changes and challenges to the university leadership. Students still fell in love, failed examinations, were bored by lectures, lost their textbooks, and went to the beach, but the focus, intensity, and importance of campus social life was conspicuously lacking. The *South Texan* did mention the traditional activities, but less frequently, with less emphasis or sense of importance. With one exception, this period even saw seasons of frustrations for the Javelina football team. The campus witnessed a rapid turnover in administrators, an increased competition for too few students by too many colleges in the region, and insufficient legislative support. The University System of South Texas (USST) faced difficulties with fluctuating enrollments on the Kingsville campus, state budget reductions, and challenges to adjust to changing circumstances.

As the new school year started in 1977, there were several important changes in the administration. D. Whitney Halladay, the first president of the campus at Corpus Christi, became Chancellor of the University System of South Texas, Duane Leach became president of Texas A&I-Kingsville, and George Coalson became the interim vice president. Professor Coalson was the only stability in this transition. He had been a soldier in the European theater of World War II, being wounded at the Battle of Bulge. He had used the G.I. Bill to attend Texas A&I after the war, receiving both his bachelor's and master's in history. After receiving his Ph.D. from the University of Oklahoma, he returned to the Kingsville campus as a history professor in 1955. He had helped organize the faculty senate and served on numerous college committees. At the time he became interim vice president he was the chairman of the History Department.[2] He provided the continuity of familiar leadership for those faculty who were defensive about the influx of new administrators who were unfamiliar and outsiders.

The Texas A&I faculty was also changing, illustrating Robert Birnbaum's description of the dynamics in higher education in the late twentieth century. A comparison of the faculty members listed in the 1950, 1970, 1990, and 1998–2000 catalogs reveals changes in gender, ethnicity, highest degree held, and composition of colleges. In the last half of the twentieth century, male faculty members decreased from 79.25 to 71.70 percent of the total faculty, while female faculty members increased from 20.75 to 28.30 percent. But increases in the female faculty was most pronounced in the last ten years of the century when the female faculty increased from 21.67 to 28.30 percent in the eight years between 1990 and 1998. The faculty also became increasingly professional with a steady increase holding doctorates going from 25.47 to 39.21 to 70.00 and to 75.88 percent. Faculty members came

increasingly from outside the state and nation. Faculty members with any degree from a college or university in Texas decreased from a high of 63.61 to 56.25 percent. Mexican-American faculty members increased from 0.00 to 12.22 percent; African-American faculty members from 0.00 to 1.61 percent; and international faculty from 0.00 to 9.97 percent. Faculty members in agriculture, arts and science, and business decreased as a percentage of the total, while those in engineering and teacher education increased.[3]

The campus struggled to meet the demands of a changing student body. The school recognized its need to accept the changed role of women, minorities, and the increased number of nontraditional students. The Education Act required the school to enhance the women's athletic program, and for the first time the women received letter jackets in recognition of their participation.[4] The Ethnic Studies Center Director, José Réyna, had a very difficult time starting his program. Réyna had joined the A&I faculty in 1973 and developed a curriculum emphasizing Mexican-American studies in history, psychology-sociology, geography-geology, and the Spanish language.

The Ethnic Studies Center became controversial. In his official capacity Réyna became involved in protesting inequality of treatment by the university of minority faculty, staff, and students. In the fall 1974 semester, the Center began discussions on discrimination and asked students to voice their experiences and concerns in open public hearings. Vice President Mario Benitez reacted, saying the university was "deeply committed to a policy of non-discrimination" and it was Réyna's right as an individual and as a citizen "to study or investigate any matter he wishes." The administration discontinued the hearings as an official function of the Ethnic Studies Center.[5] *Ciudadanos Unidos* of Kingsville, a community group, and the *Raza Unida*, a political organization, immediately led demonstrations calling for the resignation of President Gerald Robins, Vice President Benitez, and Equal Employment Opportunity Commission Officer Theodore J. Papageorge, claiming they discriminated against Chicano workers and treated Professor Réyna unfairly.[6]

The administration's confrontations with Réyna and the activities of the Ethnic Studies Center continued on through the next year—the school's 50th anniversary. Celebrations included a symbolic relaying of the cornerstone and rededication of the first building on campus. The Texas Senate passed a congratulatory resolution and Kingsville Mayor Gilbert Acuna proclaimed March 21, 1975, a Day of Observance for the 50th Anniversary of Texas A&I. An extensive group of dignitaries including the governor, Congressman Kika de la Garza, state legislators, and numerous notables and special guests attended. George O. Coalson, Chairman of the Department of History, made a presentation entitled "Highlights of March 21, 1925." Chancellor Jernigan introduced the main speaker with the observation that at a time "when inflation, recession, energy shortages and widespread suspicion of those in public office strain the fabric of our society," it was refreshing to have such a dedicated public servant as the governor. Governor Dolph Briscoe gave the main address,[7] but during the governor's presentation, demonstrators interrupted.

Professor Réyna and the Raza Unida political party demonstrated with signs denouncing the school and the governor for discrimination that had been historically suffered by Mexicans, especially in South Texas. They had 11 demands including increased efforts to recruit Mexican-American instructors and an expanded role for a Chicano Studies Program, not an Ethnic Studies Program.[8] Robins later explained that the demonstration had caused considerable embarrassment and that he had to apologize and explain to state government officials.[9]

By the 1976-1977 academic year, Réyna decided that the university was discriminating against him. He filed charges with the Equal Employment Opportunity Commission which ruled "there is no reasonable cause to believe'" that A&I had violated his civil rights. Alvaro Garza, District Director of EEOC concluded: "With respect to the matter of Mexican-American faculty personnel denied promotions, the record shows that out of 21 approved promotions in the year 1976 Spanish surnamed Americans received proportionately the greater number."[10]

In the fall of 1977, Réyna accepted a position at the University of New Mexico and Emilio Zamora replaced him. Zamora was a graduate of A&I who returned to establish a minor in ethnic studies. He wanted the program to concentrate primarily on an examination of Chicano history and experiences. He hoped to bring visiting scholars to present topics of interest to students. He came to his home campus with enthusiasm, but faced frustrations in keeping the Center viable. The Center struggled on for a few more years, but eventually dissolved piecemeal into other departments.[11]

The Chicano movement on the A&I campus remained in the hearts and minds of some students, faculty, staff, and interested supporters. While the Mexican-American population increased, even the term "Chicano" became a source of contention. The demonstration at the 50th anniversary was one of the last large organized disturbances, and even it was only a minor part of the total celebration.

The campus became more preoccupied with survival as competition for students became a major concern. Robins expressed those thoughts in his open letter to Friends of Texas A&I University: "It has been opined that the changes of the next fifty years will not be as dramatic or as rapid as those of the first fifty years. There are sobering reports of our enrollments leveling off, of diminishing dollars, of needs and demands for educational services that cannot be met. Perhaps there will be breath-catching time to reassess and regroup our resources."[12] His letter emphasized that "our task will be to pick up the thread of history of Texas A&I and to weave a future fabric with a pattern that results from a sharper focusing of institutional goals and resources."[13]

The anniversary celebration was the beginning of a new era as uncertain as the beginning had been in 1925. President Robins expressed disappointment that a "lack of harmony" prevailed on the campus and that he had not been able to get everyone to pull together on behalf of Texas A&I. "A kind of divisiveness has existed here," he noted. Hispanic leaders greeted the announcement that Robins had decided to return to the classroom by seeking assurances from acting-Chancellor D. Whitney Halladay that there would be an ethnic balance on the search committee

for a new president.[14] When it was announced that Duane Leach—president of Northern Montana College at Havre—was the new president, a small group protested. Corpus Christi attorney Ruben Bonilla announced that he was preparing a third-party complaint about the hiring of Leach to file with the Equal Employment Opportunity Commission on behalf of Texas LULAC. Some Kingsville Hispanic business leaders and a few Hispanic students on campus complained about the new president.[15] While the Corpus Christi newspaper portrayed the Kingsville campus as being rampant with protest, in fact on the day Duane Leach arrived, only a very few protesters were present to denounce his selection.[16] The local chamber of commerce welcomed Leach with a reception and the majority of the student body were disinterested—because interaction with the university president was an uncommon occurrence for most of them.[17]

The new president embarked on a round of speeches to pacify local groups disappointed about not having a Spanish surnamed president. Leach voiced optimism about the future of the school in the face of a changing society. In reviewing the needs of A&I he decided that a top priority should be to recruit a new academic vice president to replace the one who had recently resigned. He wanted to find a dean for the College of Agriculture which had historically been of great importance but had been without a permanent dean for two years. He concluded that the major problem "concerning the institution was retention; not only retention at the freshman and sophomore levels, but retention throughout the entire four years."[18]

President Leach reported to the faculty on the state of the university. "Presently we are undergoing a period of expansion without growth. That is, we are expanding our programs to meet the needs of providing educational opportunities and community services but our overall enrollment growth is slight." He concluded that the university had not had the visibility it deserved. "In many ways we are a well-kept secret, even in the state of Texas." This had been detrimental for attracting students, funds, and faculty. The university needed to increase public awareness of the school's potential and possibilities. "This will take a concerted effort on the part of all of us," Leach noted. The Faculty Senate set up a special Ad Hoc Committee on University Life to deal with publicity, with student retention and with campus beautification.[19]

Leach's conclusions were the rallying cry repeated by every president for the remainder of the century. While the community continued to say that someone from outside could not adequately understand and appreciate the uniqueness of the area, each new president would quickly recognize the need to change the curriculum and improve the public perception of the school. The Kingsville school struggled to have itself portrayed in a favorable light.

Three years after taking office, Leach prepared for the reaccreditation process by urging the faculty to review the past and consider the school's future. A professor of history before he became an administrator, the president said: "We must reexamine A&I's historic commitments, where we stand at present, where we hope to go, and how we intend to get there." Texas A&I would need to review the programs

and priorities "in undergraduate, graduate, professional education, research, and scholarship—and if we discover to our embarrassment that no priorities exist—then we have a unique opportunity to establish them." He wanted the university to establish "a centrality of purpose which animates the institution—as well as a set of generally agreed upon goals around which the university can plan and unite for the days ahead." He saw some difficulties ahead. "Inflation continues to erode college and departmental budgets, enrollment projections are fragile at best, and the general public no longer views higher education as a No. 1 priority."[20]

In viewing the future, Leach commended the College of Education for formulating a new program in adult education and the College of Engineering for its work in computer science. He warned that for at least the next 15 years the number of college-aged students would be decreasing at an accelerating rate, sometimes labeled the "birth dearth." The new age group for prime consideration was from 22 to 24. Already, attendance of women 35 years and older had increased by 65 percent. These women's career choices had shifted markedly as they entered the traditionally male professions of law, business, engineering, and medicine. Given that there were now six new institutions of higher education in South Texas and thus substantial competition for students, consideration had to be given to women with family obligations who would increasingly be part time students. Leach believed that women from lower-income families and minority women would comprise a greater percentage of the student population of Texas A&I and of most schools.[21]

As for the increased minority population, Leach stated that the challenge was "to find the means, when needed, to rectify the inadequacy of their earlier education, an education which often did not prepare them for collegiate life." He felt that A&I would need to shift to academic programs and achievements which relied primarily on human resources. Warning that the state legislature felt that A&I was "over spaced" he said that "the days of great construction projects" was very likely at an end. The school needed to identify those aspects in which it could assume positions of leadership and strengthen the education of A&I graduates. Leach added that the current call for a return to a "core curriculum" at the university was not just a lament for "Camelot," but rather a call for educational excellence which provided learning of the highest quality, both liberal and technical. He also felt the school had a responsibility to provide laboratories for research and expertise useful for regional development."Although the University has made substantial contributions to the region, it cannot afford to be complacent. There must, for the University to flourish, be a reciprocal relationship between the University and the region in which it finds itself."[22]

Leach had evaluated the past, studied the needs of higher education in South Texas, and understood the challenges for Texas A&I. However, he did not remain long as president of the Kingsville campus. In October 1980, he became chancellor of the University of South Texas System. D. Whitney Halladay, who had been named interim chancellor of the System in 1977 and then chancellor, died unexpectedly. Halladay had moved the system office to Corpus Christi, although not to the

Pence Dacus, Vice President for development, and Richard Meyer, Provost and Vice President for Academic Affairs, assisted Chancellor Leach in placing the sign outside the Texas A&I System offices on the King Ranch.

Corpus Christi State University campus. When Leach became chancellor he moved the office back to Kingsville and accepted an offer by the King Ranch to use a large home on the Ranch as the System headquarters.[23] Leach remained Chancellor for two and one-half years.

In May 1983, Leach became president of the University of Texas-Permian Basin. Before leaving he completed a survey of South Texas higher education needs. He stressed that the survey could be "a blueprint" for planning for the diamond shaped area from San Antonio to Eagle Pass, to Brownsville, to Corpus Christi, and back to San Antonio. The report covered 31 counties—an area of 345,000 square miles—and considered the needs of two million people. He felt it was obvious that South Texas needed additional professional schools, such as pharmacy or related medical fields, veterinary medicine, a school of law, and additional doctorate programs. Leach concluded that South Texans felt they were not receiving a fair share of needed professional and graduate programs, and that they wanted new high-technology programs. He believed it was extremely important for all area schools to cooperate to respond to the changing needs of the region.[24]

During the late 1970s the campus changed in major and minor ways. For example, traditional views of the role of the women were challenged. In the fall of 1977, when the Lorine Jones Lewis Hall became a coed dormitory, only a dozen women signed up and some people objected. The engineering college organized a Society of Women Engineers. The Engineering college had boasted women graduates in the past, but now there were enough women enrolling in Engineering courses and

going into the profession that they needed their own organization. In 1976, Jesusa "Susie" Salinas became the first female graduate of A&I's R.O.T.C. program to be commissioned a second lieutenant. Major Laura Bruno Castillo became the first female battalion commander in the thirty-five year history of the program, and her husband was a lieutenant in the cadet corps under her command. A new approach was tried when professors in philosophy, history, language and literature and arts introduced a team-taught interdisciplinary course on the Middle Ages.[25] Each of these actions were new departures for the small, tradition-bound college.

At the beginning of the fall 1977 semester, there was a startling opportunity for the students to vote for the establishment of a campus pub. In the faculty senate, Professor Paul Palmer of the History Department made a motion to recommend it. The faculty senate approved unanimously, the Alumni Association Executive Body voted support, and the Board of Regents of USST approved the sale of beer on the Texas A&I University campus. The grand opening of the Pub in the Student Union was at 3 p.m. March 31, 1978. President Leach cut the ribbon, the Food Services Director pulled the first stein of beer, and Student Association President Osvaldo Romero, "threw it back " to the cheers of students, faculty, and administrators.[26]

One of the more unhappy events for students in 1977 was that the winning Javelina team's 46 "non-losing" game streak ended. The unbeatable Javelinas lost to their old nemesis East Texas in a close game with the final score 7 to 6. Earlier that season the winning "victory streak" had ended at 42 games when Abilene Christian University left the field with a 42-42 tie against the Javelinas.[27] Although Gil Steinke was still athletic director, Fred Jonas was the coach. Coach Jonas remained through only one more season then left to return to the business

When the Lorine Jones Lewis Hall became a co-educational dorm in 1977, women were reluctant to be residents.

world. In July 1979, Ron Harms became the new coach and Texas A&I was picked to finish fifth in the league. The 1979 Javelinas became the Lone Star Conference champions and went on to defeat Western Colorado in the quarterfinals, Angelo State in the semi-finals, and Central Oklahoma in the Championship game. In 1979, the Hogs became N.A.I.A. National champions again. A long drought followed, with the Javelinas not getting into a playoff game again until 1988, when they lost to Portland State (27-35) in the semifinal game.[28]

In the fall of 1978, the music department delighted the student body by introducing a newly formed Mariachi band under the direction of Linda L. Pimentel and Juan Ortiz. Pimentel, a percussion instructor and assistant band director, organized the group and sponsored concerts while taking her group into the community to perform.[29] The organization of the Mariachi group was in line with the excitement of the latest school fight song, "Jalisco."

In general, however, the campus slowly slipped into what the *South Texan* frequently described as "apathy" following its years of activism. It became increasingly difficult to have activities on the campus as more and more students commuted from outlying areas. While A&I remained the only residential school in South Texas, many on-campus students generally returned to their hometowns each weekend. An increased international student population accompanied the growing engineering program but created additional problems, as a survey of international students in the late 1960s suggested. They arrived on campus with insufficient information and there was no orientation program. The greatest problem was limited English language skills. There was inadequate social life and few formed friendships since the campus was virtually deserted on weekends. Most international students were unprepared for the racial prejudice they encountered. Having a complexion darker than the lightest Caucasian automatically classed them with the Mexican-American students and on a lower social level than that enjoyed in their home countries.[30]

Sometimes international events complicated the situation for foreign students in the 1970s. As American relations with Iran deteriorated, the Kingsville campus experienced tensions between American and international students. Foreign students on campus began feeling uncomfortable.[31] A campus demonstration intimidated students who tried to defend the Iranians.[32] Letters to the editor in the school newspaper denounced the Iranian government and American students strongly supported the United States government.[33] A student who voiced his opinion about the situation in Iran received life-threatening telephone calls. Three hundred students demonstrated on the mall, burning three Iranian flags. The U.S. Immigration and Naturalization Service spent three days at Seale Hall, checking the validity of Iranian students status and their visas. Deportation hearings were held for 34 Iranian students who failed to maintain grade point averages or carry a full load.[34] For a brief time the campus was politically sensitized but quickly slipped back into the malaise prevalent in the nation.

The campus mood was also a reflection of the fact that faculty were feeling increasingly threatened that a financial exigency would lead to a loss of more jobs.

Student enrollment dropped from 6,600 in 1977 to 6,060 in 1979, to 5,355 in 1980, and to 5,125 in 1981.[35]

In an attempt to rescue declining enrollment, the administration renewed its efforts in the area of extension courses and continuing education. The school had long been involved in delivering extension, correspondence, and continuing education courses. Reports of faculty members offering correspondence courses and traveling to neighboring communities to teach were in the 1926 school catalog, which reported: "We have established extension centers in Corpus Christi, Sinton, Harlingen, and Weslaco. The subjects offered are Spanish, mathematics, English, history, economics, and education." Sarah Porter, whose father Hugh had been the principle organizer of the extension program, recalled that professors had to stay overnight when they traveled as far away as Laredo and Harlingen because there was no direct highway to those communities. She and her sister Frances were glad to have their father travel because he always brought them delightful little gifts from wherever he visited to teach.[36]

Over time, such coursework had become an accepted and expected service of the only South Texas college. Faculty members during World War II traveled extensively delivering off-campus courses especially concerning civil defense. By 1950, a faculty member used radio for an innovative distance-learning class. S. Boyd Stewart, professor of English, taught "a radio-assisted correspondence course" on "The Modern British Novel." By the 1950s what had been known as the Office of Extension was renamed the Center for Continuing Education and included both extension and correspondence courses. More than 25 courses, mostly at the entry level, were offered in this way. In the 1970s, administrators expanded continuing education offerings to garner additional funding from the state legislature based on the formula for funding semester credit hours taught. By this time there were several junior colleges operating in South Texas and they complained to the Coordinating Board that Texas A&I offering courses at the freshman and sophomore level was encroaching on their areas.[37] In 1972, the university decided the program was significant enough to require a full-time director and coordinator. The university needed to offer credit and non-credit courses for continuing education, including workshops and conferences in compliance with new Southern Association standards. Extension classes offered a way for students to take classes in their home towns from regular university faculty and to commute to the Kingsville campus for only some of their course work. It was generally felt that courses offered in this way were an excellent public relations and recruitment tool.[38]

In the next decade as the university sought ways to recruit students, the Continuing Education program grew in diversity of offerings, but with little financial support.[39] By the 1980s, the Center for Continuing Education offered to a more limited area of South Texas a wider program including credit and non-credit courses, conferences, institutes, workshops, seminars, short courses, and special training programs. The center actively sought ways to meet the needs of business, industry, educational institutions, professional organizations, governmental units, and other groups of adults. By 1987, Professor Gustavo Gonzalez offered a

graduate course, Education 567 "Language Acquisition and Development," over the Texas Interactive Instruction Network (TI-IN) via satellite. He drove to San Antonio and taught in front of a television camera with no students present.[40] Due to fierce competition among area schools, the Coordinating Board had mandated strict quality control of such courses. By 1988, Del Mar College, Corpus Christi Independent School District, the Catholic Archdiocese, Hispanic Community Inc., and Texas A&I formed a consortium to provide instructional television to area schools.[41]

As the university scrambled to find students and funds, the school's perennial benefactor once again assisted in the development of the agriculture program. Historically, the King Ranch family had supported the school. In 1981, the Caesar Kleberg Foundation for Wildlife Conservation provided an initial investment of $5.2 million to establish the Caesar Kleberg Wildlife Research Institute in the College of Agriculture and the Kleberg Hall of Natural History in the John E. Conner Museum. The Wildlife Institute was to provide professional wildlife and range management experts with the opportunity to concentrate entirely on research or continue in a teaching/research status. The research was to be both theoretical and practical and cover the broad areas of wildlife diseases, native plants, commercial utilization of wildlife, and basic ecology of native plant and animal species. The first projects included such topics as a study of the feed intake, digestive efficiency, and nutrient requirements of deer, goats, javelina, and nilgai antelope. By the second year water table fluctuations and related soil salinity and the development of uses of mesquite and other tree legumes as sources of food and fuel were studied. The institute planned a series of annual conferences to facilitate the exchange of ideas among national and international experts on topics of interest to area agriculturalists, farmers and ranchers.

The overall plan envisioned that the Kleberg Hall of Natural History would become the cornerstone for a South Texas Regional Studies Center. The proposed Regional Studies Center would have four components including the Conner Museum, Kleberg Hall of Natural History, South Texas Archives, and a new regional research center.[42] The intent was for the South East Quadrant of the campus to become the community service and research sector of the university.

The South Texas Regional Studies Center was an effort by the university to expand research and public service programs and focus on matters of regional interest. Duane Leach planted the idea during his administration and each of his successors talked about it and sought the resources to implement it. With outside consultants, the administrators nourished and kept the idea alive for several years. However, the scheme was too ambitious for the limited number of large donors such as the Caesar Kleberg Foundation available to award major funding. The university never convinced the state legislature that such a center should be developed and it remained an unfulfilled goal. The Conner Museum continued its service and educational function, including a Hall of Natural History with its a collection of trophy horns left by legendary lawman, Graves Peeler. The South Texas Archives was incorporated into the James C. Jernigan Library and continued to expand its services.[43]

By 1981, enrollment began to increase slowly. The school inaugurated its fourth president in ten years, the ninth president since the school opened. The nation was experiencing what President Jimmie Carter had labeled a malaise. Texas A&I faculty was disheartened by the continuous change in leadership which each time warned that there would be faculty reductions if things did not change.[44] Billy Joe Franklin became the new president when Leach became chancellor.[45] Throughout the summer of 1981, the school newspaper carried letters to the editor and editorials exclaiming that A&I was a better school than its public reputation. Writers maintained they knew graduates of A&I who were well prepared and competitive in the marketplace.[46] A poll conducted by the school newspaper supported the faculty and urged the administration to consider reducing other staff members but not professors.[47]

With the new administration came the need to reevaluate the program and form committees to study problems of the school. President Franklin repeated what several previous presidents had said when he announced that there was a need to conduct a public relations program to enhance the community's perception of A&I. As had President Leach and President Jernigan before him, Franklin called on the university to expand its research and public services and develop stronger programs in business and engineering. He established an "Excellence in the 1980s" program designed to recruit top students by offering them scholarships.[48]

Franklin also concluded that another problem of Texas A&I was that many students returned to their homes each weekend. By the decade of the 1960s many students came to the university with automobiles and returned frequently to their home towns. The campus was abandoned on the weekends and some of the faculty worried that this constant travel made it difficult for students to study. To provide activities to keep students on campus, President Franklin created two new positions. The dean of Student Development/Director of Student Activities was to provide leadership, work with clubs and organizations, supervise special events, negotiate for big name entertainment, plan residence hall activities, and campus wide student programing. The dean of Student Services/Director of the Student Union was to provide services for students through the Student Union.[49]

By the fall of 1982, these efforts were proving successful. Enrollment climbed by almost three percent and new scholarship funds were made available to academically worthy students. It was also felt that the increased publicity campaign was successful in spreading the word that Texas A&I university was a good choice for area students.[50]

As the enrollment continued to climb, the university embarked on a remodeling campaign. Funds for new buildings were not available through legislative appropriations, but funds for remodeling buildings and enhancing the campus were. In the remaining time that Franklin was at the school, plans were made to build a new engineering laboratory, add a third floor to the James C. Jernigan Library, and remodel Cousins, Seale, Lewis, and Martin Halls.

By the spring of 1983 enrollment had increased by 9.1 percent. The College of Agriculture grew by a hefty 35 percent, with the number of women increasing

most dramatically. The College of Business grew by 5 percent, again with women comprising most of the growth. The engineering program climbed by 6 percent, with female students being the most dramatically increased. The music program, which had long been a strong program, and the psychology department each showed a substantial 27 percent increase.[51]

However, the Kingsville school was not yet ready to settle into continuous growth and return to a comfortable security. Duane Leach, the school president who had become chancellor three years earlier, resigned unexpectedly to accept the presidency of the University of Texas at Permian Basin.[52] Slightly more than a year later, Billy J. Franklin resigned to accept the presidency of Lamar University.[53] Once again the campus plunged into searches for new leaders and interim president Richard Meyer led the school until Steve Altman became president in July 1984.[54] When Leach left, he had been replaced by Larry Pettit who did not move the office of the University System of South Texas to Corpus Christi as had been done by a previous chancellor. The constant pull by Corpus Christi to claim primacy in the system was at least not a threat during the interim, but faculty and students were aware that politically powerful Corpus Christi had consistently sought to have only one University for South Texas, located in their city. Faculty and students were aware through Corpus Christi news media that the city felt it should have been awarded an institution of higher education from the beginning and that they were incessant in their attempt to take the school to Corpus Christi.

As the administrative turnovers took their toll on the Kingsville campus, the Board of Directors decided to try another method of finding a new president. The board hired the firm of Heidrick and Struggles to help conduct a national search.[55] President Steven Altman's leadership style startled the university community. His aggressive style was untypical of the casual, conservative, rural campus and offended some faculty. Presidents Robins, Leach, and Franklin had each brought different styles to the campus. Administrators who were not from South Texas surprised the community. While they were able to articulate noble and worthwhile programs they generally were unable to motivate a frightened faculty, a worried student body and a suspicious alumni organization.

As Altman assumed the presidency, enrollment fell dramatically in the fall term.[56] It fell even further in the spring of 1986, sinking to the lowest level in 20 years.[57] The economy of Texas was in trouble because of declining oil prices and the governor called for college and universities to cut budgets voluntarily or be prepared for the legislature to appropriate less for each campus.[58]

President Altman faced a formidable challenge which he decided to attack by first evaluating conditions. By January 1986, he formed the Enrollment Task Force to study and determine factors affecting enrollment fluctuation. The large committee was subdivided into six subcommittees. After several months of study, the committee reported strategies that, while not new, at least reexamined problems previously considered: A public relations campaign to correct the poor image of academic quality generally perceived by the community, increased efforts in continuing

education and extension courses, and research to determine what programs would best suit the needs of professionals, especially schoolteachers.

To improve retention the committee recommended a one-semester orientation course for freshmen to better prepare them for college. Eventually, this concept grew to become College I—an academic college that worked with freshmen and all transfer students with fewer than 30 credits. According to Gary Low, acting dean of the new college, it would provide "effective advisement, mentoring, developmental studies, academic support and counseling strategies." He described the program as "student-centered, student-focused, and organized from the perspective of what students need to be successful at Texas A&I University."

The subcommittee on Quality of Student Life recommended ways to increase pride and morale among faculty, staff, and students. It acknowledged that like many colleges and universities, the school was admitting students unprepared for the academic world and that this was contributing to the basic problem. It urged the establishment of a two year community and technical college "under the university umbrella" to assist such students to improve their academic skills.[59]

President Altman embarked on an aggressive campaign to implement the recommendations. His public relations program sought to demonstrate the quality of the programs at the school. For example, in 1986 he issued a press release that boasted that Texas A&I, though a small school, ranked ninth out of more than one hundred college and universities in Texas in research funding.[60] Altman urged faculty to seek more research grants and private funding and the faculty responded by seeking and gaining additional grants.[61]

In the spring of 1986, shortly before the Enrollment Task Force delivered its report to the president, a student wrote to Altman expressing some ideas that the president later touched on in his evaluation of the school's needs. The student mentioned that she was a nontraditional student with a family, and was working hard to earn her college degree. She had two friends in a similar situation and each was concerned that there were not more classes offered in the evenings or other times when nontraditional students could more easily take them. She commented on the "low morale that seems to pervade the university." She urged that faculty complaints be kept at a more discreet level so that students taking a coffee break were not subjected to what she considered inappropriate and demoralizing comments. This student felt that the public perception of the school was too much the result of a demoralized faculty's negative comments.[62] The student's diagnosis of faculty morale was a reflection of the rapid turnover in administrators and of competition from new schools for students, Altman pointed out. He also reported that faculty salaries were dismal and growing worse. The president spoke often about insufficient salaries and sought pay increases through the state legislature, but to little avail.[63]

Contributing to the demoralization of faculty was the lack of a central meeting place as a forum. The Blue Room in Sam Fore Jr. Hall had once been a faculty lounge, serving as a central location for coffee and lunch. Faculty members from all colleges and departments had the opportunity to meet, discuss common problems,

and share professional concerns. The Blue Room stopped serving lunch and the faculty struggled for several years to keep it open. In the fall of 1973, faculty discovered that the food service had been replaced with vending machines.[64] The closing of the faculty lounge left some faculty members isolated without a sense of campus awareness, feeling of collegiality or common purpose. Faculty members' focus became restricted to their own departments and collegial acquaintance limited to those in their own building or with whom they served on committees.

In 1984, George Coalson, chair of the Blue Room Committee, recommended to the faculty senate that the president of the university negotiate with the food service to open a faculty room in the Student Union and keep coffee and tea available in the Blue Room. President Franklin and later Interim President Eliseo Torres noted that the low use made the cost of keeping the Blue Room open untenable.[65]

Other events seemed to conspire to create a mood of gloom on campus. On September 1, 1986, new legislation went into effect raising the drinking age from 19 to 21. This created a serious problem for the pub and the decline of the campus hangout. Before the age change, the pub on a normal Wednesday night had 250 or more students, and the profit was more than sufficient to pay for entertainment. After the change—when freshmen, sophomores and many juniors could not be admitted—attendance dropped to 50 or 60 students. By the summer of 1987, a *South Texan* editorial said that it was time to let the pub fade into history.[66] Thus, both the faculty and students were without a central meeting place.

Students gathered in the Pub, located in the Student Union.

Other developments in the state legislature seemed to threaten the existence of Texas A&I. The Texas House and Senate Joint Conference Committee in the Second Special Session reached a compromise in September 1986 on $510 million in spending cuts for higher education—equivalent to a 10.5 percent biennium reduction. President Altman said that previous savings in energy costs and a hiring freeze on faculty and staff would reduce some of the pressure. "The cut is substantial, and it'll be painful," Altman concluded. "It's serious. It's very serious not just for Texas A&I, but for the whole state of higher education." General revenue for Texas A&I was reduced 10.65 percent or $1,286,865. In the Regular Session the following year, the legislature grappled with budget problems for 1987-88 and the governor opposed any tax increases. The deadlock led to a special called session.[67]

The period of tight budgets led to a further decline in student activities on campus and poor student spirit. The Student Service Fee Allocations Committee recommended a significant cut in the athletic budget and reductions for a variety of student activities. The committee recommended decreases in athletics from $641,209 to $395,000 and also cuts for Ballet Folklorico, Health Services, Parent's Day, and the *South Texan*. They recommended some slight increases for the A&I Band, cheerleaders, Javelina Highlights, KTAI radio, intramural sports, student association, forensics, R.O.T.C., and the Counseling Center.[68]

In 1987, the decision to eliminate track and cross-country teams, supported from student fees, was very unpopular. The $85,000 track budget would be used to fund $35,000 for a tennis and rifle team and $50,000 would be diverted to other athletic department costs. As the *South Texan* editorial wrote: "This means football." Track

In 1970 KTAI, student run radio station, first went on the air.

and cross-country teams had a long tradition of winning and their athletes were popular students. The women's team had just broken 10 of their 20 records in 1987, and the decision seemed to discriminate against females. Former Students' Association President Danny Lopez and irate members of the track team donated 20 pairs of old running shoes to President Altman in protest.[69] For a brief spell, the track-cross-country controversy brought students out of their lethargy. A succession of student protests about the loss of track and cross-country continued through the summer of 1987. A *South Texan* editorial urged a continuation of protests because the track teams were inexpensive, highly successful, and were minority and women's sports. The paper also criticized the administration's failure to consult the students. A student poll showed that 71 percent were dissatisfied with the decision to suspend track and 90 percent thought student protests were justified.[70]

Student apathy was more typical, however. The apogee of apathy was reached in the spring of 1989. "For the first time in the history of the university," the *South Texan* pointed out, "the Miss Texas A&I Pageant has been canceled due to lack of interest." There actually had been six young women applying for the pageant, but the number dwindled to four. The Student Activities Special Events chairperson said that "apathy was one of the big reasons." She conceded that another factor was "the female attitude towards pageants in general as a meat market."[71]

If the students were apathetic, events in Austin were of serious concern to the administration and soon would capture the attention of students and alumni. In November 1986, Larry Temple, chairman of the Select Committee on Higher Education, issued an alarming report to the legislature. Temple, who was also the chairman of the Texas College and University Coordinating Board, distributed a memorandum to committee members and leaders of state colleges and universities recommending that Kingsville and Corpus Christi campuses be merged. He urged formation of a new comprehensive university (with whatever name was selected) to be based in Corpus Christi because it was the largest city in South Texas and capable of supporting a higher education institution. He also recommended elimination of the Bilingual Education doctoral program at Texas A&I. Some members of the Select Committee were startled by the recommendations. A&I graduates, State Senator Carlos Truan, and Representative Irma Rangel defended the Kingsville campus and expressed opposition to the merger. "It's fine to make CCSU a four-year university," Senator Truan noted, "but not at A&I's expense." Leaders in the Valley opposed the merger. The president of Pan American noted that the Valley had been under represented in higher education, and that these recommendations ignored the Valley.[72]

The Board of Directors of the University System of South Texas—which by this time had several members who strongly supported creation of a four-year college in Corpus Christi—held hearings at the Student Union on campus in late November 1986. Some four hundred alumni, students, and local supporters testified before the Board of Directors, vehemently expressing their opposition to the merger. Board members Mary Lewis Kleberg and Gilbert Acuna from Kingsville, and Blas M. Martinez from Laredo voted against the merger, but four other board members

voted in support. Busloads of Texas A&I supporters traveled to Austin to argue against the merger to the Select Committee on Higher Education. Senator Truan offered an alternative proposal, noting that Temple's recommendation would not pass as proposed. Truan felt Temple did not understand South Texas and that his use of statistics was limited to Nueces County instead of all of South Texas. "He talks of Corpus Christi as South Texas. His recommendation reflects heavy lobbying on the part of influential Corpus Christi residents."[73]

In January 1987, Senators Carlos Truan of Corpus Christi and Judith Zaffarini of Laredo introduced Senate Bills No. 657 and 658; Representatives Irma Rangel of Kingsville, Ernestine Glossbrenner of Alice, and Hugo Berlanga, Eddie Cavazos, and Ted Roberts of Corpus Christi introduced companion House Bills No. 659 and 1234. This legislation would create a comprehensive University System of South Texas, change the authority of the Coordinating Board to discontinue Laredo State University, designating the school an upper-level college, and make Corpus Christi State University into a four-year school.[74] The following month A&I supporters organized a "Texans for Texas A&I" to lobby the state ;egislature. Executive Director John A. "Tiger" Womack established a fund drive to hire an Austin lobbyist.[75] President Altman supported the expansion of educational resources in the region, but was misquoted in the Corpus

The A&I Singers on a six week USO tour of Europe during the spring of 1960.

Christi newspaper. As he commented: "When I talk about the region . . . [the reporter] hears Corpus Christi."[76] Ultimately, only the legislation dealing with Laredo State University passed the legislature and was signed by the governor.

Senator Truan noted that the legislation for a four-year CCSU and other reforms in South Texas higher education had never even made it to the floor of either house to be considered. The immediate future was not bright for higher education when the economy was so bad. The legislation had asked for reforms and programs which cost more money at a time when the legislature was slashing the budget of Texas A&I and other universities and when the governor opposed any tax increases.[77]

Searching for new solutions to ever growing problems of a demoralized school, President Altman appointed a committee to develop a strategic plan. This was a new management approach which promised to revolutionize the administration of higher education. The committee could make recommendations to "reduce, maintain or improve academic programs as well as the university administrative structure." According to Altman, "Everything will be under scrutiny." The Strategic Planning Committee set up three subcommittees to examine the external environment, the internal academic environment, and student services and personal values. Retention was such a serious problem that three members of the Strategic Planning Committee went to a national conference on the topic. Another of the committee's objectives was to improve the university's image and encourage students to enroll. The committee was to strengthen the "total educational experience" and held a series of hearings.[78]

The strategic plan further demoralized faculty because it proposed cuts in programs by using assumptions and research many faculty members found suspect. The plan recommended 95 changes. In general, it recommended increasing academic standards and implementing programs to attract more qualified students and limiting access to those less academically advantaged. Several pages of the document included recommendations for creation of honors programs and higher academic standards. Most academic departments and support areas were discussed, with recommendations offered for improvements.[79] The Strategic Planning Committee seemed to create an adversarial environment that encouraged academic departments to defend their disciplines against other disciplines rather than a broader vision of the mission of the university. Departments seemed to retreat further into a "bunker mentality."

What especially alarmed many was the recommendation to eliminate or establish different versions of existing programs. This included, for example, the termination of the agriculture economics program, elimination of certain degrees in art, the undergraduate biology, geology, geography, math, music, physics, and chemistry major in education. The arts and science equivalents would remain, however. This was partially the result of Senate Bill No. 994 for Education Reform, which required incoming students in September 1987 to major in arts and sciences and minor in education. This required a change in emphasis, so that education students would major in the subject area instead of in education. The Strategic Planning Committee also recommended the addition of several degrees, but it was the elimination

of other subjects that caused controversy. The report recommended enhancing and strengthening programs for non-traditional students and increasing the recruitment of "more academically qualified students." It called for establishment of professional schools—especially a school of pharmacy and a program for librarianship.[80] Although some effort was made, President Altman did not remain at the school long enough to implement even a small number of the suggestions.

In the last two years of President Altman's tenure, he embarked on a campaign that had a significant impact upon Texas A&I University. Altman explained to a reporter that he had envisioned and worked for the "annexation of Texas A&I plus sister schools Corpus Christi State and Laredo State universities into the Texas A&M University system—a move that has raised the institutions' funding and profiles."[81]

Before Altman came to Kingsville, he commented some years later, he believed that Texas universities were wealthy institutions with handsome buildings, fine equipment, and every advantage money could buy. After arriving at the A&I campus, he found faculty members "so overburdened with teaching loads that research seemed nearly impossible. Money for research, travel and sabbatical leave ranged from minimal to nothing. Salaries for younger professors were so low that some faculty members were leaving to teach in public schools."[82] Further, in the time that he served as president the economic situation in Texas worsened. A special Select Committee on Higher Education considered ways to streamline costs of higher education throughout the state and set university enrollment ceilings. The idea behind limiting enrollment was that if there were ceilings on the number of students at the largest universities then those unable to attend flagship universities might consider the smaller schools where enrollment and retention were problems.

Even in good times, Texas did not pay its general faculty well and as the economic situation deteriorated, faculty salaries worsened. By the summer of 1987, Vice President for Academic Affairs Richard C. Meyer explained that the legislature needed to provide adequately for salary increases or else Texas universities "will run the chance of losing faculty members." Nine faculty members had resigned by early July 1987. The salaries at Texas A&I were among the lowest in a state that did not pay well. Larry Temple, chairman of Select Committee on Higher Education noted in July 1987, that since 1982 Texas had fallen 6 percent behind the national average and by 1988 would be 19 percent below the average faculty salary of the ten most populous states.

The Select Committee on Higher Education was also concerned about inadequate funding for higher education in the next years. They considered restructuring higher education by consolidating university systems and setting up a "tier" system like California—where the top tier of universities, principally devoted to research, would include only the University of Texas and Texas A&M University. The Coordinating Board, which controlled many of the actions of the state's universities and colleges, considered ways to harness development of programs and devote dwindling dollars to the most promising programs and schools. The Select Committee questioned low usage of facilities. Like other universities in Texas, the A&I campus was overbuilt with more buildings than needed for the number of students. Utility costs for unnecessary

buildings strained budgets. The Select Committee therefore considered merging universities, and converting smaller schools into branches.[83]

In July 1987, the special session of the Texas legislature failed to pass a resolution establishing a committee on the merger of Texas A&I into the Texas A&M or UT system. Gib Lewis, Texas House Speaker, announced that he would appoint a committee by January 1988 to report to the 71st legislature in 1989. Senator Truan and Representative Rangel supported the idea as bringing attention to the question of higher education in the region and bringing the states's two largest universities into the area. Maneuverings of South Texas schools became complicated. Some A&I supporters were concerned that there was an ulterior motive to make CCSU a four-year university, or to merge CCSU with UT and A&I with Texas A&M.[84]

In September 1988, the Joint Committee on Higher Education co-chaired by Senator Truan met in Austin to discuss aspects of a merger of Texas A&I, CCSU, and Laredo State University with Texas A&M to be presented to the legislature in early 1989. At a forum on campus in October, President Altman explained: "Nothing will change. Our name, school colors, and mascot will be the same" if A&I merged with A&M. "The only thing they will probably want of ours," he joked, "will be some of our football players." If the USST board approved of a merger, it would also have to be approved by the board of Texas A&M and by the state legislature. Faculty seemed ambivalent, with one-third of the faculty senate supporting, one-third opposed, and one-third undecided. A student editorial pointed out that there were many benefits of a merger, but the loss of identity was a drawback. Another editorial in the *South Texan* noted that the name change was an important emotional issue, but clouded the real issue at stake.[85]

At the November 3, 1988 meeting of the University System of South Texas Board of Directors meeting, the vote was 9-0 to approve the feasibility study, which would merge the USST system with the Texas A&M University system. It would also bring the Reynaldo B. Garza School of Law from Edinburg to the Texas A&I campus and make CCSU a four-year university. The feasibility study also defined the educational roles for each campus in the USST system. The mainstreams for Texas A&I were engineering, natural gas fuels and manufacturing systems, bilingual education, agribusiness, agricultural and business administration; for CCSU health, marine science, mariculture, business administration, coastal environmental issues, and teacher preparation; for Laredo State an expansion into maquiladora or twin-plant industry. Two weeks later, the Texas A&M Board approved the merger of the two systems.[86]

When the 71st legislature convened in January 1989, A&I supporters expressed concern that the 8.2 percent proposed cut in higher education funding would scuttle the merger and that the merger would cause a change of the name of Texas A&I. Senators Truan of Corpus Christi, Judith Zaffirini of Laredo, and Hector Uribe of Brownsville introduced Senate Bill 122 on January 11, 1989. The Alumni Association was delighted to learn that the Senate Education Committee announced that A&I would not change its name, and the law school and four-year status for CCSU would be separated from the merger legislation.[87]

Altman recognized the need for Texas A&I to merge with a larger system where funding could be obtained with the assistance of a system with more political clout

than the small University System of South Texas. He also recognized the need for more professional education programs and, toward that end, worked to secure a law school for the Kingsville campus. In return for the political assistance the larger system could bring to the small campus, he believed that Texas A&I would bring "knowledge of the region and 65 years of experience in dealing with the issues in the region." Altman detailed A&I's resources as follows:

> We bring a talented teaching faculty, and a significant series of research programs, particularly in citrus, wildlife, robotics, biology and engineering. We have prepared many of the teachers for the public schools and have close partnerships with the districts—our future lifeline. And we know the unique culture and mores of the Hispanic population and what the State must do to respond to the needs of this important group.[88]

Altman testified before the House Higher Education Committee in March 1989 supporting the merger of the University System of South Texas into the Texas A&M University System and for establishment of a Law School at Texas A&I.[89] Before the legislative session ended, Altman resigned as president of Texas A&I University and accepted the position of president of the University of Central Florida.[90]

The Committee on Education referred Truan's Senate Bill No. 122 back to the Senate, where it passed on the third reading by *viva voce* vote. The House concurred on May 9th and the bill went to the governor the same day. The governor signed the legislation on May 17, 1989, to go into effect on September 1, 1989. In August, the Board of Directors of the University System of South Texas named Manuel Ibáñez president of the Kingsville campus and voted itself out of existence.[91]

The malaise characterizing this decade at the Kingsville campus was hardly surprising. There was a rapid turnover in top administrators who did not stay long enough to make much impact. The new presidents came from Georgia, Montana, and Florida and did not thoroughly understand the political and cultural realities of South Texas. They initiated studies of the schools problems, formed committees, established task forces, and undertook strategic plans to reevaluate programs. Although they clearly saw the challenges and grappled with the difficulties, they were unable to motivate a faculty that was in a defensive "siege mentality" resisting change. There were more non-traditional students and a greater need for continuing education programs. Students were apathetic and the climate on the campus reflected decreasing activities and fewer reasons for students to remain on campus over the weekend. Further factors contributed to overall demoralization on campus—declining enrollments, a deteriorating state economy, competition from new campuses for students, and examination of proposals by state agencies to restructure higher education.

The University System of South Texas had ardent and dedicated supporters in Austin, but lacked the political clout of the large flagship systems. It became clear that a merger with a larger system would provide stability and assistance in obtaining funding, but also that any proposed changes would face resistance and suspicion.

Chapter Eight

TAMUK

Texas A&M University-Kingsville

1989–1998

Student contributors:
Leonard Gregor, Jesús Pantel, Marcos Trevino II, and Daniel Jose Vasquez

During a decade of falling enrollment and retrenchment, with a rapid turnover in administrators who were unfamiliar with South Texas and who launched a succession of task forces and plans to reevaluate programs, the faculty became defensive. Due to their "bunker mentality," the faculty often gave students the impression they were indifferent, insensitive, uncaring, and unsympathetic. The profile of students attending Texas A&I changed—with more non-traditional, off-campus, and continuing education students. Students often worked part time and attended school full time and participated less in campus activities. Declining enrollments, a deteriorating state economy, and competition for students from new campuses presented difficult problems. Some administrators, faculty, and alumni hoped that a merger with a larger system would provide fiscal stability and enhanced political influence. However, in the fall of 1989—when the world experienced a paradigm shift in international relations with the end of the Cold War—Texas A&I University experienced a significant change in affiliation.

On August 8, 1989, the Board of Directors of the University System of South Texas (USST) appointed Manuel L. Ibáñez as president of Texas A&I University, B. Alan Sugg as the president of Corpus Christi State University, and Leo Sayavedra as the president of Laredo State University. At the end of the meeting, Blas M. Martinez noted that it was the last regular meeting of the USST Board and commented on the merger with the Texas A&M System. The board then voted itself out of existence by adjourning.[1] Three months later, on November 9, 1989, the end of the Cold War was marked by demolition of the Berlin Wall. The two events are not comparable, but the fall-out from each has this in common: it would continue to be felt for years on the local and international levels. Reunification, merger, name-changes, loss of identity, and changing affiliations became the new order.

After 65 years of existence as South Texas State Normal College, South Texas State Teachers College, Texas College of Arts and Industries, and Texas A&I University, the school underwent a major readjustment. It had endured several name change controversies, but never before had it been asked to completely change its identity. In 1989, it initially maintained its name and ardently cherished its distinctive traditions, but it was no longer a separate entity. Its sister campuses, located in more populous areas, posed serious competition. The Board of Directors were not appointed to guard South Texas schools, but to protect a large university system with campuses in all regions of the state. The school had to struggle to adjust to its new status and to present itself to the public. Texas A&I was no longer the only, or even the dominant, school in South Texas—it was a small school in a large system.

President Altman understood campus problems and had recognized the need to merge with a larger system with more resources and political access.[2] Before leaving, he had proposed creation of a law and/or a pharmacy school, and had received considerable support from area legislators who appreciated and respected his abilities. The school created attractive supporting literature and attempted to bring an existing law school to Kingsville.[3] However, Altman resigned to accept another presidency in Florida, leaving the project for a law school to his successor.

The University System of South Texas Board had approved a feasibility study to bring the Reynaldo B. Garza School of Law to Kingsville. There were 85 part-time students in the four-year program, which was in the process of seeking accreditation from the American Bar Association. The Texas Supreme Court gave a two-year waiver so Garza School students could take the bar exam in 1988 and 1989. In order to be accredited it needed state funding and it had to be affiliated with a public university to assure that funding. Members of the USST Board warned that obtaining state funding was difficult.[4]

Establishment of a law school at Texas A&I, merger with Texas A&M system, and creation of a four-year university at Corpus Christi had all been part of the same legislative proposal of 1989. Governor Bill Clements expressed his support for the merger during his "State of the State Address," but indicated that he would leave the specifics to the legislature. Altman noted that the Garza Law School had received "a bad rap over the years" and A&I would not want to relocate it to Kingsville. Texas A&I wanted to start a law school from scratch to convince the state that it intended to avoid weaknesses of the Garza school. Estimated cost was $2.6 million for the first year and $3.3 million for the second year of operation. Before the Senate bill on the merger proposal cleared the Senate Education Committee, State Senator Carlos Truan removed provisions for the law school, the name change, and the four-year university for Corpus Christi. He feared that the law school controversy could jeopardize the merger once it reached a floor vote, especially after Governor Bill Clements publicly came out against the law school and the four-year university for Corpus Christi.[5]

Texas A&M Chancellor Perry Adkisson neither supported nor opposed the law school proposal; the Board of Regents did not support the law school proposal. Altman believed that some regents doubted there was a need, some mistakenly believed that it was the Garza School in Edinburg that was being considered, and some simply

disliked attorneys. The House Higher Education Committee unanimously approved the merger bill, a law school for A&I, and a four-year school for CCSU as three separate pieces of legislation. Lieutenant Governor Bill Hobby criticized the law school bill as "ludicrous" because it would cost over $8 million in the first five years when the state was experiencing budget difficulties. Some attorneys believed it would hurt other law schools and some felt there were already too many law schools in Texas. The state bar did not take a position, but the Mexican-American Bar Association of Houston supported it, and Kingsville attorney Sam Fugate and area lawyers supported it, noting that the region needed professional schools.[6]

Supporters attended "A&I Day" in Austin to express their enthusiasm for the law school. State Representative Irma Rangel explained there were enough votes in the House to pass it, but it faced opposition in the Senate especially from the powerful lieutenant governor. Senator Truan noted that the legislation would require 21 of the 31 votes in the Senate to pass, but had only 18 supporters so far. Truan thought Lt. Gov. Bill Hobby needed to understand that Houston had three law schools but "South Texas has none." Truan noted that it was not easy to pass such a proposal on the first try and there was not much time before the end of the session to build momentum.[7] In the spring of 1989, the law school passed the House but not the Senate; the merger of USST and Texas A&M systems passed both houses.[8]

Kingsville then welcomed President Manuel L. Ibáñez to the campus. While he enjoyed a Spanish surname, the community knew that he was not of Mexican-American heritage, nor from Texas or the Southwest. His family came more directly from Spain and he had grown up in Pennsylvania. He came to A&I from the University of New Orleans. The college community hoped for a strong leader who could restore confidence in a campus that was feeling a little helpless. They had high expectations for the new president, but he became president at a difficult time.[9] When Ibáñez arrived there was already a feeling of hopelessness and he faced growing apprehension that A&I would lose its identity. Although it was not through his efforts that the school had merged, Ibáñez faced animosity and hostility from alumni and Kingsville area residents. It was popularly believed that if Texas A&I obtained a professional school in pharmacy, law, or veterinarian science, the climate of opinion would improve.

In September 1989, the Texas A&M Board of Regents visited the Kingsville campus for the first time. They questioned why it was necessary to have an Hispanic Alumni Association when there was already an established Alumni Association. The student newspaper editorial said the regents would not tolerate two divisive alumni associations. When the executive director of the Alumni Association and a professor told the regents that raising the salaries of teachers was of utmost importance, regents noted that the attrition rate among freshmen students was 40 percent. One regent commented that the school's priorities should be rearranged. "Maybe the number one priority should be to attract more students instead of raising teacher salaries." They questioned why raising teachers' salaries was a higher priority than recruiting and retaining students and were unwilling to support new programs until existing programs were brought up to A&M standards. John S.

Gillett, a member of "Texans for Texas A&I," suggested that the regents should not only consider a law school, but also a school of veterinary medicine and a library school for the campus. Representative Rangel and Senator Truan both tried to persuade the regents to support the creation of a law school in Kingsville, but the regents declined to comment.[10]

In 1991, Rangel and Truan again introduced legislation to establish a law school at Texas A&I University. President Ibáñez wrote a letter to the *South Texan* stating that a law school at Texas A&I "would be one of the finest things ever to happen to this institution, to its students and faculty, to the region and its people, and to the entire state." It would have long lasting benefits, he added, and probably spawn other high-level programs. The campus Texas Faculty Association (TFA) and Texas Association of College Teachers (TACT) both endorsed establishing a law school. The House Higher Education Committee unanimously approved House Bill No. 540 and sent it to the Calendar Committee, where it languished without action until the session ended.[11]

Senator Truan and Representative Rangel were born in Kingsville, had attended public schools in the town, and had graduated from Texas A&I. Truan had been active in student affairs and had graduated from the college in 1959. He won election to the House of Representatives in 1967, where he introduced two bills which passed—The Texas Bilingual Education Act and the Texas Public Housing Authority Act. In 1971, he attended student meetings on campus about discriminatory housing practices and introduced legislation to establish a code of rights and responsibilities for both landlords and tenants. When Larry Temple's Select Committee on Higher Education proposed the merger of A&I and CCSU, Truan quickly defended Texas A&I. The senator was also watchful of the interest of the school in Corpus Christi, which was his adopted home and within his senatorial district. He maintained that higher education in South Texas should grow, but not at the expense of A&I. In 1976, he won election to the Senate and by 1987, he was sixth in senate seniority and a member of the powerful Senate Finance Committee and vice-chairman of the Senate Education Committee.[12] Truan opposed any effort that would diminish programs at the Kingsville campus and offered proposals to enhance the school's stature.

Representative Rangel was also fiercely protective of her district. Her family had prospered in Kingsville and had been active in the political struggle for equality for Mexican Americans. The Rangel family of three daughters had grown up determined to serve the people of South Texas. As a graduate of A&I, Rangel held a special fondness for the needs of her alma mater. She was the first Mexican-American woman elected to the Texas State House of Representatives, as well as the first woman to serve as chair of the Mexican-American Legislative Caucus. As chair of that caucus, she was influential in forming the Border Initiatives Committee after the Select Committee on Higher Education issued its report in 1986. It was clear from reaction to the latter that the Universities of South Texas—including Pan American University at Edinburgh, Laredo State, and Texas A&I—were all alarmed at the heavy emphasis placed on the programs at the Corpus Christi campus which was then only a two-year upper-level school.[13]

In May 1984, the Mexican American Legal Defense and Education Fund (MALDEF) had successfully pursued the *Edgewood School District vs. Kirby* case about the distribution of funding in state secondary schools. MALDEF attorney Al Kauffman explained that the 1,063 state school districts received education funds based on the wealth of the district. There was a wide disparity from $1 million a year to $20,000 a year per child in the tax base of districts. Judge Harley Clark of Travis County 250th District court found the system for distributing state funds unconstitutional; he also found that Texas had denied equal educational opportunities to students who resided in poorer districts. Kauffman explained that "the equal protection clause of the U.S. Constitution may have a major role in any pending legal actions taken on the higher education level." Norma Cantu, associate MALDEF attorney acknowledged their effort to develop the higher education case on equal protection grounds, but said "it is just too early to discuss it at this time."[14] In June 1984, the House passed the Education Reform Act (House Bill No. 72), dealing with the administration, financing, and programs of the public school system. Rangel joined several other legislators in commenting that she supported the bill to gain additional funds for schools in her district. She believed the present system was unconstitutional and was causing a widening educational gap between the least and most affluent school districts.[15]

State legislators from the border region were also concerned that with limited funds for higher education, needless duplication of programs was poor stewardship of public resources. They felt that schools in the underfunded area should cooperate to develop quality programs distributed equitably. At the instigation of MALDEF and with cooperation of many interested citizens, a group of South Texas legislators and citizens came together to discuss and arrange an equitable distribution of funding and programs. All agreed about the need for a consensus on areas of concentration and the need not to duplicate specializations. They felt that if they worked in a united way, they might be able to bring more programs to the border area. All agreed that historically the state had treated the region unfairly, concentrating resources in central and north Texas, and that area colleges and universities needed to work together to influence how financial resources were distributed.[16]

In 1998, Texas Comptroller of Public Accounts John Sharp issued a report entitled *Bordering the Future Challange and Opportunity In the Texas Border Region* that documented statistics for South Texas institutions of higher education. Sharp reported that historically: "Border high school graduates place no less importance on a college education than do other Texans. In 1990, Border high school graduates age 25 years or older participated in post-secondary education at almost the same rate as the state average—63.2 percent compared to 64.5 percent for the state." Furthermore, his report noted these students tended to stay at colleges and universities close to home so that nearly three out of every four students who attended college would be doing so at their local school. The border population was young, and growing more rapidly than in any other section of the state. Projections were that by the year 2010 the college age student population in South Texas would increase by 30 percent

pushing total university and community college enrollment to about 170,00 students requiring additional programs, buildings, and facilities to be developed on Border college and university campuses.[17]

MALDEF filed suit in December 1987, on behalf of the League of United Latin American Citizens (LULAC), 9 other groups, and 21 students charging that funding of higher education in South Texas was unfair and unequal compared to other Texas colleges and universities.[18] MALDEF filed the suit in Judge Ben Uresti's 107th District Court in Brownsville. They maintained that the state had historically failed to provide adequate educational opportunities to educate Mexican Americans living in the border region. The legislature issued a report in January 1989, recommending additional undergraduate and graduate programs and increased funding for higher-education institutions in South Texas. The MALDEF case gained class action status in March 1990. Before the trial started, a $2 billion plan was agreed upon in September 1991, to rectify inequities, but the state did not yet know how to fund it.[19]

For many weeks before the opening of the case of *League of United Latin American Citizens v. Richard*, lawyers for MALDEF and the state tried to negotiate a settlement. Even before the trial, the legislature allocated $44 million for a program called the South Texas Initiative in the 1992-1993 budget. Responding to the 1989 legislative report, the initiative attempted to show the legislature's good intentions to improve higher-education in the region.[20]

The trial began in Judge Uresti's court on September 30, 1991. State attorneys called Manuel Ibáñez to testify. The Corpus Christi *Caller-Times* reported that Ibáñez testified he did not perceive that the state—in deciding to approve new academic programs—discriminated against schools dominated by Hispanic student population. He asserted that the university's funding problems were shared by other educational institutions, and that the lack of new programs was not the result of discrimination by state officials. He maintained that state flagship universities—the University of Texas at Austin and Texas A&M University at College Station—were treated uniquely, and while he agreed that they had a disproportionate number of academic programs, he maintained they too were seriously underfunded.[21]

In November 1991, the district court jury in Brownsville found that the state did not discriminate against Mexican Americans in funding border area colleges and universities. Jurors concluded, however, that the legislature had not established a system of higher education with equal access for Mexican Americans to first-class universities. Al Kauffman proclaimed a victory: "The jury has found that the state violated the constitutional rights of the plaintiffs." He said the plaintiffs would file a motion for judgment, asking the judge to either agree or disagree with the jury's findings on the constitutional issue.[22] In January 1992, Judge Uresti threw out the jury verdict and declared the public university system unconstitutional. He ruled that in fact there had been discrimination in funding and South Texas had not received its fair share. He gave the state until May 1, 1993, to establish a new plan for funding.[23]

On October 6, 1993, the state supreme court overturned the lower court ruling. The supreme court concluded that although there had been disparities in funding colleges in South Texas compared to those in Central and North Texas, "there is no direct evidence in this case of an intent to discriminate against the Mexican Americans in the border area." Administrators and faculty on the campus expressed concern about the turn of events. Jackie Thomas, president of the faculty senate, said there had been "very few doctoral programs and little interest in the South Texas area (in terms of program funding) until recently." A *South Texan* editorial concluded: "The bottom line is that the students at these institutions are the losers—again."[24]

At least the suit had focused attention on the historically underfunded education system of the border region. This ruling caused the state legislature to reevaluate higher education funding practices and—as suggested by the citizens group—to create the South Texas Border Initiative to increase funding for the region's higher education. The state appropriated approximately $400 million to be used for many of the programs agreed upon by the Border Initiatives meetings.[25]

In May 1993, the state senate passed Resolution No. 1155 expressing their intention that the Texas Higher Education Coordinating Board provide adequate support for border colleges and universities. The resolution noted that education was essential to preserve a democratic society but the state's system of funding disregarded needs of citizens in certain areas. It noted that one of the grievances of Texans in 1835 was the failure of the government to establish and properly support a public education system. The state constitution written at the time of the Texas revolution included provisions for a permanent and continued education system. The resolution noted that the spirit of the constitution was violated when 20 percent of Texas's population living along the border received 10 percent of the education funds. As the state approached the twenty-first century, growing international trade along the border made it urgent to develop an educated work force to meet the challenges of a global economy.[26]

In response to the South Texas Border Initiative, colleges and universities of the area submitted plans for desired programs. Texas A&I sought four bachelors programs, five masters programs, twelve doctoral programs, and professional schools of law, pharmacy, and veterinary science.[27] In their report to the state legislature, the university officials said that in the next twenty years:

Texas A&I University will continue to target resources to support our academic strengths in the areas of engineering, agriculture, and the sciences, while maintaining strong programs in business, the liberal and fine arts, and programs in education that stress subject matter training for master teachers. Undergraduate and master's programs will continue to cross the broad spectrum of academia, and selected doctoral programs in engineering, wildlife research, biology, environment, veterinary science, the arts, education, and business will round out a broad selection of available programs. The creation of at least one professional school during that period will be possible with appropriate funding.

The report explained that with additional funding, A&I would continue off-campus research and teaching sites, including the Citrus Center at Weslaco, the Welhausen Ranch in Webb County, Site 55 on Baffin Bay, and several other agriculture/wildlife

properties. The school hoped to develop distance education through interactive TV on the Trans Texas Video Network. The administration hoped to obtain funding for additional doctoral programs and to make faculty salaries more competitive.[28]

According to the Sharp report: "Measured simply by dollars invested, the initiative made an immediate, dramatic impact." From 1990 through 1996, Border colleges gained $87 million more in annual funding, a 69 percent increase. "Border colleges and universities also began to claim a bigger share of the state pie." Border schools began the 1990s with $125.5 million in general revenue funding (11 percent of $1.1 billion for all Texas academic institutions), but by 1996 they received $212.5 million (15.2 percent percent of the $1.4 billion general fund appropriation for higher education). Sharp concluded: "In 1996, South Texas institutions, with 15.6 percent of full-time students, received 15 percent of the general revenue funding for higher education.[29]

Appropriations from the South Texas Border Initiative were to be in addition to HEAF funding that had been awarded in 1985. HEAF (an acronym for Higher Education Assistance Fund) was special funds awarded to 32 schools that did not participate in the Permanent University Fund (commonly called PUF). The concept for a permanent endowment for education originated in 1839 when the Republic of Texas Congress set aside land to fund higher education. At first the income was from grazing leases, but after the May 28, 1923 discovery of oil on university property, income increased substantially. By 1931 legislation split the income, with two-thirds going to the University of Texas and one-third going to Texas A&M University, enabling the two schools to grow far beyond others in the state. A 1984 constitutional amendment added several branches of the two systems to those benefiting from the PUF.[30] HEAF money was designated to acquire land, either with or without permanent improvements, construct and equip buildings or other permanent improvements, make major repairs or rehabilitate buildings or other permanent improvements, acquire capital equipment, and purchase library books and other library materials.[31]

While the state legislature, MALDEF, and the courts were dealing with educational funding in the border region, A&I was seeking ways to enhance its existing curriculum to increase enrollment and retention. For example, the administration instituted an agreement to join as partners with area two-year schools, including Bee County College, San Antonio College, Southwest Junior College at Uvalde, Angelina College in Lufkin, and Texas State Technical Institute in Waco and Harlingen. These partnership agreements meant students could earn university credit for specialized training through such experiences as armed forces schools, technical schools, community or junior colleges, non-collegiate sponsored instruction, and work experience. Depending on the program, students could apply these specialized educational experiences to either a bachelor's degree or a bachelor of applied arts and science program. The program was designed to give students additional opportunities not previously available.[32]

In the fall of 1989, the administration created College I to provide introductory and remedial instruction to students beginning their university experience. College

Yanira Luna (Dominican Republic) and L-R standing Takashi Yano (Japan), Anita Perez (coordinator) & Xiomara Mercedes (Dominican Republic) were students in 1989 at the Intensive Language Institute operated on the A&I campus for foreign students studying to pass the TOEFL test.

I required new students and those with fewer than 30 credit hours of college credit to enroll in a one semester non-credit course orienting them to study techniques and university services. Professional counselors would provide advisement, use test results to help students determine their best program for academic success, and guide them to suitable careers. Another component was a Developmental Studies Program which offered workshops and precollege instruction in reading, writing, math and algebra or other subjects in which students had little preparation. Academic Skills Centers and a Reading and Study Skills Laboratory were also available. In the first year, College I established "Hoggie Days,"—a Freshman Orientation program. Finally, College I included International Students Services to help students from foreign countries adapt to life at Texas A&I University.[33]

As a further service to the many international students on campus, the administration accepted and extended facilities for an Intensive English Institute. The program had been at A&I since 1982 to help students pass the Test of English as a Foreign Language (TOEFL), required of students for college admission. Students came from other countries for a four or eight-week course to prepare them to take the TOEFL. Although A&I housed the institute, the university did not administer the program. The program at A&I was only the second in the country, but by 1997 there were ten such programs. In 1998, Sylvan Learning Systems Inc., headquartered in Baltimore, Maryland, purchased the Intensive English Institute and added it to its international ESL educational system. Many students who came to study in this program later enrolled in classes in regular A&I course of study. Others came only to prepare for the test and then matriculated at other American universities.[34]

An increasing number of international students came to A&I, but once again international events affected the campus. In the fall of 1990, when Iraq invaded Kuwait, faculty members and students from Oman, Iraq, and Kuwait had very different opinions about the conflict. Agriculture professor Duane Gardner had spent most of the month of May at Mosul University in Iraq when there seemed to be no indication that a war was imminent. Geography professor James Norwine was in Iraq as a Malone Fellow studying the culture of the country and left Bagdad just four days before the invasion. As the situation escalated, staff and students who were in military reserve units were called into active duty and withdrew from classes. An editorial in the *South Texan* urged students to support the troops.[35]

International interest was growing on the campus as several programs show. History professor Ward S. Albro III and Sociology professor Rosario Torres-Raines obtained a Fund for the Improvement of Post-secondary Education (FIPSE) grant. The grant supported a Faculty Transculturation Project to increase faculty awareness of Mexican-American culture. In the spring semester, faculty members attended weekly seminars about Mexican-American and Mexican culture, and in the summer they spent several weeks at the Spanish Language Institute in Cuernavaca, Mexico. In addition, the Office of International Programs established a "Semester in Mexico" program in which students could earn up to 15 semester hours of credit by studying the language, history, and culture of Mexico at the Spanish Language Institute in Cuernavaca and at the Instituto Cultural in Oaxaca. The university also established a two-week program for maquiladora managers to live with families and attend classes in Cuernavaca.[36]

The Texas International Educational Consortium (TIEC) sponsored faculty exchanges with Kiev Politechnic Institute in Ukraine, Moscow Technical University in the Soviet Union, and Shah Alam Center in Malaysia. Other faculty exchanges were with Universidad de Los Americas in Pueblo, Mexico, and universities in Vietnam, Brazil, Austria, Hungary, Argentina, and Chile. There were student exchanges and international exchange agreements with Universidad Viña del Mar in Chile, three universities in Argentina, Yang en University (Quanzhou, Fujian, People's Republic of China), two universities in Guatamala, nine universities in Mexico, Universite Montesquieu Bordeaux IV in France, University of Valencia in Spain, and Universidad Metropolitana in Caracas, Venezuela. In 1995, A&I became a "Border Institute"— one of a few state universities allowed to offer in-state tuition rates to students from Mexico.[37]

In addition to exchanging students and faculty members with other universities, the campus expanded its distance learning program. By 1992, all seven campuses of Texas A&M were connected by a long distance T-1 Link. Classes were taught through a video conference. Classes that had too small an enrollment on one campus, could now be taught by combining the number of students on two or more campuses. Texas A&I taught classes in a number of departments by this approach: physics, environmental and industrial engineering, math, and geology. In the Fall 1996 semester, an interactive sociology course became the first to be offered via cable television. Such courses helped non-traditional students whose family obligations,

employment demands, or physical restraints made it difficult to attend classes on campus.[38]

The College of Business Administration established a program to enable students to earn a master's of business administration through weekend courses. The business college believed there were many nontraditional students, who because of their work schedule were unable to attend regular weekday classes. When the university announced the program in area newspapers, it created a flurry of excitement and prompted many inquiries. The program intended students to take up to two classes for day-long sessions on two Saturdays of each month. A student could expect to complete the course of study in about four years.[39]

Despite additional funding and renewed efforts of the state, there were some problems at the Kingsville campus. Statistics reported by John Sharp's showed that the Kingsville school's students had the lowest pass rate among all border schools of those taking the ExCET Test. The ExCET test had been created by the State Board for Educator Certification (SBEC) to certify that those who wanted to teach in public schools in Texas. Potential teachers taking the test at A&I had the second fewest number of students pass the test the first time in some subjects but among the best performance in other disciplines.[40]

Events in the state legislature soon upstaged stories about campus curriculum changes, new programs and ExCET scores. While alumni had been supportive of the A&M merger, they were adamant that their school's name should remain unchanged. In 1967, alumni supported Coach Gil Steinke when he had opposed changing the name to the University of South Texas. In 1989, when Texas A&I joined the Texas A&M University System, alumni had insisted that the name not be changed. Alumni were placated for the next several years while Texas A&I University retained its name. In 1993, however, Senator Truan introduced legislation to change the name to Texas A&M University-Kingsville.[41] The legislation—offered as a rider to an appropriation bill—was unexpected.[42]

President Ibáñez began a campaign to educate the public about the need for the Kingsville campus to change its name. The school newspaper printed his presentation to the Board of Regents, which read in part: "Good things have occurred at nearly every level of our university life; from colleagues sharing ideas and energy in the classrooms and laboratories of College Station and Kingsville, to impressive efficiencies in our fiscal management system, to extended opportunities for our faculty and students to share in the daily life of Texas A&M." Ibáñez thought a name change would demonstrate the commitment of the campus to the system and would more clearly define the affiliation of the many A&M campuses to A&I.[44]

Senator Truan explained that although A&I had an excellent reputation, it was little known outside of South Texas and he felt that the name change would facilitate recruitment of students and faculty as well as fund raising. He explained that the university needed to keep pace with the regional trend of changing names to include the designation of either the University of Texas or Texas A&M. Pan American University was changing its name to University of Texas-Pan American, and Laredo State University and Corpus Christi State University would become Texas

A&M University-International and Texas A&M University-Corpus Christi. Without the name change, Texas A&I University would be considered a lesser known second tier school.[45]

A vocal group in the Alumni Association organized students, alumni, and community leaders to stop the name change. The struggle over the name change damaged the school's reputation and shattered the coalition of supporters that had worked for the university's growth and development. Opponents insisted that the name change would hurt the reputation that Texas A&I had already earned. In a special mailing of a publication, without a date, but with the official name and logo of the Alumni Association, the association's president urged those who received it to send money to help fight against the change.[46]

Supporters of the name change included the Kingsville Chamber of Commerce which passed a resolution in favor. Senator Truan made a videotape of people who approved of the change to show that there was support. Representative Rangel reported that the school might face a shutdown if the name was not changed.[47] Lt. Gov. Bob Bullock joined the controversy when he sent a letter to the Texas A&M University System Board of Regents stating that the name changes to Texas A&M at Kingsville, Texas A&M at Corpus Christi, and Texas A&M International "are essential parts of our promise to the people of South Texas." He warned that attempts to undo them were "as shortsighted as closing programs or shutting down facilities would be." Opponents filed a suit to prevent changing the name, claiming that the vote to change the name had been held in violation of the Texas Open Records Act, *i.e.* without adequate notice of the meeting. A court injunction forced the regents to call an open hearing at the Kingsville campus to allow interested citizens to explain their reasons for or against the proposed name change.[48]

The A&I Student Congress issued a protest. It was a very controversial issue on campus, with students circulating petitions opposing the change. Emotions were high as the controversy continued and each side denounced the intentions of the other. The Texas A&I Hispanic Alumni announced that, unlike the older Alumni Association, they supported their legislators and the school under the new name as well as the old. They accused the Alumni Association of opposing the name change because Senator Truan and Representative Rangel were Mexican Americans.[49]

The introduction of ethnicity into the debate caused one alumnae to voice what was probably the most common sentiment of the majority. M.A. True wrote the Kingsville *Record* that both sides were wrong when their personal opinions degenerated into name calling and personal attacks without regard to the welfare of the university. He said that for nostalgic reasons he was opposed to the name change, but because he had high regard for his alma mater he would get use to it, and support the school regardless of the name.[50]

On August 27, 1993, the Texas A&M University System Board of Regents met in Galveston and unanimously agreed to change the names of the three schools. "I hope we can begin the healing process now," President Ibáñez said. "Our main business is students; that's why we look more into the future than to the past."[51]

Thus on September 1, 1993, Texas A&I University officially became Texas A&M University-Kingsville and the Alumni Association changed its name to the Javelina Alumni after prolonged discussion and continued controversy. In 1995, the files of the Alumni Association were placed at the South Texas Archives, the office was closed, and the association was reorganized. There had been declining membership and contributions since the name-change dispute. A small group of dedicated alumni pulled together to start the rebuilding process, establishing a new Javelina Alumni Association in September 1995.[52] It would take years, however, to reestablish the spirit damaged by the controversy.

Even while the controversy raged, the South Texas school continued to initiate new programs and approaches to serve the region. For example, the struggle of women for equality had gone forward over much of the twentieth century. By the 1990s, discussions turned to the establishment of women's studies programs similar to ethnic studies programs in an earlier decade. In September 1990, President Ibáñez announced that he would establish a women's center. He noted that the reason for creating it was that 55 percent of the students at the university were female.[53]

Some found it hard to accept the name change and "A&I" was still seen displayed around Kingsville.

In 1992, the university established an advisory council to develop plans for a women's center. The new women's center was the first of its kind in Texas.[54] According to its advisory committee, an academic component would offer an interdisciplinary minor in women's studies; a research component designed to generate public and private funds would produce scientific investigations, monographs and other publications; and a service area would focus on the unique needs of women within the campus community and the surrounding area. The university already had in place limited services such as a nursery to provide child care for mothers who wanted to return to school, as well as workshops, counseling programs, and programs providing some career guidance. The center would centralize existing components, reorganizing them and drawing on university offerings and resources to focus on women.[55]

In the next few years the center produced a newsletter about issues of concern to women on campus and in the community. The center's administration—which answered directly to the office of the president—noted that the newsletter was so popular that multiple copies were claimed almost as quickly as it appeared. The center offered workshops and counseling for women facing such issues as sexual harassment or gender discrimination. The office offered its facilities as a place for the Corpus Christi area women's shelter to hold counseling sessions. The director used her position to help the university recruit more women and minority teachers and urged changes in some job recruitment notices that would limit applications from women. The Women's Center's director explained that one of its important roles was to promote a comfortable and safe campus environment.[56]

When later interviewed about difficulties that the center faced, the first director, Gilda Medina, recalled:

> Upon reflection, I must say that my greatest battle was simple: Women, their views and their work are important. There were too many times when I had to fight others over the idea that a woman's perspective was valid, regardless, of how new or different that perspective was. It still shocks me when I remember how angry both women and men could get if they encountered an idea that didn't follow the traditional gender role. One would think that a university would encourage free exchange of ideas and opinions. But there were very few people who didn't get out of whack when a new idea crossed their path. There was also the assumption that a women's center is anti-male and anti-family. I never devalued a woman who chose to stay at home with her children.[57]

In addition to the Women's Center, the university initiated other new programs. The Texas Higher Education Coordinating Board approved another doctoral program on January 31, 1992. The degree was a doctorate in educational leadership to be offered cooperatively by Texas A&I and by CCSU. This was the second doctorate to be offered by A&I, the first being the doctorate in bilingual education approved in 1975. The new program had been in the planning process since 1988. Professor Ivan Bearden, chairman of the Joint University Doctoral Council, announced that the first class of 20 students would have 10 students from each university. This new degree brought advanced training to South Texas without requiring students go to Houston—the closest of seven state education administration programs.[58]

While the university was dealing with fall-out from the name change controversy and establishing these new programs, there were other major challenges. A serious threat to accreditation by the Commission on Colleges of the Southern Association of Colleges and Schools (SACS) absorbed energies and attention of the campus for the next several years. In 1992, the university established a 26 member steering committee with 10 to 12 subcommittees to prepare the university for its 10-year accreditation review. In December 1994, after Texas A&M University-Kingsville had submitted its initial Self Study Report, SACS responded by issuing two serious warnings which threatened accreditation.[59]

At the December 1994 meeting, the Southern Association of Colleges and Schools, Commission on Colleges, "denied reaffirmation of accreditation, continued accreditation until December 1995" and placed Texas A&M University-Kingsville "on warning for one year."[60] The commission had examined the university in 13 areas and found it deficient in two. SACS instructed the campus to devise a more cohesive assessment program, to take a more comprehensive approach to accreditation in all academic units, engage in continuous study of its programs, and establish adequate procedures for planning and evaluation for its departments. They also expected the university to provide more adequate library resources, audio-visual equipment, language laboratory equipment, computer laboratory equipment, and science laboratory instrumentation. To improve the library, the school needed to increase the library staff.[61]

Reacting under pressure, the university's administration sought immediately to correct the deficiencies. Working with the university's Executive Committee, the Faculty Senate Executive Committee, the Staff Council Executive Committee, the Council of Deans, the Board of the Texas A&M University-Kingsville Foundation, and the board of the Javelina Alumni Association, President Ibáñez formulated a new mission statement and appointed several committees to produce a more acceptable accreditation plan.[62] Then he created the Assessment, Budget, and Planning Committee (ABP) by the summer of 1995 to track progress toward attaining goals and objectives of a new 1995 Strategic Plan and measure effectiveness of the university's program.[63]

President Ibáñez's included in his vision statement that the university would strengthen the school's presence in South Texas through innovative, broad-based undergraduate and graduate programs, especially renewing its commitment to teacher training. The administration promised that the school would make a renewed effort in public service and would promote and develop regional, national, and international links to strengthen the university's programs. He promised a renewed effort to foster a spirit of community among faculty to promote increased collegial participation in campus governance. Finally, the university committed the necessary financial resources to upgrade the library.[64]

A year later, the Southern Association returned to the campus and after careful consideration reaccredited the school, much to the relief of administration, faculty, staff, and students. Then the work of implementing the lofty goals began. The administration increased library staff and allocated more money for improvements

in automation, remodeling, and new equipment. The library moved to automate and put its 480,000 volumes on-line in a public access catalog. On November 5, 1997, OASIS, the on-line catalog, was introduced in a ribbon-cutting ceremony. With the help of an outside consultant, the ABP Committee focused on making assessment, planning, and budgeting functions linked together as an ongoing process.[65]

The university undertook a new and aggressive recruitment and retention plan. An Enrollment Management Team proposed compiling a list of prospective students that the deans could use to contact potential students. There was also a telemarketing effort where students made personal telephone calls to prospective students. More displays and booths were established at local events and the financial aid department obtained additional telephones to answer student questions. The university initiated a public relations campaign, including new billboards, and radio and television advertisements.[66]

To help increase recruitment and retention, the administration undertook to make the campus more appealing to students. The campus embarked on a massive renovation program, targeting residence halls, with a five-year plan for complete renovation, as well as renovations for the Student Union Building. Four years earlier, Ibáñez had said: "If you haven't walked through the residence halls, if you want to be frightened, I suggest you do." He noted that the campus could not attract students unless it was a more appealing environment. The administration sought additional scholarship funds to lure students to the campus.[67] As a result of these efforts, student enrollment did increase temporarily.

The university added new programs and activities including a Ph.D. in Wildlife Science, an M.Ed. in English as a Second Language, an M.S. in Communications Sciences and Disorders, an agribusiness course in the Rio Grande Valley, and a women's softball team. These helped increase enrollment and gave the university a more collegiate environment.[68] On October 23, 1996, the National Institute of Health gave the university a three million dollar medical research grant to expand biomedical research efforts, increase Ph.D. opportunities for students, and lay the groundwork for a doctoral program in environmental biology.[69]

New campus activities celebrated the heritage of South Texas and increased students' awareness of the contributions of the region. Sociology professor Joe Graham and Agriculture College dean Charles DeYoung, co-chaired the South Texas Ranching Heritage Festival. The festival featured ranch crafts, exhibits, cowboy poets and storytellers, music, a rodeo, chuck wagon cook-off, and a scholarly papers symposium celebrating some 250 years of ranching heritage. The festival quickly became a popular annual event.[70]

A Hispanic Heritage Committee developed a Hispanic Heritage Month in the fall semester. The month-long celebration included speeches, art exhibits, music, movies, dances, and a banquet. One of the co-chairs of the committee described its purpose this way: "Hispanic Heritage is an attempt at the education of Hispanics so they will know and appreciate their culture, and those who aren't can come to know what is Hispanic culture." The Hispanic Heritage Month developed into a major campus celebration.[71]

196

Ballet Folklorico was another reflection of the Hispanic culture on South Texas.

When the state legislature reconvened in 1997, the Kingsville campus received a significant boost when Senator Truan and Representative Rangel managed approval of tuition revenue bonds for a total of $15 million. The funds would be used to construct a new engineering building which would allow for housing of a new environmental engineering program plus much needed modernization of laboratories.[72]

By the fall of 1997, a 2x2 program for the college of Arts and Sciences was combined with the already existing College of Engineering 2x2 plan and Joint Admission Agreement. The Joint Admission program of the College of Engineering allowed students at certain community colleges to be admitted to TAMUK with a 2.0 GPA to pursue degrees in civil, electrical, industrial, natural gas, and mechanical engineering. A similar arrangement was made with the Arts and Sciences Departments of Biology, Chemistry, Physics and Mathematics. The agreements with Bee County College, Del Mar College, Laredo Community College, Palo Alto College, and San Antonio College stated that students could complete 67 hours at the community college then transfer to A&M-Kingsville, applying those courses toward a bachelor's degree.[73]

In November 1990, Athletic Director Ron Harms announced that, at the urging of President Ibáñez, the campus was considering reestablishing a baseball team—which had been discontinued 60 years earlier. An editorial in the *South Texan* enthusiastically endorsed the idea. In November 1992, a local rancher Frank Horlock and baseball legend Nolan Ryan announced the start of a $200,000 fund raising

Famous baseball player, Nolan Ryan helped raise funds for a new baseball field on the Kingsville campus.

effort to build a first-rate baseball field. In February 1993, at "An Evening with Nolan Ryan and Friends" gala, Ryan, Bum Philips, Larry Hagman, other celebrities, and over 350 baseball supporters contributed to construct a baseball diamond. In November 1993, Nolan Ryan attended the beginning of the construction of the baseball field—the "Diamond in the Rough." In February 1994, Ryan returned to dedicate the new field named in his honor. In December 1997, President Ibáñez's dream project to develop a baseball team was enhanced when lights were added to the new baseball field for night games. The money came from private donations and included box seats behind the home plate and the installation of an electronic scoreboard.[74]

To provide additional opportunities for the students preparing for careers in medicine, the university undertook two programs. In 1991, Mauro Castro of the chemistry department announced orientation courses for Hispanic students considering a medical career. In 1997, the university entered the Partnership for Primary Care between Texas A&M University-Kingsville and Texas A&M University Health Service Center to provide doctors for rural South Texas. The partnership allowed for early acceptance and admission to attend medical school for students who lived in rural or medically under-served areas of the state. Applicants needed a 3.5 GPA and needed to have completed the required courses at TAMUK. Upon completion of class work, the student would enter Texas A&M College of Medicine to study primary care or rural medicine without taking the Medical College Admission Test (MCAT).[75]

In early January 1998, President Ibáñez announced that he planned to return to the classroom at Texas A&M University-Kingsville and formed a committee to select his replacement. Upon announcing his resignation, he noted that during his administration he was able to secure for the university, master's degrees in gerontology, engineering, environmental engineering, and English as a second

language. He had been instrumental in securing a doctoral degree in wildlife science. The university had created a department of environmental engineering. During his presidency, the curriculum had also added bachelor's degrees in criminology, industrial engineering, international business management, food service management, and anthropology. Enrollment rose from 5,614 in the fall of 1989 to approximately 6,050 in the fall of 1997.[76]

Ibáñez's administration was also characterized by several controversies besides the name change. He faced a media scandal about allegations of drug trafficking by a small number of former and current student athletes in May 1990. The president acknowledged the right of the press to focus on university's athletic programs, but disliked what he called journalistic sensationalism. He noted the athletic program was not designed to monitor drug trafficking, that the AMK's drug-testing program was meant to defeat substance abuse and that athletes had tested drug-free for the previous three years. Overall, he stressed that the campus drug problem mirrored the national drug problem. He then launched an investigation and set up panels of faculty and staff to prevent future incidents. Coach Ron Harms was instructed to report details to the NCAA and to discipline guilty athletes. As had other presidents at the Kingsville campus, he charged that the Corpus Christi media over emphasized and exaggerated a small problem. He noted the arrested suspects were former students already expelled for various reasons.[77]

Ibáñez faced further problems in October 1991, when students protested unfair funding practices by the administration. Student association protesters claimed too much of student fee revenues had been used for athlete funding and not enough for other student programs and services. Students claimed 67 percent of an estimated $1.2 million in student fee revenues were given to athletic programs. According to the students, the athletic budget for 1991 was $968,913, with $806,913 coming from student fees. They maintained that the funding was not in the best interest of the school. Ibáñez agreed that student clubs and services were underfunded, but wanted these programs financed from private donations or other external sources. He refused to change the student budget and maintained that sports and the publicity it generated were the best method to acquire donations for other programs. Students collected 1,400 signatures on a petition and staged several protests denouncing fee allocations. An editorial in the South Texan noted that the protest march might be a signal of the end of student apathy.[78] However, student activism was brief.

In March 1992, faculty became alarmed when the university threatened to eliminate over a dozen academic degrees in 1994 unless more students enrolled in them. State guidelines mandated that bachelor's degree programs needed to graduate at least nine students, master degree programs needed to graduate six students, and doctoral degree programs needed to graduate three students in a three-year time span. Under this rule, nine bachelor's programs and four master's programs were in jeopardy. Three more bachelor's programs and six master's programs were in some danger. The Texas Higher Education Coordinating Board responsible for administration of such regulations felt that A&M-Kingsville was

The Homecoming bonfire has long been a campus tradition.

not wisely administering state funds. The controversy resulted in a fury of charges and countercharges between the President and faculty members. Some faculty maintained that Ibáñez was playing political games. Others blamed the president's emphasis on new programs for deterioration in existing programs. Ibáñez tried to place the heaviest responsibility on the Coordinating Board and perceived the cuts as detrimental to South Texas, which already had few programs.[79] Little resulted from the controversy, except for increased antagonism between faculty and administration, in which some faculty members had little confidence.

A juvenile student prank sparkled additional criticism of the president in December 1994. Students were tossing tortillas at football games, which a local county commissioner found indicative of the permissive attitude at A&M-Kingsville toward racism. He argued that the practice was not only a waste of food, but suggested an underlying tone of racism which could lead to worse behavior. He called on AMK to set an example and produce a more positive image for the youth of the community. Ibáñez responded that tossing of tortillas was not racism, but

was only a school prank.[81] Eventually the administration outlawed the practice, but only when it became a threat to safety because the tortillas were sometimes hard and capable of hurting people in the stadium.

Students briefly became upset by the tortilla-tossing ban. They continued, however, to experience the usual delights, anxieties, and problems of college life. They flirted, dated, agonized about rejection, and endured common frustrations of college undergraduates. The student newspaper ran numerous stories and a regular advice column for students about human sexuality. Students missed classes, procrastinated, failed examinations, commuted to Kingsville, and worked in part-time jobs. The Rodeo team rode bulls and carried on the glorious heritage of South Texas *vaqueros* and cowboys. Women volleyball, basketball, and softball teams excelled, and male athletes continued the winning "Hoggie" traditions in football, basketball, and baseball.

Individual professors still engaged in the noble profession of teaching young people. Some faculty members conducted research, published articles and books, attended conferences, devoted far too much time to frivolous committee-work, sponsored student organizations, participated in scholarly organizations, and engaged in community service. Professors experienced the joy of witnessing the expansion of students' minds in class discussions, on examinations, and from research projects—and the agony of under-prepared and disinterested pupils.

The president who led Texas A&I University into the Texas A&M University System remained in office longer than any president since James C. Jernigan in the 1960s. The campus experienced an identity crisis and a period of drift as it became a part of a large university system. It lost autonomy, self-sufficiency, and an independent identity. Administrators seemed to struggle to discover the relationship of the school to the Texas A&M system. Faculty members perceived a lack of direction and indecisiveness by campus administrators. Texas A&M University-Kingsville lacked a positive, unifying sense of mission. There seemed inadequate support for aggressively pursuing new professional programs such as a law school or school of pharmacy.

Texas A&M University-Kingsville had long been the avenue of education through which many South Texas young people had gained training to enter the work world. Now, the problems of inadequate preparation for college level work seemed even greater, and the demoralized faculty seemed unwilling, or incapable of dealing with students who were poorly prepared for college level work, and needed to hold outside jobs to finance that college work. The Sharp report noted:

> At the dawn of the new century, public college and university leaders face three persistent challenges: the financial hardship of many students, who despite low state tuition often find higher education too costly; a seemingly endless need to teach students material previously taught in high school; and institutional desires to increase the number and quality of academic programs at both the community and senior college levels. While paying for college concerns most Texas families, low per-capita incomes magnify the challenge for many Border students. In 1996, 63 percent of students receiving financial assistance at Border universities came from households with annual incomes of less than $20,000, compared to 55 percent of students receiving financial aid throughout the rest of Texas. Border students borrowed substantial amounts to attend college.[82]

201

The report further stated that because of the poverty of the area there were fewer full time residential students who could afford to complete their college education in the typical four year period. Instead the student at the border institutions needed to work, take few courses each semester and take a longer time to complete their education.[83] Although the Kingsville school had long been involved in working with programs that acknowledge the bilingualism and multiculturalism of the area, the school was not doing well with the students of the 1990s.

President Ibáñez had offered continuity in leadership, but had also experienced considerable controversy and concern. Enrollment and retention were constant worries. Funding was a perennial issue. The leadership did not communicate to the faculty a strong sense of common purpose and positive achievement. An aimless faculty and an apathetic student body looked forward eagerly to a new president. In the summer of 1998, Retired Army General Marc Antonio Cisneros, a tenth generation Tejano from the neighboring community of Premont, Texas, became president of Texas A&M University-Kingsville. A new era was about to begin.

Chapter Nine

Proud Past,

Promising Future

Student contributors:
George Cavazos Jr. and Christopher J. Maher

Undoubtedly the founding faculty and first students of 1925 would be proud of their school today. On June 8, 1925, in room 129 of the Main Building, the first faculty meeting convened. President Cousins had 26 faculty members that first summer. There was only the one academic building in the middle of a cotton field with the president's house nearby. There were no paved roads, dormitories or cafeteria. Students and most faculty members did not own automobiles. The student body consisted of 114 regular college students, 100 summer normal students, and 63 sub-college (high school) students. Of the 277 total students, 224 were female (81 percent) and 53 were male (19 percent). Twenty-eight of the first class were Mexican American (10 percent). South Texas State Teachers College was the only four year college south of the 29th parallel in Texas.[1]

Cousins reminded students at the end of the first year that they had set the precedents and the first issue of *El Rancho* documented that historic beginning. He said that in years to come "those who follow in your tracks will be interested to see the faces and finger prints that you have left here, and will be influenced by the traditions which you have begun." President Cousins noted that the first faculty and students built the school and their foundation would "bear safely the weight of a great superstructure." He told them there was "a wholesome atmosphere about the college which you yourselves have helped to create." He believed there were four cornerstones of the institution:

> *Let us agree to build our institution upon these four rocks of imbedded truth:*
> *1. Democracy—the Worth of the Individual.*
> *2. Patriotism—Intelligent Belief in Our Country.*
> *3. Philanthropy—the Brotherhood of Man.*
> *4. Religion—The Father Hood of God, as Revealed in His Son.*[2]

S.T.S.T.C. began as a school to train teachers; students for the first decade were mostly young women. Summer enrollment was more female than male by a ratio of two, three, or four to one. Not until 1938 did regular term enrollment exceed summer enrollment. Not until after the Second World War—when returning veterans enlarged the student enrollment—were there more men than women in summer school. When it became a College of Arts and Industries, male enrollment increased, but decreased dramatically during World War II. After the war, returning veterans sent the enrollment and male percentage of the students soaring, only to decrease again during the Korean conflict.

In fall 1999 semester, at Texas A&M-Kingsville, the number of female students was 2,868 (49.08 percent) and the number of males students was 2,975 (50.92 percent). Since 1988, the percentage of female students compared to male students has hovered near 50 percent (from a high of 52.04 percent in 1988 to a low of 48.39 percent in 1996).[3] This reflects the historical trend of the beginning of the school but also national trends. Nationally, young women became the majority in colleges in 1979 or 1980 and the gender gap has widened since. Approximately 60 percent of students on college campuses in 1999 were female. This is true of large and small campuses, public and private schools. The U.S. Department of Education projected that by 2008, females will outnumber males by 9.2 million to 6.9 million—in undergraduate and graduate programs.[4]

South Texans had unified to work for the establishment of a teachers college in the first part of the century. Name changes were a part of the school's past—being created as South Texas State Normal College and having its name changed to South Texas State Teachers College before it even opened its doors. The fight to change the name to Texas College of Arts and Industries was difficult and when it finally happened in 1929, the state legislature failed to appropriate enough money to allow for a comfortable expansion of the curriculum. The name was changed again in 1967, but only after a quarrel with the alumni and the football coach. The administration, students, faculty, and many community members wanted the school to be named the University of South Texas, but Coach Gil Steinke and his supporters among the alumni convinced the state legislature to change it to Texas A&I University. The name was changed in 1993 to Texas A&M University-Kingsville against the wishes of a vocal group of alumni.

Funding was a major obstacle in 1917 and continued to be one well into the 1990s. Insufficient funding was a perennial problem. When the school was established in 1925, there was one academic building and no dormitories. Kingsville citizens had provided boardinghouses for students, but increasing numbers of students made accommodations scarce. The administration utilized New Deal programs to build the earliest dorms, a cafeteria and other facilities. During the Depression years, students constructed their own cooperative housing and worked in government projects improving the campus.

Fighting for new buildings to adequately house growing programs was a chore each president confronted. The state rarely appropriated sufficient funds to those schools who did not qualify for the Permanent School Fund and it was not until the

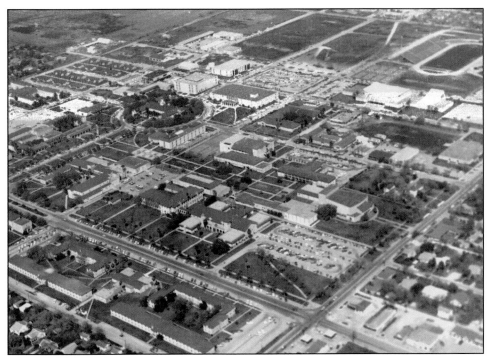

This aerial view shows that the main campus now extends from Richard Street on the south to Corral on the north, from Armstrong on the east to Seale on the west.

1980s that HEAF funding was established to address the problem. It was not until the 1990s that the South Texas Border Initiative recognized that South Texas had faced discrimination in state appropriations and in programs for higher education. By the end of the century, South Texas schools in general and Texas A&M University-Kingsville in particular had been underfunded for so long that the faculty, staff, and students were weary of the struggle.

The school had been created to train teachers and especially to cope with what was termed "the Mexican Problem." President Cousins and his staff had worked to implement a curriculum that included training teachers who would be in classrooms with children who were non-English speakers. The teacher training curriculum was progressive for its time, but the school was insensitive to integrating all South Texans into a school where diversity of cultures and races would be appropriately celebrated. Racial, ethnic, and gender discrimination were prevalent not only on the Kingsville campus but throughout the United States. In the 1960s, minority groups were no longer willing to tolerate mistreatment. The decades of the 1960s and 1970s were as tumultuous at A&I as they were on many college campuses.

By the 1970s, the school faced other problems as the Texas State Legislature began creating additional schools of higher education in South Texas, thus dividing even further the resources devoted to the region. A&I had to fight harder for funding and for students. In 1925, Dr. Cousins had talked about the need for recruitment and retention because the school was new. The faculty had been asked to travel

throughout South Texas, taking extension courses to students who wanted additional education. By the 1950s, the administration created a department for continuing education to provide higher education courses for South Texans. The school had been established with the mission to serve South Texas, and each succeeding president had advocated and pushed for increased programs for that mission. Now, each community was to have its own college and there was competition for students such as the Kingsville campus had never experienced. Recruitment and retention became more difficult.

National and international events reverberated on campus. The Great War, the Great Depression, World War II, Korean Conflict, Civil Rights movement, struggle for gender equality, Vietnam War, and national malaise were all manifested at Texas A&I. It was not that the campus merely was a microcosm of larger events—it was also unique and demonstrated distinctive achievements. Located in an area with great energy resources, it developed one of the great natural gas engineering programs. Situated in a region of historic ranchos and ranches, it established a substantial program in agriculture, contributed to the citrus industry and developed a prominent wildlife research institute. Established in the multicultural borderlands area—it created a nationally recognized bilingual education program.

In 75 years of service, the school struggled to plant the seed of higher education in South Texas. The plant took root, grew and ultimately prospered and flourished in a hostile environment in the face of adversity. The school endured periods of drought, lacking adequate nurture and support; but it was hardy, adapted to the inhospitable

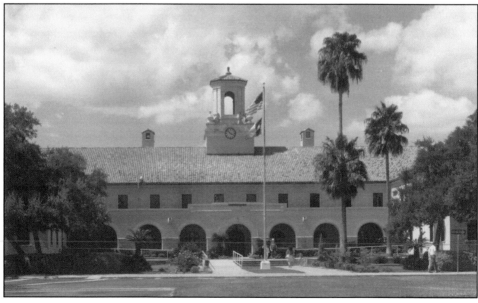

College Hall located in the center of the campus was completed in 1951. Its Spanish Mission Revival architecture is dominated by a bell tower that is a replica of the one found on Mission San Jose in San Antonio.

206

environment. The javelina was a suitable mascot, reflecting an indomitable spirit and perseverance under difficult circumstances.

The university was a portal for South Texas's young men and women to higher education. It developed programs in teacher education, agriculture, engineering, business administration, the arts and sciences, and graduate studies. Its thousands of graduates include men and women who pursued careers in education, business, law, medicine, the military, agriculture, art, music, drama, humanities, agriculture, sports, public service, and engineering. Graduates of the graduate program went on to receive doctorates and became faculty members at many universities in the United States and other countries. It provided for art, drama, and musical education of students in the region—producing prominent Chicano artists and a Bilingual Theater. The John E. Conner Museum, South Texas Archives, and Caesar Kleberg Wildlife Research Institute preserve, research, and provide services for the history and natural history of the region. The Ranching Heritage festival encourages South Texas to celebrate the history and culture of the region. Beyond that, the school has prepared young men and women for "lifetime learning" and a broad appreciation of the arts, humanities, literature, politics, music, philosophy, and other intellectual pursuits.

Created as a normal college, one of its most important contributions has been to train the teachers—who in turn have taught generations of elementary and secondary students in South Texas schools. It has served an Hispanic bilingual population at a time when there were no other schools in the state fulfilling that mission. The title page of the first catalog under President Cousins boasted: "A College of the First Rank for the Professional Training of Teachers." Within a few years the title page had added "Open to All Earnest Students," but did not admit African-American students for more than 30 years after it began.

In the last decades of the twentieth century, the university endured a crisis of leadership. With the creation of the University System of South Texas had come an era where presidents and other administrators passed through the school with bewildering speed. From 1925 through 1972 the school had six presidents and one acting president. From 1973 to 1997 the school had six presidents and two acting presidents.

Several new presidents brought high hopes and grand plans. They appropriately reviewed the situation, announced what needed to be done, but before accomplishing many of their goals, moved on to other universities. Only Manuel Ibáñez had stayed long enough to make a difference but unfortunately became embroiled in controversy, due to the name change, the threat of loss of accreditation by the Southern Association and a loss of confidence by some area politicians. When Ibáñez announced his return to the classroom, the campus was ready for a new president who could deal with funding problems from the legislature, competition from other schools, recruitment, and retention problems and loss of alumni support.

Dr. Leo Sayavedra, deputy chancellor for Academic Institutions and Agencies in the Texas A&M System, chaired the search committee to select a replacement for President Ibáñez.[5] Sayavedra had served as president of the Laredo campus

and was a South Texas native who understood the needs of the region and school. His search committee evaluated applicants, finally inviting five candidates for campus visits. On August 19, 1998, the committee unanimously selected retired Army Lt. General Marc A. Cisneros as the university's new president. Barry Thompson, chancellor of the A&M System, explained: "Lieutenant General Cisneros has certainly proved his leadership abilities during such military conflicts as the Vietnam War and 'Just Cause' in Panama." Thompson added that Cisneros' military experience "has additionally sharpened his feelings of obligation toward the young people of our nation, his support of advanced technology and his sense of accountability to the public."[6]

Many faculty and students were excited at the prospect of a national hero and a proven leader with a South Texas background coming to the school. General Cisneros, a tenth generation Tejano, had been raised with a sense of duty and obligation to the people of the area.[7] Born in Brownsville, he grew up in Premont, graduated from St. Mary's University in San Antonio, and received a commission as an officer in the field artillery in the United States Army in 1961. While growing up on a ranch in the small community of Premont, Cisneros developed his strong family values and belief in hard work. It was also during this early time in his life that he developed leadership capabilities as he often instructed ranch hands in the work that needed to be done.[8]

Upon entering the military, he began his long and outstanding career as a commissioned officer in the U.S. Army. Among his numerous military assignments, Cisneros served as Senior Line Executive Officer (Commanding Officer, 2nd Armored Division Artillery, Fort Hood, Texas) of a 3,000 person organization that consisted primarily of track-propelled artillery elements with conventional and nuclear capabilities. He also served as the Chief Executive Officer (Commanding General, 5th U.S. Army, San Antonio, Texas) of a major headquarters responsible for U.S. Army activities in all states west of the Mississippi River.[9]

The new president was most known for his role in "Operation Just Cause" in Panama. On May 7, 1989, Panama held elections and Manuel Noriega—Panama's military leader—was defeated but refused to relinquish his position. As protesters demanded that Noriega step down, riots broke out in the streets and the country quickly degenerated into chaos and turmoil.[10] In September 1987, the U.S. Senate passed a resolution urging Panama to reestablish a civilian government and in November passed a resolution to cut economic and military aid to Panama. Panamanians retaliated by adopting a resolution restricting U.S. military presence in Panama. After Noriega was indicted on drug-related charges in February 1988, the U.S. deployed military and security forces to Panama and began to evacuate military dependents and civilian diplomats. In the months following the Panama election, Noriega announced he was supreme leader of Panama and that a state-of-war existed with the United States.[11] On December 19, 1989, three days after Panamanian forces killed a U.S. Marine Officer, U.S. Forces went on full alert and began to deploy to Panama. Although the operation had limited military objectives it was "the largest single contingency operation since World War II."[12]

During "Operation Just Cause," Cisneros was a Major General and played a vital role in Panama. *U.S. News and World Report* later noted: "Marc Cisneros is the Panamanians' real hero. It was Cisneros who visited their little towns and spoke to them in their native Spanish."[13] His ability to communicate in Spanish endeared him to the people but angered the dictator Noriega and his followers. Noriega declared Cisneros and his family mortal enemies and death threats became common. The military arranged for General Cisneros to be transported in an armored car and assigned him a helicopter to transport him from his home to the base. His wife faced harassment and danger and on one occasion Panamanian forces surrounded the church where she was praying and attempted to intimidate her. U.S. military forces quickly and successfully came to her rescue. Even Cisneros' home was not safe. The Panamanian dictator ordered mortar rounds fired that exploded on the lawn of the Cisneros' home.[14]

When the invasion of Panama became inevitable, Cisneros took the operation to a more personal level. According to *U.S. News & World Report*, "It was Cisneros again, as commander of the U.S. Army South in Panama, who challenged Noriega *mano-a-mano* before the invasion, calling him a 'dime-store dictator.'" It was reported that Cisneros said at the time that "Panamanians should grow up and take charge of their country."[15]

Cisneros visited a POW camp to assess captured soldiers' living conditions. He met Captain Amadis Jimenez, an officer in Noriega's PDF [Panamanian Defense Forces], who had surrendered to U.S. troops. By Cisneros' own account, he then discovered that the young captain was no favorite of Noriega's, and so had him flown to Panama City where the general was able to persuade the captain that "it's all over, Noriega's forces are running."[16] The captain telephoned his PDF comrades and convinced them to surrender.[17] When Jimenez telephoned other military leaders in Panama, Cisneros reported that he got on the phone and told them: "If you surrender we will spare you. We will not mistreat you. You'll be doing a great service to your country. You know you won't win. Everything you've done to this point is honorable to your country. Everything you continue to do will be dishonorable to your country."[18]

Panamanian officers seemed astonished, Cisneros said, that an American officer was personally talking to them on the phone. Subsequently, almost 75 percent of the Panamanian Military Force surrendered peacefully.[19] Captain Jimenez later said: "It's hard to say how many, but I know we saved lives." Cisneros sought no glory or fame after the operation was concluded. It was reported that "Cisneros plays down his Panamanian role. Asked by a friend how he wanted to be remembered, he offered this epitaph: 'Just say, He was a hell of a soldier.' Panamanians would surely agree."[20]

Cisneros later told a Texas A&M-Kingsville student, "Soldiers who have been in combat, appreciate better, winning without having to fight. That's the humane thing to do. The Art of Warfare is that, if you can win a battle without losing any of your soldiers, that's better than losing soldiers. But even better is to win a battle, not lose any soldiers and not kill any of the enemy either. That's the real art of battle."[21]

209

On June 6, 1996, Secretary of Defense William J. Perry announced "that the President has nominated Lt. General Marc A. Cisneros, United Sates Army, to be placed on the retired list in his current grade." Cisneros retired after completing more than 35 years of service.[22] After leaving the Army, Cisneros joined Fluor Daniel Inc.—a large construction company in San Antonio. He served as "general manager of its Government Services Operating Company" before being named president of Texas A&M University-Kingsville.[23]

Stephen "Tio" Kleberg, a community leader, a strong supporter of A&M-Kingsville and then vice president of Agribusiness-King Ranch, responded well to Cisneros' appointment: "I couldn't be more excited, I know the community is very supportive because we had a lot of community [citizens] make input during the selection process. Cisneros is a strong leader . . . whose ties to South Texas will make him a good fit for the university." Kleberg also said he thought Cisneros' experience leading young people in the army "will make him a good leader for students." Kleberg concluded that Cisneros' leadership capabilities were not the only aspects that made him qualified for the position. He also had strong emotional qualities. "Marc is a very caring person. . . . He's very sincere. He looks you right in the eye, and I think he will be able to communicate with these young people."[24]

On campus, faculty and students prepared for one more president, this time a man from outside the world of academia. There were mixed emotions about this general who was considered a hero. There was also a general consensus that the school needed a strong leader to face an uncertain future.

General Cisneros arrived on campus on September 1, 1998, and immediately challenged the university to improve its retention rate, increase recruitment, and expand cooperation between faculty, staff, alumni, and the community. He wanted to see all of elements that had built the school working as a team.[25]

On March 15, 1999, the university celebrated his inauguration in a ceremony of academic ritual and tradition. The campus was "spruced up" for a grand party. Dr. Kay Clayton, vice president for Student Affairs and chairman of the inauguration committee, stressed the importance of inaugurations noting that they gave the campus the opportunity "to reflect on our history, the history of our institution." She maintained that inauguration ceremonies were a time for new beginnings and for healing old wounds.[26]

President Cisneros addressed the large crowd that attended the first inauguration since President Jernigan's in 1963. While praising faculty and staff for their past accomplishments, he asked them "to dig even deeper to encourage and nurture students."[27] "I envision a university that stands out in the whole nation, not just Texas, as the institution able to take students in an open admissions policy and take them through to the successful completion of a quality education and a valuable degree certificate. I am determined that we can do that better than anyone else. We relish the opportunity to become the premier open admissions university in the state, and in the nation."

The new president commented that Texas A&M-Kingsville had a unique and noble mission, one which brought with it many challenges and sacrifices because

it provided a quality education to the students of South Texas under an open admissions policy. Admitting that open admissions was a controversial issue he commented:

> For many of us it [open admissions] means 'moral courage'—the willingness to take the risk to allow opportunity to those who on a cold piece of statistical paper are made to feel inferior—before the legal age of being an adult. A process that doesn't measure the size of the heart or the hunger of the soul to achieve. I say moral courage because there is risk in this approach. Risk in how we compare at the beginning of the race. College standings based on SAT and ACT levels of their students do not in themselves measure potential—they measure past performance. But if you were to measure a university by the nobility of its cause, its essence for being, then you also need to measure its contribution in dealing with the toughest challenges. And I say that taking students who come to you with one or two hands tied behind them and getting them to graduate under top standards that apply to all is much nobler and contributory than taking a student with less risk involved.[28]

Cisneros addressed students directly in part of his inaugural remarks. He told them to accept nothing less than the best from themselves and to take advantage of every opportunity to prepare for challenges they would face in the work place. He appreciated the students accepting him as their president. "I want to assure you that I am committed to having this university be one you are proud to attend." He pledged the campus would strive "to meet or surpass all of your expectations." He told them they faced great obstacles, personal and financial, like no others in the nation. "The important thing is for you to reach your full potential, but you can't do that unless you constantly challenge yourself to learn and grow and accept nothing but the very best from yourselves."

In 1999, the University inaugurated Marc Cisneros. The ceremony began with a faculty procession to Jones Auditorium.

211

Lamenting that there were few job opportunities in South Texas, he warned that too many would need to go out into the world to seek new opportunities. However, he noted that many graduates wrote him letters to "tell me what they have achieved and what their time at Texas A&M-Kingsville meant to them, and I truly want that kind of success and fulfillment for all of you."[29]

Concerning the controversial issue of the most recent name change, he said: "Our name has changed many times, but our mission to serve the students of South Texas has remained the same. To do that, we need your help. I know that deep down, all of our graduates have great memories from their days here and great feelings for this university, and we need to build upon those feelings in order to continue the growth of an institution that has great importance in the South Texas community. It is time to rededicate ourselves to our mission, and move forward for the good of the university and the good of the students who are counting on us to be here for them."[30]

President Cisneros then embarked on his first year in office with the dedication and commitment that he had shown as a soldier. He had enlisted in the battle to bring education and a better future to the people of South Texas, the very people who had supported the school and who needed the opportunities an education could bring.

Almost immediately he became embroiled in a dispute with the Corpus Christi *Caller-Times*. It appeared that the *Caller-Times* wanted to elevate the Corpus Christi campus by denigrating the Kingsville campus. Partisan reporting culminated in a series of stories in early January 1999. The new president reacted by refusing further

Marc Antonio Cisneros, a tenth generation Tejano, a native of South Texas, and a retired military General, assumed the presidency in 1998 to lead Texas A&M University-Kingsville into the new millennium.

contact with the newspaper. He sent a letter to the editors of many other South Texas newspapers championing the cause of TAMUK and asking for support.[31] Students at the Kingsville campus also reacted with animosity to the large city newspaper and a feeling of unity permeated the campus. Students in Kingsville were proud of their school and voiced that sentiment in polls and letters to the school newspaper.[32]

President Cisneros became aware that the perception of the school was one of low academic standards, and he set about to correct that image. During his first year in office, the legislature met and he spent a great deal of time in Austin testifying about the school's funding. He had the support of two of the school's influential alumni: Senator Carlos Truan, dean of the senate and a ranking member of the Senate Finance Committee, and Representative Irma Rangel, chair of the House Higher Education Committee. Both had considerable seniority, commanded respect, and were delighted to help the new president win support. Representative Rangel reported how happy she was to work with a fellow South Texan who was committed to serving the people. By the end of the 1998 session, the new president was able to boast of a successful first encounter with the legislature.[33]

On campus, changes were also obvious. A new signage program—which had been in the planning stage for several years—finally was implemented. Campus improvement became visible with grounds being beautified and buildings being cleaned. Also, the administration shifted personnel and redrew the organizational chart of top administrators. President Cisneros challenged faculty and staff to "reach out and encourage the students you meet every day. We need to constantly mentor and nurture our students and provide a supportive environment for their success." He said: "This is not just my idea; this is the message I have heard repeatedly from students, the Regents, and the Chancellor. And I don't want to focus only on numbers or assessment. What's more important . . . what we should be concerned with . . . is the level of caring and involvement we put into each of our students."[34]

The president urged faculty to become mentors to incoming students and work with them as friends and advisors, but more than that, he envisioned a time when faculty members would be mentors to those parents, who if they did not understand the preparation needed for their children to be college ready, could turn to them for advice. He believed that faculty members should be proactive in recruiting new students. To the people of South Texas, he pledged a commitment to service by all university personnel.[35] When talking about his vision for the school in the coming century, Cisneros sounded very much as if he had heard the words from the first president of the school, Dr. Robert Bartow Cousins.

President Cousins told students of the first class at the end of the first year: "The members of the faculty have through the year been your sympathetic older brothers and sisters." In a few years you "shall be out in the world men and women, shoulder to shoulder, helping the big world to carry its load. Your task is already laid out and is waiting for you. Arise and gird yourself, and repair to your place of service."[36]

In 1905, when Cousins was Texas State Superintendent of Public Instruction, he reported that public school enrollment was growing at a tremendous rate, and that "public free school funds are benefited by the general prosperity of the country."

However, he noted: "Attention is called to the greater amount of money spent upon the city child than upon the country child." Cousins explained: "It would do the makers of the Republic of Texas, and the founders of the State, gross injustice to interpret their command to mean that one child should have the best advantages for nine or ten months a year and that others, equally capable and as important to the State, should have school facilities for two or three months in each year." The laws made it impossible for small districts and rural communities to build and maintain schools for even six months. "More liberal constitutional provisions are desired by the people."[37]

Ninety-four years later, President Cisneros lamented that rural school students who were best served by TAMUK were coming from this same handicapped educational environment. The MALDEF suit of the 1980s had forced the state of Texas to recognize that public school funding was unequal, especially in rural South Texas. MALDEF had also pushed for more equal funding for higher education. Like all of his predecessors, President Cisneros had joined the ranks of college and university administrators beseeching the legislature for equal funding to best serve a growing academic population. Like President Cousins, President Cisneros advocated reaching out to the economically poor and educationally disadvantaged to help them realize their full academic potential. He sought ways to build strong academic programs, attracting the brightest South Texas students, but continue the open admissions policy that gave all who wanted an education an opportunity to seek and perhaps realize their dreams.[38]

As State Superintendent of Public Instruction, R.B. Cousins had urged development of state teachers colleges and normals.[39] President Cisneros also talked about developing a stronger college of education to train teachers who will return to rural classrooms of South Texas to teach future TAMUK students. And like Cousins—who recognized in 1925 the need to make the school more than a teacher's college— President Cisneros recognized that the school must grow to meet challenges of the new millennium. Cousins sought and won the expansion of the mission of the South Texas State Teachers College to become Texas College of Arts and Industries in 1929. Cisneros is seeking ways to expand programs especially in agriculture, engineering, sciences, and technology. He hopes to bring to the campus more professional schools, perhaps a school of veterinary science and one of pharmacy. He maintains that the school needs to have the highest level of technological training to bring in the very best students. To accomplish this, he believes that it is necessary to listen to the people and to pay close attention to reports such as that of the demographer Steve H. Murdock about challenges ahead.[40]

The changes which took place in the past 75 years have been dramatic. When S.T.S.T.C. opened in 1925, the population of Texas was somewhere between 4,663,228 (1920 census) and 5,824,715 (1930 census). The total number of foreign born and children of foreign born in 1920 was 805,903. The *Texas Almanac* anticipated that when the 1930 figures were released they would "undoubtedly show a decrease in percentage of both foreign born and foreign stock, especially since measures were made effective prior to the 1930 census to restrict movement into

Texas from Mexico."[41] In the last week of 1999, the U.S. Census Bureau announced that Texas's population had exceeded 20 million to 20,044,141—which was an 18 percent increase for the decade, almost double the national rate of 9.6 percent.[42]

In 1920, in the 36 counties that the Committee for the South Texas Normal District included south of the 29th parallel, the population totaled 440,143. Some of the counties have grown modestly over the decades, a few have lost population, and 24 have increased over 100 percent. Growth has been substantial in Cameron, Hidalgo, Nueces, and Webb counties. Some small counties have enjoyed a large percentage increase although their total population is relatively small. By 1998, the 36 counties' population totaled 2,336,418—an increase of 430.83 percent from 1920.[43]

The elementary and secondary scholastic population of Texas in 1925 (students 7 to 18 years of age) was 1,340,083.[44] The scholastic population of Texas in 1990 was 3,606,848.[45] The scholastic population of 1998 was 3,900,488.[46] Projections for 2030, depending upon the rates of population change, could be as high as 5,738,843.[47]

Steve H. Murdock reported in *The Texas Challenge: Population Change and the Future of Texas* that the school-age population at all levels, from elementary through college, is growing at a substantial rate. Growth at the college level between 1970 and 1990 increased 241.9 percent—from 350,668 to 1,199,047 students.[48] Total elementary, secondary, and college enrollment in Texas in 1990 was 4,769,432. Depending upon net migration rates, he projected that continued growth from 1990 to 2030 could be an additional 71.1 percent—to 2,048,966 college students and 7,787,809 total elementary, secondary, and college students.[49] He noted that "the percentage increases are substantially larger than those experienced in the nation."[50] According to Murdock's calculations, the increase of enrollment will continue at a substantial rate and the growth will be characterized by increased ethnic diversity.[51] Murdock's calculations project that in the period from 1990 to 2030 "minority population would account for a majority of growth in enrollments at all educational levels in the state" and "Hispanic students would account for . . . 80.2 percent of the net increase in college enrollment."[52]

Considering the future of education in Texas, Murdock reported that "educational costs will continue to be substantial in the coming years." Growth in education will increasingly involve minority students and specialized programs—especially Bilingual, Chapter One, English as a Second Language, and immigrants programs. Murdock concluded that "Texas will need to employ careful planning in elementary and secondary and in higher education to ensure that it can adequately address the needs for such services. Provision of adequate educational opportunities for all Texans is likely to continue to require extensive attention by the state in the coming years."[53]

Public awareness and concern about challenges for Texas in the twenty-first century can be seen in area newspapers. An alumnus of Texas A&I who was a student activist as an undergraduate, has written in the San Antonio *Express-News* about the condition of education in South Texas and how far the region has come and how far it has to go. "In 1900, only 11 percent of America's 14 to 17-year olds had

attended high school. That percentage grew to 93 percent in 1997." At the beginning of the twentieth century "95,000 Americans graduated from high school and 28,700 obtained a bachelor's degree. By 1997, the number of graduating high school seniors had grown to 2.7 million and 1.2 million received a bachelor's degree." "In the first decade of the 1900s, 2 million Italians and 50,000 Mexicans came to the United States. Between 1991 and 1997, that number had shifted to 1.8 million Mexicans and 54,000 Italians." A San Antonio based education think tank calculated "that 46 percent of African Americans, 28 percent of Anglos and 50 percent of Latinos dropped out of Bexar County's high schools during a four-year period. Overall, our county has lost 44 percent of its high school students in the last four years."[54]

John Sharp's report, *Bordering the Future: Challenge and Opportunity In the Texas Border Region*, concluded: "Two factors—the youth of the Border population and the region's rapid population growth—will increase demands for access to quality higher education in the years ahead." By 2010 more than 52,000 residents of El Paso will be in the college age population, a 54 percent increase form 1997. In South Texas, student enrollment is projected to increase by 30 percent to more than 40,000 by 2010. If projections are correct, the Border region will need more educational facilities in years ahead.[55]

The Statistical Abstract of the United States calculated the change in the number of Hispanic children ages 5 to 17 with difficulty in speaking English. In 1979, 28.7 percent had difficulty speaking English, but by 1995 the percentage had increased to 31.0 percent. The percent who speak another language at home who are Hispanic has increased from 38.2 percent in 1979 to 41.9 percent in 1995.[56] Hispanic students in public schools at the national level have increased from 4,263,000 to 9,032,000 from 1980 to 1997.[57] Census Bureau statistics reveal 4.9 percent of the Mexican-American population over 25 years of age had completed four years of college or more in 1980, but the numbers increased to 7.5 percent by 1998.[58] The statistics are not broken down by gender, but in 1970, 7.8 percent of Hispanic males and 4.3 percent of females (including Puerto Rican, Cuban, and Mexican American) completed four years of college or more.[59]

Implications of the above statistics and Professor Murdock's projections are not just for colleges which will need to accommodate increased numbers of students and especially minority students. The increase in elementary and secondary schools raises the question: Who will prepare the teachers for public schools? The deans of the University of Texas at El Paso College of Science and of the College of Liberal Arts noted: "The education of all children begins in the classroom . . . the classroom in which their teachers are prepared."[60]

In 1999, the American Council on Education challenged colleges and universities in its report "To Touch the Future: Transforming the Way Teachers are Taught." The report is the result of a year's study by the ACE President's Task Force on Teacher Education and is subtitled: *"An Action Agenda for College and University Presidents."* The Task Force concluded: "The single factor that is more powerful than any other in influencing student achievement gains is the quality of the teacher."[61] They found that students who enter secondary school teaching had academic records comparable

to the general students population, but those who became elementary school teachers were below the average in academic capacity. Teachers in general were inadequately prepared to understand and apply technology to teaching. In the next decade there is an unusual opportunity to transform the quality of teachers because schools will need to hire 2.5 million teachers to replace teachers who retire, deal with enrollment increases, and achieve teacher-pupil ratio declines.[62] "Currently, only about two-thirds of newly prepared teachers enter the profession immediately after graduation." Thousands of well qualified teachers leave the profession each year to pursue other careers. "At best, five years after graduation, only half of these teachers will remain in teaching."[63]

Recommendations of the Task Force are based on assumptions that the quality of schools is inadequate for the times, that strengthening the way colleges train teachers is the major approach to improving schools, and college presidents need to take decisive action if higher education is to fulfill its responsibilities. Recommendations of the study include: university presidents should move teacher education to the top of their agenda; presidents should clarify the strategic connection of the preparation of teachers to their institution's mission; presidents and governing boards should establish periodic campus reviews of the quality of teacher education; presidents should require the coordination of education faculty and courses with arts and sciences faculty and courses; presidents should make certain that Teacher Education programs have the faculty, facilities, and equipment to prepare future teachers to use technology; and, presidents should make certain that graduates of their programs are supported, monitored and mentored.[64]

The South Texas State Teachers College began and Texas A&M University-Kingsville continues to fulfill that most vital function for a society—to teach the teachers who teach the children! President Cousins understood that and the American Council on Education understands that. The challenge is as great or even more critical in the dynamic borderlands environment today than it was 75 years ago.

If the current demographic projections are challenging, in 1900 the situation was no less daunting. There was no higher educational institutions south of the 29th parallel. Educators were concerned about the quality of public elementary and secondary education in Texas. Access to the rudiments of education was limited for every child in South Texas—but especially for Mexican-American and African-American children. Young men and women had difficulty obtaining training and certification to become teachers.

Ninety-five years ago, State Superintendent of Public Instruction Robert B. Cousins pointed out that barely one half of the children in Texas attended classes for more than half of the time that they should have been in school. The average number of school days taught was 117.24 compared to 146.7 for the nation. He noted that less than 1 percent of Texas high school students would enter college. That number included only white students in urban areas because little or no high school education was available for students in rural areas and certainly not for minority students. Of 914,000 public school children in the state, only 136,000 had access to

public high school. Of 17,500 public school teachers in Texas, 9000 held teaching certificates which showed that they were not high school graduates.[65]

In 1925, higher education began in South Texas with 114 regular college students in a four year college (S.T.S.T.C.) and 51 students in a Community College (Victoria College) for a total of 165 students.[66] Tabulating statistics from the Texas Higher Education Coordinating Board reveals how far South Texas has come in 75 years. In the fall semester 1997, there were 40,578 students in public colleges and community colleges in South Texas. The profile of these students was 11,072 "white" (27.29 percent), 895 African American (2.21 percent), 27,378 Hispanic (67.47 percent), 358 Asian (.88 percent), 91 American Indian (.22 percent) and 784 International students (1.93 percent). Of the 40,578 students, 23,403 were female (57.67 percent), and 17,175 were male (42.33 percent). The 36 counties of the South Texas Normal District increased from 440,143 population in 1920 to 2,336,418 in 1998; college enrollment has increased from 165 students to 40,578 students. Population has increased by 5.3 times but college enrollment has increased 246 times, or 46 times faster than the population growth![67]

In 1905, Superintendent Cousins reported that the purpose of the University of Texas at Austin was "to furnish men who are going into the pursuits of life with disciplined minds and bodies and with liberal and broad training and ideals, to train lawyers and doctors of high standards, turn out efficient pharmacists, nurses, civil, electrical and mining engineers, and well trained teachers, especially for the high schools and colleges. Above all things, the university aims to make every student who comes here a better citizen."[68] President Cisneros envisions a similar mission to bring the best and brightest from the schools of South Texas to the Kingsville campus where a strong academic program will help them gain the disciplined mind necessary for success in whatever field they eventually enter.[69]

This then would appear to return us to where this account of the history of this university began. The situation of education in South Texas is critical. With dedicated students, inspired teachers, committed administrators, involved citizenry and legislative leadership Texas A&M University-Kingsville and South Texas can carry out the designs of Robert B. Cousins and his founding faculty, staff, and students. Some of his language may sound strange to our ears, and his attitudes seem condescending, but his desire to provide education for the young men and women of South Texas is still relevant and critical.

Today, Texas A&M University-Kingsville faces the same obstacles and problems that they have faced historically: a rural, bilingual, multicultural population with inadequate funding from the state legislature. Now, the state of Texas is facing the same problems that the Kingsville campus has faced for 75 years. If Professor Murdock's projections are correct, Texas faces an increasingly minority and immigrant population which will demand special programs to compensate for past educational deficiencies. With 75 years of experience in dealing with the problems of the future, Texas A&M University-Kingsville rushes into the new millennium prepared by experience.

ENDNOTES

Abbreviations used in Endnotes

Abbreviations were used to keep the citations as concise as possible but give sufficient information to guide other researchers to the documents used.

A&M@K	Texas A&M-Kingsville
CAH	Center for American History, University of Texas, Austin
CC*Caller*	Corpus Christi *Caller*
Cousins Paper	Robert Bartow Cousins Papers, Center for American History
JST	*Journal of South Texas*
KCCH	Kleberg County Court House
KCHCC	Kleberg County Historical Commission Collection
KR	Kingsville *Record*
LBJ	Lyndon Baines Johnson Library, University of Texas, Austin
OPA	Office of Public Affairs
Reg. Sess.	Regular Session of the Texas State Legislature
SA*Express*	San Antonio *Express*
ST	*South Texan*, Student newspaper of Texas A&M-Kingsville
STA	South Texas Archives, James C. Jernigan Library, Texas A&M-Kingsville
TSA	Texas State Archives, Texas State Library and Archives, Austin
UA	University Archives, Texas A&M-Kingsville
34th etc.	34th Legislature of Texas

Chapter One: Creation

1. South Texas State Normal District included counties: Aransas, Bee, Brooks, Calhoun, Cameron, Dimmitt, Duval, Frio, Goliad, Hidalgo, Jim Wells, Jim Hogg, Karnes, Kennedy, Kleberg, La Salle, Live Oak, Matagorda, Maverick, McMullen, Medina, Nueces, Refugio, San Patricio, Starr, Victoria, Uvalde, Webb, Willacy, Zapata, Zavala and parts of Atascosa, Brazoria, DeWitt, Jackson and Wilson counties which were south of the 29th parallel. "Facts Relative to South Texas Normal School District . . .," "Legislative Battle for A&I," A1999–028.014, South Texas Archives. (Hereafter cited as STA.)

Two master's theses deal with the establishment of South Texas State Normal College and are the starting point for this chapter. See: Nettie Lee Kellam, "The History of the Texas College of Arts and Industries," M.A. thesis, University of Texas, 1938; Floy Ashmore Benson, "The Founding of the South Texas State Teachers College, The First Name of the Texas College of Arts and Industries," M.A. thesis, Texas College of Arts and Industries, 1951. The chapter also benefited greatly from the research of Sandra Rexroat on Robert Bartow Cousins.

2. John E. Conner, "The History of Texas College of Arts and Industries 1954," Kleberg County Historical Commission Collection, A1998–023, STA, 2. (Hereafter cited as KCHCC.)

3. Gus Kowalski document, KCHCC, A1998–023.008, STA.

4. Cecilia Aros Hunter and Leslie Gene Hunter (eds.), *Historic Kingsville, Texas: Guide to the Original Townsites* (Kingsville: Kingsville Historical Development Board, 1994), 5–9, 60–65; Kleberg County Historical Commission, *Kleberg County, Texas* (Kingsville: Kleberg County Historical Commission, 1979), 441–454.

5. James Bryant Conant, *The Education of American Teachers* (New York: McGraw–Hill, 1963), 1–14.

6. Conant, *The Education of American Teachers*, 1–14; Charles Athiel Harper, *A Century of Public Teacher Education; The Story of the State Teachers Colleges as They Evolved from the Normal Schools* (Washington, D.C.: Hugh Birch–Horace Mann Fund for the American Association of Teachers Colleges [c1939]).

7. Dewey W. Grantham, *Southern Progressivism: The Reconciliation of Progress and Traditionation* (Knoxville: University of Tennessee Press, 1983), 246.

8. Michael John Dennis, "Educating the 'Advancing' South: State Universities and Progressivism in the New South, 1887–1915," Ph.D. dissertation, Queen's University, 1996, ii; Lawrence A. Cremin, *The Transformation of The School: Progressivism in American Education, 1876–1957* (New York: Alfred A. Knopf, 1961).

9. Guadalupe San Miguel Jr., *"Let All of Them Take Heed": Mexican Americans and the Campaign for Education Equality in Texas, 1910–1981r Education Equality in Texas, 1910–1981* (Austin: University of Texas Press, 1987), 13–25.

Between 1890 and 1910 the influx of Mexicans joining the Tejanos increased the Hispanic population of Texas from approximately 83,000 in 1887 to over 300,000 in 1910. Terry G. Jordan, "A Century and a Half of Ethnic Change in Texas, 1836–1986," *Southwestern Historical Quarterly*, 89 (April, 1986), 394–395.

10. Frederick Eby, *The Development of Education in Texas* (New York: The Macmillan Company, 1925), 312–314.

11. Eby, *The Development of Education*, 293–296.

12. Eby, *The Development of Education*, 218–222; William Seneca Sutton, "Some Wholesome Educational Statistics," *Bulletin of the University of Texas* No. 28 (March 1, 1904), 6–8; R.B. Cousins, *Fifteenth Biennial Report of the State Superintendent of Public Instructions, for the Years Ending August 31, 1905, and August 31, 1906*, (Austin, Texas: Von Boeckmann–Jones Co., Printers, 1906), 11–12.

13. Cousins, *Fifteenth Biennial Report*, 8–11.

14. Cousins, *Fifteenth Biennial Report*, 18–20, 40.

15. R.B. Cousins, "Need of High Schools in Texas," *The Texas Magazine* 1 (April, 1910), 60–61.

16. Cousins, "Need of High Schools," 61–63.

17. Nat Benton, *Two Decades of Educational Progress in South Texas* (Corpus Christi: Corpus Christi Printing, 1923), 1–10.

18. Kellam, "The History," 17; Leslie Gene Hunter, "The Robert J. Kleberg Public Library," *Texas Libraries* 43 (Winter, 1981), 183–189; Cecilia Aros Hunter and Leslie Gene Hunter, "The Fading of an Era," *JST* 2 (Spring, 1989), 29–44; Lisa A. Neely, "And the band played on," *Wellspring*, 10 (Summer, 1998), 8–10.

19. "A History of State," *KR*, July 3, 1929, section 4, 1.

20. "The Tri–County," Alice *Echo*, Dec. 4, 1913, 5; Benson, "The Founding," 9.

21. *JHR*, Reg. Sess., 32nd, 319, 355, 660, 684–686, 711–712, 716, 800, 980, 987, 998; *JHR*, Reg. Sess. 33nd, 1958.

22. *JHR*, Reg. Sess. 34th, 29; "Colquitt's Last Message," *SAExpress*, Jan. 15, 1915, 4.

23. "Normal School," *KR*, Jan. 8, 1915, 1.

24. "Movement Launched," *KR*, Jan. 15, 1915, 1.

25. "History of the ," *KR*, March 26, 1915, 9.

26. Benson, "The Founding," 12–15; "South Texas Normal," *KR*, Jan. 29, 1915, 1.

27. "South Texas Wants," *KR*, Jan. 15, 1915, 8.

28. *JHR*, Reg. Sess. 34th, 156, 287, 1256; *JS*, Reg. Sess. 34th, 140, 209, 230.

29. "South Texas Normal," *KR*, March 19, 1915, 1; Benson, "The Founding," 16–17.

30. *JHR*, Reg. Sess. 34th, 99, 149, 156, 286–287, 595–597, 659, 1041, 1078, 1081, 1141, 1157, 1212–18.

31. "South Texas Normal," *KR*, Jan. 29, 1915, 1.

32. "Governor Will Not," Austin *Statesman*, Feb. 7, 1915, 1–2; "South Texas," *KR*, March 19, 1915, 1; Benson, "The Founding," 18.

33. Eby, *The Development of Education*, 224, 230–231; *JHR*, Reg. Sess. 34th, 132; Carlos Blanton, "The Strange Career of Bilingual Education," Unpublished manuscript, STA, 100–110, 118–129.

34. *JHR*, Reg. Sess., 34th, 140–141, 320, 347, 512, 565–569, 573–579, 660, 803, 879, 883, 988, 1001.

35. Eby, *The Development of Education*, 231.

36. "Mass Meeting," *KR*, March 26, 1915, 3.

37. Flato to Bailey, March 30, 1915, "Correspondence—South Texas Normal," Charles Flato III Papers, A1974–030, STA; "Reasons Why," *KR*, April 2, 1915, 1.

38. "The 'Magic," *KR*, April 23, 1915, 1; "Kleberg County," Brownsville *Herald*, April 20, 1915, 3.

39. "The 'Magic," *KR*, April 23, 1915, 1; "Brownsville Will," Brownsville *Herald*, April 21, 1915, 4.

40. HR, First Called Sess., 34th Legislature, 117, 139, 168.

41. "Gov. Ferguson," *KR*, May 7, 1915, 1; "Gov. Ferguson," *KR*, May 14, 1915, 1; "Normal Locating," *KR*, May 21, 1915, 1.

42. *JHR*, First Called Sess., 34th Legislature, 369, 383–384; "Normal School Bill," Austin *American*, May 14, 1915, 5; "No Normals," *KR*, June 4, 1915, 1.

43. Benson, "The Founding," 21.

44. See, for example: L.H. Warburton, "The Plan of San Diego," *JST* 12 (1999), 125–155.

45. *Kleberg County Texas*, 441; "José Tomás Canales," in Ron Tyler (ed.), *The New Handbook of Texas* 6 vols. (Austin: The Texas Historical Association, 1996), I, 953–954.

46. *JHR*, Reg. Sess., 35th, 94.

47. Benson, "The Founding," 26.

48. *JHR*, Reg. Sess., 35th , 710–712, 765, 833–834, 914, 1194, 1217.

49. Benson, "The Founding," 28; *JS*, Reg. Sess., 35th, 708, 759, 914, 982–983, 1023, 1061.

50. "4 State Normal," SA*Express*, April 5, 1917, 4; "Teacher College," SA*Express*, June 14, 1925, 17.

51. Benson, "The Founding," 29–30.

52. "Kingsville Pulling," Alice *Echo*, March 15, 1917, 1.

53. "Kingsville Merits Your Consideration," 7; "Extract from Speeches: Claude Pollard," NOR–MAL–ITE, [*KR*], July 19, 1917, Reference File, A1983–010, STA.

54. Benson, "The Founding," 33–34; "Kingsville Given," San Antonio *Light*, July 15, 1917, 2.

55. Benson, "The Founding," 34–35; *Kleberg County Texas*, 875.

56. "DEDICATION," NOR–MAL–ITE, [*KR*], July 19, 1917, Reference File, A1983–010, STA; "Caesar Doth Speak," ibid.

57. *JS*, Third called Sess., 35th, 998; A. C. Goeth to Chas. H. Flato, Oct. 12, 1917, "Legislative Battle for A&I," A1999–028.014, STA; "Deed Records of Kleberg County," vol. 7, 566–560, KCCH.

58. *JHR*, First called Sess., 35th, 14.

59. *JHR*, Third Called Sess., 35th, 205, 210, 214, 220–223, 233, 254–258, 266, 269, 273, 278–281–282.

60. *JHR*, Fourth called Sess, 35th, 228, 237.

61. "Summary of vote," "Correspondence—South Texas Normal, 1915–1917," Charles Flato III Papers, A1974–030, STA.

62. "Two Normals," SA*Express*, Feb. 1, 1919, 6; "House Passes," ibid., Feb. 4, 1919, 4; "Passions Roused," Austin *American*, Feb. 26, 1919, in Flato Family Collection, A1997–011.004, STA; Benson, "The Founding," 38–40.

63. "Kingsville Merits Your Consideration," 7; *Kleberg County Texas*, 442; "Urge Building," SA*Express*, Jan. 31, 1919, 4; Ernest W. Hawkes, *How Texas Stood in the First Draft*: University of Texas Bulletin, No. 1913 (Austin: Publications of the University of Texas, 1919).

64. "House Repudiates," SA*Express*, Feb. 9, 1921, 3; Benson, "The Founding," 40–42.

65. Cousins to Dunlap, March 20, 1923, "Correspondence: 1923," Cousins Papers, CAH; "How's The

Port," *CCCaller*, Feb. 3, 1923, 1; "Kingsville Has," ibid., Feb. 3, 1923, 1; Benson, "The Founding," 44–45.

66. Texas Educational Survey Commission, *Texas Educational Survey Report*, vol. 1, Organization and Administration (Austin: Texas Educational Survey Commission, 1925), 236–242.

67. San Miguel Jr., *"Let All of Them Take Heed,"* 25.

68. Cousins to Doyle, April 28, 1923, "Correspondence: 1923," Cousins Papers, CAH; Cousins to Dunlap, Feb. 13, 1923, ibid.

69. *JS*, Reg. Sess., 38th, 169, 321, 897, 919–920, 924,947,1438, 1440, 1460; Eby, *The Development of Education*, 296–297.

70. Cousins to Flowers, Jan. 21, 1926, in "Literary Productions—Robt. B. Cousins—Personal," A1999–024.011, STA.

Chapter Two: Establishment

1. Cousins to Lankford, April 1, 1908, A1999–018.005, Cousins Collection, STA; Joseph Abner Hill, *More Than Brick and Mortar: West Texas State College, 1909–1959* (Canyon: West Texas State College Ex–Students Association, 1959), 10–17, 31–76.

2. Henry Alexander Davis, *The Contribution of Robert Bartow Cousins* (Canyon: West Texas State Teachers College, 1934), 28–29.

3. Cousins letter of resignation, Dec. 20, 1923, "Correspondence: 1923," Cousins Papers, CAH.

4. Quoted in Beatrice Stolterfoht, "The Life and Services to Education of Robert Bartow Cousins," M. A. thesis, University of Texas, 1934, 106.

5. *Announcements and Course of Study*, 1925–26. (Kingsville: S.T.S.T.C., 1925), 1.

6. Hunters (eds.), *Historic Kingsville, Texas* (1994); Cecilia Aros Hunter and Leslie Gene Hunter (eds.), *Historic Kingsville Texas, Volume II* (Kingsville: Kingsville Historical Development Board,1997).

7. Turner to Flato, Oct. 11, 1917, UA, A1999–028.014, STA; Goeth to Flato,Oct. 12, 1917, ibid.; "Deed Records of Kleberg County," vol. 7, 566–570, KCCH.

8. Charles Flato III to Steven Weems, May 9, 1973, interview, STA. The firm was called the Kleberg Town & Development Company.

9. Julie Brandt, "The Main Building," *JST* 6:1 (1993), 105–107; "Miss Cousins," *ST*, Feb. 7, 1964, 1.

10. James N. Krug, "The President's Home," *JST*, 6:1 (1993), 113–120.

11. Conner to Allen, Dec. 8, 1945, "Miscellaneous 1947–1981," A1999–028.021, STA; Benson, "The Founding," 46.

12. Hunter to Henry, May 16, 1997, STA; Henry to Hunter, June 2, 1997, STA; Jay C. Henry, *Architecture in Texas, 1895–1945* (Austin: University of Texas Press, 1993), 144–152.

13. R.B. Cousins, "A Short Visit Among Schools," *Texas School Magazine*, IX (Nov., 1908), 6.

14. Brandt, "The Main Building," 105–108; "Kingsville Normal," *SAExpress*, July 28, 1923, 4; Cousins to Endress, Jan. 23, 1924, "Correspondence: 1924," Cousins Papers, CAH.

15. "Actual Work Begins," *KR*, Sept. 17, 1924, 1.

16. "Dr. Cousins Preaches," *KR*, Dec. 17, 1924, 6; *Announcements and Course of Study*, 1925–1926; "The Town's Duty," *KR*, September 10, 1924, 9; "Duty To Be," *KR*, Sept. 17, 1924, 6; Robt. J. Eckhardt," *KR*, Sept. 17, 1924, 8; "Housing Situation," *KR*, Jan. 28, 1925, 1.

17. George O. Coalson, speech March 21, 1975, Coalson Collection, "South Texas State Teachers College," STA; Ben F. Wilson Jr. to Cecilia Aros Hunter, Dec. 11, 1999, interview.

18. "A History of State," *KR*, July 3, 1929, section 4, 1; "Untitled," 1913 and 1917 and 1924–25 Reference File—University History, STA; "Teacher's College Head Renamed," *SAExpress*, June 14, 1925, 17; *JHR*, Reg. Sess., 35th, 1381–1382; Benson, "The Founding," 49.

19. "College Registrations," *KR*, June 10, 1925, 1.

20. "Untitled," 1913 and 1917 and 1924–25 Reference File—University History, STA; "College Faculty," *KR*, Sept. 1, 1926, 1.

21. Ibid; *Announcements and Course of Study*, 1925–1926 *Catalog*, 5–7.

There were 26 members of the faculty, including summer normal faculty, in the first summer session, 1925: Harper Allen, L. G. Allen, Miss Frances Alexander, Lila Baugh, J. D. Bramlett, L. F. Connell, J. E.

Conner, Miss A. K. N. Craig, Mrs. May H. Dickens, A. H. Engle, Dr. W. A. Frances, Miss Anne Hibbits, Miss Helen Mar Hunnicutt, Miss Mattie B. McLeod, J. M. Mommeny, Dr. J. L. Nierman, E. A. Perrin, C. F. Reed, Charlie Sherman, Miss Jennie L. Splawn, Mrs. Ema G. Stewart, Mrs. Frances Volck, M. B. West, and Miss Lillian Wheat. The Secretary was Miss Leona Hoop, the Librarian Miss Ann L. Kirven, and the Business Manager, Mr. R. E. May. The South Texas Sate Teachers College, *Announcements and Course of Study*, 1925–26. There are conflicting lists of who is on the faculty in "Faculty Lists, 1925," John Conner Family Collection, A1982–023, South Texas Archives, STA.

22. Edith Blair Cousins, "Robert Bartow Cousins, Life, Labor, Appreciations," Unpublished manuscript in "Literary Productions—Robert B. Cousins—Personal," A1999–018.011, STA, 1–9; "Robert Bartow Cousins," *New Handbook of Texas*, II, 375; "Pres. Cousins Given," *KR*, July 7, 1926, 4.

23. Cousins, "Robert Bartow Cousins," 10–13; "Death Unexpectedly," *ST*, March 12, 1932, 1, 4.

24. Davis, *The Contribution of Robert Bartow Cousins*, 18; Hill, *More Than Brick and Mortar*, 179–180; Stolterfoht, "The Life and Services," 13–20; "Gen. Ralph P. Cousins," New York *Times*, March 16, 1964, 31.

25. Cousins, "Robert Bartow Cousins," 11–32; Kellam, "The History," 19, 35. For Progressive educators and "community" system, see Blanton, "The Strange Career of Bilingual Education," 68–70, 95–100, 131–138.

26. Davis, *The Contribution of Robert Bartow Cousins*, 21–23; Cousins, "A Short Visit," 5–7.

27. Cousins, "A Short Visit," 7.

28. Cousins, "Robert Bartow Cousins," 32–43; Kellam, "The History," 35.

29. Kellam, "The History," 34; Marshall to Cousins, Jan. 6, 1921, in "Correspondence, 1921," Cousins Papers, CAH; Flowers to Cousins, Jan. 8, 1921, ibid; Eckhardt to Cousins, Jan. 19, 1921, ibid.

30. "Dr. Cousins Leaves," *ST*, Nov. 5, 1965, 2.

31. Baugh to Cousins, Dec. 24, 1924, in "Correspondence, Nov. 1924–1926," Cousins Papers, CAH; Bruce to Cousins, Jan. 15, 1925, ibid; Dickens to Cousins, May 10, 1925, ibid; "Untitled," 1913 and 1917 and 1924–25 Reference File—University History, STA.

32. Charles Flato III to Steven Weems, May 9, 1973, interview, STA; Cousins to Cousins, July 20, 1925, "Correspondence: 1925," Cousins Papers, CAH.

33. J.E. Conner, Unpublished manuscript, A1999–015.034, STA, 52–53.

34. John E. Conner was on the first faculty of S.T.S.T.C. in 1925 and died at age 105, in September 1989 the same week that A&I became part of the Texas A&M system. "John E. Conner dies at 105," *ST*, Sept. 8, 1989, 1.

The 1926 *El Rancho* shows 11 men and 10 women faculty members (not counting Registrar, Business Manager, Librarian, *Cataloguer*, and President's Secretary). The 1925 catalog, with some names written in, includes 14 men and 11 women. The 1927 summer catalog shows 26 men and 23 women. *El Rancho*, 1926; *Announcements and Course of Study*, 1925–1926, 7–8; ibid., 1926–1927, 5–7; ibid., *1927 Summer School*, 7–11.

35. Davis, *The Contribution of Robert Bartow Cousins*, 99.

36. *Announcements and Course of Study*, 1925–26, 17–32.

37. "President's Report," in "Literary Productions—Robert B. Cousins—Personal," A1999–018.011, STA. This was printed in *Eighth Biennial Report of the Board of Regents*, UA, A1998–012, STA, 39–43.

38. *Announcements and Course of Study*, 1925–26, 13.

39. Conner, Unpublished manuscript, 63.

There were 114 students listed as regular college students in the Registrar's Records but 116 listed as regular students in the first catalog. Three are in the catalog, but not on the Registrar's roll (Janie Colston, Ella Goforth, and Jewell Magee) and one is on the Registrar's list but not in the catalog (Mary Norton). Registrar's Office, "Local Reports, 1925–1933," UA, A1999–002, STA; *Announcements and Course of Study*, 1925–26, 90–92.

40. *Announcements and Course of Study*, 1925–26, 17, 23.

41. Registrar's Office, "Local Reports," STA.

42. Ibid., 91–96; "President's Report," in "Literary Productions—Robert B. Cousins—Personal," A1999–018.011, STA.

43. Neely, "And the band played on," 8–10; Untitled photograph by J. W. Gardner, Pharr, Texas of Band Trip to Valley July, 1925, King Ranch Archives, Kingsville, Texas.

44. "President's Report," in "Literary Productions—Robert B. Cousins—Personal," A1999–018.011, STA.

45. Bartlett to Conner, June 3, 1929 Conner Collection—Correspondence, 1927–1941, A1982–023, STA. This chapter and others are especially dependent for traditions upon Eden J. Straw, "Texas A&I Campus Traditions, 1925–1996," JST 10:1 (1997), 121–136.

46. "College Mascots," ST, Aug. 31, 1926, 1.

47. "College Mascots," KR, Sept. 1, 1926, 5.

48. "College Professor," KR, Sept. 15, 1926, 2; "Baby Run Over," ST, Nov. 2, 1926, 1.

49. "Dr. Cousins ," ST, Sept. 28, 1929, 1.

50. Cousins to Cousins, Oct. 17, 1929, "Correspondence: 1929," Cousins Papers, CAH; Cousins to Mother, Oct. 18, 1929, ibid.

51. Edith Cousins interview by Vance Shaw, Reference File: Texas A&I History, STA.

52. "A&I mascot bold," ST, Sept. 13, 1974, 2.

53. "Annual Staff Busy," ST, Nov. 18, 1925, 1.

54. "History Club," El Rancho 1926, [Organization section, 3].

55. El Rancho, 1926, 1927, 1928. Information is scattered in organizations sections, unnumbered pages.

56. El Rancho, 1926, 1927, 1928; Engle to Cousins, May 6, 1926, "Correspondence: 1926," Cousins Papers, CAH. The information is scattered in organizations sections, unnumbered pages.

57. "Untitled," ST, Dec. 16, 1925, 2, col 1.

58. "Agriculture Plans," ST, Dec. 2, 1925, 1; ,"Untitled," 1913 and 1917 and 1924–25 Reference File —University History, STA.

59. "College Secures," KR, Sept. 1, 1926, 4.

60. "Untitled," 1913 and 1917 and 1924–25 Reference File—University History, STA; "42 Citrus Arrive," ST, March 2, 1926, 1; "Warren Sets Out," ST, Feb. 8, 1927, 1.

61. "Miss Dobrandt," ST, Jan. 6, 1926, 1; "Librarian Using," ST, Jan. 20, 1926, 1; Joe Bill Lee, "A History of the Library of Texas College of Arts and Industries, 1925–1955," MLS thesis, University of Texas, 1958, 27–31, 40, 45.

Library expenditures averaged 3.76 percent of total yearly expenditures from 1934 to 1960. Fred L. Connell, Jr., "A Brief Historical Analysis of Income–Expenditure Patterns of Texas College of Arts and Industries," M. A. thesis, Texas College of Arts and Industries, 1961, 132.

62. "College Library One," KR, Dec. 22, 1926, 3.

63. Cousins to Flowers, Jan. 21, 1926, " in "Literary Production—Robert B. Cousins—Personal," A1999–018.011, STA; "President's Report," ibid; "Board of Regents," KR, Jan. 27, 1926, 1.

64. El Rancho, 1926, 1927, 1928. Information is scattered in athletic sections, unnumbered pages.

65. "A&I's First Coach," ST, Nov. 5, 1965, 3.

66. El Rancho, 1926, 1927, 1928. Information is scattered in athletic sections, unnumbered pages; "Baseball Opens–Victory," ST, April 13, 1926, 1; "Tennis Popular," ibid.

67. "Dora K. Cousins," ST, April 13, 1926, 1.

68. "First South Texas," ST, April 27, 1926, 1.

69. "Cousins recalls," ST, March 21, 1975, 4.

70. Cousins to Flowers, Jan. 21, 1926, " in "Literary Productions—Robert B. Cousins—Personal," A1999–018.011, STA; Ludlam to Cousins, July 13, 1925, "Correspondence: 1925," Cousins Papers, CAH.

71. El Rancho ["Features" and "Our Campus" sections] 1927; "A&I Housemothers," ST, Oct. 30, 1943, 2; "Dawson House," ST, March 22, 1947, 1; "East Campus," ST, Jan. 7, 1950, 1; Aurora Garza to Leslie Gene Hunter, Aug. 21, 1999, interview.

72. "Depression Idea," ST, July 19, 1963, 1, 3.

73. "Untitled," 1913 and 1917 and 1924–25 Reference File—University History, STA.

74. "College and City," ST, Feb. 3, 1926, 1; "S.T.S.T. College," KR, Feb. 3, 1926, 9.

75. Cousins, *Fifteenth Biennial Report*, 19.

76. "Education Dep't," *ST*, Oct. 26, 1926, 1; "College Experiments," *KR*, Nov. 3, 1926, 15.

77. *Texas Educational Survey Report*, vol. 1, 236–245; ibid., vol. 5, 9.

78. "Education Department," *ST*, July 20, 1926, 1.

79. "Stephen F. Austin Elementary School," Hunters (eds.), *Historic Kingsville, Texas* (1994), 88.

80. "Nadine Brown Appointed," *ST*, Jan. 25, 1927, 1.

81. Herschel T. Manuel, *The Education of Mexican and Spanish–Speaking Children in The Education of Mexica* (Austin: The Fund for Research in the Social Sciences, The University of Texas, 1930), 134–139, 150–159.

College catalogs listed class at first as "Method of Teaching English to Foreign Children" but by 1935 it became "Methods of Teaching English to Non–English–Speaking Children." It is Bilingual Education 3325 with the same name in catalog for years 1999–2002.

82. Cousins to Rogers, Sept. 20, 1927, "Correspondence: 1927," Cousins Papers, CAH.

83. Scott to Cousins, Oct. 22, 1928, "Correspondence: 1928," Cousins Papers, CAH; Scott to Cousins, Sept. 21, 1929, "Correspondence: 1929," ibid.

84. English-Only emphasis led to state legislation in 1918 which had a chilling effect on language teachers and ethnic communities. It was applied inconsistently to younger Mexican American children than to older Anglo children learning a foreign language. Blanton, "The Strange Career of Bilingual Education," 117, 206–212, 239–245.

85. *A and I Student Hand Book* [Kingsville: Texas College of Arts & Industries, no date, but after 1932], A1986–035, STA, 12.

86. *Announcements and Course of Study*, 1925–1926, 90–96; "College Attendants," *KR*, June 4, 1930, 1; "Men Now," *ST*, Oct. 12, 1935, 1.

In 1922–23, 80.8 percent of Texas teachers were female and in 1923–24, 79.1 percent were female. Dallas *Morning News, Texas Almanac and State Industrial Guide*, 1926 (Dallas, A. H. Belo & Company, 1926), 102.

87. *A and I Student Hand Book* [no date, but after 1932], A1986–035, STA, 17–18, 22; *Announcements and Course of Study*, 1925–1930, 36–38.

88. Davis, *The Contribution of Robert Bartow Cousins*, 99–100.

89. "Committee Asks," *ST*, March 2, 1926, 1; "Rooms Wanted," *KR*, May 26, 1926, 10; "Visiting Students," *KR*, June 9, 1926, 2; "The Housing Problem," *KR*, May 11, 1927, 10.

90. "Board of Regents," *ST*, May 25, 1926, 1.

91. Ibid; "Gov. Ferguson," *KR*, March 24, 1926, 1, 12; "Board of Regents," *KR*, May 19, 1926, 1; "Suits Us," *KR*, July 28, 1926, 10.

92. "Work Begun," *ST*, Dec. 21, 1926, 1; *Announcements and Course of Study*, 1925–1926, 14.

93. "Basketball Season," *ST*, Jan. 14, 1928, 1; Henry to Hunter, June, 2, 1997, STA; "New Athletic," *ST*, Jan. 16, 1967, 4..

94. "Natatorium to Open," *ST*, July 14, 1928, 1; "Physical Exam," *KR*, Aug. 1, 1928, 1.

95. Cousins to "sweethearts," Nov. 29, 1927, "Correspondence: 1927," Cousins Papers, CAH; Cousins to "sweethearts," Dec. 2, 1927, ibid; "S.T.C. Admitted," *KR*, Dec. 12, 1928, 6; "A History," *KR*, July 3, 1929, section 4, 5.

96. The first student to register at the College was Ema O'Dell Stewart, who graduated in the last class of S.T.S.T.C. in August, 1929. She was a principal of a junior high school in Houston. The second student, first male student to register in 1925, was Porter S. Garner who became the Superintendent of schools in Premont and then the second President of Victoria Junior College. "College Students," *ST*, May 31, 1927, 1; S.T.S.T.C. Ex–Students," *ST*, June 30, 1928, 1; "Students to Receive," *ST*, Aug. 17, 1929, 1.

97. Registrar's Office, "Local Reports," STA.

A graduate student incorrectly identified Humberto Gonzales, a transfer from A&M as first to graduate from Texas A&I in 1927 based upon a photograph in the yearbook of the senior class. Seventeen students wore graduation robes in yearbook, but the *ST* only mentioned eight unnamed students graduated. Eleazar M. Paredes, "The Role of The Mexican American in *Kleberg County, Texas*

1915–1970," M. S. thesis, Texas A&I University, 1973, 24; *El Rancho*, 1927, [Senior section, 6]; "College Confers," *ST*, May 31, 1927, 1.

98. Cousins to Kelly, July 18, 1927, "Correspondence: 1927," Cousins Papers, CAH.

99. Hill to Cousins, Sept. 27, 1925, "Correspondence: 1925," ibid.; Martin to Cousins, Oct. 13, 1925, ibid; Marquis to Cousins, March 27, 1926, "Correspondence: 1926," ibid; Estill to Cousins, March 29, 1926, ibid; Cousins to Kelly, Jan. 10, 1928, "Correspondence: 1928," ibid; Cousins to Kelly, Jan. 11, 1928, ibid; Horn to Cousins, "Correspondence: 1928," Aug. 4, 1928, ibid.

100. R.B. Cousins," The Advancement of Education in South Texas," *Texas Outlook* XII (Jan. 1928), 19–21; "South Texas C. of C.," *KR*, Aug. 11, 1928, 1; Stolterfoht, "The Life and Services," 117–120; "South Texas Tech.," *KR*, Dec. 12, 1928, 1; "Senator Archie Parr," *ST*, Jan. 12, 1929, 1; "Building Blox," *KR*, June 1, 1930, 1.

101. *Kleberg County, Texas*, 442.

102. "T.C.A.I. New," *ST*, Jan. 26, 1929, 1; "College Bill," *KR*, March 13, 1929, 1; "Ed Erard," *KR*, Oct. 16, 1963, 1, 7B; *General and Special Laws of the State of Texas*, Reg. Sess., 41st, 627–630; *JS*, Reg. Sess., 41st, 180, 234, 312, 353–354, 383, 1249, 1257, 1263; Bramlette to Cousins, Feb. 5, 1929, "Correspondence: 1929," Cousins Papers, CAH.

103. Flowers to Cousins, March 16, 1929, ibid.; "A History," *KR*, July 3, 1929, section 4, 1, 5; "Governor Moody," *KR*, April 3, 1929, 1; "Ed Erard," *KR*, Oct. 16, 1963, 1, 7B.

104. "Elmore Constructing," *ST*, April 20, 1929, 1.

105. "New H. E. Cottage," *ST*, Feb. 23, 1929, 1.

106. "History of A&I," *ST*, April 17, 1943, 3; "And Though the Years," *ST*, March 11, 1944, 2.

107. "Lantana Ladies," *ST*, July 20, 1929, 1; "Lantana Adopted," *ST*, April 6, 1929, 2; "Lantana Ladies," *El Rancho*, 1929, 78.

108. "Let's Call Our," *ST*, May 4, 1929, 1.

109. "South Texas Educator," *KR*, Sept. 25, 1929, 1; "When the Doors," *KR*, Sept. 25, 1929, 1.

Chapter Three: Building

1. "T.C.A.I. New," *ST*, Jan. 26, 1929, 1; "Tech College," *ST*, March 9, 1929, 1; *General and Special Laws of the State of Texas*, Reg. Sess., 41st, 627–630; *JS*, Reg. Sess. 41st, 180, 234, 312, 353–354, 383, 1249, 1257, 1263. This chapter benefited greatly from the research of Sandra Rexroat on Robert Bartow Cousins.

2. *Kleberg County, Texas*, 443; "Governor Moody," *KR*, April 3, 1929, 1; "Ed Erard," *KR*, Oct. 16, 1963, 1, 7B.

3. "A History, " *KR*, July 3, 1929, section 4, 1, 5; "Governor Moody," *KR*, April 3, 1929, 1.

4. Cousins to Cousins, Feb. 24, 1930, "Correspondence: 1930," Cousins Papers, CAH.

5. R.B. Cousins, "The College," manuscript, A1999–018.011, STA; "The College," *ST*, April 6, 1929, 1.

6. "The South Texas State Teachers College," A1999–028.018, 6, STA; J. E. Conner, Publicity Committee document in "Literary Productions—Robert B. Cousins—Personal," A1999–018.011, STA; "Provisions of Our," *KR*, April 10, 1929, 2, 7.

7. "School Funds," *ST*, July 20, 1929, 1. In 1934 there were some renovations and additions to the Health Science building. See "Health Education Bldg, 1935," UA, A1992–036.004, STA.

8. R.B. Cousins, "Address To New Directors," A1999–028.014, STA.

9. "T.C.A.I. Celebrated," *ST*, April 6, 1929, 6.

10. "Lets call Our,"*ST*, May 4, 1929, 1.

11. "Southern Association," *ST*, Dec. 9, 1933, 2; Seale to Conner, June 2, 1932, President E. W. Seale, 1932–1934, John Conner Family Collection, A1982–023.

12. Cousins to Hooper, Jan. 20, 1932 in "Board of Directors of Texas A&I University, 1930–1955," Conner Family Papers, A1982–023, STA; "A.& I. Admitted," *ST*, Dec. 9, 1933, 1.

13. "A.& I. Admitted," *ST*, Dec. 9, 1933, 1.

14. "Students Nos. 1," *ST*, July 20, 1929, 1.

15. "Fifteen Javelinas," *KR*, Dec. 16, 1925, 1; "Javelinas Receive," *KR*, Feb. 15, 1928, 3.

16. *El Rancho*, 1932 [Athletic Section]; "Texas Inter–Collegiate," *ST*, Dec. 3, 1932, 1.

17. "Toughest Little Team," *ST*, Oct. 19, 1962, 1; "The Sporting Pulse," Boston *Evening Transcript*, Feb. 6, 1933 in Scrapbook "Education in S. Texas," in University Archives–Legislative Battle for A&I, UA, A1999–028.014, STA.

18. J.A. Butler, "Report to the Athletic Committee of the Association of Texas Colleges on Athletic Conditions in the College of Texas, Section III—Texas Intercollegiate Athletic Association," (Chicago: National Amateur Federation of America, [1932]), 133–135, in "Correspondence Personal & Professional Pres. Seale," A1989–008, STA.

19. "A.& I. Enters," *ST*, Dec. 22, 1934, 1; *El Rancho*, 1935, [October 26th game, Athletic Section]; "Hogs Smash Lobos," *ST*, Oct. 27, 1934, 1.

20. *El Rancho*, 1934, 1935, 1936, 1937, 1938, 1939 [Athletic Section].

21. *El Rancho*, 1935 [Athletic Section]; "Barnes in Hospital," *ST*, Nov. 10, 1934, 2; "Barnes Condition," *ST*, Nov. 17, 1934, 1; "Allen Barnes," *ST*, Nov. 24, 1934, 1.

22. *El Rancho*, 1935, 1936, 1937, 1938 [Athletic Section]; "Know Your Javelinas," *ST*, Sept. 29, 1934, 5; "Hogs Wind," *ST*, Nov. 20, 1937, 5; "Five Men on," *ST*, Nov. 20, 1937, 5; "A&I Javelinas," *ST*, Dec. 4, 1937, 3; Paredes, "The Role of the Mexican American," 24; Fred Nuesch to Leslie Hunter, July 31, 1999.

23. Fred Nuesch, "The Steinke Years: Profile of a Coach," *The Tusk*, vol. 4, no. 1 (May 1973), 8; Otis Malvin Montgomery, *Who Me? Stories From a Charmed Life* ([Austin: Otis Malvin Montgomery, 1993]), story 30 [unnumbered pages]; *El Rancho* 1941 ["Season's Honors to . . ." section, unnumbered pages]; *El Rancho* 1942 ["Javelinas of 1941" section, unnumbered pages].

24. Nuesch, "The Steinke Years," The Tusk, vol. 4, no. 1 (May 1973), 8.

25. "College Song," *ST*, March 9, 1929, 1; "History of A&I," *ST*, April 17, 1943, 3.

26. "Fight Song," *ST*, Oct. 30, 1937, 1.

27. Various issues of the *El Rancho*.

28. *El Rancho*, 1932, 183.

29. "Registration For Summer," *ST*, June 18, 1932, 1.

30. "Men Now In Majority ," *ST*, Oct. 12, 1935, 1.

31. Julie Leininger Pycior, *LBJ & Mexican Americans: The Paradox of Power* (Austin: University of Texas Press, 1997), 30–35; Registrar's Office, "Local Reports," STA; Robert R. McKay, "Mexican Repatriation From South Texas During the Great Depression," *JST*, 3 (Spring, 1990), 1–17; Nora E. Ríos McMillan, "The Repatriation of Mexicans During the Great Depression," *JST* 11 (Spring, 1998), 44–73. See also: Abraham Hoffman, *Unwanted Mexican Americans in the Great Depression* (Tucson: University of Arizona Press, 1974).

32. *Catalogue of The Texas College of Arts and Industries*, 1934–1935, 8; Ibid., 1937–1938, 10; Ibid., 1938–1939, 10; Ibid., Summer School, 1941, 33; Ibid., Summer School, 1942, 40; Ibid., 1941–1942, 9; Ibid., 1943–1944, 9.

33. "Average Salary," *ST*, April 13, 1935, 1; "Kingsville Began," *KR*, Oct. 6, 1954, 1C.

34. "Real Farm Program," *ST*, Sept. 29, 1934, 6.

35. "Vocational Teacher Training," *ST*, Sept. 29, 1934, 6.

36. "Stock Show," *ST*, Nov. 18, 1939, 1.

37. *Catalog of Texas College of Arts and Industries*, 1930, 40.

38. "Engineers To Install," *ST*, April 13, 1935, 1.

39. "Kingsville Began," *KR*, Oct. 6, 1954, 1C.

40. "Engineers To Install," *ST*, April 13, 1935, 1; "Smith speaks," ibid.

41. "Kingsville Began Move," *KR*, Oct. 6, 1954, 1C.

42. Frank H. Dotterweich Biography, "Chair History," Frank Dotterweich Collection, A1996–030.008; "Gas Engineering," *ST*, Oct. 28, 1950, 1; "Johns Hopkins Graduate ," *ST*, Sept. 25, 1937, 2. For forty years, research papers of Dotterweich's students were bound as "A&I Engineering Reports," 1938–1977, UA, A1996–030, STA.

43. "Death Unexpectedly Claims," *ST*, March 12, 1932, 1; "Funeral Service," ibid; "Dr. Nierman Pays Homage," ibid; "Heritage Group,'" ibid, Oct. 16, 1954, 1; *JS*, Third Called Sess., 42nd, 219; "Dr. Cousins' Educational," *SAExpress*, March 6, 1932, 10A.

44. Krug, "The President's Home," 117–118.

45. "Liberty Ship Launched," Rosenberg *Herald*, July 21, 1944, 1.

46. "Address by E.W. Seale," June, 1932, President E.W. Seale, 1932–1934, John Conner Family Collection, A1982–023.

47. "Story of College," *ST*, Dec. 10, 1932, 1; Scrapbook "Education in S. Texas," in University Archives–Legislative Battle for A&I, UA, A1999–028.014, STA; "Kingsville Began," *KR*, Oct. 6, 1954, 1C.

48. "Total Appropriations for Texas College of Arts and Industries For Years Ending August 31," in "P.W.A. Project 2099 (1926–1939)," UA, A1992–036.001, STA. See also: Fred L. Connell, Jr., "A Brief Historical Analysis of Income–Expenditure Patterns of Texas College of Arts and Industries," M. A. Thesis, Texas College of Arts and Industries, 1961, 77–87.

49. Seale to Kleberg, Sept. 30, 1932, in "Correspondence Personal & Professional Pres. Seale," A1989–008, STA.

50. "PWA Approves," *KR*, July 14, 1932, 1.

51. "Unexpected Death," *ST*, July 7, 1934, 1.

52. "President Seale," *ST*, July 7, 1934, 1.

53. Robert Dallek, *Lone Star Rising: Lyndon Johnson and His Times 1908–1960* (New York: Oxford University Press, 1991), 122–123; Robert A. Caro, *The Years of Lyndon Johnson: The Path to Power* (New York: Alfred A. Knopf, 1982), 338–339; "Heads N.Y.A.," *ST*, Aug. 17, 1935, 2.

54. Dallek, *Lone Star Rising*, 125–132.

55. "$300,000 For," *ST*, July 7, 1934, 2.

56. "Directors Name," *ST*, March 23, 1935, 1.

57. "Ibid.; Excavation Begun," *ST*, March 2, 1935, 1; "Boys Occupy," *ST*, Sept. 28, 1935, 1.

58. "Texas A&I Boasts," *ST*, Nov. 23, 1935, 1.

59. "Javelinas Occupy," *ST*, Oct. 16, 1937, 1.

60. "Westervelt Lumber," *ST*, May 21, 1938, 1; Kellam to Lull, Sept. 15, 1938, in "Administrative Reports: July–Dec., 1938," National Youth Administration, 1935–1938," LBJ.

61. "Co-Operative House," *ST*, Jan. 7, 1939, 1; "N.Y.A. Project," *ST*, May 28, 1938, 1.

62. Ibid. By 1939 there were seventy–five part–time training centers in Texas and twelve full–time training centers, one of which was the Agricultural Engineering project at Texas College of Arts and Industries. Edwin William Knippa, "The Early Political Life of Lyndon B. Johnson, 1931–1937," M.A. thesis, Southwest Texas State College, 1967, 73–74. See also the monthly reports in the "Administrative Projects" and "Administrative Reports," National Youth Administration, 1935–1938, LBJ.

63. "30 Sub College," *ST*, Nov. 18, 1939, 1.

64. Carol A. Weisenberger, *Dollars and Dreams: The National Youth Administration in Texas* (New York: Peter Lang, 1994), 141.

65. "107 Students," *ST*, July 17, 1937, 1.

66. "65 Students Living," *ST*, Nov. 18, 1939, 2.

67. For the model farm and homemaking cottage see: "P.W.A. Project – Farm Cottage," UA, A1992–036.003, STA. For the tennis courts, sidewalks, dairy barn, and palm trees, see: "W.P.A. 1936–1938," UA, A1992–036.006, STA. For an overview of federal agency projects, see: "Texas College of Arts and Industries Appraisal Report," in "W.P.A., 1936–1938," UA, A1992–036.006, STA. "For an overview and the stadium, "Texas College of Arts and Industries 1934 to 1941," in "E. N. Jones, 1942–1948," Conner Family Collection, A1982–023, STA, "Stands for Stadium Among Improvements for Campus During the Year," *ST*, Feb. 12, 1938, 1.

68. "Governor's Aid," *ST*, Jan. 18, 1936,1.

69. "A.& I. One of Four," *ST*, Sept. 23, 1939, 6; *Catalogue of The Texas College of Arts and Industries 1937–1938*, 124.

70. "Papering On H.E.," *ST*, May 9, 1936, 1.

71. *Catalogue of The Texas College of Arts and Industries 1937–1938*, 19.

72. Loftin to Kleberg, Nov. 15, 1938, in "P.W.A. Project 2099 (1926–1939)," UA, A1992–036.001, STA.

73. West to Loftin, Aug. 4, 1938, ibid; Johnson to Fore, Aug. 13, 1938, ibid.; Johnson to Bull, Aug. 5, 1938, ibid; Thoron to Loftin, Apr. 28, 1939, ibid.; Clark to Loftin, Sept. 11, 1939, ibid.

74. Joe E. Brown," A Brief Analysis of the Financial History of the Dormitories of The Texas College of Arts and Industries," M. A. Thesis, Texas College of Arts and Industries, 1941.

75. "$200,000 Science," *ST*, June 12, 1937, 1.

76. "Cornerstone of College," *ST*, April 2, 1938, 1.

77. "We Are Hosts," *ST*, March 26, 1938, 4.

78. "Governor on Cornerstone," *ST*, March 26, 1938, 1; "Progress of Texas," *ST*, April 9, 1938, 1.

79. "A. & I. Praised Highly," *ST*, April 23, 1938, 1.

80. *El Rancho*, 1926 [Organization section].

81. "Music Contest," *ST*, April 4, 1931, 1; "Death Claims," *ST*, Nov. 11, 1931, 1; "Mr. Engle," *ST*, Nov. 11, 1931, 2; "Professor A.H. Engle," *ST*, Nov. 11, 1931, 2.

82. "Amos H. Engle," *ST*, Nov. 11, 1931, 3.

83. *Catalog of the Texas College of Arts and Industries*, 1939, 21.

84. Graduate Council Meeting Minutes, Oct. 8, 15, 1935, Office of Graduate Studies, Texas A&M University; "Graduate School Starts," *ST*, May 16, 1936, 1.

85. Lucy Rose Chamberlain, "Low sixth grade, Laredo, Texas, age and achievement retardation with possible causes," M.A. thesis, Texas College of Arts and Industries, 1937; Harold Owen Brown, "The Building of the Texas–Mexican Railroad," M.A. thesis, Texas College of Arts and Industries, 1937.

86. "Federal Authorities," *ST*, Oct. 12, 1935, 1.

87. *Catalog of The Texas College of Arts and Industries*, 1937, 118. Ibid., June 1939, 123. The Military Science classes remained the same and the Military Science program stayed in the Department of History and Government until the 1952–1953 catalogue.

88. "Artillery Unit," *ST*, June 19, 1937, 1.

89. "Loftin Receives Application," *ST*, Aug. 12, 1939, 1.

90. "CAA Training To," *ST*, Nov. 4, 1939, 1.

91. "The Texas College of Arts and Industries," Reference File: Texas A&I University History. STA.

92. "117 Officers and Men Mobilized In Kingsville Unit," Battery "F" News, Dec. 25, 1940, 1 in Reference File: "Kingsville, TX—National Guard Unit, Battery 'F,' 133rd FA," STA; Initial Roster in "Battery F," Ben F. Wilson Jr. Collection, UA, A2000–003.001, STA; "Kingsville National Guard unit," in "Battery F," UA, A2000–003.002, STA; "National Guard call," *ST*, Oct. 12, 1940, 1.

93. "President J.O. Loftin," *ST*, July 18, 1941, 1; "Loftin Named," *ST*, Aug. 16, 1941, 1.

94. "New President," *KR*, Aug. 29, 1934, 1; "Loftin Named," *ST*, Aug. 16, 1941, 1; "James Otis Loftin," *The New Handbook of Texas*, IV, 262.

95. *El Rancho*, 1939, unnumbered page with President Loftin's portrait.

96. "Reflections on Early Life at A&I," *The Tusk*, (Spring, 1987), [5].

97. "President J.O. Loftin," *ST*, July 18, 1941, 1.

98. "'The Charge' Delivered ... Dec. 12, 1942," at Kingsville, Reference File: Texas A&I – History. STA.

99. "Statement and Announcement ... March 12, 1942," Reference File: Texas A&I History. STA.

100. Patterson to Flato III, Oct. 13, 1942, Charles Flato, III Papers, A1981–025.003, STA.

101. Flato III to Patterson, Dec. 11, 1942, Charles Flato, III Papers, A1981–025.003, STA.

102. Jones to Flato III, Nov. 26, 1942, Charles Flato, III Papers, A1981–025.003, STA.

103. Jones to the Executive Secretary of the Lulacs, Aug. 28, 1942, Charles Flato, III Papers, A1981–025.003, STA; Bess Hal Yakey, "A&I's New Dean of Women," *ST*, March 15, 1941, 1.

104. Nine leave teaching staff," *ST*, Sept. 16, 1942, 1

Chapter Four: Trial and Triumph

1. Marie Bennett Alsmeyer, "Memories of Texas A&I–Kingsville—1941–42," with Marie Bennett Alsmeyer to Cecilia Hunter, Aug. 3, 1999, A1999–032, STA.

2. Professor Montgomery became Lieutenant (j.g.) on the staff of Chester Nimitz, commander–in–chief of the Pacific Fleet. "Lieut. Montgomery," *ST*, Feb. 20, 1943, 1.

Holmes joined Army Air Corps and returned to the campus after the war to become a faculty member in the Journalism Department and Director of the University News Service. "Airman

Holmes," *ST*, Feb. 27, 1943, 1.

3. "President Jones Speaks," *ST*, June 6, 1942, 1.

4. *Bulletin of The Texas College of Arts and Industries Catalog*, 1942–1943, 17; "Miss Hunt Still," *ST*, Feb. 20, 1943, 1.

5. Jones to Nolle. July 22, 1942, John Conner Family Collection, Dr. E.N. Jones file. A1982–023, STA.

6. "Former Student, RAF Ace," *ST*, June 6, 1942, 1.

7. "A&I Ex Brings Back," *ST*, Nov. 28, 1942, 1.

8. "Erard Gets Captain Rating," *ST*, June 13, 1942, 1.

9. "Pearl Hightower Is First," *ST*, Aug. 8, 1942, 1.

10. Vernon D. Harville, "Field Artillery Battalion History," in Reference File: "Kingsville, TX — National Guard Unit, Battery 'F,' 133rd FA," STA.

11. "A.Y. McCallum," *ST*, Aug. 8, 1942, 2.

12. "Exes Gather for," *ST*, Dec. 12, 1942, 1.

13. Jones to Bergeron, "Financial– Purchasing, Honor Roll Board," UA, A1992–036.023, STA.

14. Photo, no headline just a cutline, *ST*, Dec. 11, 1943, 2.

15. "Rainey Worked Way," *ST*, Dec. 12, 1942, 1.

16. "Exes Hear Auditorium," *ST*, Jan. 9, 1943, 1; "College Grieved," *ST*, Oct. 14, 1950, 1; "Dr. Nierman's," *ST*, Oct. 14, 1950, 2; Eric Grant, "Edward Newlon Jones Auditorium, 1942–1996," *JST* 10:1 (1997): 137–146; Adam Gonzalez, "John L. Nierman Science Hall, 1938–1996." *JST* 10:1 (1997): 146–154.

17. "Exes Gather," *ST*, Dec. 12, 1942, 1.

18. "A&I Now on War," *ST*, March 13, 1943, 1.

19. Donovan to Conner, Jan. 9, 1942 in "War Department, 1942," UA, A1992–036.005, STA.

20. *Bulletin of The Texas College of Arts and Industries Catalog*, 1943–1944, 13–14.

21. Jones to Conner, Nov. 3, 1942, Conner Family Collection—Dr. E.N. Jones File, A1982–023, STA.

22. "A&I Nursery School," *ST*, Jan. 19, 1946, 1.

23. "Nursery School Children," *ST*, July 30, 1949, 1.

24. Pauline R. Kibbe, *Latin Americans in Texas* (Albuquerque: University of New Mexico Press, 1946), 100–122; San Miguel Jr., *Let All of Them Take Heed*," 91–112; Blanton, "The Strange Career of Bilingual Education," 324–344.

25. Southwest Texas State Teachers College, *Border Institutions Attack Border Problems* (Texas: Southwest Texas State Teachers College, 1943?), 1–25; Kibbe, *Latin Americans in Texas*, 107–110.

26. "First Regional Conference on the Education of Spanish–Speaking ," Dec. 13–15, 1945 in "Conferences of Inter–American Relations, 1945–6," UA, A1992–036.007, STA; Sanchez to Jones, Oct. 17, 1945, ibid.; Jones to Sanchez, Oct. 22, 1945, ibid.; Johnson to Woods, Dec. 18, 1945, in "Inter–American Activities, 1945–1946," UA, A1992–036.008, STA; Jones to Woods, Dec. 5, 1945 with "Information Needed," "Inter–American Activities, 1945–1946," UA, A1992–036.008, STA; San Miguel Jr., *Let All of Them Take Heed*,"101.

27. *El Rancho*, 1942.

28. Registrar's Office, "Local Reports," STA.

29. "Auditorium Lounge," *ST*, Dec. 12, 1942, 1.

30. "How A&I Has Changed," *ST*, Nov. 11, 1944, 2.

31. "Bergeron Retires," *ST*, Sept. 23, 1950, 1; "Retired Teacher's Death," *ST*, April 14, 1961, 4.

32. "How A&I Has Changed," *ST*, Nov. 11, 1944, 2.

33. "Mitchell, Gipe," *ST*, March 6, 1943, 1.

34. "How A&I Has Changed," *ST*, Nov. 11, 1944, 2.

35. "How A&I Has Changed," *ST*, Nov. 11, 1944, 2; Jones to Smith, March 24, 1944, in "Instr–Misc. Commence 4 Spring 1944," UA, A1992–036.019, STA.

36. "Electrical Labs," *ST*, Sept. 23, 1944, 1.

37. "G.I. Bill Starts," *ST*, Aug. 12, 1944, 1; Keith W. Olson, "The Astonishing Story: Veterans Make Good on the Nation's Promise," *Educational Record*, 75 (Fall, 1994), 20.

38. "Committees Appointed," *ST*, Aug. 12, 1944, 1.

39. Ibid, 4.

40. "Board Appoints Eggers," *ST*, Sept. 23, 1944, 1.

41. "Registrar's Office, "Local Reports," STA; "Registration Increases," *ST*, Sept. 23, 1944, 1.

42. "Registrar's Office, "Local Reports," STA.

43. Marie Bennett Alsmeyer, *The Way of the WAVES* (Conway, Arkansas: HAMBA Books, 1981), 183.

44. Ibid., 183.

45. "Registrar's Office, "Local Reports," STA.

46. Ernest Poteet, "Brief History of the Citrus and Vegetable Training Center," in "Citrus Center (A), 1975–1979," UA, A1992–036.031, STA.

47. "A&I Administrators," *ST*, Jan. 13, 1945, 1; "A & I May Establish," *ST*, Oct. 27, 1945, 1.

48. Ibid.

49. Stanley D. Casto, "A History of the Valley Training Center, August 1963" in "Citrus Center, 1975–1979," UA, A1992–036, 30.

50. Ernest Poteet, "Brief History of the Citrus and Vegetable Training Center," 31; Fred L. Connell, Jr., "A Brief Historical Analysis of Income–Expenditure Patterns of Texas College of Arts and Industries," M. A. thesis, Texas College of Arts and Industries, 1961, 179.

51. "Registrar's Office, "Local Reports," STA.

52. This section is from Michelle Lynne Riley, Riley's paper "Texas College of Arts and Industries, East Campus: 1946–1951,"*JST* 10:1 (1997), 88–104.

53. Olson, "The Astonishing Story," 20.

54. "College Secures," *KR*, Dec. 19, 1945, 1.

55. The loan from the Federal Works Agency totaled $50,000; bonds totaled $150,000; citizens of Kingsville donated $50,000; the Ex–Students' Association donated $1,000; Mr. H.E. Butt donated $10,000; and college faculty contributed $10,000 to development project. *Kleberg County, Texas*, 444.

56. Enrollment for the first summer term of 1946 surpassed the previous record of 777 in the summer of 1937. "Freshmen Set Pace ," *ST*, June 29, 1946, 1.

57. "Navy to Abandon," *KR*, Sept. 19, 1945, 1; "Mayor, Chamber," *KR*, Sept. 26, 1945, 1: "No Statement on NAAS," *KR*, Oct. 3, 1945, 1; "Air Station," *KR*, July 3, 1946, 1.

58. "NAS Dedicated," *CCCaller*, June 17, 1966, Sec. B, 1; George Bush, *All the Best* (New York: Scribner, 1999), 32–34.

59. "City and County to Lease," *KR*, July 24, 1946, 1.

60. Kleberg County Commissioners, In the Matter of Proposed Lease, Special Session, County Commissioners Record, Vol. 3, (July 23, 1946), 2; Jones to City–County Board, Aug. 28, 1946 in "Acquisition of lease on Kingsville NAAS (1951–1946)," UA, A1992–036.010, STA; "Lease of Naval Airfield," Feb. 5, 1947, ibid.

61. "City and County to Lease," *KR*, July 24, 1946, 1.

62. *Bulletin of the Texas College of Arts and Industries*, 1947, 16

63. "Registrar's Office, "Local Reports," STA.

64. "Enrollment Reaches 1,704," *ST*, Oct. 11, 1946, 1.

65. "Resident of East Campus," *ST*, Oct. 26, 1946, 1.

66. Corpus Christi resident M.M. Buchanan leased the movie theater for $100/month plus 5% of the gross receipts, the bowling alley for $20/month, the barber shop for $20/month, and the snack bar for $40/month.

67. P.D. Turner and B.J. Patrick leased the laundry facilities for $265/month. Joe Lukas rented the bakery facility for $250/month. The Photo Shop was leased for $40/month to an unidentified person. "Laundry and Bakery Open," *KR*, Oct. 9, 1946, 1; "Groceries, Fish, and Alarms,"*ST*, Feb. 18, 1950, 3; "East Campus Budget," in "East Campus," UA, A1992–036.011, STA; Connell, Jr., "A Brief Historical Analysis," 119–120.

68. *El Rancho*, 1946–51.

69. "Informal Dance," *ST*, Oct. 19. 1946, 1. The first Mesquite Grove was located on East Campus. In 1951, when East Campus closed, an area on Main Campus was designated "Mesquite Grove."

70. "All–Day Picnic For A&I," *KR*, July 23, 1947, 6.

71. *Bulletin of The Texas College of Arts and Industries*, 1947.

72. "Navy Swimming Pool," *KR*, March 19, 1947, 1; "Bathing Beauty Contest," *KR*, April 2, 1947, 1; "Mary Bayliss," *KR*, April 16, 1947, 1.

73. *Bulletin* of The Texas College of Arts and industries, 1948, 20; "Greater A&I," *KR*, May 21, 1947, 2.

74. "College Farm," *ST*, July 29, 1950, 2; David Neher to Michelle Riley, Nov. 15, 1996, interview.

75. David and Pat Neher to Michelle Riley, Nov. 15. 1996, interview.

76. "Aggie Roundup," *KR*, April 30, 1947, 1; "700 Attend 18th," *KR*, May 7, 1947, 1.

77. "Big Parade," *KR*, Nov. 1, 1950, 1; "Record Crowds," *ST*, Nov. 11, 1950, 1.

78. "Large Group," *ST*, Oct. 22, 1949, 1; "Broncs Easier," *ST*, Oct. 22, 1949, 1; "Quarter Horse," *ST*, Nov. 5, 1949, 1; "Sul Ross Takes," *ST*, Nov. 5, 1949, 1; "Sul Ross Team," *ST*, Nov. 19, 1949, 1; "Fourteen College," *ST*, Nov. 4, 1950, 1; "New Mexico A&M," *ST*, Nov. 18, 1950, 1.

79. "Revokable Permit Signed," *KR*, Aug. 21, 1946, 1.

80. *Bulletin of The Texas College of Arts and Industries*, 1948, 22; Leo and Lou Bailey, King *Ranch Country, Reflections*, 28, (December, 1992), 68.

81. David and Pat Neher to Michelle Riley, Nov. 15. 1996, interview. See also: "Conversion of Naval Cadet Barracks into Faculty Housing," UA, A1992–036.012, STA.

82. Ibid.

83. Jack Mathis leased a hangar with office space and an airfield with four runways for $250/month plus utilities and maintenance costs. G.I. Bill benefits were used to pay for crop dusting lessons at the school. "Facilities of NAAS," *KR*, Sept. 25,1946, 1.

84. John Howe to Michelle Riley, Nov. 14, 1996, interview.

85. "Dorm Names Honor," *ST*, April 9, 1949, 1; "East Campus Girls' Dorm," *ST*, Jan. 7, 1950, 1.

86. "At East Campus,"*ST*, Oct. 7. 1950, 1; "Groceries, Fish, and Alarms,"*ST*, Feb. 18, 1950, 3.

87. No one was injured in the fire but the damage was estimated at $200,000. "Varsity Theatre Burns," *KR*, Feb. 2. 1949, 1.

88. "SUB Dedication,"*ST*, Oct. 28, 1950, 1; "Bus Schedule," *ST*, Oct. 14, 1950, 1.

89. "East Campus Girls' Dorm," *ST*, Jan. 7, 1950, 1.

90. "Korea Here We Come," *ST*, Dec. 9, 1950, 1.

91. "Veterans Fade," *ST*, Oct.21, 1950, 1; "A&I Campus," *ST*, Jan. 13, 1951, 1.

92. "Navy May," *ST*, Dec. 9, 1950, 1; "Acquisition of Lease on Kingsville NAAS (1950–1951)," UA, A1992–036.009, STA.

93. "A&I Gets 500," *ST*, Feb. 24, 1951, 1; "New Ag," *ST*, March 3, 1951, 4.

94. "Navy Ups," *ST*, Jan. 20, 1951, 1; "Air Station, " *ST*, April 7, 1951, 1; "22nd Aggie," *ST*, May 5, 1951, 1; "Jet Pilot Training," *KR*, April 14, 1951, 1.

95. Connell, "A Brief Historical Analysis," 28–29.

96. "A New Divisional Organization," in "Divisional Reorganization Plan, 1946–1947," UA A1992–036.001, STA.

97. Nielson to Jones, June 16, 1947, in in "Divisional Reorganization Plan, 1946–1947", UA, A1992–036.001, STA.

98. "Jones Resigns," *ST*, Aug. 8, 1948, 1. Jones served as the sixth president of Texas Tech from 1952 to 1959, as the Secretary of the Christian Education Commission of the Baptist General Convention of Texas, and became an Acting President of the University of Corpus Christi, 1965. Carl R. Wrotenbery, *Baptist Island College: An Interpretive History of the University of Corpus Christi, 1946–1973* (Austin: Eakin Press, 1998), 127, 257.

99. "Poteet Begins Year," *ST*, Sept. 28, 1948, 1;" E.H. Poteet," *ST*, Oct. 23, 1948. 1.

100. "How A&I Has Changed," *ST*, Nov. 11, 1944, 2; "Texas A&I's Fifth President," *TUSK* (May, 1976), no page.

101. "A Union Building," *ST*, Oct. 2, 1937, 2.

102. USST Board Meeting Minutes, 1929–88, vol. 1–10, June 22, 1945, vol. 2, 165–166, UA, A1989–020.001A, STA.

103. "Chamber of Commerce," *ST*, Feb. 17, 1945, 1; Smith to Kidd, Jr., Aug. 19, 1946 in "Acquisition of lease on Kingsville NAAS (1951–1946)," UA, A1992–036.010, STA.

104. USST Board Meeting Minutes, Feb. 4, 1949, vol. 2, 297–98, STA.

105. USST Board Meeting Minutes, July 28, 1950, vol. 3, 83–84, STA; "Student Union Started," *ST*, Sept. 17, 1949, 1.

106. "Students get tour," *ST*, March 19, 1950, 1.

107. "Student Union Opening," *ST*, Oct. 21, 1950, 1; "SUB Dedication," *ST*, Oct. 28, 1950, 1.

108. "Student Union Opens," *ST*, Nov. 4, 1950, 1.

109. "Union Fountain Opens," *ST*, Dec. 2, 1950, 1; Connell, "A Brief Historical Analysis," 120.

110. "Elmore Constructs," *ST*, April 20, 1929, 1.

111. "Missing Landmark," *TUSK*, (July/August, 1971), 16.

112. Ibid.

113. "How A&I Has Changed," *ST*, Nov. 11, 1944, 2;"Texas A&I University in Kingsville, Campus Plan 1980, UA, A1992–036, 16–18, STA; Connell, "A Brief Historical Analysis," 121; "'51 Hogs," *ST*, Oct. 28, 1950, 1; "The Hogs Official ," *ST*, Sept. 15, 1951, 1; "A&I Downs," *ST*, Sept. 22, 1951, 3.

114. Straw, "Texas A&I Campus Traditions," 121–136; "Lee Roy Finds," *ST*, Oct. 24, 1953, 1; "'53 Kleptomaniacs," *ST*, Oct. 5, 1957, 3.

115. Fred Nuesch, Press release, May 13, 1977, in "Gil Steinke," UA, A1992–036.041, STA.

116. "Converting South Texas State Teachers College into the Texas College of Arts and Industries" Senate Bill No. 293, Chapter 286, Texas, Forty–First Legislature, Regular Session, 627.

117. "Negro Veteran Seeks Admission," *KR*, Aug. 25, 1954, 1.

118. "Negro Would Plead Case," *KR*, Sept. 8, 1954, 1.

119. "VA Rejects Negro Veteran's," *KR*, Oct. 6 , 1954, 1.

120. "Negro Ends A&I Entry Try," *CCCaller*, Oct. 7, 1954, 23.

121. "Miss Splawn Retires," *ST*, May 21, 1955, 1.

Chapter Five: Growth

1. Hayes, Burrell, and Royal applications in "Segregation," UA, A1992–036.047, STA.

2. Letters to Burrell, Royal and Hayes, Sept. 3, 1954, ibid.

3. Stafford to Poteet, Aug. 10, 1954, ibid.

4. "Negro Seeking Entry," *CCCaller*, Sept. 10, 1954, 14D.

5. Letter to Poteet, Aug. 28, 1954, ibid. Perhaps a reference to "Student Journeys," *ST*, Oct. 31, 1953, 4.

6. Letter to Poteet, Aug. 29, 1954, in "Segregation," UA, A1992-036.047, STA.

7. Letter to Lynch, Sept. 10, 1954, ibid.

8. Letter to Poteet, Nov. 21, 1954, ibid.

9. Cornell to Poteet, [August, 1955], ibid.

10. Poteet to Cornell, Aug. 4, 1955, ibid.

11. Speech by Dr. Hall to the Board, Feb. 2, 1956, ibid.

12. USST Board Meeting Minutes, Feb. 2, 1956, vol. 3, 257, STA.

13. "Segregation Ban Extended," New York *Times*, March 6, 1956, 1.

14. "TISA Makes Resolution," *ST*, March 10, 1956, 1.

15. USST Board Meeting Minutes, May 17, 1956, vol 3, 267, STA.

16. Office of the Registrar, Sept. 27, 1956, in "Segregation," UA, A1992–036.047, STA; "Blanks, Summers," *ST*, Feb. 26, 1988, 1.

17. Letter to Poteet, May 28, 1956, in "Segregation," UA, A1992–036.047, STA.

18. Letter to Poteet, May 18, 1956, ibid.

19. Note to Poteet, May 19, 1956, ibid.

20. Note to Poteet, Dec. 6, 1961, ibid; Letter to E. T. Lindsey, Nov. 29, 1961, in "*ST* Miscellaneous (1940–1973)," UA, A1992–036.052, STA; "Editorials," *ST*, Nov. 10, 17, Dec. 1, 1961.

21. Gee to Poteet, May 4, 1957, in "Segregation," UA, A1992–036.047, STA.

22. Poteet to Gee, May 9, 1957, ibid.

23. Sid Blanks, "MY FOUR YEARS AT TEXAS A&I," in "Essays of Students Who Attended Texas A&I,"

UA, A1989–028.005, STA. In comparison, University of Texas voted to integrate varsity athletics in November, 1963, the first Southwest Conference to do so. "Restrictions Cleared," CC*Caller*, Nov. 10, 1963, 1.

24. Blanks, "MY FOUR YEARS AT TEXAS A&I"; "Blanks, Summers," *ST*, Feb. 26, 1988, 1.

25. "General Statement of Policy Regarding Inter–Personal Relationships at Texas College of Arts and Industries," in "Segregation," UA, A1992–036.047, STA.

26. "Gil Steinke," Texas A&I University News Service, May 13, 1977, UA, A1992–036.041, STA; *El Rancho*, 1942, [Athletic section]; Nuesch, "The Steinke Years," *Tusk Magazine* 4 (May, 1973), in "Overtures–USST/Pan Am. Univ.," A1989–019.020, STA, 8–9.

27. "Scrappy Says," *ST*, Oct. 3, 1959, 1; *Javelina Highlights*, 1950–1951: *Student Handbook* in "Student Handbooks," 36, STA; Sports Information Office, 1998 Texas A&M–Kingsville: Football Media Guide, A1999–036, 65, STA; "A&I. vs. Hillsdale," *ST*, Dec. 5, 1959, 1; "A&I In Holiday Bowl," *ST*, Dec. 12, 1959, 1; "Hoggies Win," *ST*, Jan. 9, 1960, 1; "Rock–Ribbed Hoggies," *ST*, Jan. 9, 1960, 3.

28. "Gil Steinke," Texas A&I University News Service, May 13, 1977; *El Rancho*, 1942, [Athletic section]

29. Mount Union in Ohio had a 48 game winning streak as of late October, 1999 and University of Oklahoma won 47 straight games in 1953–1957. Actually, each team ranks No. 1 in their division, division 3, 1, and 2. "Streak Makes History," 1998 *Texas A&M–Kingsville Football Media Guide*, 46–47; "Javelina dynasty," *ST*, Nov. 11, 1977, 1.

30. "Center named," *ST*, Jan. 30, 1976, 1; "Coach Steinke," *ST*, Sept. 17, 1976, 1.

31. "Gil Steinke," Texas A&I University News Service, May 13, 1977; *El Rancho*, 1942, [Athletic section].

32. "Javelinas Deserve Better Coverage," *ST*, Nov. 10, 1967, 2.

For another complaint about sports coverage, see, "What Game?," *ST*, Sept. 12, 1986, 2.

There were other examples about Corpus Christi newspaper. In 1933, the secretary to Congressman Kleberg, Lyndon B. Johnson, seemed displeased with quality of *Caller–Times* reporting. He contacted President Seale about a publicity project for A&I, involving the subsidizing of "a wide awake reporter" to cover the two–hundred–mile territory around Corpus Christi. Johnson to Seale, Nov., 5, 1933, in "Correspondence Personal & Professional Pres. Seale," A1989–008, STA; E. W. Seale to Lyndon Johnson, Nov. 25, 1933, ibid.

33. *El Rancho*, 1947. [Javelina Roundup section]

34. "Captors Chase," *ST*, Sept. 27, 1958, 1; "You Can't Hold," *ST*, Sept. 26, 1959, 4; "Henrietta," *ST*, Sept. 20, 1968, 1; "Henrietta enjoys people," *ST*, Oct. 25, 1968, 3.

35. "Pena Wins Flag Contest," *ST*, May 2, 1965, 1; "Rally Round the Flag," *ST*, Sept. 24, 1965, 1.

36. "Project Organized," *ST*, Nov. 20, 1964, 1.

37. "Sculpture Unveiling," *ST*, Feb. 14, 1986, 1.

38. "South Texas State Teachers College" in "School Song and Alma Mater," UA, A1999–028, STA.

39. "We Are the Exes from Texas A&I," in "School Song and Alma Mater," UA, A1995–017, STA.

40. "Hail A&I," in "School Song and Alma Mater," UA, A1999–028, STA; "The Javelina Victory March," ibid.

41. "Conference Game," *ST*, Oct. 22, 1955, 1.

42."A&I School Song," *ST*, April 17, 1943, 3; "The Blue and Gold," *El Rancho*, 1927 ["Our Campus" section].

43. "Jalisco Adopted," *ST*, Oct. 13, 1956, 2; Clara Mae Marcotte, "Jalisco At Football Game started After War," OPA, A&M@K, Sept. 28, 1998. See also:

 http://www.tamuk.edu/news/archive/arch98/october/jalisco.html

44. Texas A&I *Student Handbook*, 1959–1960, 48; "Jalisco, Where are you?," *ST*, Oct. 17, 1969, 2.

45. "Jalisco," *ST*, Nov. 21, 1969, 1. To hear the Javelina band play "Jalisco" on the world wide web, go to: http://www.tamuk.edu/sounds/jalisco.wav

46. "S.C. Recommends," *ST*, Dec. 5, 1969, 1; "'Jalisco' now official song," *ST*, June 5, 1970, 1.

47. USST Board Meeting Minutes, May 17, 1956, vol. 6, 31, STA.

48. "Bell of USS Corpus Christi," *ST*, June 8, 1957, 1; "A&I Gift Bell Rings," *ST*, Sept. 14, 1957, 1.

49. "Campus Clash," *ST*, June 16, 1967, 1.

50. "A&I Victory Bell Tolls," *ST*, June 16, 1967, 2.

51. "Campus Clash," *ST*, June 16, 1967, 1; "President Reaffirms Ban," *ST*, Dec. 15, 1967, 1.

52. "Returning exes," *ST*, Oct. 13, 1967, 4.

53. "A&I Victory Cannon," *ST*, Oct. 4, 1963, 1.

54. "'Little Jav'," *ST*, Nov. 15, 1963, 1.

55. "Student council president," *ST*, Oct. 7, 1966, 1.

56. "Fire one . . . ," *ST*, Sept. 27, 1991, 1.

57. Blakeney to Connally, July 21, 1948 in "R.O.T.C. Signal Corps, 1945–1956," UA, A1992–036.011, STA.

58. Johnson to Wilson, Jr., Aug. 17, 1948, ibid.

59. Whitney to Connally, Aug. 13, 1948, ibid.

60. Jenkins to Poteet, Oct. 30, 1950, ibid.

61. "First Year History of the RESERVE OFFICERS TRAINING CORPS," R.O.T.C. Signal Corps, 1951–1953, UA, A1992–036.012A, [1], STA.

62. "Five Army officers," *ST*, March 17, 1951, 1.

63. "ROTC Head," *ST*, May 5, 1951, 1.

64. "First Year History of the RESERVE OFFICERS TRAINING CORPS," 7.

65. "First Year History of the RESERVE OFFICERS TRAINING CORPS," 8.

66. *El Rancho*, 1953. [ROTC section]

67. "Women Army Corps," *ST*, June 5, 1970, 3.

68. Williams to Commanding General, March 7, 1972 in "ROTC – General 1971–1972," UA, A1992–036.003A, STA.

69. Information for members of Congress: 23 March 1972, ibid.

70. "ROTC selects coeds," *ST*, Sept. 15, 1972, 4; "ROTC women," *ST*, Oct. 13, 1972, 4; "ROTC open to women," *ST*, Dec. 7, 1973 [Jan. 25, 1974], 4; Carol Taylor to Kevin Alexander Thomas, Nov. 21, 1997, interview.

71. "Calendar," *El Rancho*, 1932, 183.

72. "History of Homecomings," *ST*, Nov. 2, 1946, 1.

73. "A&I Ex Students," *ST*, Nov. 21, 1953, 1.

74. "Second Homecoming Queen," *ST*, Oct. 25, 1968, 3.

75. "Traditional bonfire," *ST*, Oct. 16, 1992, 1.

76. *"Javelina Highlights*: Students' Handbook," 1946–1949, 1950–1960, 1961–1963, 1964–1969, in "Student Directories," A1986–035, STA.

77. "Shirt–Tail Parade," *ST*, Sept. 30, 1939, 1; "Annual Shirttail Parade," *ST*, Sept. 20, 1963, 4; *Texas A&I Student Handbook*, 1946–1947, 27.

78. *El Rancho*, 1929 ["Lantana Ladies"] section; *El Rancho*, 1930 ["Lantana Ladies" and "Features" sections].

79. *El Rancho*, 1930–1945 ["Lantana" and "Royalty" sections].

80. Texas College of Arts and Industries, The Thirty–Third annual Lantana Coronation, March 9, 10, 1962 in "Lantana 1962," UA, A1974–067, STA; *El Rancho*, 1942–1946, 1948, 1956–1957, STA.

81. Martha Stanley account in "Lantana, 1933–1948," UA, A1974–067, STA; "Alicia Krug Goes," *ST*, March 4, 1944, 3; "Alicia Krug Dances," *ST*, April 21, 1945, 3.

82. Registrar's Office, "Local Reports," STA. Counting the Spanish surnames is probably an under counting, missing students whose names are not obviously Spanish or whose names are ambiguous.

83. Registrar's Office, "Local Reports," STA.

84. Ruth Cobb Arnold, "Factors Related to Student Retention and Withdrawal at Texas College of Arts and Industries," M.A. thesis, Texas College of Arts and Industries, 1962, 3.

85. Alberta Faye Maddox, "Expectations and Perceptions of College Freshmen," M. A. thesis, Texas College of Arts and Industries, 1962, 6, 13, 20–48.

86. Fred L. Connell, Jr., "A Brief Historical Analysis of Income–Expenditure Patterns of Texas College of Arts and Industries," M. A. thesis, Texas College of Arts and Industries, 1961, 192.

87. Jerry Borup, Floyd Elliott and John Guinn, *Freshman Student Identity: Analysis of Attitudes, Motivation and Achievement* (Kingsville: Texas A&I University, 1968), 1–50.

88. *El Rancho*, 1969, 160.

89. "A&I Homecoming Queen," *ST*, Oct. 26, 1962, 1; "Rosario Mora," *ST*, Oct. 18, 1963, 1.

90. "The Future of Lantana," *ST*, April 19, 1963, 1.

91. Interview with David Neher by Cecilia Aros Hunter, Sept. 17, 1999, South Texas Oral History & Folklore Collection, A1999–041, STA..

92. Telephone interview with Paul Barlow by Cecilia Aros Hunter, Sept. 17, 1999.

93. Interview with David Neher by Cecilia Aros Hunter, Sept. 17, 1999; Interview with Gloria Garza Cantu by Cecilia Aros Hunter, Sept. 19, 1999.

94. "Texas A&I University Greeks," 1970, 14, A1989–015.059, STA.

95. Interview with Aurora Garza and Maggie Salinas by Cecilia Aros Hunter, Sept. 16, 1999; Interview with Gloria Garza Cantu by Cecilia Aros Hunter, Sept. 18, 1999.

96. "Lantana Queen," *ST*, Nov. 2, 1962, 1.

97. "Latin–Anglo Clash," *CCCaller*, Nov. 7, 1963, 1.

98. "Election for Lantana," *ST*, Nov. 1, 1963.) ; "Letters to Editor by Claris Glick," *ST*, Nov. 8, 1963, 2.

99. "Latin–Anglo Clash," *CCCaller*, Nov. 7, 1963, 1.

100. "Discrimination?," *ST*, Nov. 8, 1962, 2.

101. "Lantana Plans Changed," *ST*, Nov. 22, 1963, 1.

102. "Lantana Plans Changed," *ST*, Nov. 22, 1963, 1.

103. "What Do You Think?," *ST*, Dec. 13, 1963, 2; "Brains Versus Beauty," *ST*, March 6, 1964, 2.

104. "Texas A&I's annual," *ST*, March 13, 1964, 1, 6.

105. José Angel Gutiérrez, *The Making of A Chicano Militant: Lessons from Cristal* (Madison: University of Wisconsin Press), 1998, 85–86.

106. Gutiérrez, *The Making of A Chicano Militant*, 86–87.

107. Jernigan to Terry, Feb. 28, 1967, in "College Name Change—Coordinating Board, 1960s," UA, A1992–036.028, STA; "Hale Proposes," *ST*, Feb. 10, 1967, 1.

108. Jernigan to Tarbox, March 7, 1967, in "College Name Change—Coordinating Board, 1960s," UA, A1992-036.028, 8TA.

109. "Students, Alumni,," *ST*, Oct. 14, 1966, 1.

110. "Football Players Question," *ST*, Feb. 24, 1967, 1.

111. Tarbox to Jernigan, March 15, 1967, in "College Name Change—Coordinating Board, 1960s," UA, A1992–036.028, STA.

Chapter Six: Turmoil

1. "James C. Jernigan," UA, A1995–007, STA.

2. "Former A&I Chancellor," *CCCaller*, Aug. 13, 1996, B2.

3. "Jernigan Resigns," *ST*, June 3, 1975, 1.

4. "A Brief History: The University of Texas–Pan American," http://www.panam.edu/about/brief –history.html. Accessed Sept. 15, 1999; "Overtures–USST/Pan American University," University Archives, A1989–019.020, STA.

5. Schilling to Head, in "Overtures–USST/Pan American University," UA, A1989–019.020, STA; "A&I System," *ST*, Feb. 16, 1973, 1.

6. "Pan Am turns," *CCCaller*, March 30, 1982, 1B.

7. Halladay to Jernigan. March 3, 1975, in "Overtures–USST/Pan American University," UA, A1989–019.020, STA; Robins to Jernigan, March 3, 1975, ibid.

8. Lyman A. Glenny, "State Systems and Plans for Higher Education," in Logan Wilson (ed.), *Emerging Patterns In American Higher Education* (Washington: American Council on Education, 1965), 86–103; Peter T. Flawn, *A Primer for University Presidents: Managing the Modern University* (Austin: University of Texas Press, 1990), 175–187.

9. "A&I–Laredo Has Unique Role In Bicultural, Bilingual Region," in "Special Report Touring A&I's Campuses, System Texas A&I University, 1972–73" UA, A1989–019.019, STA; USST Board Meeting Minutes, Nov. 11, 1968, vol. 5, 251, STA.

10. "A&I–Laredo Has Unique Role," in "Special Report Touring" UA, A1989–019.019, STA.

11. Wrotenbery, *Baptist Island College*, vii–ix, 119–158.

12. "Tentative Format For a Ten Year Plan," in "System Texas A&I University," UA, A1989–019.019, STA; *JS*, Reg. Sess., 61st, 139, 1553, 1615, 1620, 1624–1625, 1827, 1968–1969; Wrotenbery, *Baptist Island College*, 161–165; "C.C. group incorrect," *ST*, April 16, 1971, 1.

13. *JHR*, Reg. Sess., 62nd, 260, 1801, 2603–2611, 2696, 2701, 5328, 5651, 5749, 6195; Wrotenbery, *Baptist Island College*, 188–212; "Legislature receives," *ST*, Feb. 12, 1971, 1; "House okay," *ST*, May 7, 1971, 1; "A&I at Corpus," *ST*, June 11, 1971, 1; USST Board Meeting Minutes, June 24, 1971, vol. 6, 98, STA.

14. "What is the True Situation," in "Texas A&I University At Corpus Christi, 1972–1973," UA, A1989–019.013, STA; USST Board Meeting Minutes, Feb. 8, 1973, vol. 6, 176, STA; "Gov. Smith vetoes," *ST*, Aug. 4, 1972, 1; "Bond issue," *CCCaller*, Dec. 10, 1972, 1; "UCC facilities," *ST*, Feb. 16, 1973, 1; Wrotenbery, *Baptist Island College*, 216–229.

15. "A&I–CC's Innovative Programs," in "Special Report Touring A&I's Campuses, System A&I University, 1972–73," UA, A1989–019.019, STA.

16. Jernigan to Reed, July 2, 1971, in "System Texas A&I University," UA, A1989–019.019, STA.

17. "Minutes, Special Called Meeting," Aug. 27, 1971, in "System Texas A&I University," UA, A1989–019.019, STA; USST Board Meeting Minutes, Nov. 18, 1971, vol. 6, 122, STA.

18. "Status Report on Texas A&I University," in "System Texas A&I University," UA, A1989–019.019, STA; USST Board Meeting Minutes, April 13, 1972, vol. 6, 136–137, STA.

19. "Operational Plan—8/17/72," in "System Texas A&I University," UA, A1989–019.019, STA.

20. USST Board Meeting Minutes, April 17, 1975, vol. 7, 48, STA.

21. Halladay Memo, Sept. 17, 1976, in "System Texas A&I University," UA, A1989–019.019, STA.

22. "The University System," ibid; H.B. 944, May 27, 1977, ibid.

23. "Academic Freedom, Tenure, and Responsibility For Faculty of Texas A&I University" in "Statement of Rights, 1969," UA, A1992–036.051, STA; "A Statement of the Rights, Freedoms, and Responsibilities of Texas A&I University Students," ibid; "Freedoms Statement," *ST*, May 16, 1969, 1.

24. "A Brief History," in "First Annual Report of Faculty Senate," 1967–1968, 1–2, UA, A1992–036, STA.

25. "Eleven enroll," *ST*, Sept. 27, 1968, 1.

26. Senate Bill No. 121, in "System Texas A&I University," UA, A1989–019.019, STA

27. Ibid.

28. Maria E. Morales to Amalia Riojas, Oct. 17, 1997, interview; "Specialization Added," *ST*, June 23, 1972, 1.

29. *An Orientation to Bilingual Education in Texas* (Austin: Division of Bilingual Reading, Texas Education Agency, 1972), 2.

30. USST Board Meeting Minutes, May 21, 1970. vol. 6, 27, STA.

31. "Courses to survey," *ST*, June 6, 1969, 1; "Minority group," *ST*, Nov. 14, 1969, 3; "Board sets," *ST*, June 5, 1970, 1; "Ethnic studies," *ST*, June 5, 1970, 2; "Mexican–American," *ST*, June 5, 1970, 1.

32. "Main goals," *ST*, June 5, 1970, 1; "Nelson heads," *ST*, June 5, 1970, 1.

33. Richard Scherpeerel to Cecilia Aros Hunter, Sept. 24, 1999, telephone interview.

34. Joe Rosenberg to Donna Tobias, "Progress Report," in "Bilingual Theater. 1983–1985," UA, A1992–036.010, STA.

35. Ibid, 6.

36. "Students claim," *ST*, Sept. 18, 1970, 1.

Copies of *El Chile* and *El Machete* in "Underground Newspapers," UA, A1991–004.001, STA. Other underground newspapers over the years included *The Javelina Post, Hog Wash, and The Aroused Rabble*. "Reference File–Texas A&I Newspapers," UA, A1995–038, STA.

37. Untitled article, *El Machete* (no date), [1], in "Underground Newspapers," UA, A1991–004.001, STA. Left column, front page, issue printed in green ink.

38. Paul Barlow to Cecilia Aros Hunter, Sept. 16, 1999, interview.

39. Gutiérrez, *The Making of A Chicano Militant*, 91–92.

40. "Committee to," *ST*, Feb. 28, 1969, 1; "Open letter," *ST*, June 19, 1970, 1; "Student Council," *ST*, June 19, 1970, 1; "Add a little," *ST*, June 19, 1970, 2; "City committee," *ST*, June 26, 1970, 1; "My Side," *ST*, June 26, 1970, 2.

41. "Truan introduces," *ST*, April 6, 1971, 1; *JHR*, Reg. Sess., 62nd, 321, 3964–3965, 6097.

42. "Students Comment," *ST*, April 16, 1971, 2; "Shay to aid," *ST*, Sept. 3, 1971, 1; "Shay continues," *ST*, Sept. 24, 1971, 1.

43. "PASO joins," *ST*, Feb. 28, 1969, 1; "Arrests impede," *ST*, April 15, 1969, 1; "MALDF," *ST*, April 25, 1969, 2; "MAYO halts," *ST*, April 25, 1969, 1; Juan Rocha, "Letter to," *ST.*, May 3, 1958, 2.

44. "Narciso Aleman," *ST*, Feb. 21, 1969, 1; "PASO joins," *ST*, Feb. 28, 1969, 1; "President received," *ST*, March 28, 1969, 1; "President calls," *ST*, Aug. 8, 1969, 1; "Groups write," *ST*, May 9, 1969, 1; "We Give," *ST*, May 2, 1969, 4; "La Causa," *ST*, Aug. 7, 1970, 2; "Student Congress," *ST*, Oct. 20, 1972, 1; "Greeks demand," *ST*, May 8, 1970, 1; "Sorority–fraternity," *ST*, Sept. 14, 1973, 1; "Council creates," *El Rancho*, 1972, 230.

45. "Carr challenges," *ST*, May 16, 1969, 1.

46. "Afro–Americans," *ST*, Nov. 1, 1968, 2;"Students query," *ST*, Nov. 1, 1968, 1; "Black students ,'" *ST*, April 24, 1970, 1; "Blacks relate," *ST*, May 1, 1970, 1.

47. "So–Called," *ST*, Oct. 6, 1967, 3; "Sex Revolution," *ST*, Oct. 13, 1967, 5; "Observers of," *ST*, Oct. 20, 1967, 3; "Social Worker," *ST*, Oct. 20, 1967, 1.

48. "Letters from," *ST*, Jan. 29, 1971, 2; "Women's lib," *ST*, March 5, 1971, 3; "ROTC," *ST*, July 28, 1972, 1.

49. "Volleyball season," *ST*, Nov. 7, 1957, 1; "Bra no," ibid., Nov. 14, 1975, 1; "Chicana Rights," *El Chile*, (Nov. 1975), 2, in "Underground Newspapers," UA, A1991–004.001, STA.

50. Ms. Livia Diaz to Darren Earhart, Oct. 19, 1998, interview; Betty Brewer, to Darren Earhart, Oct. 21, 1998, interview.

51. "Bra issue," *CCCaller*, June 8, 1976, 3A, in "Title IX and Related Materials," UA, A1992–036.009, STA.

52. Julia Smith, "Title IX Self–Evaluation: Preliminary Report" in "Title IX Self–Study Preliminary Report," UA, A1992–036.008, 1–39, STA.

53. "Softball team," *ST*, Oct. 1, 1976, 5.

54. "Focus: Women's," *ST*, Jan. 30, 1970, 2; "Survey reveals Coeds," *ST*, March 12, 1971, 2; "Dorm women," *ST*, May 7, 1971, 1; "No 'pills," *ST*, April 16, 1971, 1; "Panty raiding," *ST*, Nov. 12, 1976, 2.

55. "'Corner' draws,"*ST*, March 14, 1969, 1; "Speaker's Corner," *ST*, Sept. 12, 1969, 1; "Corner runs," *ST*, Nov. 13, 1970, 1; "Salute to," *ST*, Nov. 20, 1970, 2.

56. "A&I graduate," *ST*, Feb. 14, 1969, 1; "Army awards," *ST*, Aug. 1, 1969, 3; "It's a dirty," *ST* Nov. 14, 1969, 3; Poetry in *ST*, Oct. 24, 1969, 3; Nov. 14, 1969, 2; "Vietnam veterans," *ST*, March 27, 1970, 3; "Pilot says," *ST*, March 26, 1971, 5; "Silver Star," *ST*, June 18, 1971, 2; "ROTC completes," *ST*, Feb. 27, 1970, 1.

57. "'Moratorium," *ST*, Oct. 17, 1969, 6; "Local group," *ST*, April 10, 1970, 1; "Peace rally," *ST*, April 17, 1970, 1; "Sharply divided," *ST*, May 8, 1970, 1; "Draft," *ST*, July 16, 1971, 2; "Is Vietnam," *ST*, June 30, 1972, 2.

58. "Student group," *ST*, March 6, 1970, 1.

59. Paul Barlow to Cecilia Aros Hunter, Sept. 16, 1999, interview.

60. "Failure to wear tie," *ST*, Nov. 22, 1968, 2; "Council approves resolution," *ST*, Dec. 6, 1968, 1.

61. "The Reader's," *ST*, Dec. 13, 20, 1968, 2; "Who makes," *ST*, Jan. 10, 1969, 2; "Pat–pourri," *ST*, Jan. 31, 1969, 2; "Petitioners gain," *ST*, Dec. 20, 1968, 1; "Dorm students," *ST*, Feb. 14, 1969, 1; "Dorm revision," *ST*, Feb. 21, 1969, 1.

62. "Hogs," *ST*, Nov. 26, 1969, 1; "Hogs Blitz," *ST*, Dec. 5, 1969, 1; "A&I Has," *El Rancho*, 1970, 121.

63. "Javelinas Win," *ST*, Dec. 19, 1969, 1; "Stand up," ibid, 3.

64. "SC calls," *ST*, Jan. 30, 1970, 1.

65. Mount Union (Ohio) had 48 game winning streak in Oct. 1999, and University of Oklahoma won 47 straight victories 1953–1957. The three teams rank first in their divisions—3, 1, and 2. The streak

ended in the fourth game of 1977 when Abilene Christian tied the Javelinas 25–25. *1998 Football Media Guide*, 35, 46, 66–67, STA; "Gil Steinke," *ST*, Feb. 11, 1977, 1.

66. "Linda Salinas," *ST*, Feb. 21, 1969, 1.

67. "Lantana plan," *ST*, Nov. 21, 1969, 1; "Enrollment down," *ST*, May 9, 1969, 2.

68. "Barbie Rosse," *ST*, May 8, 1970, 1.

69. "Lantana Revived," *TUSK Magazine*, 4 (May, 1973), 12–13; "News Blackout," *ST*, March 1, 1974, 2.

70. "Libidinal violence," *ST*, March 15, 1974, 2; "To be specific," *ST*, March 15, 1974, 5; "Delts acquire," *ST*, Nov. 15, 1968, 1; "Tau Tau," *ST*, Sept. 12, 1969, 6; "Greek Week '73," *ST*, March 30,l 1973, 9; "Mascots missing," *ST*, Nov. 13, 1970, 3.

71. "Campus Plan, 1980, STA; "Cumulative Space Listing," May 22, 1995, Office of University Engineer/Director of Campus Planning.

72. Registrar's Office, "Local Reports," STA; "Proposal for Ethnic Studies," in "Ethnic Program, 1970," UA, A1992–036.043, STA.

73. "Robins Announced," *ST*, Aug. 10, 1972 [1973], 1; "Ortego objects," *ST*, Sept. 7, 1973, 1; Gerald Robins to David Trevino, March 24, 1994, interview, STA; "Enrollment drops," *ST*, Sept. 7, 1973, 1.

74. Undated news release, "Gerald Burns Robins," UA, A1995–007, STA; Gerald Robins to David Trevino, March 24, 1994, interview, STA.

75. Ad Hoc Committee B–73, in "Activities of the Texas A&I University Faculty Senate, Sept. 1, 1973–Aug. 31, 1974," 80; "Faculty dismissals," *ST*, April 5, 1974, 1.

76. "Faculty dismissals," *ST*, April 5, 1974, 1.

77. "Minutes of the Regular Senate Meeting, April 23, 1974," in "Activities of the Texas A&I University Faculty Senate, Sept. 1, 1973–Aug. 31, 1974," 42; Report of Ad Hoc Committee E–73, ibid., 117–136; "Faltering Academia," *ST*, May 5, 1974, 1.

78. "Faltering Academia," *ST*, May 5, 1974, 1; "Dr. Tylicki," *ST*, May 2, 1975, 1.

79. "Gunn in," *ST*, July 7, 1972, 1; Wayne Gunn to Cecilia Aros Hunter, Oct. 11, 1999, interview.

80. Wayne Gunn to Cecilia Aros Hunter, Oct. 11, 1999, interview.

81. "Dr. Robins," *ST*, Jan. 28, 1977, 1; "Robins accepts," *ST*, April 22, 1977, 1.

82. George Fred Rhodes to Cecilia Aros Hunter, Sept. 24, 1999, interview, STA; Paul Barlow to Cecilia Aros Hunter, Sept. 16, 1999, interview.

83. Robert Birnbaum, *How Colleges Work: The Cybernetics of Academic Organization and Leadership* (San Francisco: Jossey–Bass Publishers, 1988), 1–29.

84. Ibid.

Chapter Seven: Malaise and Retrenchment

1. Christopher J. Lucas, *Crisis in the Academy: Rethinking Higher Education in America* (New York: St. Martin's Press, 1996), ix–xvi

2. "Heart attack," *Javelina Bulletin*, 5 (June 16, 1995), 1.

3. University catalogues, 1950, 1970, 1990, 1998–2000. Beginning faculty members were surely under counted, arriving after the catalogs were printed; adjuncts, part–time faculty and graduate assistants not included in the catalogs. Percent of female, minority and international faculty members is probably higher than indicated.

4. "Women receive," *ST*, Sept. 2, 1977, 4.

5. "Language Instructor," *KR*, UA, A1995–007, STA; "Discrimination hearing," *ST*, Oct. 4, 1974, 1; Benitez to Brown, Feb. 25, 1975, "Dr. Jose Reyna File," UA, A1992–036.021, STA.

6. "A&I students," *ST*, Oct. 11, 1974, 1.

7. Senate Concurrent Resolution No. 33, May 11, 1975, in "Fiftieth Anniversary," UA, A1992–036.010, STA; Proclamation, March 17, 1975, ibid; Fiftieth Anniversary program, March 21, 1975, ibid; "Platform Guests," in "Fiftieth Anniversary," UA, A1992–036.011, STA; "Highlights," ibid; Jernigan, "Introduction," ibid.

Ema O'Dell Stewart (Mrs. Carter Stewart), had been the first student to register at S.T.S.T.C. in 1925, sent a letter to President Robins with a copy of her diplomas. Stewart to Robins, Sept. 20, 1973, ibid.

8. "Demonstrators jeer," CC*Caller*, March 22, 1975, 14A; "Briscoe booed," *KR*, March 23, 1975, 1.

9. Gerald Robins to David Trevino, March 24, 1994, interview, STA.

10. Benitez to Reyna, May 9, 1975, "Dr. Jose A. Reyna, File" UA, A1992–036.021, STA; "Texas A&I," SA*Express*, May 6, 1977, 20A.

11. "Ethnic Center news release," Texas A&I University News Service, August 25, 1977, "Emilio Zamora Jr. File," UA, A1995–007; "Zamora named," *ST*, Sept. 16, 1977, 1; Emilio Zamora Jr. to Cecilia Aros Hunter, Sept. 24, 1999, interview.

12. "President's Report, 50th Anniversary," UA, A1999–045, 2.

13. Ibid.

14. "Dr. Robins," *ST*, Jan. 28, 1977, 1; "Ethnic balance," CC*Caller*, March, 1977, in "Duane M. Leach," UA, A1995–007, STA.

15. "Bonilla readies," CC*Caller*, June 22, 1977, 1B.

16. "President's fete," CC*Caller*, June 18, 1977, in "Duane M. Leach," UA, A1995–007, STA.

17. "Optimistic New," CC*Caller*, June 18, 1977, in "Duane M. Leach," UA, A1995–007, STA.

18. "Getting on with the job," *TUSK Magazine*, vol. 7, no. 3 (Fall, 1977), 4–5.

19. Faculty Meeting, August 27, 1979, speech in "Duane Leach File," UA, A1995–007, STA; "Getting on with the job," *TUSK Magazine*, vol. 7, no. 3 (Fall, 1977), 4–5; ; Report of Ad Hoc Committee C–76, "Eleventh Annual Report Faculty, Senate, 1977–1978," 32–37.

20. "Leach sees potential," CC*Caller*, Aug. 23, 1977, in "Duane Leach File," UA, A1995–007, STA.

21. Faculty Meeting, August 27, 1979, speech in "Duane Leach File," UA, A1995–007, STA. For the term "birth dearth" see George Keller, *Academic Strategy: The Management Revolution in American Higher Education* (Baltimore: Johns Hopkins University Press, 1983), viii.

22. Faculty Meeting, August 27, 1979, speech in "Duane Leach File," UA, A1995–007, STA.

23. "Leach named," *KR*, Oct. 6, 1980, 1.

24. "Leach cites need," CC*Caller*, July 5, 1983, 1B.

25. "Lewis Hall goes Co–ed," *ST*, Sept. 30, 1977, 1; "Lewis Hall," *ST*, Oct. 28, 1977, 2; "Society of women," *ST*, Oct. 7, 1977, 2; "Woman Commissioned," *ST*, Jan. 21, 1977, 8; "Female battalion," *ST*, Oct. 10, 1986, 3; "Professors offer," *ST*, Oct. 21, 1977, 2.

26. "A&I attractiveness," *ST*, Sept. 2, 1977, 6; Faculty Senate Minutes, Oct. 11, 1977, "Eleventh Annual Report of Faculty Senate, 1977–1978," 11, UA, A1992–036, STA; "Pub easily," *ST*, Nov. 4, 1977. 6; "Board clears," *ST*, Nov. 11, 1977, 1; "Festivities mark," *ST*, April 14, 1978.

27. "Javelina dynasty," *ST*, Nov. 11, 1977, 1.

28. "Jonas resigns," *ST*, July 20, 1979, 5; *1998 Football Media Guide*, A1999–036, 8, 67–68, STA; "Javs make," *ST*, Nov. 18, 1988, 1; "Javs two games," *ST*, Nov. 18, 1988, 1.

29. "Mariachi to perform," *ST*, Nov. 10, 1978, 1.

30. Sally L. Donaldson, "The Social Adjustment of the Male Foreign Student at Texas A&I University," M. A. thesis, Texas A&I University, 1968, 17–32.

31. "Embassy takeover," *ST*, Nov. 16, 1979, 1.

32. "Monday's protest," *ST*, 1.

33. "Opinions," *ST*, Nov. 16, 1979, 2.

34. "Monday's protest," *ST*, Nov. 16, 1979, 1; "Embassy takeover," *ST*, Nov. 16, 1979, 1; "Deportation hearings," *ST*, Dec. 7, 1979, 1.

35. Registrar's Office, "Local Reports," STA.

36. *The South Texas State Teachers College, Bulletin No. 13, 1926–27*, 12–13; Sarah Porter to Cecilia Aros Hunter, Sept. 9, 1999, interview, STA.

37. "Radio English," *ST*, Feb. 18, 1950, 1; Memorandum Jerry Bogener to Dr. Robins, March 1, 1977, in "Continuing Education 1977," UA, A1992–036.020, STA.

38. *Texas A&I University, 1971–1973: Self Study Report*, UA, A1991–007, 413, STA.

39. Mark Walsh to Cecilia Aros Hunter, Oct. 11, 1999, interview.

40. *Texas A&I University, 1982–1983: Institutional Self–Study*, UA, A1992–016, IX, 9, STA; Brenda Nettles, "Graduate courses," *ST*, Feb. 6, 1987, 1.

41. Mark Walsh to Cecilia Aros Hunter, Oct. 11, 1999, interview; "Texas A&I University, Center For

Continuing Education, Self Study Report, October 1992," UA, A1999–052, STA.

42. News Release: "Texas A&I Receives $3.3 million gift," Jan. 7, 1982, in "Caesar Kleberg Foundation," UA, A1992–036.027, STA; "The South Texas Regional Studies Center," in "So. Tex. Regional Studies," UA, A1992–036.041, STA.

43. "The South Texas Regional Studies Center," ibid.

44. "Enrollment appears," *ST*, July 3, 1981, 2.

45. "Franklin foresees," *ST*, July 3, 1981, 1.

46. "Pride reflects," *ST*, July 23, 1982, 2.

47. "*ST* Opinions," *ST*, April 24, 1981, 2.

48. "Excellence In the 1980s," *ST*, Dec. 4, 1981, 2.

49. "Two offices created," *ST*, Jan. 22, 1982, 1.

50. "Enrollment is up," *ST*, Sept. 17, 1982, 1; Photo, *ST*, March 26, 1982, 1; "College of Business," *ST*, Feb. 26, 1982, 3; "$10,000 goal," *ST*, March 12, 1982, 1.

51. "9.1 Percent Enrollments up at A&I," *ST*, Feb. 11, 1983, 1.

52. "Chancellor accepts," *ST*, July 1, 1983, 1.

53. "Franklin accepts," *ST*, Nov. 9, 1984, 1.

54. "Pettit announces," *ST*, July 26, 1985, 1.

55. "General Background Information," in "Dr. Steven Altman," in UA, A1992–036.016, STA.

56. "A&I enrollment falls," *ST*, Sept. 20, 1985, 1.

57. "Enrollment hits," *ST*, Feb. 7, 1986, 1.

58. "University faces," *ST*, Feb. 28, 1986, 1.

59. "Texas A&I University Enrollment Task Force Recommendations, April 24, 1986," in "Enrollment Task Force," UA, A1992–036.022; "College One," *ST*, Jan. 20, 1989, 4.

60. "University ranks," *ST*, April 18, 1986, 1; "Figuring It Out," *ST*, July 23, 1987, 1.

61. "Steve Altman," UA, A1995–007, STA.

62. Rhonda Barrera to Steve Altman, Feb. 8, 1986, in "Dr. Steve Altman," UA, A1992–036.016, STA.

63. "University faculty," CC*Caller*, Nov. 24, 1985, 1C.

64. "Faculty resents," *ST*, Sept. 21, 1973, 1.

65. "Seventh Annual Report Faculty Senate, 1973–1974," 21, UA, A1992–036, STA; "Annual Faculty Senate, 1984–1985," 38, 40,162, UA, A1992–036, STA.

66. "New drinking age," *ST*, March 20, 1987, 1; "Pub copes," *ST*, Sept. 26, 1986, 3; "The once," *ST*, June 25, 1987, 2.

67. "Legislators reach," *ST*, Sept. 26, 1986, 1; "University budget," *ST*, Oct. 3, 1986, 1; "Legislators tackle," *ST*, June 25, 1987, 1.

68. "Fee committee," *ST*, June 25, 1987, 1.

69. "Fat athletic budget," *ST*, June 18, 1987, 2; "A&I Mourns," *ST*, June 18, 1987, 3; "Upset students," *ST*, June 18, 1987, 3; "Cross–country," *ST*, June 18, 1987, 3.

70. "Track protest," *ST*, July 2, 1987, 1; "Track issue," *ST*, July 23, 1987, 2; "Track–CC," *ST*, July 30, 1987, 3.

71. "Apathy Kills," *ST*, March 3, 1989, 8.

72. "Temple recommends," *ST*, Nov. 14, 1986, 1, 6.

73. "Board endorses," *ST*, Nov. 21, 1986, 1; "Texans for," *ST*, Nov. 21, 1986, 1; "Truan offers," *ST*, Dec. 5, 1986, 1.

74. *JS*, Reg. Sess., 70th, 237, 587, 667, 693–694, 1183, 1221–1222, 1305, 1446, 1724–1725, 2748; *JHR*, Reg. Sess., 70th, 278, 465, 518, 525, 1494, 3431; "Administrators not," *ST*, Jan. 30, 1987, 1.

75. "Texans for," *ST*, Feb. 13, 1987, 1.

76. "Altman says," *ST*, April 10, 1987, 1.

77. "Truan unsure over," *ST*, June 25, 1987, 1; "Legislators tackle," *ST*, June 25, 1987, 1.

78. "Strategic Planning," *ST*, May 1, 1987, 1; George Keller, *Academic Strategy: The Management Revolution in American Higher Education* (Baltimore: Johns Hopkins University Press, 1983); "Committee examines," *ST*, Feb. 6, 1987, 1; "Retention problem," *ST*, July 30, 1987, 1; "Why do," *ST*, July 30, 1987, 2.

79. "Texas A&I University Final Report Strategic Planning Committee," Feb. 5, 1988, 1–3.

80. "Texas A&I University Final Report Strategic Planning Committee," Feb. 5, 1988, 45–65; "Legislation prompts," *ST*, July 2, 1987, 3; *JS*, Reg. Sess., 70th, 326, 992, 1053–1054, 2178, 2293, 2744, 2754.

81. "Stepping on Stage," *Orlando: The Magazine of Business*, (Aug., 1989), 45, in "Steven Altman," UA, A1995–007. STA.

82. "Hard times force," Houston *Chronicle*, Dec. 26, 1986, ibid.

83. "Hard times force," Houston *Chronicle*, Dec. 26, 1986, ibid; "Altman states," *ST*, Sept. 23, 1988, 1; "Meyer says," *ST*, July 2, 1987, 1.

84. "Merger study," *ST*, July 23, 1987, 1; "A&I supporters," *ST*, July 30, 1987, 1.

85. "Committee to," *ST*, Sept. 30, 1988, 1; "Vote on," *ST*, Oct. 21, 1988, 1; "A&M or," *ST*, Oct. 21, 1988, 2; "The Name Change," *ST*, Jan. 27, 1989, 2.

86. "Board okays," *ST*, Oct. 7, 1988, 1; "USST board," *ST*, Nov. 4, 1988, 1; "A&I–A&M," *ST*, Dec. 2, 1988, 1.

87. "Berlanga says," *ST*, Jan. 20, 1989; *JS*, Reg. Sess., 71st, 21; "Alumni pledges," *ST*, Jan.27, 1989, 1; "Name–change," *ST*, Feb. 24, 1989, 1.

88. "Testimony to House Higher Education Committee, March 27, 1989," in "Steven Altman," UA, A1995–007. STA.

89. "A&I law school," *ST*, March 31, 1989, 1.

90. "Altman accepts," *ST*, April 14, 1989, 1.

91. *JS*, Reg. Sess., 71st, 21, 278, 300, 305, 1093, 1154, 1161, 1469; "Ibanez," *ST*, July 20, 1989, 1.

Chapter Eight: TAMUK

1. USST Board Meeting Minutes, Aug. 8, 1989, vol. 10, 53–63, STA. This chapter is especially based on the work of Daniel Jose Vasquez, "Dr. Manuel L. Ibáñez: Texas A&M University–Kingsville President: 1989–1998," STA.

2. Irma Rangel to Cecilia Aros Hunter, Oct. 26, 1999, interview.

3. "Altman accepts,' *ST*, April 14, 1989, 1.

4. "Board okays," *ST*, Oct. 7, 1988, 1; "Law school," *ST*, Nov. 11, 1988, 1.

5. "Clements' support," *ST*, Feb. 3, 1989, 1; "Law school," *ST*, Feb. 24, 1989, 1.

6. "Law School," *ST*, March 3, 1989, 1; "A&I law," *ST*, March 31, 1989, 1; "State lawyers," *ST*, April 7, 1989, 1.

7. "Law school," *ST*, April 21, 1989, 1.

8. *JHR*, Reg. Sess., 71st, 539, 898, 1438, 1485, 1528; *JS*, Reg. Sess., 71st, 282, 308.

9. "Ibanez named," *ST*, July 20, 1989, 1.

10. "A&M Regents," *ST*, Sept. 22, 1989, 1; "Mean Business," *ST*, Sept. 22, 1989, 2.

11. *JHR*, Reg. Sess., 72nd, 278, 1070; *JS*, Reg. Sess., 72nd, 86, 623; "Ibanez responds," *ST*, Feb. 8, 1991, 2; "Law school, YES!," *ST*, April 5, 1991, 1; "Faculty groups," *ST*, April 26, 1991, 1.

12. "Truan introduces," *ST*, April 6, 1971, 1; "Shay continues," *ST*, Sept. 24, 1971, 1; "Temple recommends," *ST*, Nov. 14, 1986, 1; "Alumnus plays," *ST*, July 23, 1987, 1.

13. Hunters (eds.), *Historic Kingsville, Texas*: Vol. II , 82–84; Irma Rangel to Cecilia Aros Hunter, Oct. 26, 1999, interview.

14. "Education funding," *ST*, July 2, 1987, 1.

15. *JHR*, Second Called Session, 68th, 324–325.

16. Irma Rangel to Cecilia Aros Hunter, Oct. 26, 1999, interview; "Task force," *ST*, Feb. 21, 1986, 1; "Mexican American," *ST*, Sept. 19, 1986, 1.

17. John Sharp, *Bordering the Future: Challenge and Opportunity In the Texas Border Region* (Austin: Texas Comptroller of Public Accounts Publication #96–599, 1998), 50–51.

18. "Perseverance Wields Power," *Texas Bar Journal*, 57 (March 1994), 309; "MALDEF trial," CC*Caller*, Sept. 13, 1991, B1.

19. "MALDEF bullies," *ST*, Jan. 29, 1993, 1; "Lawsuit may," *CCCaller*, Aug. 18, 1991, B1.

20. "Lawsuit may," *CCCaller*, Aug. 18, 1991, B1; "MALDEF trial," *CCCaller*, Sept. 13, 1991, B1.

21. "Bias charge," *CCCaller*, Nov. 1, 1991, B1.

22. "No funding," *CCCaller*, Nov. 21, 1991, B7.

23. "Judge rules," *ST*, Jan. 24, 1992, 1; "Perseverance Wields Power," 309; "MALDEF bullies," *ST*, Jan. 29, 1993, 1.

24. "MALDEF outcome," *ST*, Oct. 15, 1993, 1; "Pride or Prejudice?," *ST*, Oct. 15, 1993, 2.

25. "Perseverance Wields Power," 309; "Mexican American," *ST*, Sept. 19, 1986, 1; "Texas Border Colleges Forge Ahead Despite Court Ruling," *Black Issues in High Education*, 10 (Dec. 30. 1993), 30.

26. *JS*, Reg. Sess., 73rd, 3626–3628.

27. "CCSU, A&I," *CCCaller*, March 21, 1992, B2.

28. "Texas A&M University System Presentation, February 17, 1993," Texas A&I University, 3.

29. Sharp, *Bordering the Future*, 53.

30. "Permanent University Fund," *The New Handbook of Texas*, V, 154–155.

31. "The Higher Education Assistance Fund, July 14, 1994," 1 in "HEAF Funding" UA, A1999–052, STA.

32. "A&I signs," *ST*, Jan. 2, 1990, 1.

33. *Texas A&I University Catalog*, 1992–1994, 23; "College I registers," *ST*, March 2, 1990, 1; "College I," *ST*, Jan. 18, 1991, 7.

34. "Japanese students," *ST*, Feb. 22, 1991, 3; "Intensive English," *KR*, Aug. 30, 1987, 4E; Gary Gunderson to Cecilia Hunter, Nov. 11, 1999.

35. "Students, faculty," *ST*, Sept. 7, 1990, 1; "Professor in Iraq," *ST*, Sept. 7, 1990, 9; "Students leave," *ST*, Jan. 25, 1991, 1; "Protests can hurt," *ST*, Jan. 25, 1991, 2; "Gardiner speaks," *ST*, Feb. 15, 1991, 1.

36. "FIPSE grant," *ST*, Nov. 2, 1990, 1; "A&I to offer," *ST*, Sept. 20, 1991, 1; "Cuernavaca program," *ST*, Oct. 18, 1991, 4; "Semester in Mexico," *ST*, April 3, 1992, 1.

37. "Russia, A&I meet," *ST*, Oct. 16, 1992, 3; "Students, teachers," *ST*, Oct. 14, 1994, 3; "New Border," *ST*, Sept. 5, 1995, 1; Mark Walsh to Leslie Gene Hunter, Dec. 9, 1999, "International Programs," A1999–052, STA.

38. "TAMUS video profs," *ST*, Oct. 2, 1992, 1; "Sociology 2361," *ST*, Oct. 11, 1996, 1.

39. "A&I to offer," *ST*, Sept. 28, 1990, 1.

40. Sharp, *Bordering the Future*, 62–63.

41. "Truan's A&M," *ST*, Feb. 26, 1993, 1.

42. "A&I is facing," *KR*, Feb. 24, 1993, 1.

44. "President's reasons," *ST*, April 2, 1993, 2.

45. "Benefits of Change," *The Tusk: Special Edition*, n.d., 2, UA, A1995–008, STA.

46. Publication in "Name Change 1993," UA, A1995–008.015, STA.

47. "Rangel fears," *KR*, Aug. 8, 1993, 1.

48. "Name change forum," *KR*, Aug. 15, 1993, 1, 8.

49. "Regents to decide," *ST*, March 5, 1993, 1; "Change Reaction," *ST*, March 12, 1993, 1; "Anti–A&M," *KR*, Aug. 8, 1993, 1.

50. "Name Change debate," *KR*, Aug. 8, 1993, 2.

51. "A&M designation," *KR*, Aug. 29, 1993, 12.

52. "A&I Alumni," *ST*, Nov. 5, 1993, 1; "Association, University, Foundation," *The Tusk* 2 (June, 1994), 1; Jeff Chapel, "Javelina Alumni, "*ST*, Feb. 17, 1995, 1; "Born–again alumni," *ST*, Sept. 5, 1995, 1.

53. "Ibanez backs," *ST*, Sept. 28, 1990, 4.

54. "Finding a niche," *CCCaller*, July 22, 1994, 1B.

55. "TAMU–K implements," *ST*, Sept. 24, 1993, 1.

56. "Staff has," 9B/10B in "Women's Center, UA, A1999–052, STA; "Center to," *ST*, April 2, 1993, 1; "Women's Center," *ST*, Sept. 13, 1996, 5.

57. Gilda Medina to Cecilia Hunter, Nov. 5, 1999, interview.

58. "Board approves doctoral," *ST*, Feb. 14, 1992, 1.

59. "Meyer appointed," *ST*, Jan. 31, 1992, 1; "Report says," *ST*, Sept.30, 1994, 1; "A&M–Kingsville," *CCCaller*, Dec. 20, 1994, B1.

60. James T. Rogers to Manuel Ibanez, Jan. 4, 1995, in "Southern Association of Colleges and Schools, Commission on Colleges," UA, A1999–052, STA.

61. "A&M–Kingsville," CC*Caller*, Dec. 20, 1994, 1B.

62. "Institutional Response to Reaffirmation Report, September 1995, 1, UA, A1999–052, STA.

63. "Texas A&M University–Kingsville Assessment Plan, September 1995, 1, ibid.

64. "Texas A&M University–Kingsville Assessment Plan, September 1995, 1, ibid.

65. James T. Rogers to Manuel Ibanez, Jan. 8, 1996, in "Southern Association of Colleges and Schools, Commission on Colleges," ibid.; "Intergrating OPAC," *ST*, Jan. 21, 1994, 1; "Jernigan library," *ST*, Nov. 6, 1997, 1; "SACS team," *ST*, Oct. 20, 1995, 1.

66. "A&M Kingsville," *KR*, June 30, 1996, A2.

67. "Kingsville Rotary Club," Texas A&M University at Kingsville, OPA, July 15, 1996, l, Accessed Sept. 21, 1998, at http://www.tamuk.edu/news/archives/arch96/july/rotarsch.html; "Dorms will," *ST*, Jan. 24, 1992, 1.

68. "Enrollment Continues," Texas A&M University at Kingsville, OPA, Sept. 12, 1996. Accessed Sept. 21, 1998, at:

 http://www. tamuk. edu/news /archives/arch96/September/enrollment.html.

69. "Texas A&M University–Kingsville," A&M@K, OPA, Oct. 23, 1996. Accessed Sept. 21, 1998, at http://www.tamuk.edu/news/archives/arch96/October/biogrant.html.

70. "South Texas Ranching," *ST*, Feb. 25, 1994, 1; "Festival honors 250," *ST*, Feb. 24, 1995, 1.

71. "Alumna, Justice," *ST*, Oct. 2, 1997, 1; "Alumna Flores–Vela," *ST*, Oct. 9 1997, 1; "Hispanic Heritage Banquet," *ST*, Oct. 16, 1997, 1.

72. "New TAMUK engineering," *KR*, May 28, 1997, 1.

73. "2x2 program Eases Transition,"A&M@K, OPA, Dec. 17, 1997, Accessed September 21, 1998, at

 http://www.tamuk.edu/news/archives/arch97/octnovdec/articulation.html.

74. "Batter up," *ST*, Nov. 9, 1990, 1; "Field of Dreams," *ST*, Nov. 9, 1990, 2; "'Ryan *Express*'," *ST*, Nov. 20, 1992, 1; "Ryan pitches," *ST*, Feb. 19, 1993, 1; "Nolan Ryan dedicates," *ST*, Nov. 19, 1993, 1; "Ryan returns," *ST*, Feb. 11, 1994, 1; "Lights Being Installed," A&M@K, OPA, Dec. 16, 1997. Accessed Sept. 21, 1998, at:

 http://www.tamuk.edu/news/archives/arch97/octnovdec/baseball.html.

75. "Program aimed," *ST*, Nov. 15, 1991, 1; "Texas A&M–Kingsville Partnership," A&M@K, OPA, Feb. 16, 1997, Accessed Sept. 21, 1998, at

 http://www.tamuk.edu/news/archives/arch98/march.partnership.html.

76. "Texas A&M-Kingsville," CC*Caller*, Jan. 17, 1998, A1; "Manuel L. Ibáñez," A&M@K, OPA, Jan. 15, 1998, Accessed Sept. 23, 1998, at:

 http://www.tamuk.edu/news/archive/arch98/march/partnership.html.

77. "University and media," CC*Caller*, May 6, 1990, A13.

78. "Students, Ibanez," *ST*, Oct. 25, 1991, 1; "Takin' it to the streets," *ST*, Oct. 31, 1991, 1; "Editorial," *ST*, Oct. 31, 1991, 2; "Ibáñez agrees," CC*Caller*, Oct. 19. 1991, B3.

79. "A&I degree programs," CC*Caller*, March 26, 1992, B1.

80. "Tortilla incident," CC*Caller*, Dec. 21, 1994, A15; "Critics," CC*Caller*, Dec. 14, 1994, A11.

81. Sharp, *Bordering the Future*, 53.

82. Sharp, *Bordering the Future*, 54.

Chapter Nine: Proud Past, Promising Future

This chapter is especially based upon the research of George Cavazos, Jr., "From Army Troops to University Students," STA.

1. The South Texas State Teachers College, *Announcements and Course of Study*, 1925–26; Registrar's Office, "Local Reports," STA.

2. R.B. Cousins, "A Message to the Students," *El Rancho*, 1926.

3. Office of Institutional Research, A&M@K, Jan. 7, 2000.

4. Brendan I. Koerner, "Where the boys aren't," *U.S. News & World Report*, Feb. 8, 1999, 46–50; U. S. Census Bureau, Statistical Abstract of the United States, 1999, Table No. 262. http//www.census.gov/sgtatab/www/

5. "TAMUK presidential," *KR*, March 1, 1998, 1.

6. "The latest News: Recent News Releases," Texas A&M University System, Aug. 19, 1998. http:// tamusystem.tamu.edu/news/kingsvil.html (Accessed Sept. 21, 1999).

7. "Marc and Eddy Cisneros at home," *Proud Past, Promising Future: The Inauguration of Marc Cisneros* (Supplement to the *KR*, [March 5, 1999]), 6, UA, A1999–016, STA.

8. Marc Cisneros to George Cavazos Jr., Dec. 7, 1999, interview, STA. See also: David Adams, "An Overlooked hero . . . ," St. Petersburg *Times*, Dec. 20, 1999, in UA, A1999–052, STA.

9. "The Last Campaign of an Hispanic General," *El Defensor*, Aug. 30, 1998, 1.

10. "Operation Just Cause," FAS Military Analysis Network, Jan. 22, 1999. http://www.fas.org/man/dod–101/ops/just cause.htm (Accessed Sept. 21, 1999); "Key Events Summary," Operation Just Cause: Lessons Learned Volume I. http: call. army.mil/ call/ctc_bull /90 –91 key.htm (Accessed Sept. 21, 1999).

11. "Key Events Summary," Operation Just Cause: Lessons Learned Volume I. http:call.army.mil/call/ ctc_bull/90–91key.htm (Accessed Sept. 21, 1999).

12. "Operation Just Cause," FAS Military Analysis Network. 22 Jan. 22, 1999. http://www.fas.org/ man/dod–101/ops/just_cause.htm (Accessed Sept. 21, 1999).

13. "The Simpatico Soldier," *U.S. News and World Report*, July 30, 1990, 32.

14. Cisneros to Cavazos, Dec. 7, 1999, interview.

15. "The Simpatico Soldier," 32.

16. Cisneros to Cavazos, Dec. 7, 1999, interview.

17. "The Simpatico Soldier," 32.

18. Cisneros to Cavazos, Dec. 7, 1999, interview.

19. Ibid.

20. "The Simpatico Soldier," 32.

21. Cisneros to Cavazos, Dec. 7, 1999, interview.

22. "General Officer Announcement," Defense Link: U.S. Department of Defense, Reference No. 330–96. June 6, 1998, http://www.defenselink.mil/news/Jun1996/b060696_bt330–96.html (Accessed Sept. 21, 1999).

23. "10th generation *ST* returns to roots," *Proud Past, Promising Future: The Inauguration of Marc Cisneros* (Supplement to the *KR*, [March 5, 1999]), 4.

24. "Retired Army General," CC*Caller*, August 20, 1998, 1.

25. "Cisneros optimistic about TAMUK," *ST*, Sept. 10, 1998, 1.

26. "Ceremony Friday," *ST*, Feb. 4, 1999, 1.

27. "Cisneros outlines vision for university," *Javelina Bulletin*, March 17, 1999, 1.

28. "Cisneros Inauguration speech," UA, A1999–016, STA.

29. Ibid.

30. Ibid.

31. "TAMUK better than," *ST*, Jan. 21, 1999, 1.

32. Ibid.

33. Irma Rangel to Cecilia Aros Hunter, Oct. 26, 1999, interview.

34. "Cisneros Inauguration speech," STA.

35. Marc Cisneros to Cecilia Aros Hunter, Dec. 7, 1999, interview.

36. R.B. Cousins, "A Message to the Students," *El Rancho*, 1926, [n.p.].

37. Cousins, *Fifteenth Biennial Report* , 8–9.

38. Marc Cisneros to Cecilia Aros Hunter, Dec. 7, 1999, interview.

39. Cousins, *Fifteenth Biennial Report* , 18.

40. Steve H. Murdock *et al*, *The Texas Challenge: Population Change and the Future of Texas* (College Station: Texas A&M University Press, 1997).

41. Dallas *Morning News, The Texas Almanac and State Industrial Guide, 1931* (Dallas: A. H. Belo

Corporation, 1931), 133.

The illiteracy rate for Texas in 1910 and 1920: Native white—4.3 and 3.0 percent; Foreign born whites—30.0 and 33.8 percent; and, Negro 24.6 and 17.8 percent. See U. S. Department of Commerce, *Statistical Abstract of the United States*, 1926, (Washington, D.C.: Government Printing Office, 1927), Table No. 26.

42. "21st–century," SA*Express*–News, Dec. 30, 1999, B1.

43. "Facts Relative to South Texas Normal School District. . . ," University Archives–Legislative Battle for A&I, UA, A1999–028.014, STA; *The Texas Almanac*, 1931, 135–138; *The Texas Almanac*, 2000–2001, 130–284.

44. *The Texas Almanac* , 1928, 118.

45. Murdock *et al*, *The Texas Challenge*, 135.

46. *The Texas Almanac*, 2000–2001, 533.

47. Murdock *et al*, *The Texas Challenge*, 139.

48. Ibid, 135.

49. Ibid, 156.

50. Ibid, 136.

51. Ibid, 142.

52. Ibid, 144.

53. Ibid, 157–188.

54. "Dropouts' cost," SA*Express*–News, Nov. 2, 1999, B1; "21st–century Texas," SA*Express*–News, Dec. 30, 1999, B1; "Computer bug," SA*Express*–News, Jan. 2, 2000, B1.

55. Sharp, *Bordering the Future*, 50–51.

56. U.S. Census Bureau, *Statistical Abstract of the United States*, 1999, Table No. 272. http//www.census.gov/sgtatab/www/

57. U.S. Census Bureau, *Statistical Abstract of the United States*, 1999, Table No. 260. http//www.census.gov/sgtatab/www/

58. U.S. Census Bureau, *Statistical Abstract of the United States*, 1999, Table No. 263. http//www.census.gov/sgtatab/www/

59. U.S. Census Bureau, *Statistical Abstract of the United States*, 1999, Table No. 264. http//www.census.gov/sgtatab/www/

60. "UTEP focuses," El Paso *Times*, Dec. 18, 1999, 15A.

61. American Council on Education, *To Touch the Future: An Action Agenda for College and University Presidents*. (Washington, D.C.: American Council on Education, 1999), 5.

62. Ibid., 6–11

63. Ibid., 12–13.

64. Ibid., 17–26.

65. Cousins, *Fifteenth Biennial Report* , 11–20, 40.

66. Charles Spurlin to Leslie Gene Hunter, Jan. 7, 2000, interview.

67. "Fall Headcount Enrollment, Texas Public Universities, 1993–1997," Texas Higher Education Coordinating Board; "Headcount Enrollment by Classification, Ethnic Origin, Gender, Texas Public Universities, Fall, 1997," ibid; "Headcount Enrollment by Ethnic Origin, Texas Independent Senior Colleges and Universities, Fall, 1997," ibid; "Headcount Enrollment by Classification, Ethnic Origin, Gender, Texas Public Community and Technical Colleges, Fall, 1997," ibid. http://www.thecb.state.tx.us

68. Cousins, *Fifteenth Biennial Report*, 26.

69. Marc Cisneros to Cecilia Aros Hunter, Dec. 7, 1999, interview.

INDEX